THE
ARTIST'S CRAFT

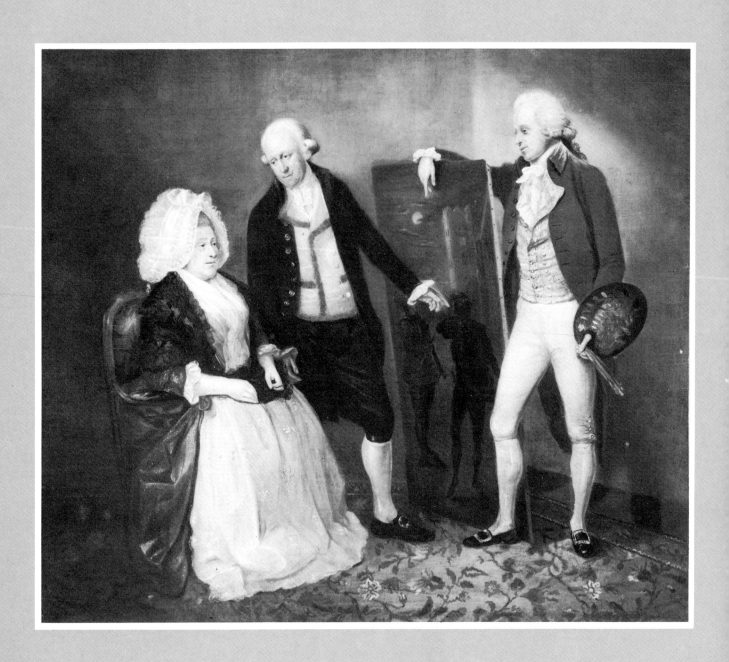

THE
ARTIST'S CRAFT

A History of
Tools, Techniques and Materials

JAMES AYRES

PHAIDON · OXFORD

Phaidon Press Limited, Littlegate House, St Ebbe's Street, Oxford, OX1 1SQ
First published 1985
© 1985 James Ayres

British Library Cataloguing in Publication Data

Ayres, James
 The artist's craft.
 1. Art—Technique—History 2. Artists'
 materials—History 3. Artists' tools—
 History
 I. Title
 702'.8 N5303

 ISBN 0-7148-2343-0

Typeset by BAS Printers Limited, Over Wallop, Hampshire
Printed in Spain by H. Fournier, S.A.–Vitoria

FRONTISPIECE
William Dunlap, *The Dunlap Family: The Artist showing a Picture from 'Hamlet' to his Parents*, 1788, oil on canvas, $42\frac{1}{4} \times 49$ in. (107.3 × 124.5 cm.). *The New York Historical Society*

OPPOSITE LIST OF CONTENTS
Panel of carved limewood on oak, school of Grinling Gibbons, late seventeenth century, $49 \times 51\frac{1}{2}$ in. (124.5 × 131 cm.), from Billingbear House, Berkshire (demolished in 1924). *Private Collection*

*For my painter mother, Elsa Grönvold,
and my sculptor father, Arthur J.J. Ayres*

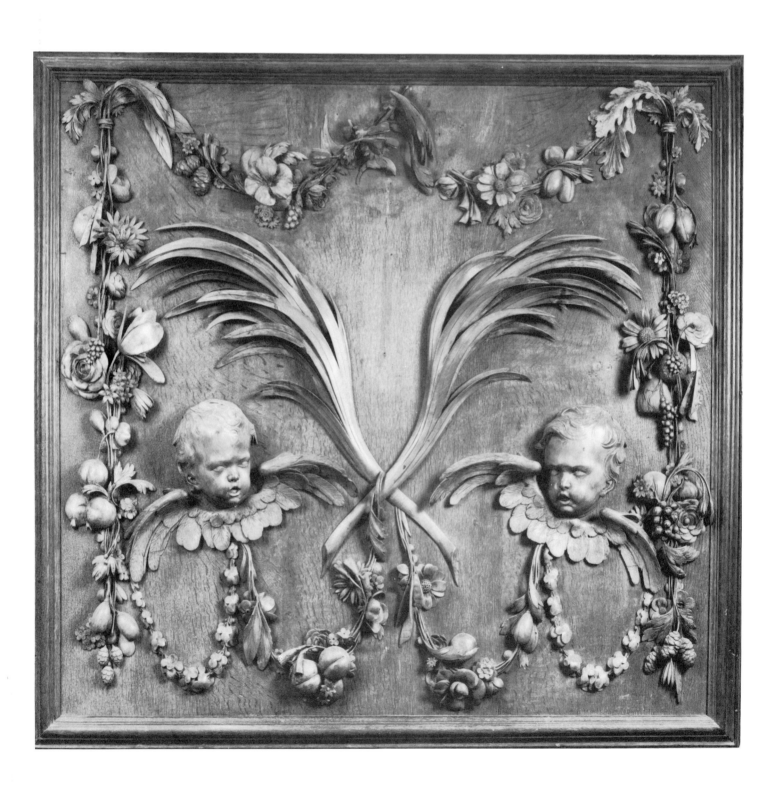

CONTENTS

FOREWORD 8

I INTRODUCTION 11
 The Prospective View 11
 Trade or Profession? 13
 Art or Craft? 15

II THE STUDIO 23
 Light and Colour 24
 Painters' Studios 32
 Sculptors' Studios 37
 Anatomy and the Human Figure 38
 Studio Equipment 45

III DRAWING 54
 Materials and Supports 54
 Auxiliary Devices 63

IV PAINTING 72
 Supports and Grounds 72
 Pigments, Media and Varnishes 86
 Painters' Supplies 111
 Hand Tools 111
 Palettes and Palette Knives 111
 Brushes and Mahlsticks 122
 Artists' Oil and Colourmen 126
 Framing 133

V SCULPTURE 147
 The Plastic Arts 153
 Modelling 153
 Casting in Plaster 161
 The Toreutic Arts 162
 Casting and Chasing Metal 162
 Die-Sinking 170
 The Glyptic Arts 176
 Carving in Stone and Marble 176
 Carving in Wood 189
 The Surface Treatment of
 Sculpture 202

VI POSTSCRIPT 210

APPENDICES 213
 1. Sizes of Frames 213
 2. Dating Canvases 213
 3. Reeves, Artists' Colourman 214
 4. A Sculptor's Tool-Kit 214

NOTES 215
SELECT BIBLIOGRAPHY 229
GLOSSARY 232
ACKNOWLEDGEMENTS 235
INDEX 236

FOREWORD

1 Georgio Vasari, from the second edition of his *Lives of the Most Eminent Painters, Sculptors and Architects* (1568).

It is my contention that the materials and tools used in picture making and sculpture are not simply important in relation to the way in which things were done – to history – but are central to our understanding and appreciation of existing work. This assertion is by no means original, but it is more often accepted as a conclusion than argued as a proposition. This book attempts to assemble some of the existing information and suggest new avenues of research. To keep the whole enterprise within manageable proportions much is omitted. The more theoretical aspects of perspective (as opposed to empirical observation of the phenomenon by means of a drawing frame or camera obscura) are excluded as such questions have been fully examined elsewhere. Similarly print-making is omitted, a craft for which the methods used are widely known, perhaps because so many of the procedures and materials are relatively recent innovations. In contrast, the daunting antiquity of the sculptor's techniques have inhibited the full development of an awareness of them. Much of this type of information may be found only through oral and visual history. For this reason the following acknowledgements are more than just that – they are a tribute submitted to those whose accumulated knowledge was conveyed to me by example and by word of mouth, craftsmen who were themselves a survival from a past that is unconnected with the craft revival of today. Among them was Mr Woollett, a mason and carver still working hard in his late eighties and who, as a young apprentice, assisted with the installation of Cleopatra's Needle on Thames Embankment in 1878; Sidney Newman, the letter cutter, and his brother Walter, the chief die-sinker to the Royal Mint; the carver and gilder Cerrio Fiaschi; and J. E. Clark, one of the last, if not the last, chasers of quality in Europe. There were also those who made tools, craftsmen like Pound or Grimes (with names like that they could only be smiths), whitesmiths who 'drew out' a sculptor's tools so that they were hard enough for their purpose and yet not so hard as

to be brittle. Non-fiction is inevitably autobiographical and I would not have had the opportunity of meeting any of these highly educated individuals had I not chosen my parents with care – my thanks to them for a background steeped in craftsmanship. This was the point of departure for an interpretation of further evidence.

Although numerous accounts of the chemistry of painting have appeared, the craft of that art is considered in very few works. I have therefore searched many publications for fleeting references to such matters and these are cited in the following pages. I am indebted to the British Library, the Bodleian, and Bath Reference Library. Trade cards have provided an important source of information for this book: the Ambrose Heal Collection in Bath Public Library and the British Museum (which also houses the Banks Collection) were abundant with detail. I should here acknowledge the Soane Museum for their holdings of drawings and manuscripts and Maya Humbly of the Drawings Collection of the Royal Institute of British Architects for her help with the history of drawing instruments and architects' 'linen'.

Artists' tools are more elusive. Sarah Postgate was good enough to assist in locating such items in the Department of Prints and Drawings at the Victoria and Albert Museum. Despite his personal interest in the importance of sculptors' tools, Anthony Radcliffe, the Keeper of the Department of Sculpture at the V. & A., had to admit that in the past his department had not acquired such objects. The best collections of tools and materials are to be found in museums of science – pigments (chemistry), claude glasses etc. (optics), as well as hand tools and measuring devices. The Science Museum in London and Dr Allen Simpson and Miss Alison Morrison-Low of the Royal Scottish Museum were most helpful. Academies of Art provide a further important source. These institutions, being primarily gatherings of people rather than things, tend to possess memorabilia associated with individuals. I am indebted to Miss Constance Anne Parker for her help at the Royal Academy at Burlington House and to Mr F. K. B Murdoch of the Royal Scottish Academy in Edinburgh.

Of the many other individuals that provided assistance, and who in no way may be held responsible for the use to which I have put it, I would like to record the following: Mr Timothy Bailey, Mr C. A. Bell-Knight, Mr Richard Constable, Miss Jeanne Courtauld, Dr Donald Crowther, Mrs Raymond Erith, Mr Ian Fleming-Williams, Mr John Hardy, Mr John Harris, Mr Hugh Honour, Mr John Keffer, Dr Dallas Pratt, Cdr. and Mrs Malcolm Shirley, Lord Snowdon, Mr Peter Staples, Dr Michael Weaver, Mr Kenneth Woodbridge, and Mr Andrew Wyld. Correspondence has been capably handled by Katie Skipper and assistance with picture research provided by Caroline Lucas. David Morgenstern of Phaidon Press brought his professional knowledge of publishing to the task with good effect. Finally no book is possible without a wife to type and edit the manuscript. To all these my thanks for their patience and help.

James Ayres
Freshford, 1984

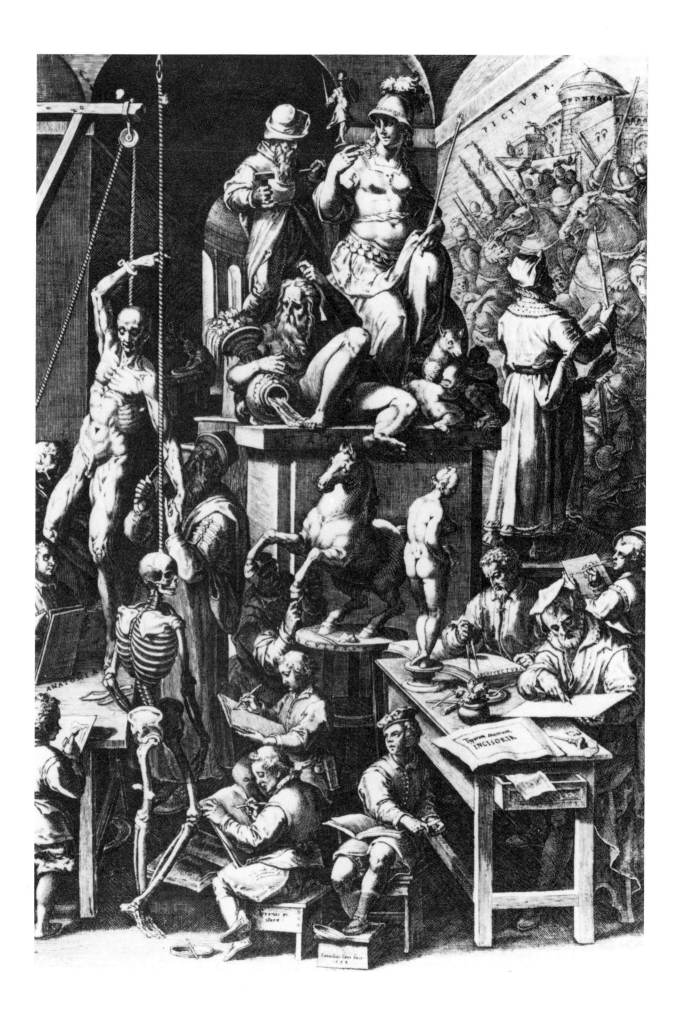

1 INTRODUCTION

The Prospective View

Curiously little has been published on the history of the physical manipulation of the various materials employed by sculptors and painters and the tools that have been evolved for their use. Few editions of Giorgio Vasari's *The Lives of the Most Eminent Painters, Sculptors, and Architects* (1550) include his introductory chapters on these matters, although he believed that they would 'delight those who are not engaged in these pursuits, and will both delight and help those who have made them a profession'. The dearth of information in print on the history of the artist's craft is probably because much of the existing literature takes a retrospective view based upon completed works. It is the separation of the practice of art from art history that has obscured the importance of the craftsmanship of painting and sculpture.

It is my intention to give a general and prospective history of the making process from the tools and materials to the completed work. A general survey of this kind would not be justified or possible were it not for the sparseness and scattered nature of the material and the universal and timeless values and needs of craftsmanship. For this reason the following chapters are not arranged chronologically although, where possible, the information within them is. In effect this book aims to provide an anthology of published and unpublished accounts which have been selected, organized, and interpreted in an attempt to give a coherent narrative which will serve to illuminate our understanding of the tools and techniques used in the making of sculpture and paintings.

The eighteenth-century designation of painting and sculpture as 'polite arts' would have had a debilitating effect in a less robust century. The term was used in order to improve the position of artists, but it was an uncertain compliment which virtually posed the question it was intended to answer. The exclusion of the 'visual arts' from the 'liberal arts' was a source of regret to many practising artists at this time. In their attempt to establish the intellectual respectability of their profession, they suppresssed or even denied the importance of the mechanics of making. In doing so they unconsciously denigrated the craft and made possible the trivialization of art. The badly made object as the basis for a well-constructed polemic has its genesis in the writings of painters such as Reynolds. They in their turn derived their views, directly or indirectly, from the elder Pliny who, as a good Roman, was aware of the contempt for manual labour that only the inherent contradictions of the slave-owning democracies of Greece could have produced.

The multi-layered shift in outlook that began in Italy in the fifteenth century resulted in an architecture that abandoned the sophistication of late medieval building in favour of the primitive post and lintel of Classicism. In the Middle Ages the weights and counterweights in the engineering of buildings were given sculptural emphasis, and in much the same spirit murals respected wall surfaces and did not destroy them with illusions of physical depth. In its resurrected form Classical architecture demanded much less embellishment and painters turned increasingly to the creation of movable pictures whilst sculptors found much of their employment in making free-standing statuary and commemorative monuments. The picture frame, and the pedestal and mural tablet, provided the means whereby the arts of painting and sculpture could be added as afterthoughts to an architecture that made little provision for them. In other respects painters and sculptors continued to use the techniques and materials of medieval craftsmen and to these were added new ones. Consequently, artists like Vasari and Cellini writing in the sixteenth century about the procedures that they and their contemporaries employed also throw light on the methods used by earlier generations of artists.

The artists of the quattrocento were inspired by the tenets of an élite whose privileges were

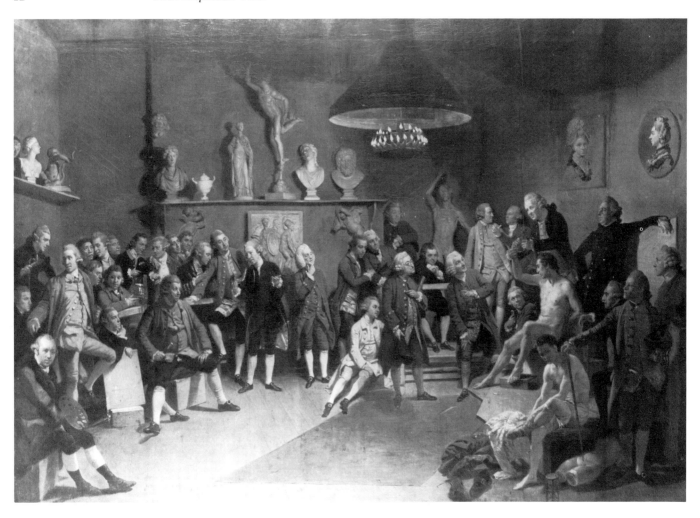

3 Johann Zoffany, *A Gathering of Members of the Royal Academy in the Life Room*, 1772, oil on canvas, 58 × 89¾ in. (147.5 × 228 cm.). *Royal Collection, Windsor Castle*

both material and intellectual. Against this the no less far-reaching upheavals in artistic thought that occurred in the second and third quarters of the nineteenth century were founded upon a more democratic but also more prosaic substructure. The art that emerged organically through industrialization freed painters from the drudgery and also the discipline of their craft. The commercial production and packaging of paints are central to the history of art in the nineteenth century. Although at least some of these innovations occurred in direct response to the demands of two painters, sophisticated colour theories and a passionate belief in *plein-air* painting were the result and not the cause of these technical improvements. British colourmen were in the vanguard of these developments from the 'colour-clothlets' of the medieval limner down to the appearance of bladder colours in seventeenth-century London, to the watercolour cakes of the Reeves brothers and onwards to the final triumph of collapsible metal tubes for oil paints. These, together with photography, were at the root of a revolution in painting, and therefore many British sources are cited in the following chapters.

The so-called craft revival of the 1970s was dominated by pottery and textiles. Historically the West has based craftsmanship on the practical needs of building. The words 'architecture' and 'art' somehow fail to acknowledge the vernacular skills of workshop tradition that produced a conscious craft capable of unconscious art. This education gave individuals the necessary basic skills; only some would become supreme 'craftsmen' and still fewer 'artists'. This tradition recognized making and designing as simultaneous activities which neither the Reformation nor the Renaissance could rupture. Its decline came with industrialization. At first, innovations like the fly shuttle (for weaving large canvases), watercolour cakes, the tube oil paints, and metal ferruled brushes assisted the development of landscape painting and furthered the social position of the painter by detaching him from many manual skills. Sculptors, despite the nineteenth-century development of carving machines and electrolytically produced works in metal,[1] remained curiously unaffected by many of these events, but they were to be greatly influenced by the changed position and working conditions of painters. Although industrial development created new patronage it would ultimately remove the need for much of the art-

ist's stock-in-trade with a consequent loss of vitality. The new vision that grew on the compost of that decline was inevitable. The eye of the past was rejected but so too were many of the methods, materials and tools. In these circumstances art historians have understandably tended to ignore the importance of tools.

This book is concerned with the skills of the hand in the art of the past. An understanding of the artist's craft may bring us close to the underlying truth of Oscar Wilde's assertion that 'there are moments when Art almost attains the dignity of manual labour'.[2]

Trade or Profession?

Towards the end of the eighteenth century a number of painters working in England developed an obsession with the 'Venetian secret'.[1] These artists, in their historical interests combined with their practical experience of materials, believed that Titian's genius could be attributed to the use of a secret medium. That these heirs to the Age of Reason should have fallen victim to such an extraordinary view is almost beyond belief; and yet Benjamin West became so convinced by the concoctions produced by Thomas Provis as to jeopardize his position as President of the Royal Academy. The whole episode demonstrates the confusion that arose between the practice and theory of art, a conflict of understanding for those painters and sculptors who had been trained in the traditions of workshop experience and who now aspired, as others had done before them, to the intellectual and social distinction which the Royal Academy[2] institutionalized and for which Reynolds's *Discourses* provided a manifesto.

In many respects the events surrounding the 'Venetian secret' were exceptional – otherwise it would not have provided the court and artistic community with so much satisfactory gossip. So long as art history remained the almost exclusive preserve of her practitioners,[3] reference to materials, tools or techniques are usually reliable. Curiously though, these writers were in general reticent about discussing those material questions that they were so well qualified to review. Why was this so?

One possible explanation may be found in Reynolds's fifth *Discourse*.[4] 'It is very natural', he observed, 'for those unacquainted with the *cause* of anything extraordinary, to be astonished at the *effect*, and to consider it as a kind of magic.' Again, in his first *Discourse*,[5] Reynolds makes reference to the orderly way in which a painter proceeds through various stages from the subject or idea to the preparatory draw-

ings and finally to the canvas; 'The pictures thus wrought with such pain, now appear . . . as if some mighty Genius has struck them off at a blow.' For a practising artist to have explained his methods – his 'kind of magic' – would have been tantamount to demythologizing the impact of the work.

For eighteenth-century artists the question of writing about their craft was a matter for the individual conscience or vanity, but for earlier carvers and painters brought up under the strictures of the guilds, secrecy was important to their craft, their 'art and mystery'. Perhaps this is why the identity and even the period of the author of *De Diversis Artibus* is uncertain although cloistered humility in his own declared explanation: 'an unworthy human creature, almost without a name.' The consensus of opinion is that Theophilus was an early twelfth-century German Benedictine monk, possibly Roger of Helmarshausen. These early books were written in manuscript and their circulation was therefore limited, perhaps to those who had themselves been admitted to a particular craft. The threat to the workshop solidarity over trade secrets came with the introduction of the printing press and many of the subsequent printed instruction manuals indicate a sense of betrayal. In the preface to the *Illuminir Buch* (1566, 1589, 1645) Valentine Boltzen[6] apologizes to his professional brethren for publishing their secrets but excuses himself on the grounds that no useful knowledge should be concealed, and John Elsum expresses the hope that his *The Art of Painting* (1704) will not cause 'offense to the Masters of the Mystery'. Padre Gesuato published in 1601 at Dort his *Secreti*,[7] an honest if provocative title. On 4 June 1677, 'Mr Comer the Painter' told Mary Beal 'as a secret, that he used black chalk ground in oil instead of blue black and found it a much better

4 Detail of a portable altar, gilt copper, *c.* 1100, by Roger of Helmarshausen, the possible identity of 'Theophilus'. *Franciscan Church, Paderborn*

MERCVRIO E PIANETO MASCHVLINO POSTO NELSECONDO CIELO ET SECHO MAPERCHE LA
SVA SICITA EMOLTO PASSIVA LVI EFREDO CONSVEGLI SENGNI CH SONO FREDDI EVMIDO COG
LI VMIDI ELOQVENTE INGENGNIOSO AMA LESCIENSIE MATEMATICA ESTIVDIA NELLE DIVI

5 Print of *c.* 1465
attributed to Maso
Finiguerra, illustrating
various trades and crafts,
including a painter
working *in situ* on a
fresco and an apprentice
grinding pigments. *British
Museum, London*

and more innocent colour.'[8] If the seventeenth-century Dutchman de Mayerne is to be believed, 'Bouffault, a very excellent workman, gave me these secrets [concerning "a beautiful green" pigment] on his deathbed.'[9] The importance of secrecy in the eyes of at least some artists evidently survived the advent of the printing press. Reynolds (despite his remarks cited above) makes derisive reference to the importance attached to the 'secrets' of their art by some who, like jugglers, lived 'in perpetual fear lest the trick should be discovered'.[10]

Not all artists were secretive. Thomas Bardwell published a book (1756) exclusively concerned with the 'practical part of art', as Edward Edwards termed it whilst making clear that Bardwell was of 'no very high rank' as a practising painter.[11] Edwards evidently shared Reynolds's belief in the 'intellectual dignity . . . that enobles the Painter's art; that lays the line between him and the mere mechanic'.[12] The painter Prince Hoare the Younger (1755–1834) was at pains to point to 'the personal rank conferred . . . on the collective body of Academicians or on particular individuals among them'. In this he had in mind 'The diploma granted to every Academician on his becoming a member of the body [which] has the Kings sign manual and gives him the rank of Esquire.'[13] Although in theory the position of artists in society could by the late seventeenth century be reasonably assured, in practice it was much less certain.

Towards the end of van Dyck's life, 'the King bestowed on him a wife, Mary the daughter of the unfortunate Lord Gowry which he meaned as a signal honour [but which] might be calculated to depress the disgraced family by connecting them with the blood of a painter.'[14] The difference between the actual and theoretical social position of the artist was well summarized by Prince Hoare: 'Our present system of opinions allows Painters to be of a liberal class, but will not allow men in the liberal classes to be painters.'[15] Financially, artists were more secure. The Swiss-born Jacques Antoine Arlaud (1668–1743) was 'designed for the church, but poverty obliged him to turn painter'.[16]

Artists were not immune to the vanities of a stratified society in which the laws of precedence gained in complexity with the rise of the middle classes. No wonder J. T. Smith (1766–1833) gloried in Sir Peter Paul Rubens and his 'seven brother knights of the pallet'.[17] These were the social conditions that doubtless persuaded artists to avoid discussion of their 'trade' and focus attention upon their 'art'.

The medieval 'picture drawer' or 'image maker' was in an anomalous position and since 'God himself was the first Plasticke worker,'[18] the princes of the early Church did not disdain to make objects of beauty.[19] Ultimately, such humility was not consistent with their temporal ambitions. Against this, the aspirations of craftsmen themselves probably improved following the Black Death which did so much to signal the decline of serfdom. The crafts, being of varying difficulty, were accorded varying degrees of respect. In his schemes for the Vatican City, Pope Nicholas V intended to keep 'the nobler and richer trades separate from the humbler'.[20] After the musicians, the first of these manual workers to establish their 'profession' were the physicians who shared with the painters the patronage of St Luke.

The Renaissance was something of a caesarian birth, the brutality of which cut across medieval Europe in a quite arbitrary way. Hybrid though its early progeny may have been, the literature of the Classical Mediterranean reasserted itself, to shape our prejudices and inspire a new vision.

As the artist emerged from the ranks of the artisan (or was it simply a semantic change?) the practice of art became socially acceptable as 'an amusement' for the élite. Some professional painters who were gentry, such as Sir Nathaniel Bacon (1585–1627), were compelled to maintain the fiction that they were but amateurs who dabbled in a spot of painting. Walpole cites many examples, perhaps the saddest being the daughter of the painter William de Keisar, who 'painted small portraits in oil . . . but marrying one Mr Humble a gentleman, he would not

permit her to follow her profession. After his death she returned to it and died December 1724.'[21] Others, like Mr Taverner the eighteenth-century proctor of the House of Commons, painted landscapes for their 'amusement'.[22] Some amateurs actually advanced their art, as was the case with Prince Rupert of the Rhine and his contributions to the development of the technique of mezzotint engraving.[23]

The freedom to dabble in the visual arts was one that had been known in earlier periods but it was given great authority by Baldassare Castiglione's book *The Courtier*, which gained a wider readership when translated into English in 1561. In it, Castiglione asserts that a woman's beauty can only be fully appreciated and enjoyed by a man who is capable of painting such a subject. Evelyn, in his *Sculptura*,[24] states that Lord Arundel considered that 'one who could not design a little, would never make an honest man.' The extraordinary nineteenth-century view that art and morality were linked has a long pedigree. In late Classical Greek art criticism there developed a special genre known as *ekphrasis*[25] in which works of art were discussed in a rhetorical and moralizing vein. With Classicism the idiom seems to have reappeared. Lord Kames, writing in 1817, argued that 'A taste in the fine arts goes hand in hand with the moral sense.'[26] Washington Allston echoes this view: 'next to the development of our moral nature to have subordinated the senses to the *mind* is the highest triumph of civilized taste.'[27] This highly cerebral notion that the 'mind' and the 'senses' may be divorced was fortunately not maintained by the American painter, who abandoned this high moral tone in favour of a more worldly approach: 'If ever the soul may be intoxicated, it is then, when it feels the full power of a beautiful bad woman.'[28] Eastlake was right: 'as the senses must be sensual the end cannot be too high and pure.'[29] This brings us full circle to the material if not the materialistic nature of art.

Art or Craft?

There was a time when 'art' was defined as 'skill' and 'craft' was 'strength'. The word 'artist' with all its attendant significance was unknown. It is comparatively recently, so the *Shorter Oxford Dictionary* informs us, that the word 'craft' has come to mean 'skill, art, occupation'. Vasari uses the word *artefici*, the meaning of which is closer in feeling to 'craftsman' than to 'artist'. In much the same spirit Christopher Wren alluded to 'The eminent Artificer Mr Gibbons'.[1] The artisan could then be an eminent personage. The shifting

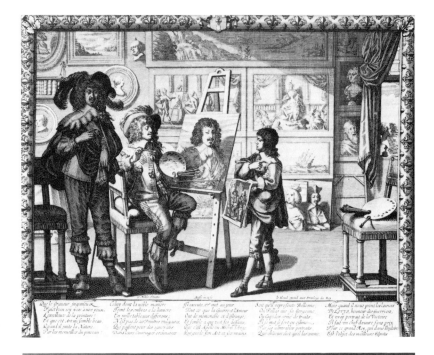

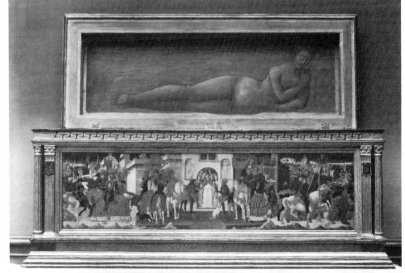

meaning of such words has been a continuous process reflecting the fluctuating status of the artist.

In reporting that Michelangelo was said to have made a snowman for Piero de Medici, Vasari evinces no surprise.[2] Writing in the sixteenth century he could look back to artists like Piero della Francesca painting a processional banner, to Uccello painting furniture and at least one clock-face, and to Donatello carving coats of arms for chimney-pieces and fronts of houses.[3] When Giotto agreed to paint a coat of arms on a buckler it was not the job but the client who proved to be beneath him.[4] Gradually though, a change developed in the notion of the 'master piece' and the status accorded to its maker. As a sample providing evidence of craft skill (demanded by the guilds) the masterpiece came to mean a demonstration of imaginative genius.[5]

6 Abraham Bosse (1602–76), *Le Noble Peintre*, engraving. *British Museum, London*

7 Mid-fifteenth century cassone painted with an allegorical scene, shown open to reveal a painting of a nude woman. In Renaissance Italy many distinguished painters decorated furniture. *Statens Museum for Kunst, Copenhagen*

8 Terracotta sketch model for a side table, height 7¼ in. (18.5 cm.), by the Dordrecht sculptor H. Noteman (1657–1734). Such objects question our notions of the 'fine' and 'applied' arts. *Simon van Gijn Museum, Dordrecht*

9 Side table designed by H. Noteman. The polychrome decoration is modern. *Hofje van Oorschet Collection, Haarlem*

10 The arms of the Masons and Coopers of Leith, Scotland – carved wood, painted, early eighteenth century. The achievement originally hung over the pew belonging to the guild in the parish church. The motto reads, 'The Hand of the Diligent Maketh Rich'. *National Museum of Antiquities, Edinburgh*

In the course of the sixteenth century a number of writers considered the relative merits of architecture, painting and sculpture. It was generally concluded that architecture was the vehicle for both painting and sculpture, and that the last two were sister arts born to the same father. J. T. Smith, developing the views of Lomazzo and Vasari, was of the opinion that 'Architecture should be considered the last mentioned of the sister arts, whatever some architects may entertain on the subject [since] . . . few would be enduced to travel twenty miles out of their way to see a house destitute of its collection.'[6]

The terms 'fine art' and 'applied art' (or 'decorative art') bedevil our understanding. It is a quite arbitrary division convenient (up to a point) for museum departments but otherwise meaningless. Is a sculptor's sketch model for a pier table an example of sculpture (fine art) or a furniture design (applied art)? The 'picture drawers' and makers of '*ymagines rotunde*'[7] were oblivious to such distinctions. Although their appropriate guilds protected the scope of their 'trades' they nevertheless acknowledged an equality with other craftsmen. One artefact could be the product of the members of different guilds, each having a separate area of responsibility. The post-Freudian assumption that an object of art, or an art object, is the product of the reflexes of an individual psyche is based on the premise that works of art are produced by one individual. Such an assumption is false. A portrait 'by' Kneller could include draperies painted by John Pieters[8] and a landscape background by Henry Vergazoon.[9] A work of art was often the product of a team. The solo performance of the prima donna was the exception.

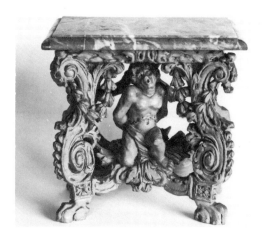

During the sixteenth century 'easel painting' began to assume the dominance that to some extent it retains. In Tudor England the painter-stainers and serjeant-painters to the crown became secondary to the many foreign artists who introduced the Renaissance following the Reformation. In discussing the alleged invention of oil painting by van Eyck, Eastlake argued that the Flemish painter simply refined an existing technique and that not the least of his achievements was to overcome the stigma associated with oil paint as being only suitable for use out-of-doors.[10] It is even possible that the introduction of canvas supports in place of panels was hindered by association with the 'stained cloths' of the 'inferior' painter-stainers. The serjeant-painter John de Critz is known to have gilded carriages: 'If this . . . should seem to debase the dignity of [a] serjeant-painter it may comfort the profession to know that Solimeni who was inferior to no painter of any age in vanity, whatever he was in merit, painted a coach for the present King of Spain when King of Naples . . .'[11] Despite the pressures to conform to the high social aspirations of their fellow artists, some painters in the eighteenth century remained loyal to the values of the craft traditions within which so many of them had been trained. Some like Dobie the 'Painter, Plumber and Glazier'[12] or

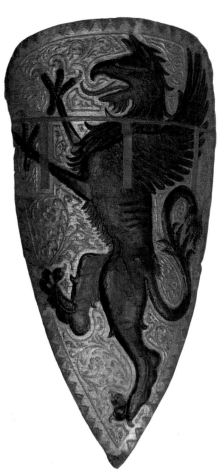

Borguis & Son, 'Figure, Ornament and House Painter and Gilder'[13] remained static within the trade; others turned to scene painting, like the Norwich drawing master Robert Dixon who, in 1805, advertised himself as a house painter producing 'Clouded and Ornamental Ceilings, Transparencies and Decoration in General'.[14] Edward Edwards refers to a number of easel painters who began their careers apprenticed as coach painters (among them Charles Catton, Richard Dalton and Joshua Kirby), as ship painters (Richard Wright) and as house painters (Tilly Kettle and Guy Head). These trades remained valuable training grounds long after they ceased to be held in respect and even after the foundation of academies and schools of art. William Williams in his little-known pamphlet *An Essay on the Mechanic of Oil Colour* (Bath, 1787) acknowledges the importance of such a practical background for the training of artists. After commending the establishment of the (Royal) Society of Arts 'for the encouragement of arts manufactures and commerce ... which encouragement brought forward many ingenious painters', he continues:

> ... then strange to tell! an order went forth for the abolition of signs to counteract them, signs were at that time the nursery and reward of painters, for great sums were expended on

11 Shield or pavoise with the arms of Villani of Florence, mid-fifteenth century, painted and gilded gesso over wood, artist unknown. Most artists in Renaissance Italy were prepared to undertake such commissions. *Victoria and Albert Museum, London*

12 Seventeenth-century stained hanging, 6 × 4 ft. (1.83 × 1.22 m.), Munslow Farm, Shropshire. The work of the 'stainer' was distinct in technique and sometimes in status to that of the 'painter'.

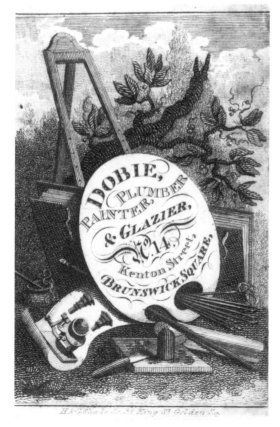

13 *The White Ram* (1846)
by William Bagshaw of
Rugby, who advertised as
a 'Plumber and Glazier
. . . and artist'. *Kalman
Collection, London*

14 Trade label for Dobie,
a 'Painter, Plumber and
Glazier'. *British Museum,
London*

those ornaments, and the best artists of the age
employed in executing them, 'twas necessary
to be sure to alter their situation (which were
become a nuisance) but not to abolish them
entirely, and now the bull, the lion &c, are
fled, and left only their names behind; for-
merly too, coaches were embellished with
historic or fancy compositions &c. which
gave employment to genius, now those beauti-
ful ornaments are disused, are removed to
make room for the unmeaning stuff or pur-
chased heraldry [ormolu mounts?], vain
ostentations of upstart pride! another, and 'tis
almost a shame to mention so depraved a
taste, but that many an artist has been hurt
by it, I mean that ridiculous and disgusting
fashion of introducing shades, that ABC of the
art with which the genteelest apartments are
disgraced and blackened by a group of
caffries.

These were no little blows given to the
arts.[15]

Quite apart from the distinctions between dif-
ferent types of painting were those of subject
matter. Pliny objected that whilst few could rank
above Peirakos in the mastery of his art, his suc-
cess was marred by his lowly subject matter

which included barber's shops, cobbler's stalls, asses and still-life compositions.[16] The most obvious example of this preoccupation with the status of subject matter was the eighteenth-century belief in the superiority of history painting. John Elsum in *The Art of Painting* (1704) goes even further by considering the 'quality' of the client and argues that painters should 'suit their works to the quality of the place and person'.[17] However, the importance of a work of art lies not in its subject matter and still less in its original client but in the handling of the work, the 'form' rather than the 'content'. This is what Washington Allston meant when he wrote that 'Titian, Tintoret, and Paul Veronese, absolutely enchanted me, for they took away all sense of subject . . .'[18] It therefore follows that since the form has more potential to be influenced by the material than the content, an understanding of the historical evolution of the 'media' as an influence on the 'message' is of central importance.

Apart from the disposal of pictures in a house

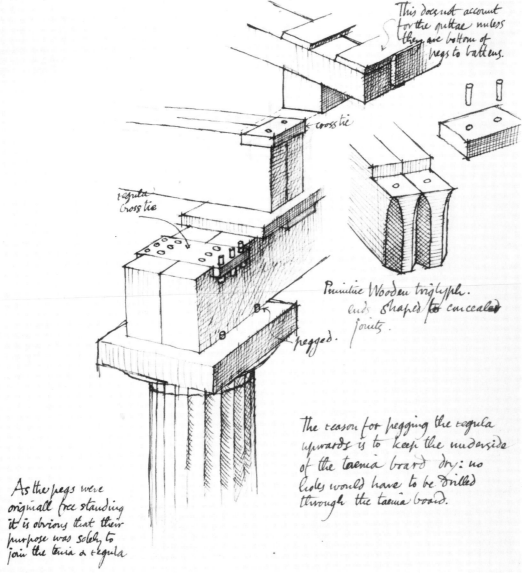

15 Pendentive boss (*c.* 1600), Chelvey Court, Avon. This extraordinary example of plasterwork was apparently inspired by masonry, where the projecting block of stone would have been built flush into the fabric of a vault or ceiling.

16 Drawing by the late Raymond Erith showing the possible timber origins of the Doric order.

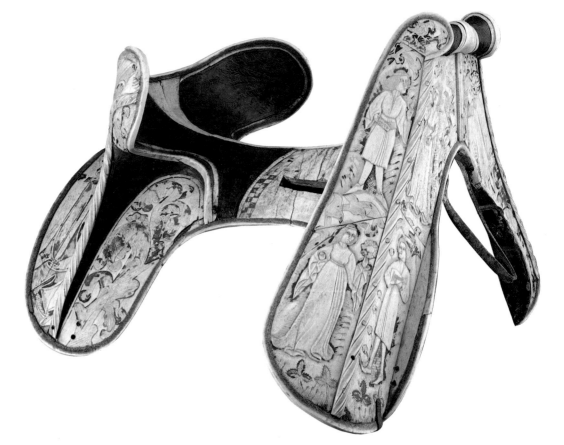

17 Parade saddle of King Ladislaus of Bohemia, 1455, wood covered with ivory, carved and painted. There was a close association between the trades of the saddle-maker and painter. *Kunsthistorisches Museum, Vienna*

18 William Williams, *Portrait of a Gentleman and his Wife*, 1775, oil on canvas, $33\frac{3}{16} \times 39\frac{1}{8}$ in. (84.2×99.4 cm.). Williams, the first teacher of Benjamin West, has also been acknowledged as the first American novelist. In addition, he was the author of the little-known pamphlet *An Essay on the Mechanic of Oil Colours* (1787). *Henry Francis du Pont Museum, Winterthur, Delaware*

OPPOSITE
19 The Adam and Eve design in gouache on paper, 14×10 in. (35.5×25.4 cm.), for a sign with a carved wood frame – probably London, third quarter of the eighteenth century. The Adam and Eve was often used as a sign for fruiterers. Harp Alley, Shoe Lane, became a centre for the production of signs, and the trade of sign painting, like coach and house painting, provided many young easel painters with their first introduction to the skills of the artist. *Eyre & Hobhouse, London*

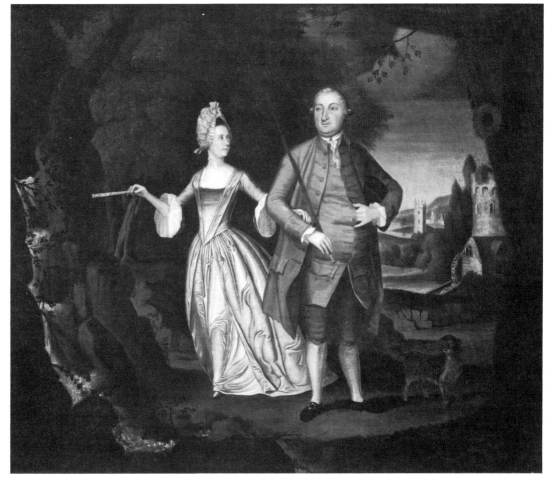

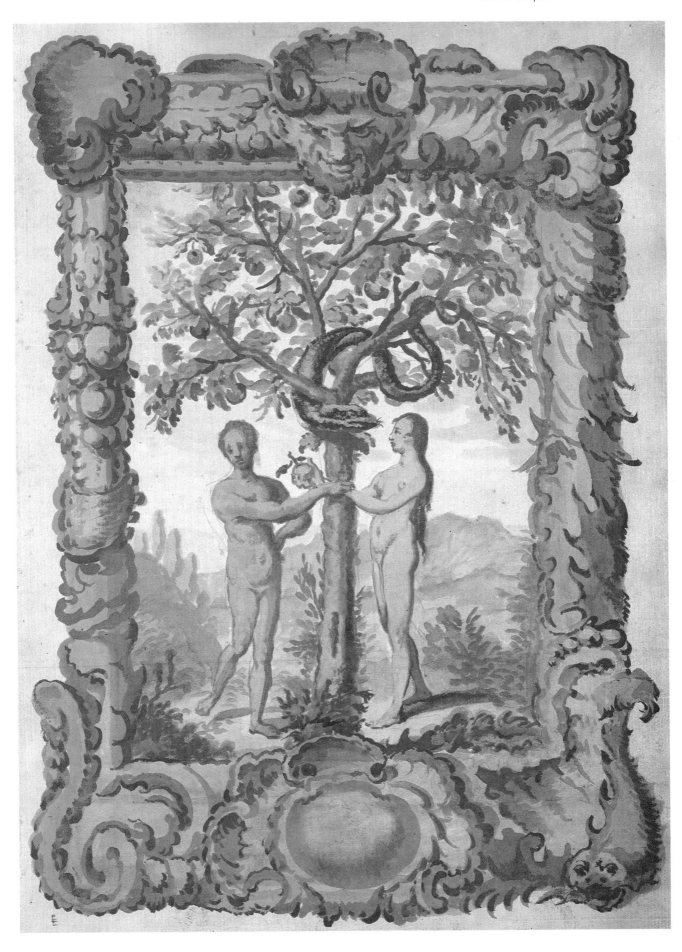

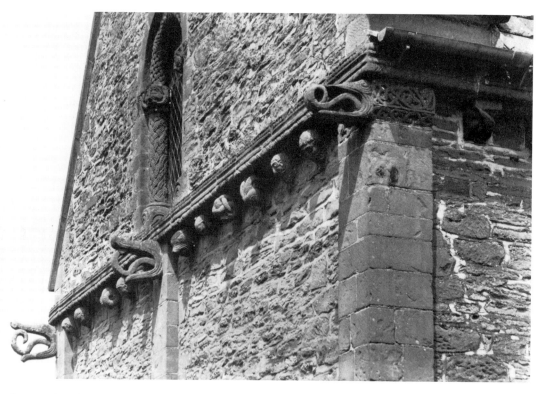

20 Kilpeck Church
(*c.* 1140), Hereford and
Worcester. The possible
Scandinavian origins of
these stone dragon heads
is indicated by their form,
which was evidently
evolved in wood.

21 Gol Stave Church
(twelfth century),
Norway. Detail of a
timber dragon head that
decorates the roof.

or houses their location within a room may have indicated the esteem in which they were held. Overmantel pictures, perhaps because they were exposed to smoke damage, and overdoor pictures, because they were all but out of sight, were held in little regard as 'furnishing pictures', whilst 'chimney boards' were not considered as pictures at all.

In the seventeenth and eighteenth centuries the medieval 'image makers' became the 'figure makers' and both David Crashlay[19] and Francis Pillgreen[20] advertised themselves as such in eighteenth-century London. The multifarious activities of 'masons and carvers' like James and Elizabeth Annis of Aldersgate Street, London, indicate no false pride. Their trade card announced that they did work 'In the most Modern and Curious manner, consisting of marble Monuments, Tombs, Chimney Pieces &c. Also performs All sorts of Mason's works whatsoever necessary to Building And are well acquainted by great Experience in [the needs of] all sorts of Brewers, Chemists, Dyers, Soap Boilers & Sugar Bakers works . . .'[21] Many sculptors, such as Parker and Harris of the Strand, listed themselves simply as 'Statuaries'. Such men were masters of large workshops and throughout the nineteenth century it was they, rather than the art schools, that provided the basic craft education for many sculptors.

The distancing of artists from their craft became general in the nineteenth century, but it was a trend that had begun much earlier. By the early seventeenth century the dominance of architects over master masons and carpenters in

the design of buildings was established and at about the same time some painters assumed precedence over some sculptors. The artificial division between design and production may have been convenient and even necessary for the purposes of industrialization, but it has had far-reaching effects upon the practice and understanding of the visual arts. Materials began to be used capriciously, construction became less important than effect. In some ways the arbitrary use of materials had been seen earlier through tradition – that very different cause. The best-known example is the presumed timber origins of Classical architecture executed in marble. Neither was a reversion from stone to wood unknown. The dragon heads of Kilpeck Church bear mute testament to the influence of Viking Scandinavia where such details were more easily accomplished in softwood rather than in stone. The post-Renaissance designer was invested with a power that had previously been reserved for the natural evolutionary processes of craftsmanship. This power could be used at whim, it could be wayward. The reaction was inevitable. The Arts and Crafts Movement, despite its supposedly 'progressive' leader, was flawed and is now chiefly remembered for the wallpaper so easily produced by the despised machinery. The Pre-Raphaelites used a post-Raphaelite medium. Although Eric Gill was much concerned with direct carving, he is now chiefly remembered for his linear design and, together with Johnson, for his lettering. Perhaps in the end these men were writers with a compulsion to make, rather than makers with a compulsion to write.

II THE STUDIO

The tools and equipment in a painter's or sculptor's studio are close to the activity of his art. They tell us more about his work than does the detritus of a writer's desk or the contents of an actor's wardrobe. The physical nature of painting and sculpture may be comprehended not only through the work itself but also via the tools used. Through them the act of creation is palpable. Even in the absence of such equipment few could enter Lord Leighton's great establishment in Holland Park Road, London, and not be awestruck by its large studio, its eclectic splendours, its confidence. It is, in short, a concatenation which puts us in direct touch with the worldly success and scale of this eminent Victorian's work. Here the status of the artist and the grandeur of the studio reached its zenith in the social and political life of late nineteenth-century England. Leighton's studio stands, so to speak, as a living mausoleum to that achievement. In it a nice balance was reached between Bohemian daring and good solid bourgeois upholstery. The models who posed nude arrived at a special entrance leading to a back stairway that took them directly to the east end of the studio.[1] Discretion was everything.

The ateliers of the rich and successful are not the only cause of the romance of the studio, and although for poor and struggling artists discomfort could be the ever-present reality, it is the romance that persists. The glamour of these truths and fictions have combined to create meaningless commodities like the 'studio flat' and the 'studio couch'.

'The studio' of popular imagination was virtually an invention of the nineteenth century. Its appearance owes much to the growing importance of history painting in the eighteenth century. Art produced speculatively (like building) was no longer the exception but the rule, and the large canvases both for history and landscape painting resulted in the need for larger, and consequently more important space in which to work. By the mid-nineteenth century, when *plein-air* landscape painters were becoming more

numerous, work 'on location' tended to be brief and seasonal and the need for a studio remained. The 'artists' stampede' in May which marked the summer evacuation of the well-known Tenth Street studios in New York (built 1857, demolished 1955) did nothing to diminish their importance for the remaining three-quarters of the year.[2]

Before the creation of academies, their schools and galleries, sculptors and painters produced so much work on commission *in situ* that their 'workshops' were of much less consequence than they later became. Sir Charles Eastlake noted that the early Italian masters had the 'advantage of first displaying their works to the public in the situation they were ultimately to occupy'.[3] Not all artists responded well to these circumstances and Vasari condemned those whose works looked better in the workshop than *in situ*.[4] Among the disadvantages of working 'on the spot' may be included the discomfort of working out of doors in winter, a lack of 'hammer room' for sculptors, a draughty location for gilders, poor drying conditions for painters and possibly a general lack of light. Mariotto Albertinelli (1474–1515) insisted on working his panel painting of *The Annunciation* in its final location and to enable him to do so 'he caused special windows to be made.' This was especially remarkable with a movable panel painting (the work now hangs in the Accademia in Florence).[5] Despite all these difficulties and the extremes to which artists went to circumvent them, working *in situ* remained and remains important for both painters and sculptors. Apart from matters of conscious deliberation, of adapting the work to the circumstances in which it is seen or even responding to the comments of passers by, the artist absorbs unconsciously the spirit of the place.

In attributing works of art to a particular 'school', art historians refer to 'the studio of' or 'studio copy after'. In this scholars are often employing a metaphor retrospectively to periods more familiar with terms like 'the painting

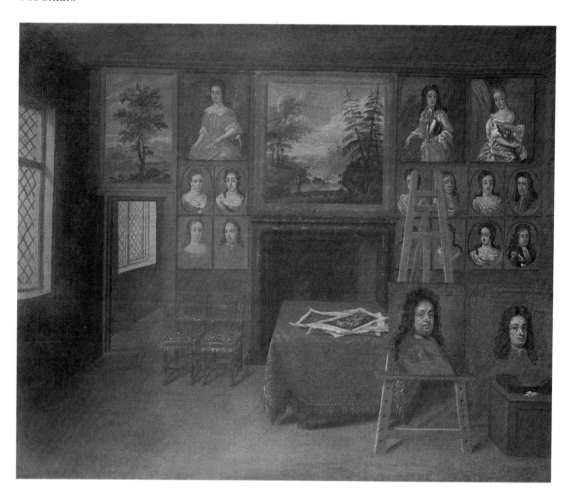

22 *The Painting Room*, English school, late seventeenth century. This very rare record illustrates the domestic character of the rooms in which painters worked. *Private Collection*

23 Rembrandt's House and Studio (with red shutters) in Amsterdam.

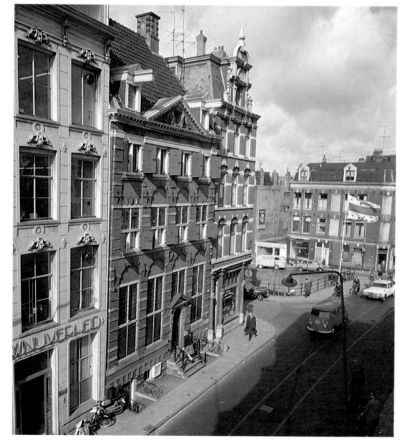

room'. As its name implies, this was a room, domestic in character, used for painting. Raphael's father, Giovanni Santi (1435–94), now best known for his belief in mothers breast-feeding their own babies,[6] worked in such a room which miraculously survives in Urbino.

Whatever term is used to describe their places of work, painters ideally sought different conditions to those required by sculptors. Furthermore, the cold, impersonal, north-facing skylight may have created an appropriate theatre for the productions of the history painter, but it would have been inappropriate to the intimate and domestic needs of portraiture, the basic stock-in-trade of most painters. The domestic character of most painting rooms of the eighteenth century or earlier probably accounts for the few descriptions of them in surviving literature. Early drawings and paintings reaffirm the domestic appearance of such rooms whilst displaying the paraphernalia of their use.

Light and Colour

The most important feature of a painter's studio was daylight. In early periods when glass was a scarce and valuable commodity artists probably

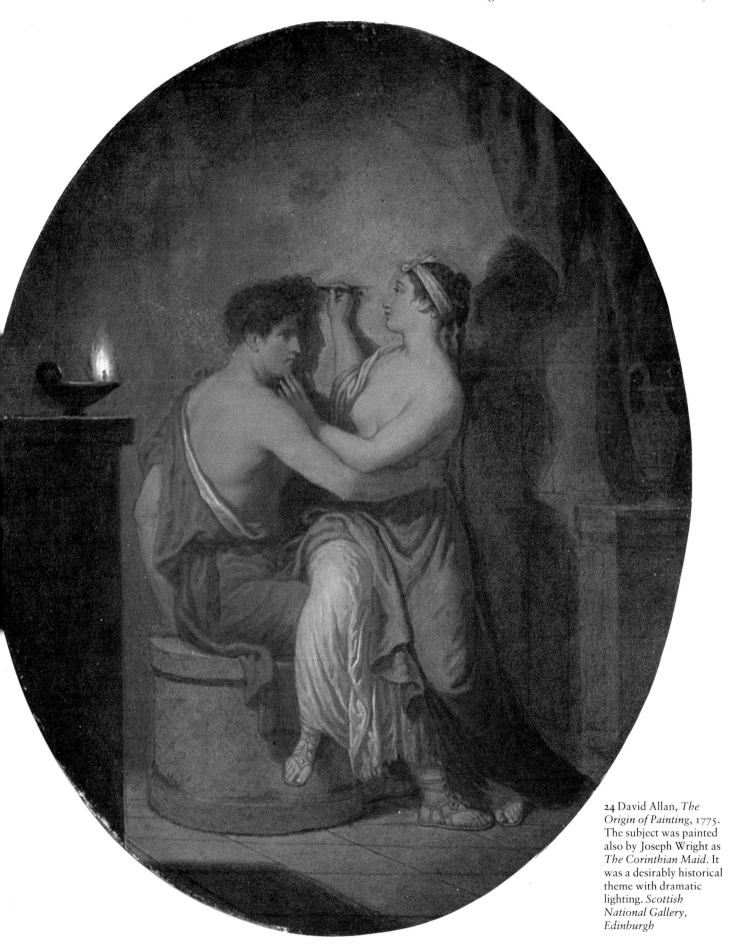

24 David Allan, *The Origin of Painting*, 1775. The subject was painted also by Joseph Wright as *The Corinthian Maid*. It was a desirably historical theme with dramatic lighting. *Scottish National Gallery, Edinburgh*

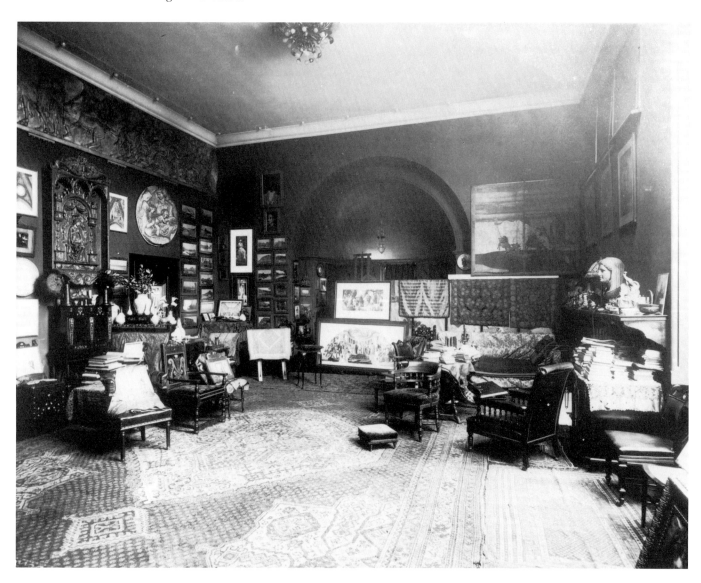

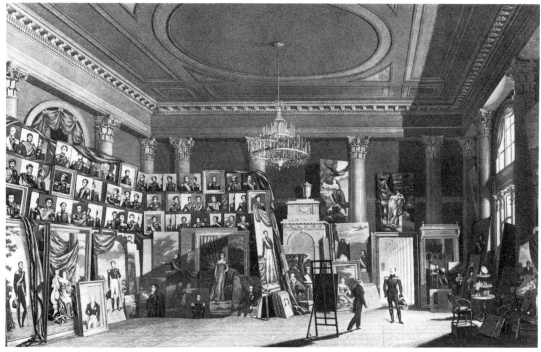

25 The Great Studio in Lord Leighton's house, London (completed 1866). The grandeur, size, scale and drawing-room atmosphere are typical of the studios built by successful painters in the second half of the nineteenth century.
Photo: Royal Borough of Kensington and Chelsea Library, London

26 George Daw visited in his painting room in the Winter Palace by Alexander I. The portraits are of generals who fought Napoleon, painted for the Military Gallery.

followed the usual practice of covering their window openings with fenestrals of waxed linen or paper.[1] Sir Hugh Platt's *The Jewel House of Art and Nature* (1594) gives instructions on how these should be made of parchment or paper, oiled and stretched on a frame, with the additional recommendation that they add privacy by excluding the prying eyes of 'overseers'.[2] By the seventeenth century, glass for windows was coming into general use, but as late as 1774 le Vieil commented that in Paris paper windows were found exclusively in the studios of painters and engravers.[3] This must have produced the effect known as *la lumière mysterieuse* which Soane in his *Lectures on Architecture* considered 'so successfully practised by the French Artist'.[4] The diffuse light offered by such windows had the invaluable effect of reducing the variables of daylight to a more constant level. A similar precaution is sometimes still taken by painters: Braque, for example, whitewashed the south-facing windows of his studio and hung them with linen blinds. Photographers regularly use cages covered with tissue paper to produce a similar effect. In 1821 William Dunlap (1766–1839) was forced to move an exceptionally large canvas he was working on to the garret of the house he occupied 'with conflicting lights all below the centre of the cloth'.[5] The use of translucent blinds would have helped to reduce his difficulties. In Rembrandt's drawing of *A Model in the Artist's Studio* (c. 1655)[6] the cloth shown raised over a window to reflect light down could also have been lowered to produce a diffused light. Rembrandt's studio in Amsterdam faced north over the Breestraat and its four windows

were fitted with shutters which could be used to further control the light.[7]

Above all other considerations, artists working in the northern hemisphere have sought a north light where the variables of direct sunlight are reduced to a minimum. Hilliard (1547–1619) is most precise on this point:

> Conserning the light and place wher yo worke in, let yr light be northword, somewhat toward the east which comonly is without sune, Shininge in. On[e] only light great and faire let it be, and without impeachment, or reflections, of walls, or trees, a free sky light the dieper the window and farer, the better, and no by window, but a cleare story.[8]

Hilliard had a natural preference for line which 'showeth all to good Iugment' whereas 'shadowe without lyne showeth nothing'.[9] Nevertheless, his preference for a top or clerestory light may have had something to do with a conversation he records between himself and Elizabeth I. After discussion with Her Majesty he 'afirmed that shadowes in pictures weare indeed caused by the shadow of the place, or coming in of the light as only one waye into the place at some small or high windowe which many workmen couet to worke in for ease to their sight, and to giue vnto them a grosser lyne,' whereupon Her Majesty 'conseued the reason, and therfor chosse her place to sit in for that porposse in the open ally of a goodly garden, where no tree was neere, nor anye shadowe at all.'[10] In general, painters have preferred to work in a room with a large side light rather than a top light. For this reason their studios, unlike those of sculptors, may

27 Federico Zuccari (c. 1540/3–1609), *Michelangelo watching Taddeo Zuccari at Work.* The rise in the importance of easel painting has distanced artists from their public and given them less opportunity for working *in situ. Albertina, Vienna*

28 The Tenth Street Studios (built 1857, demolished 1955), Greenwich Village, New York, as they appeared in 1906. *Photo: New York Historical Society*

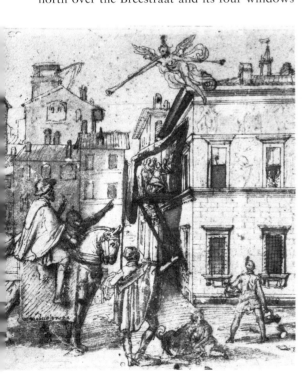

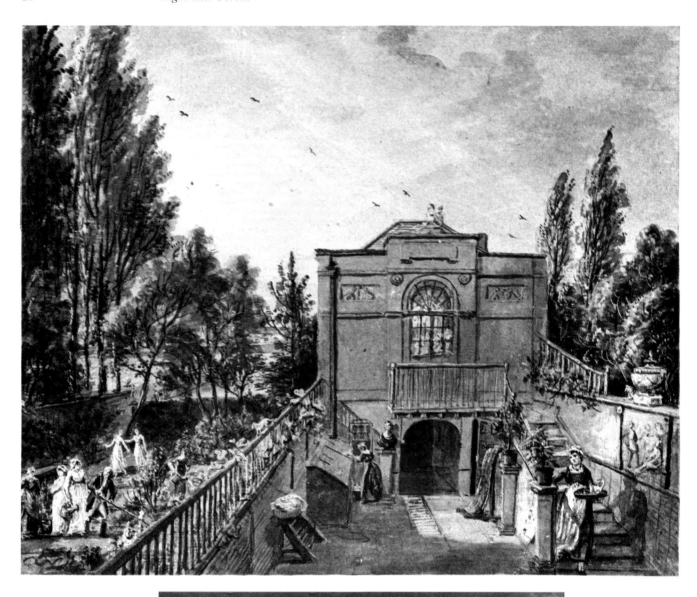

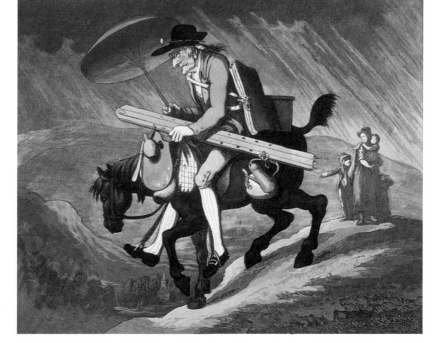

29 Paul Sandby, *The Artist's Studio* (4 St George's Row, Bayswater), *c.* 1800, watercolour on paper, 9 × 11 in. (23 × 28 cm.). *British Museum, London*

30 Thomas Rowlandson, *An Artist Travelling in Wales,* coloured aquatint, 1799. *British Museum, London*

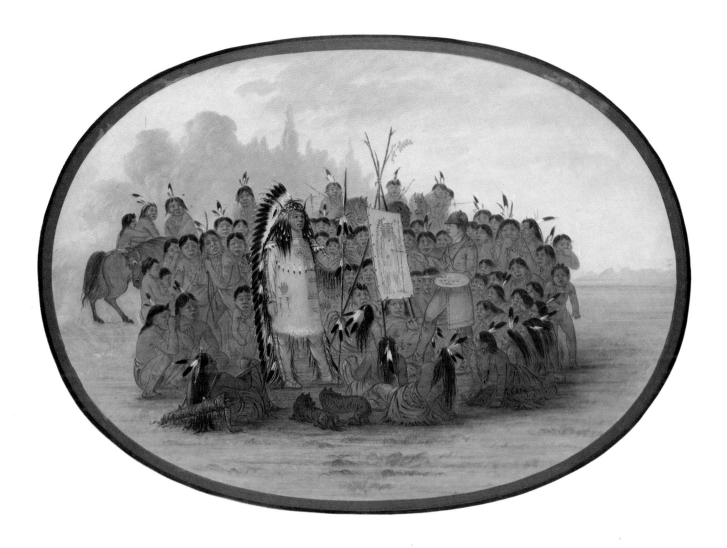

occur at any level in a building. With great precision (necessary for an American working briefly in London) Dunlap refers to his 'painting room on the first floor, or second story'.[11]

Although the movement of the sun no longer regulates our lives it would be a mistake to assume that artificial light was unimportant before the days of gas and electricity. It is the use of artificial light which is the one constant factor in most of the early illustrations of the first academies of art. These institutions were for the most part used by working artists or their apprentices whose leisure hours were necessarily after dark. Candles were of course expensive until recent times, and the single source of light and the range of ages from apprentice to master are clearly illustrated in Agostino Veneziano's engraving of the Academy of Baccio Bandinelli (1493–1560). These academies, perhaps unwittingly, fostered the fashion for chiaroscuro that Caravaggio (1573–1610) and his followers, the Caravaggisti, made so popular.[12] Of course, although these paintings were inspired by artificial light, they were created in daylight, as Walpole explains in his description of Godfrey Schalcken (1643–1706):

A great master of tricks in an art, or the mob could decide on merit . . . his chief practice was to paint candle-lights. He placed the object and a candle in a dark room, and looking through a small hole, painted by day-light what he saw in the dark chamber . . . he once drew King William, but as the piece was to be by candle-light, he gave his majesty the candle to hold, till the tallow ran down upon his fingers. As if to justify this ill-breeding he drew his own picture in the same situation.[13]

The association between 'the evening class' and candlelight occurs again in the story of Sir James Thornhill (1646–1734) taking a profile drawing of Charles Christian Reisen (1679–1725), the Anglo-Norwegian seal-engraver and director of Sir Godfrey Kneller's (1646–1723) Academy. To this drawing the poet 'Mr Prior' added the following 'districh':

31 George Catlin (1796–1872), *The Artist at Work painting Indians on the Plains*, 1857–69. The itinerant artist was compelled to improvise. According to Dunlap, Catlin had no competitors as an artist 'among the Black Hawks and White Eagles, and nothing to ruffle his mind in the shape of criticism'. *National Gallery, Washington, DC*

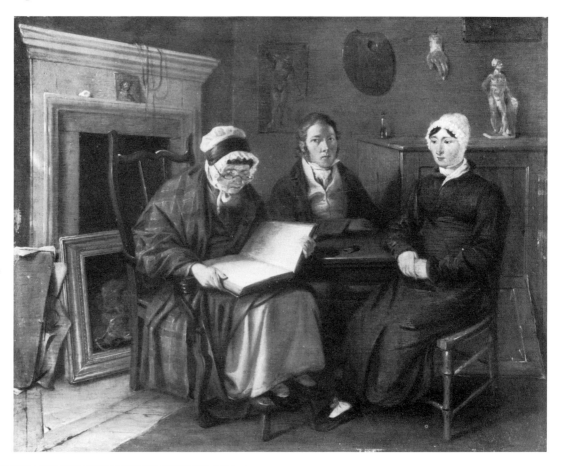

32 Alexander Carse (active 1808–36), *The Artist with his Mother and Sister*, oil on panel, 8½ × 10¾ in. (21.7 × 27.5 cm.). This simple Scottish genre painter has given a clear insight into the appearance of the early nineteenth-century 'painting room' before the 'studio' became commonplace. *Scottish National Portrait Gallery, Edinburgh*

33 Rembrandt, *A Model in the Artist's Studio*, *c.* 1655, Indian ink on paper, 9¾ × 7½ in. (20.5 × 19 cm.). The lighting in the studio could be defused by dropping the gauze over the window or, as here, lifted to provide reflected light. *Ashmolean Museum, Oxford*

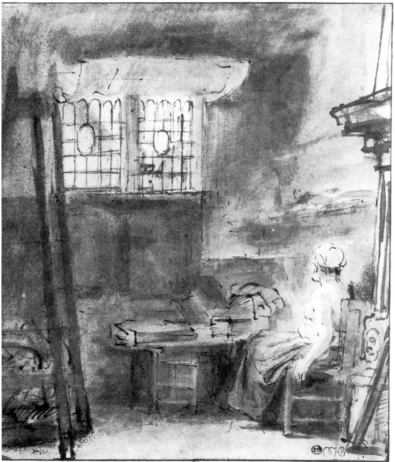

This drawn by candle-light and hazard
Was meant to show Charles Christian's muzard.[14]

The reference to 'hazard' in art shows that David Pye's thesis, which has found many disciples in the United States, concerning 'the workmanship of risk and the workmanship of certainty' has a long history.[15] The Elder Pliny describes drawing a profile with the help of a shadow cast by a lamp,[16] an invention celebrated in David Allan's (1744–96) canvas, *The Origin of Painting* (The Maid of Corinth, 1775),[17] and in *The Corinthian Maid* (1782–4) by that great English exponent of chiaroscuro, Joseph Wright of Derby (1734–97).

The greatest disadvantage of candlelight was the high cost of candles. When the Protectorate disposed of the Royal Collections by tender in 1653, 'Part of the goods were sold by inch of candle',[18] and in the late eighteenth century the sculptor Nollekens regarded a candle as 'a serious article of consumption'.[19] Nevertheless, some artists persisted in using candlelight, among them Abraham Hondius who 'frequently painted by candle-lights'.[20] As the grandson of Jodocus, 'an engraver of maps', it was just possible that the younger Hondius found recourse to a device much used by engravers. This was a method of increasing the feeble light produced by a single candle by means of a water-filled,

clear glass globe. Sir Hugh Platt in his *The Jewel House of Art and Nature* (1594)[21] attributes the origin of this device to Venice, and with the glass-works at Murano this is quite possible. He adds that such a gadget was used by a jeweller at Blackfriars, a district in London that with its royal workshops seems to have been much favoured by artists and other craftsmen in the late sixteenth and early seventeeth centuries.[22] John White in his book of 1651 gives instructions on making this device which, he assures the reader, will give 'a glorious light with a Candle like the Sun Shine'.[23]

In exhibiting paintings the source of daylight was almost as important as it was for painting them. For example, in a portrait in which the cast shadows of the nose and other features are quite significant, they will become distractingly notice-able if not lit from the appropriate side when finally hung – although top lighting is at least neutral. A more obscure but no less important consideration relates to paintings with a strong impasto. In such works the artist unconsciously accommodates within the picture the shadows cast by the physical relief or texture of the paint. In hanging paintings of this kind every attempt should be made to reproduce the incidence of the light in which they were created. It was probably with this in mind that John Constable (1776–1837) wrote to M. Jolly in Brussels in 1833 regarding the exhibition of one of his pictures there: 'May I presume to suggest, without arrogating to *myself any particular favour*, that I should much prefer the light coming from the left side (on) of my picture, and . . . placed about level with the eye should such a situation con-veniently offer itself.'[24]

A number of artists owned private galleries attached to their houses,[25] among them T. M. Richardson of Newcastle (1784–1848) whose gallery was not top lit.[26] Following Benjamin West's death on 11 March 1820 his sons, Raphael and Benjamin jnr., built a gallery wing on their father's Newman Street house as a showroom for the sale of his work. This gallery, which was designed by John Nash, measured 70 by 43 feet and cost between £1,500 and £2,000 to build. Its

top lighting, which was confined to the walls leaving the central ceiling unglazed, was advanced for its time and was influential on the design of later picture galleries. Nash's earlier gallery (of the 1790s) at Attingham Park, Shrop-shire, and the picture gallery at Somerly, Hampshire, designed by (and for) the second Earl Normanton (*c.* 1850), both incorporate this feature.[27]

The use of candlelight by sculptors was rare. Nevertheless, to make sure that the quality of 'the exterior surface, as it were' was perfect, Antonio Canova (1757–1822) generally com-pleted a marble by candlelight.[28]

Another feature affecting lighting was the col-our scheme of the walls. Documentary evidence is not easily interpreted since the distinction between rooms used for painting and those reserved for the display of paintings is not always clear. In general, artists probably preferred neutral colours for their painting rooms, and pic-tures of artists' studios generally support this view. Distinctive or dramatic colours may have been all very well for the display of pictures, dark red and dark green having been popular for this purpose for much of the eighteenth and nine-teenth centuries, but in the working studio such colours would have been a distraction to the art-ist and would have tinted the reflected lights on his subject. Some artists appear to have ignored such basic matters. In *The Looking Glass* (1805) Theophilus Marcliffe describes a painter's studio of the late eighteenth century:

> The painting-room of an artist was a new scene to him . . . He admired the green baize with which the room was hung, and the magnitude of several of the pictures which were placed against it. I suppose he had never till this time seen a painting larger or better than the sign of a London inn.[29]

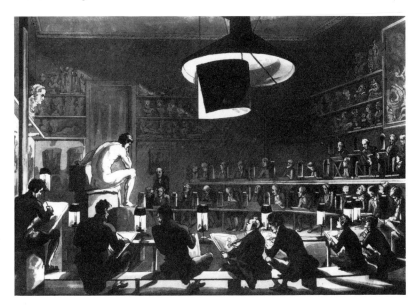

34 Woodcut from John White's *A Rich Cabinet with a Variety of Inventions* (1651) showing, 'How to make a glorious light with a Candle like the Sun-shine.' The device was much used by jewellers, painters and engravers. *British Library, London*

35 Rowlandson and Pugin, *Drawing from Life at the Royal Academy, Somerset House*, aquatint from Ackermann's *Microcosm of London* (1808–11). The existing life-drawing studio at the Royal Academy Schools in Burlington House was evidently designed on the basis of this studio.

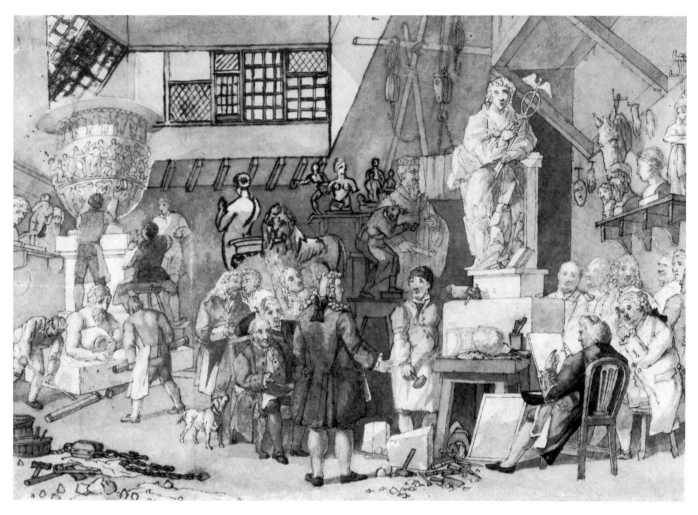

When Sir Thomas Lawrence (1769–1830) took
possession of a house in Russell Square in
December 1813 he changed his 'painting room'
wall-covering to a rich crimson and his 'show
room' to a yellow. A year later he found the latter
'hurtful' to his pictures probably because, unlike
the more traditional colours for the display of
paintings, the yellow conflicted with the gilded
frames.[30] Despite the general preference for
neutral, drab-coloured walls in studios, Paul
Gauguin (1848–1903) favoured a brilliant yel-
low, Bernardin de Saint-Pierre preferred green,
whilst Paillot de Montabert (1771–1849) used
screens covered with textiles of different colours
which he moved about to form backgrounds
as occasion demanded.[31] The use of a simple,
moveable background may be seen in Abraham
Bosse's (1602–76) engraving (1659) showing a
draughtsman at work using a 'drawing frame'.

Painters' Studios

Magnificent though the painting rooms of Rem-
brandt (1606–69) and Rubens (1577–1640) were,
their studios were domestic in feeling. As we

have seen, the purpose-built studio different in
kind from the domestic architecture of the home
was, until the eighteenth century, the exception.
By then some artists, even quite minor ones, were
in possession of purpose-built studios. John
Watson (1685–1768) of Perth Amboy, New Jer-
sey, had a 'dwelling house' and a 'painting pic-
ture house' which implies a separate structure.
This 'picture house' was well known in its day
for the series of portraits painted on the panels
of the window shutters.[1] Another rather obscure
artist, Joshua Shaw (1776–1860) the animal pain-
ter, 'lived several years in Mortimer Street,
Cavendish Square, where he built a large paint-
ing room with conveniences to receive the
animals from which he painted.'[2] Sir James
Thornhill (1675–1734) attempted to establish an
academy 'in a room he built at the back of his
own house', but this studio was hardly a work-
place for one artist and his assistants.[3]

The post-medieval itinerant artist shared with
earlier generations of craftsmen the tradition of
working on or within the building that was to
receive their work. In the sixteenth century this
position still obtained and even an artist of the
eminence of Holbein the Younger (1497/8–
1543) may be considered, in this sense, part of

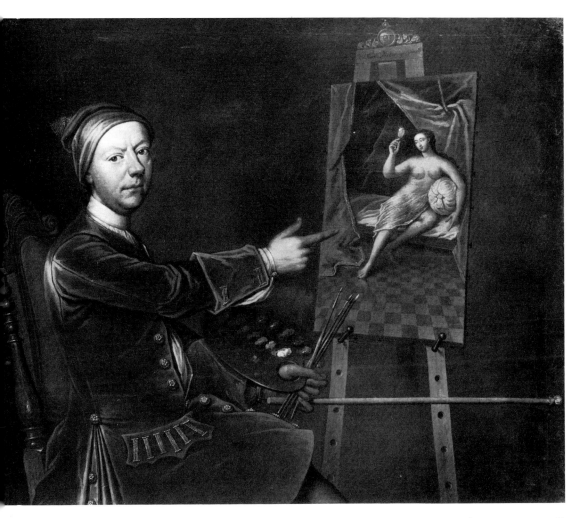

the earlier tradition. Indeed his wanderings have been used as datum lines for the dendrological examination of his paintings on panel.[4] For Rubens and his generation, the position was more confused, but by the late seventeenth century the situation was resolving itself into a new order. At this time Sir Peter Lely (1618–80) was invited to produce a series of portraits of judges for the Guildhall in the City of London, 'but refusing to wait on the judges at their own chambers [Michael] Wright got the business and received £60 for each piece.'[5] The judges were clearly of the old school, Lely of the new. Isaak Walton tells us, in his biography of John Donne (1573–1639), that towards the end of his life when the poet was infirm 'A monument was resolved upon' and after various preliminaries, 'without delay a choice painter was got to be in readyness to draw his picture' in his apartment.[6] This example was due to the exigencies of approaching death. Nevertheless in the course of the seventeenth century the itinerant artist, like the painter-stainer somewhat earlier, became a second-class citizen in the world of art. In the eighteenth century a characteristic example was John Foldsone (d. 1784), 'A painter of portraits in oil, small heads of no great merit but with suf-

ficient likeness to procure employment at a small price. His practice was to attend his sitters at their dwellings. He commonly began in the morning, generally dined with them, if they lived at a distance, and finished his work before evening.[7] Another artist of this kind had a trade label printed stating that 'Gentlemen & Ladies Pictures Drawn at Their Houses in Crayons, and Deliver'd in a Handsome Frame and Glass at half a Guinea and a larger Size at Sixteen Shillings by S. Morley at ye Golden Head in Salisbury Court, Fleet Street, London. – And in Oil very reasonable with frames Compleat.'[8] There can be no doubt that many of these artists were regarded contemptuously in relationship to the 'polite arts' of eighteenth-century England. This is confirmed by Oliver Goldsmith's description of an itinerant portrait painter in *The Vicar of Wakefield*.

When the painter Sir John Medina (1655–1711) came to England in 1686, he was found work in Scotland by the Earl of Leven and 'went, carrying a large number of bodies and postures, to which he painted heads'.[9] In America a tradition has grown up that this was the practice with itinerant and provincial portrait painters there, but no such unfinished headless 'portraits' have

37 Richard Waitt, *Self-Portrait*, 1728. The easel accommodating the artist's signature is probably fanciful, but the mahlstick was a highly practical and important implement. *Scottish National Portrait Gallery, Edinburgh*

been found to substantiate the claim, which may owe its genesis to Walpole's anecdote. On the other hand, itinerant painters were not, it seems, ridiculed in America for in 1820 Dunlap happily declared, 'I was now an itinerant portrait painter.'[10] This apparently more enlightened attitude may have had something to do with the low esteem in which *all* artists were held there (at least in some quarters) during the early decades of independence. The *National Arithmetick, or Observations on the Finances of Massachusetts*, published in Boston in 1786, classed 'Painters (particularly inside, house, miniature and portrait painters), hairdressers, tavern keepers, musicians, stage players and exhibitors of birds and puppets' as unprofitable members of the commonwealth'.[11] Delightful though this anecdote is, it is unlikely that in America, where conventions were in the making and where migration was a way of life, a social or even artistic distinction would have been drawn between nomadic and sedentary painters.

In effect the itinerant painter turned the client's premises into his studio. It was, however, necessary for these artists to bring with them drawing materials, brushes, a palette, pigments and media. At times this could be a truly pioneering enterprise. In America, 'In 1805 Mr Trott [the miniature painter, *c.* 1770–1843] visited the western world beyond the mountains, travelling generally on horseback, with the implements of his art in his saddle bags.'[12] This was of course

an unusually strenuous 'expedition'. The mural painters of the seventeenth century used a large 'craike' or basket in which brushes and paints could be put in order to haul them on to the scaffold,[13] and no doubt from one country house to the next. Most characteristic of all were those travelling painters who took with them specially devised boxes constructed to contain their tools and materials. By the late eighteenth century, portrait painters in miniature or pastels were probably the most numerous, together with those who cut silhouettes. The miniature painters' travelling boxes were furnished with a lid which opened up on a ratchet to provide an easel. Others working on a larger scale no doubt had to improvise, although the Royal Scottish Academy possesses a fine collapsible easel that once belonged to Sir Henry Raeburn (1756–1823).

The seventeenth-century artists who specialized in shipping 'pieces' are known to have produced preparatory sketches at sea as is confirmed by the grisaille of the *Battle of Scheveningen* (1655) which includes the delightful self-portrait of Willem van der Veld the elder sitting in a boat making a few visual notes in the field of battle. Another Flemish marine painter, Jan Griffiere (1652/6–1718), came to London shortly after the Great Fire of 1666 and, perhaps because alternative accommodation was neither available nor convenient for his subject matter, 'he bought a yacht, embarked with his family and his pencils [brushes], and passed his whole time on the Thames, between Windsor, Greenwich, Gravesend &c.',[14] using the vessel as both his home and his studio.

In the two centuries of geographical exploration and discovery between Jacques le Moyne and John White and on to Sydney Parkinson and John Webber, painting on board ship was probably less remarkable than it now appears. Dunlap managed, thanks to calm weather, to paint a couple of portraits of the captain of the *Betsy* on his return voyage to the United States from Britain and even assisted a sailor in repainting the figurehead.[15]

Painting at sea was one way of guaranteeing a dust-free atmosphere. Lorenzo di Credi (*c.* 1458–1537) was one of many painters to stress the need for a dust-free working environment.[16] Gerard Dou (1613–75) is reported to have been so obsessed with the problems of dust that he clambered into his studio through a trap door in the ceiling and then did not begin work for ten or fifteen minutes to allow the dust he himself may have created time to settle. After such efforts he doubtless needed to time to settle himself.[17] For miniature painting a dust-free environment was vital and Hilliard was particularly forceful in his recommendations: 'them the fierst and

38 Sir Henry Raeburn's (1756–1823) collapsible easel, Scottish, oak, height 60 in. (152 cm.). *Royal Scottish Academy, Edinburgh*

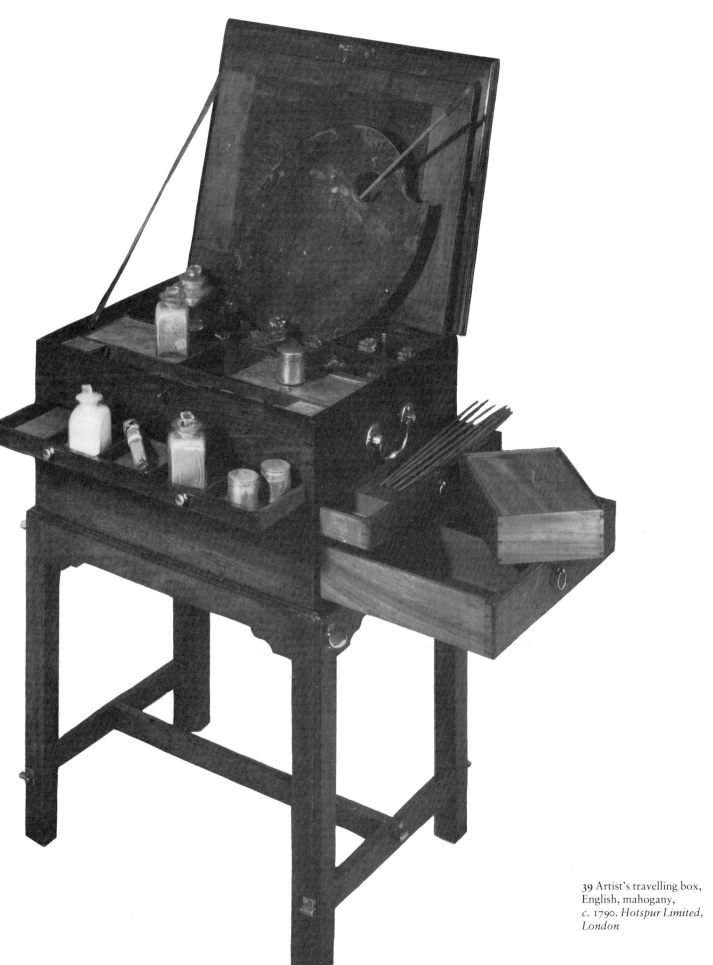

39 Artist's travelling box,
English, mahogany,
c. 1790. *Hotspur Limited,*
London

cheefest precepts I giue, is cleanlynes, and therfor fittest for gentlemen, that the practicer of *Limning* be presizly pure and klenly in all his doings.' He goes on to mention the need to keep pigments free of dust and to advise that 'yr aparell be silke, such as sheadeth lest dust or haires . . . beware yo tuch not yr worke with yr fingers . . . neither breath one it, especially in could weather, take heed of the dandrawe [dandruff] of the head sheading from the haire, and of speaking ouer yr worke for sparkling, for the least sparkling of spettel . . .' in short, to work 'in a place wher neither dust, smoak, noisse, nor steanche may offend, a good painter hath tender sences, quiet and apt, and the culers them sellues may not endure some ayers, especially in the sulfirous ayre of seacole, and the guilding of Gowldsmithes.'[18] These observations probably account for the more convincing representations of artists' studios in which the apprentices are shown grinding pigments in an adjacent room. Such pigments were usually ground with their media or with water. In the latter process the resulting powder colour could generate dust. Benjamin West's establishment in Newman Street is known to have had a 'colour closet at the bottom of his painting room'.[19]

Newman Street was, of course, the destination for three generations of American painters who came to Britain. They came to meet their fellow countryman with a sense of awe which West's studio did everything to confirm. The Newman Street gallery and studio was in many ways more characteristic of the nineteenth century than the eighteenth century. The visitor passed 'through the long gallery hung with sketches and designs, filled with gigantic paintings, to the inner painting room of the artist where he sat at work upon an esel [*sic*]'.[20]

No matter whether painting rooms were purpose-built or adapted, they often seem to have possessed characteristics that kept them in use as such down through the generations. Edward Hawker 'succeeded Sir Peter Lely in his house, not in his reputation.'[21] This was the house in Covent Garden that J. T. Smith mentioned as having been occupied successively by Lely, Kneller, Thornhill and later by Richard Wilson (1714–29).[22] Similarly John Robinson of Bath (1715–45) followed Charles Jervas (1675–1739) in his house in Cleveland Court, London, with a consequent increase in business.[23] In a house later divided into numbers 55 and 56 Great Queen Street lived Hudson and later Worlidge (1700–66), the etcher.[24]

40 M. Geeraerdts, *Miseries of a Painter*, 1577. In the more convincing representations of a painter's studio the 'colour closet' is shown as a room apart. *Bibliotéque Nationale, Paris*

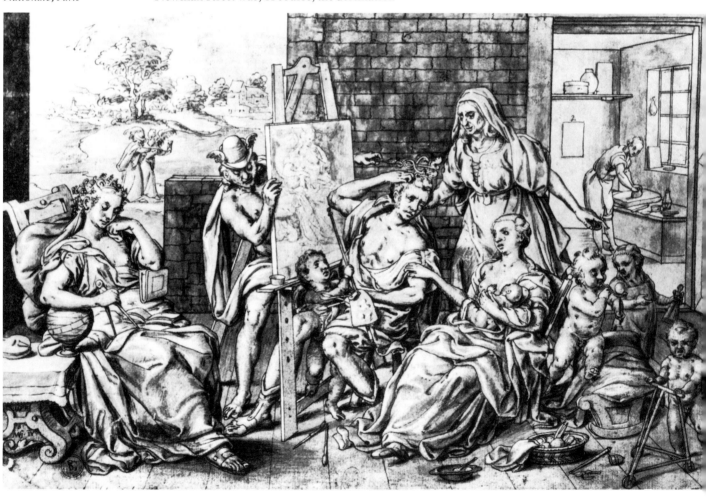

Sculptors' Studios

At times sculptors would take over the premises of a painter. J. T. Smith observed that 'Mr Nollekens [1737–1823] soon turned over the Muster Master's [a derisive reference to Francis Milner Newton RA, 1720–94] painting room into a studio for sculpture.' For the purposes of modelling portrait busts (Nollekens's main activity) similar conditions were necessary as for portrait painting. Smith goes on to say 'That which we will call the dining, sitting and sitter's parlour, was a corner room which had two windows looking south, the entrance to it being on the right-hand in the passage from the street door in Mortimer-street … the artist's modelling stool [stand?] was placed near the street-door window, and the sitter's chair nearer the door'[1] Elsewhere Smith suggests that Nollekens had in addition more usual workshops for a sculptor, together with a yard for the storage of marble. South-facing windows were not a problem for sculptors and Theophilus, writing in the twelfth century, goes so far as to stipulate for metal workers 'a high, spacious building whose length extends to the east. In the south wall put as many windows as you wish and are able to, provided that there is a space of five feet between any two windows … The windows should not be more than a foot above ground level and they should be three feet high and two feet wide.'[2] This description of a metal worker's shop with daylight entering from the side accords, in this respect, with the mason's 'lodge'. Sculptors, as Carl Bluemel has shown,[3] worked alongside masons in the quarries in antiquity; they also worked on building sites. In these circumstances a temporary shed was necessary and these were most easily provided with daylight along an open side. In medieval Europe these sheds or lodges were, if attached to major building undertakings, semi-permanent structures but otherwise resembled the more expendable buildings. Master Michael of Canterbury was furnished with fifteen shillings for the purchase of fifty oak poles to make a lodge which was to be constructed by Robert le Hackre, a carpenter, in only four days. This lodge was for the masons building the chapel of St Stephen (begun in 1292) in the Palace of Westminster. In contrast, the carpenter John Heyden and his boy were given eleven weeks in 1387 to build a lodge for the masons at Ely Cathedral.[4] Apart from the tendency for the permanence of the lodge to be related to the scale of the undertaking, it seems that late medieval and Tudor masons expected greater comfort. For example, the lodge built at York Place, Westminster, in 1515 was provided with a window and a door with a lock and key.[5] The distinctions between mason, architect and sculptor were not so

41 Thomas Rowlandson (1756/7–1827), *Nollekens at Work on 'Venus chiding Cupid'*, engraving. *British Museum, London*

entrenched in the past as they are today. The masons' lodge would doubtless have provided a sheltered working space for both 'banker masons' and 'fixing masons'. Since the carvers and architects were drawn from their ranks, the medieval masons' lodge probably served as workshop and studio, quite apart from its significance as a court of law; the 'free court' of the free masons of England.[6] The evolution of architecture as a 'profession' distinct from the trade of 'mason' has been the subject of considerable study, but much work remains to be done on the parallel division that evolved in the seventeenth and eighteenth centuries between sculptors and masons.

Although moulding- and frame-carvers prefer a cross-light, sculptors have traditionally favoured the skylight, although sculptors working in the typical masons' lodge were not so served. Since a sculptor's materials, and even his tools, are of considerable weight, this presupposes that the sculptor's workshop is of a single storey. This was the ideal, but only the most successful sculptors could realize it. Furthermore, the sculptor's studio was best organized as a series of separate chambers reserved for modelling, casting in plaster, metalwork, carving in wood and carving in stone. It was especially important to separate the last two since stone dust could so quickly blunt the edge of wood-carving tools. For the same reason, a wood-carving 'shop' should have a timber floor. Despite these specifications, many sculptors, like the painters, adapted existing buildings to their needs. Benvenuto Cellini (1500–71) converted his lodgings in the castle of Le Petit Nesle, which once stood on the other side of the Seine from

OPPOSITE LEFT
43 Jean-Antoine Houdon
(1741–1828), *L'Écorché.*
This famous figure is an
idealized flay and not cast
from life. *École des
Beaux-Arts, Paris*

OPPOSITE RIGHT ABOVE
44 *The Dying Gladiator,*
a flay prepared by
William Hunter and cast
in plaster by Agostino
Carlini, from the corpse
of a man who was hung
as a smuggler in 1775.
*Royal Academy of Arts,
London*

OPPOSITE RIGHT BELOW
45 A flay of a horse, cast
in plaster. The English
painter George Stubbs
(1724–1806) did much to
advance the knowledge of
equine anatomy through
his dissections. *Royal
Academy of Arts, London*

42 Rembrandt, *Johan
Deyman's Anatomy
Lesson* (fragment), 1656,
oil on canvas,
$39\frac{3}{8} \times 52\frac{3}{4}$ in.
(100 × 134 cm.). The
corpse is that of Joris
Fonteijn, known as Black
Jan, who was executed
on 27 January 1656.
Dissections were most
conveniently carried out
in the winter.
*Rijksmuseum,
Amsterdam*

the Louvre in Paris, to 'workshops with conveniences for carrying on my business'.[7] He claimed to have employed up to forty assistants at any one time while in Paris, so, even allowing for his typical bombast, the adaptation of the castle must have been a considerable undertaking.

By the late eighteenth century the studios of successful painters and sculptors were becoming places of pilgrimage, as is attested by the numerous descriptions of Benjamin West's establishment. The complex of studios that Canova and his many assistants occupied from the last decade of the eighteenth century to his death in 1822 were one of the 'sights' of Rome. Writing of his visit in 1809, the French painter François Marius Granet (1775–1849) described the sculptor's studio as '*rempli de grands personnages et de belles dames de toutes nations*'. Granet passed through a series of studios divided according to function and material as mentioned above. The street outside was thronged with carriages and waiting servants. Understandably Canova made it a general rule, so Granet noted, to receive only fellow artists[8] in the '*atelier particulier de Canova*'.[9]

Although the sculptor's studio could never achieve the informal drawing-room atmosphere that was possible for affluent painters in the nineteenth century, it was nevertheless much frequented when occupied by an illustrious figure such as Rodin (1840–1917). Indeed by about 1882 the French government had provided their greatest sculptor with a rent-free studio in the Rue de l'Université in Paris[10] and by 1900 official patronage resulted in a Rodin pavilion at the Paris Exhibition of that year. It was this gal-

lery that the sculptor later moved and re-erected in his garden at Meudon. As Rodin's fame grew he found it increasingly difficult to work in his official establishment and Rainer Maria Rilke recorded a number of secret studios where the sculptor could work without interruption.[11] In Britain, late Victorian and Edwardian sculptors with commissions for public statuary throughout the Empire were able to set themselves up with considerable efficiency. Hamo Thornycroft (1850–1925) was able to call on the services of the family firm to engineer his studio equipment, figure irons and turntables. The last flowering of this affluence was funded by the tragic need for memorials following the First World War. Even before this the Ditchling (Sussex) studio of Eric Gill (1882–1940) developed from October 1907 into far more than an artists' colony. It became a commune-cum-monastery for the lay brothers of the Third Order of St Dominic. By 1924 Gill had moved on to Capel-y-ffin in the Welsh Black Mountains and he moved again in 1928 to Pigotts, near High Wycombe, Buckinghamshire – was he seeking to shed at least some of his acolytes as an earlier generation of sculptors had sought to avoid tourists?

Anatomy and the Human Figure

The observation of nature in the studio included still-life and flower pieces, but most important of all for both painters and sculptors was the human figure, naked or clothed, nude or draped, entire or dissected. For Humanism, for the Renaissance, the human figure held a special significance in elevating man in relation to God and in recalling the Classical convention for works of art whose subject was the naked male and female figure. Certain Christian inhibitions had to be overcome and the notion of the artist and his model remains a lively topic of speculation in popular imagination and in the work (and experience) of artists such as Picasso. J. T. Smith referred to 'the abandoned women who sat to him [Nollekens] for his Venuses', but Rowlandson's brilliant engraving (c. 1800) shows how demure were his models, no matter how lascivious the sculptor or indeed his sculptures! For these reasons, life classes in colleges of art were traditionally segregated. Female students were permitted to study the strategically draped male figure or nude small boy. Something of an uproar was caused when it was alleged that the painter Angelica Kauffmann (1740–1807 – a much maligned coquette) had studied from 'an exposed male living model', probably Mr Charles Cranmer.[1]

For a thorough study of the human figure, art-

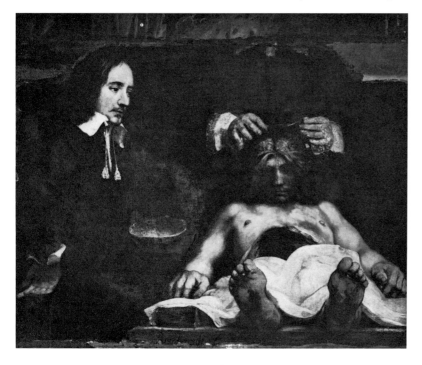

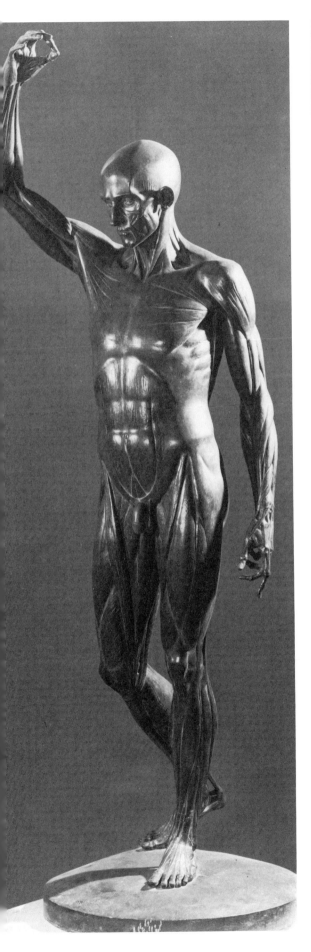

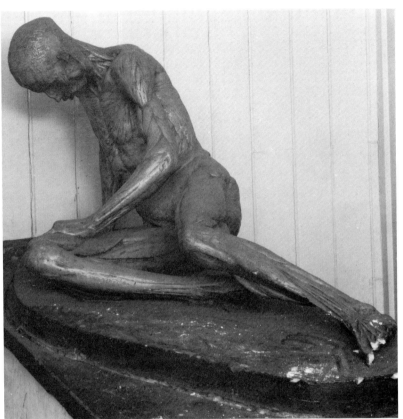

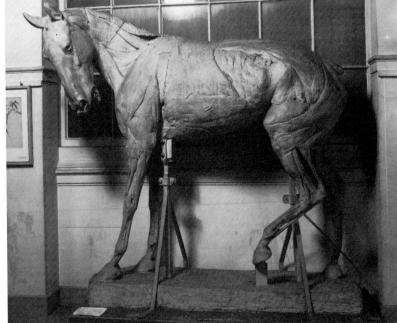

ists were expected to form some understanding of its armature, the skeleton, and a fairly comprehensive knowledge of 'superficial anatomy'. In this field Leonardo da Vinci augmented and perhaps eclipsed the work of the physicians (who shared with painters the patronage of St Luke). Again the conventions of society created an obstacle to artists who, like physicians, were compelled to use the bodies of executed criminals for anatomical research. In Rembrandt's Dr

Joan (or Johan) Deyman's *Anatomy Lesson* of 1656 the corpse of the criminal Joris Fonteijn, known as Black Jan (who was executed on 27 January 1656), was used.[2] Karel van Mander (1548–1606) describes how the painter Aert Mytens (1541–1602) went so far as to venture out one night to cut down a corpse from a gallows to make anatomical studies. In the eighteenth century Dr William Hunter produced an *écorché* of the body of a man who was hung for smuggling in 1775, which was then cast in plaster by the sculptor Augostino Carlini (d. 1790) in the pose of *The Dying Gladiator*.[3] This reliance on the bodies of executed criminals continued into the nineteenth century. The 'flay' of a crucified man was cast in plaster by the anatomist Joseph Constantine Carpue (it is now in the Royal Academy, London) from the posed body of Ensign James Legg, who was executed in 1801 for the murder of a fellow pensioner at the Royal Hospital, Chelsea. The cast was taken at the request of Benjamin West, Joseph Banks (1743–1820) and Richard Cosway (1742–1821).

For obvious reasons, dissections were generally confined to the winter months. The eighteen-month struggle encountered by Stubbs in dissecting horses makes this very understandable. With these various legal and physical difficulties it is hardly surprising that artists came to rely upon a plaster cast of a 'flay', human or animal. These figures without skin were cast or modelled to reveal the muscles which the subcutaneous fat obscures. Rembrandt owned several such casts[4] and a number of sculptors produced these figures, either life size or smaller, for their fellow artists and others. Thomas Baniere made 'the anatomic figure commonly seen in the shops of apothecaries taken from his original model',[5] and the Danish sculptor Michael Henry Spang (*fl.* 1750–67) 'produced that small anatomical figure so well known to every draughtsman who assiduously studies his art'.[6] Most famous of all is Jean Antoine Houdon's (1741–1828) *L'Échorché*, which so effectively combines the encyclopaedic quality of a work of reference whilst at the same time being an important work of sculpture.[7] These figures, together with various published anatomies, formed the basis for many an artist's understanding of anatomy. With the possible exception of the human skeleton, with which many studios were equipped, few studied the subject direct.[8] As a student, the painter William Mulready (1786–1863) was advised 'to buy Walker's *Anatomy*, price half a crown; an anatomical figure by Roubiliac (that is a figure where the body is supposed to be stripped of its skin and the more fleshy integuments or the muscles in some other way are represented as particularly prominent) and a cast of Apollo'.[9]

The use of commercially available 'flays', together with the desire for the 'ideal' in human beauty, led to the standardization that reached such frigid proportions with the Classical Revival. There were some mitigating circumstances for not referring to life models. Nollekens relied on casts of feet because English models had such 'very bad toes in consequence of their abominable habit of wearing small pointed shoes'.[10]

Just as one work of art could be the product of many hands, so the ideal figure could be a composite reconstruction of nature. Benvenuto Cellini recommended that artists should 'always be on the look out for beautiful human beings, and from among even these choose the most beautiful . . . parts, and so shall your whole composition become an abstraction of what is beautiful'.[11] The selection of male models whose occupation led to well-developed muscles was part of this process of selection. Female models were selected with no less, indeed probably greater, care. The model Bet Balmanno became so popular that she posed for Nollekens, Fuseli (1741–1825) and Tresham (1751–1814). If not exactly the ideal figure, the Farnese *Hercules* imposed a certain expectation as to the appearance of a Hercules. When the sculptor John Rysbrach (1694–1770) embarked on this subject,

> he borrowed the head of the Farnesian god [Hercules . . . and used] various parts and limbs of seven or eight of the strongest and best made men in London, chiefly the bruisers and boxers of the then flourishing amphitheatre for boxing . . . The arms were Broughton's, the breast a celebrated coachman's, a bruiser, and the legs were those of Ellis the painter, a great frequenter of the gymnasium.[12]

Such a procedure led John Elsum, writing before 1704, to exclaim that he knew of no 'greater folly than of those, who sometimes in their Works of Nudity, put things that are ridiculous as to a delicate Head and tender Limbs, a Body full of Muscles'.[13]

Although the notion of the composite figure reached its most exaggerated form in the nude, the average patron who had his or her portrait painted (generally but not always clothed) would be subjected to similar treatment. The idea that the human personality was in the total man or woman was unknown or ignored in the interests of the ideal and, it should be added, of convenience. For the client it was a chore to pose and for the artist the greater potential interference of the patron was an annoyance. The bucolic and ruddy features of an elderly magnate with pale, delicate, long-fingered hands in one of the later portraits by Lely is an unlikely jux-

taposition that must be explained by studio practice: the employment not simply of assistants to paint hands but also the use of stand-ins to pose for them. Walpole relates the sad story of a lady disfigured by smallpox pleading with the painter Godfrey Schalcken (1643–1706) to let her pose for her own beautiful hands only to be rebutted with the remark, 'No, I always draw them from my house-maid.'[14]

In the use of a stand-in for a full length figure in painting or sculpture, some physical resemblance, with a tactful tendency to improve on the original, was necessary. Governeur Morris, in a letter of 5 June 1789, recorded that 'I stand for his [Houdon's] statue of General Washington, being in the humble employment of a manikin.'[15] Posing was such an irksome business that in the interests of the model, sessions were timed, and in the interests of the artists, breaks were also regulated. The hour glass owned by the Royal Academy in London may have been for the latter purpose since it only runs for seven minutes. It may well be the timer that Nollekens gave to the Academy to replace one he had broken.[16] Another aspect of this question was the sitter's

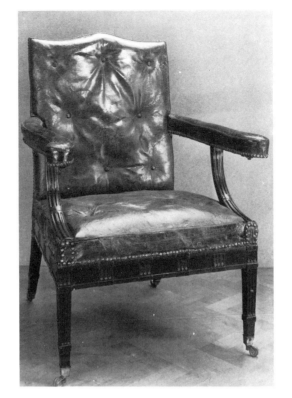

46 'Throne' chair, mahogany. A sitter's chair once owned by Sir Joshua Reynolds. (See fig. 62.) *Royal Academy of Arts, London*

BELOW LEFT
47 Hour glass, late eighteenth century. This sand timer may well be the one given to the Academy by Joseph Nollekens. It runs for only 7 minutes and could have been used to time a model's rests. *Royal Academy of Arts, London*

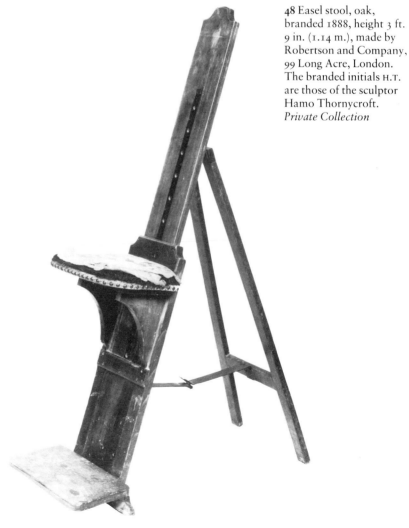

48 Easel stool, oak, branded 1888, height 3 ft. 9 in. (1.14 m.), made by Robertson and Company, 99 Long Acre, London. The branded initials H.T. are those of the sculptor Hamo Thornycroft. *Private Collection*

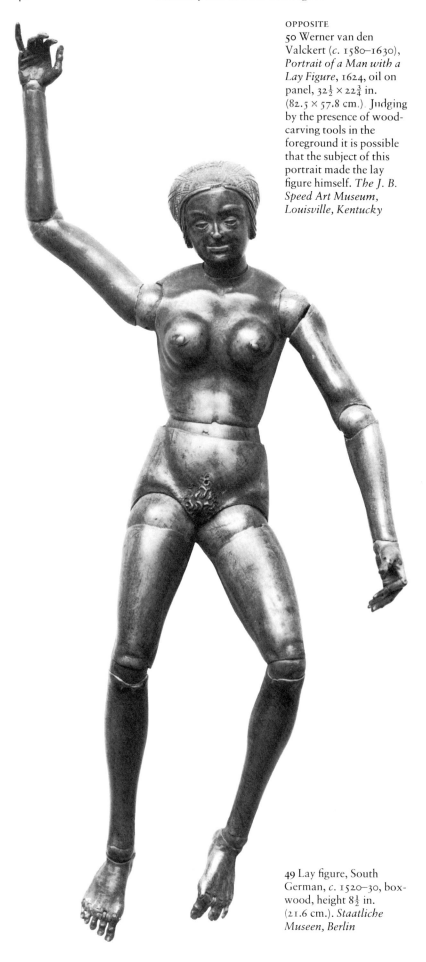

OPPOSITE
50 Werner van den
Valckert (*c.* 1580–1630),
*Portrait of a Man with a
Lay Figure*, 1624, oil on
panel, 32½ × 22¾ in.
(82.5 × 57.8 cm.). Judging
by the presence of wood-
carving tools in the
foreground it is possible
that the subject of this
portrait made the lay
figure himself. *The J. B.
Speed Art Museum,
Louisville, Kentucky*

49 Lay figure, South
German, *c.* 1520–30, box-
wood, height 8½ in.
(21.6 cm.). *Staatliche
Museen, Berlin*

chair, and the Royal Academy preserves Reynolds's (1723–92) 'throne'.[17] It is of the type now known by antique dealers as a Gainsborough chair. The Scottish Royal Academy owns Raeburn's (1756–1823) sitter's chair which, though lighter in character, is of a similar type.

Ultimately the most painless model for all concerned was the lay figure. According to Vasari, Fra Bartolommeo (1472/5–1517) was the first to devise such a figure, although the earliest description of one occurs in Book Three of Filarete's *Treatise on Architecture* (1461–4). It was in wood, life size, and fully articulated.[18] A fine early sixteenth-century carved boxwood, articulated figure 8½ in. high survives in the Staatliche Museum, Berlin. Another fine example is Roubiliac's (1702/5–62) lay figure which, together with a male and female costume to fit it[19] and an oak box (relined in 1793 with 'Shamy Leather which Douth not Engender Moths like woolen Cloth'),[20] is preserved in the Museum of London. By 1763 Simon Henekin is listed in *Mortimers Directory* at Edward Street, Soho, where the wood-carver claimed on his trade label that he was 'eminent for making laymen for painters'.[21] Towards the end of the century lay figures became widely available. Sometime between 1784 and 1787 Dunlap purchased one in Paris from the maker.[22] These miniature figures exerted a considerable influence on the eye of some artists. The interiors and landscapes by Arthur Devis (1711–87) are inhabited by near doll-like figures of great charm. Although few lay figures survive from the eighteenth century, some costumes for a now vanished figure once used by Devis survive in the museum at Preston, his birthplace. More useful than these 'dolls' were the life size lay figures which were sometimes the occasion of a good deal of innocent merriment. They could be surreptitiously substituted as a drinking companion for a semi-conscious tippler,[23] or mistaken by a short-sighted and 'respectable' elderly lady for an artist's 'fine Miss, in his silks and satins'.[24] The small lay figures that may still be purchased in art supply shops are especially convenient for working out initial stages of a composition. Related to these in function, although not articulated, were the small clay models that Vasari says were used by Piero della Francesca (*c.* 1410/20–92) – they were draped with wet cloths arranged in folds for use in the study of drapery.[25] Eastlake, with reference to Mengs,[26] mentions the possible use of clay models by Correggio for this purpose, and J. T. Smith, quoting Betew, asserts that the sculptor Fiamingo was employed by Rubens to model children for the Flemish master to use in his compositions.[27] The English artist W. H. Pyne (1769–1843) modelled a series of 8-in.

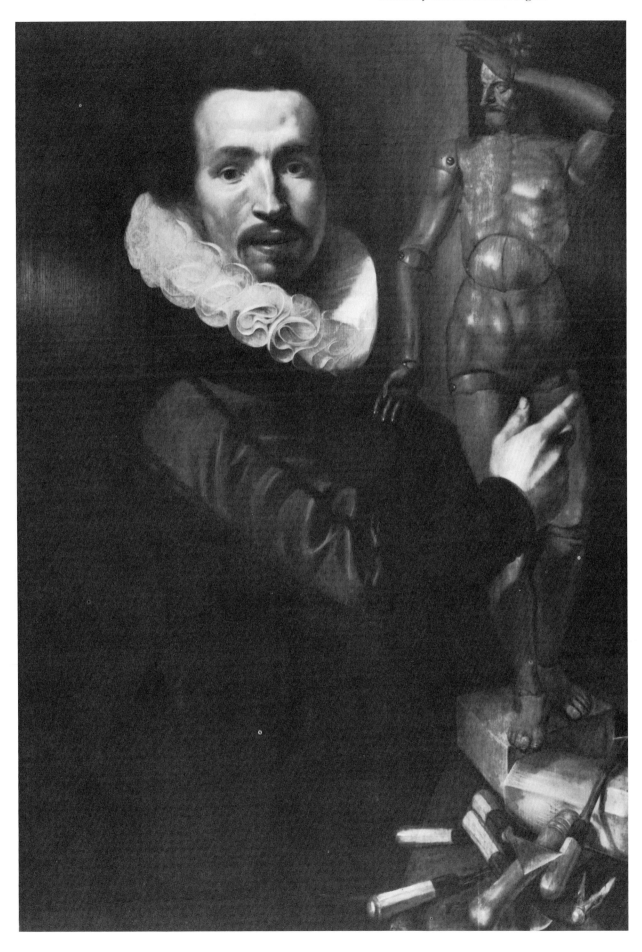

51 The androgenous features of this lay figure's head enables it to be dressed convincingly as either a man or a woman (see fig. 54). The figure was made by the sculptor Louis François Roubiliac (1705–62). *Museum of London*

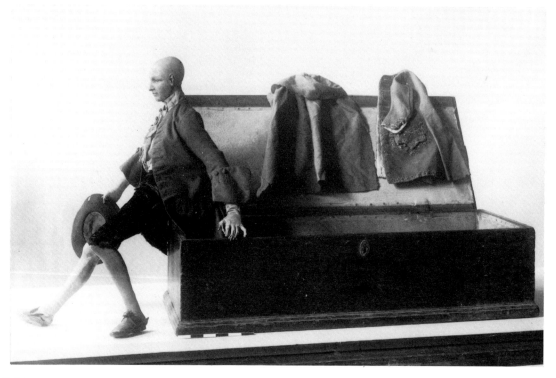

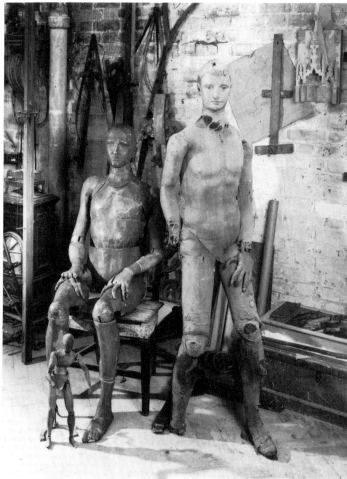

52 Two late nineteenth-century lay figures, life-size. The seated figure is made of papier mâché, possibly German; the standing figure may be English and has a papier mâché head, but is otherwise upholstered with a remarkable resemblance to life. *Private Collection*

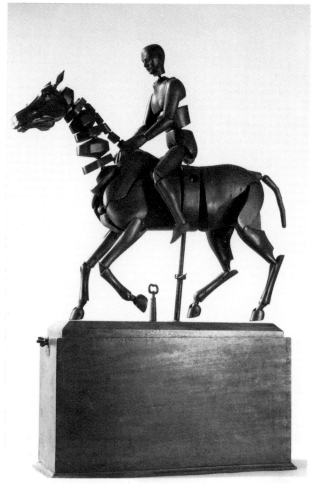

53 Horse and Rider, lay figure made by Robertson's of Long Acre, late nineteenth century – American walnut, overall height with plinth 20 in. (50.8 cm.). The plinth provides a box in which to store the figures. *Collection of C. A. Bell-Knight*

figures for the assistance of those who drew land-scapes.[28] The tradition for these small three-dimensional models as an *aide-mémoire* for two-dimensional work has been perpetuated in the animation studio of Walt Disney.

In addition to lay figures, the well-equipped studio contained a collection of plaster casts of limbs and some 'casts from the antique', by which was meant Classical antiquity; casts of medieval sculpture were virtually unknown until the nineteenth century. The catholic taste in the casts displayed in their original gallery (opened October 1873) in the Victoria and Albert Museum in London is both a manifestation of, and visual reference for, the eclecticism of high Victorian design. It does much to vindicate the whole notion of founding the South Kensington Museum (later the Victoria and Albert) and the South Kensington School of Art (later the Royal College) not as separate institutions pursuing their respective courses, but as physically and spiritually adjacent parts of one intention – the study and creation of art.

Many of the plaster casts from the antique that were used in eighteenth-century studios were bought in Italy 'from Papera who . . . carried the new things round to the artists in baskets'[29] or they were 'purchased . . . at a trifling rate from the boys of Luca, who at that time exhibited them for sale at fairs'.[30] Some of these casts occasionally provoked a raised eyebrow when seen in a cold northern light or when illuminated by the prudish attitudes of colonial life. Robert Edge Pine (1730–88) brought a cast of the Venus de Medici with him to America 'which was kept shut up in a case . . . as the manners of our country at that time would not tolerate a public exhibition of such a figure'.[31] One has only to recall the public outcry caused years later by Hiram Powers's (1805–73) *Greek Slave* to realize that this was a real and not imagined concern. By the early nineteenth century J. B. Gianelli's plaster cast shop near Smithfield in London supplied much of the demand for casts in Britain.

So long as studios were relatively domestic in scale and appearance they could be heated by an ordinary fireplace. As they grew in size and as the Classical Revival asserted the importance of nude or lightly dressed human subjects, so more radical solutions had to be sought.[32] The aged Dr John Donne had his picture drawn towards the end of his life (he died in 1639) when his need for warmth was evidently important. 'Several charcoal fires being first made in his large study [presumably in portable braziers] he brought with him into that place his winding-sheet in his hand, and having put off his clothes, had this sheet put on him . . .'[33] In countries with a 'continental' climate, in Germany and North America, the stove has had a long history. It was

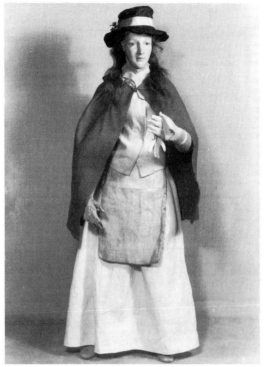

an essential method of heating, and it was the free-standing stove with its large areas of cast iron and metal flue providing conducted heat that was introduced into the artist's studio and for that matter into cabinet-makers' workshops, cathedrals, churches and schools.

Studio Equipment

The painter's easel is almost as much an emblem of the art as is the palette. The impact of Flemish artists on seventeenth-century England is commemorated in words like landscape (*landschap*), mahlstick (paint-stick) and easel, which Dunlap[1] spelt 'esel' by way of perpetuating the Dutch origin of the word *ezel* or 'ass'. The notion of the easel as a beast of burden recurs in the 'donkey' used as a support both for the drawing board and the draughtsman (fig. 56). There are three basic types of easel in common use: (i) the three-legged easel: (ii) the studio easel, and (iii) the sketching easel, which is usually a light-weight version of (i). The standard three-legged easel is probably the oldest type and elaborate versions of it in exotic woods were made for use by fashionable portrait painters and for display purposes in art galleries. A number of examples are illustrated on pp. 46–7, including a fine specimen in mahogany with ormolu mounts that may have belonged to the American portrait painter Henry Sargent (1770–1845). Similarly, the painter's cabinet could be both a receptacle for the storage of pigments, media and brushes and a fine example of cabinet-making. The two cabinets in Delacroix's studio in the Place Furst-

55 A typical studio stove, late nineteenth or early twentieth century.

56 A typical artist's 'donkey'. A drawing board is rested against the 'neck' and the artist sits astride the 'back' when drawing.

57 Sir Joshua Reynolds's easel, English, late eighteenth century, mahogany. *Royal Academy of Arts, London*

58 Mahogany easel, American (New York?), 1805–15, height 59½ in. (151 cm.). It has been suggested that this easel may have belonged to the American painter Henry Sargent, since it resembles the furniture in his painting *The Tea Party* (1825). *Museum of Fine Arts, Boston*

enberg in Paris are typical. A very fine seventeenth-century artist's cabinet with painted drawers decorated by A. J. Croos (born 1606, died after 1662) is preserved in the Rijksmuseum, Amsterdam. Unfortunately the 6-foot high mahogany example owned by the landscape painter Richard Wilson (1714–82), and made to resemble a large architectural model with a rusticated 'ground floor', has disappeared. 'The rustic work of the piers was divided into drawers, and the openings of the arches were filled with pencils and oil bottles.'[2]

The drawing room atmosphere, possible and even desirable in the painter's studio, was out of the question in the sculptor's workshop where dust and damp prevailed. The contrast is underlined by the sturdy practicality of much of the sculptor's equipment. The humble mason's 'banker' in the form of a simple block of stone became for the sculptor a sturdy wooden truck fitted with wheels and a turntable for manoeuvrability. In essence it remains a utilitarian object

and nothing more. The turntable comprised a ring track of iron on the base, with the heavy 'table' fitted with small castors running on the track and held in place by a central pin (see fig. 64). Benvenuto Cellini mentions a more elegant version designed to display his silver figure of Jupiter. The gilded pedestal incorporated 'a wooden plinth that only showed a little; upon the plinth I introduced four little round balls of hard wood, more than half hidden in their sockets, like the nut of a crossbow. They were so nicely arranged that a child could push the statue forwards and backwards, or turn it round with ease.'[3]

In forming a collection of 'props' for still-life studies and for backgrounds, together with the acquisition of works by others, an artist could rapidly assemble a cabinet of curiosities. Of course artists are in the business of creating possessions (hopefully for others) so that the notion of the artist as a free spirit unencumbered by property and able to move on at a moment's

notice is a romantic view based on a few exceptions. Quite apart from anything else, the equipment needed by sculptors and, until the appearance of 'convenience paints', by painters too, weighed the artist down with more baggage than most travellers.

As many of Rembrandt's paintings show and as the inventory drawn up (following his bankruptcy) in 1656 confirms, the painter had, along with much else, a considerable collection of armour, halberds and swords.[4] Some objects were simply too large to get inside a studio and in such cases scale models seem to have been used. Verrio is known to have owned, as part of his equipment as a painter, two brass and eight iron guns, a ship and an anchor, all of which were probably models.[5] This use of models in the seventeenth century is confirmed in George Jamesone's (1587–1644) self-portrait (fig. 110), in which the artist has shown himself with an assortment of scaled-down armour. Much later John Cotman (1782–1842), in addition to casts from the antique, owned a collection of model ships and armour.[6] Constable's 'props' included a model windmill made for him by his friend John Dunthorne (1778–1840), and a plaster model of a horse made by Gainsborough (1727–88) and purchased by Constable in about 1800.

Until the sixteenth century, drawings were primarily seen not as works of art in themselves but as a means to an end. They were therefore collected at first, in so far as they were collected at all, by artists. Vasari makes intermittent reference to his collection of drawings. It was very much an artist's collection. By the seventeenth century, Rembrandt and Rubens were able to form collections of paintings which approached princely proportions. In some accounts it is not always easy to differentiate the extent to which an artist's collection was of his own work and therefore in effect his 'stock', and to what extent it was a 'study collection' of works by others. In addition a number of artists are known to have traded in art. At the time of his bankruptcy Rembrandt owned works by sixty artists including Holbein, Bruegel, Lucas van Leyden, Schongauer, Raphael, Michelangelo, Titian, Cranach and Rubens.[7]

Among the artists who purchased works of art from the Royal Collections sold by the Protectorate were de Critz, Wright, Baptist van Leempat and Sir Balthazar Gerbier, though some of them were probably buying to sell again at a profit.[8] Lely's collection was described by Walpole as 'magnificent' and included many van Dycks from the Arundel collection. To some extent Lely's collection must have been accessible since Mary Beal (1632–97) occasionally took visitors to see it.[9] The scale of Lely's hoard was such that when it was sold following his death the auction,

59 Painter's cabinet of Italian walnut, designed and used by Alfred Stevens (1817–75). *Dorset Natural History & Archaeological Society and Museum*

60 Easel, palette and painter's cabinet once the property of Eugène Delacroix (1798–1863). The walnut cabinet, 22 × 20 × 14 in. (55.8 × 50.8 × 35.6 cm.), with a sheet-metal liner, is one of two surviving examples that he owned. *Delacroix Studio, Paris*

which began on 18 April 1682, went on for forty days.[10] One of the principal purchasers was the artist William Gibson.[11] Some works of art seem to have remained within the profession perhaps because they possessed qualities best understood by those 'in the trade' or because of some family connection. In 1745 Thomas Hudson purchased at auction 'his father-in-law's [Richardson's] capital collection of Old Master drawings'.[12] Joseph Nollekens formed an important collection of engravings after Poussin, a Stubbs painting of a dog and other works by contemporaries like West and Barry. Moreover the sculptor was mentioned, together with Benjamin West and Richard Cosway, in the will of Mary Moser (Lloyd) as a potential beneficiary of her collection of works of art,[13] but few artists of this period could rival the collection formed by Sir Thomas Lawrence. In the late nineteenth century Seymour Lucas (1849–1923) assembled a mass of 'props' into what became an important collection of early oak furniture and armour. This painter actively used his collection to give some veracity to his spurious historical canvases of the kind that the late Sir Henry Rushbury dubbed 'the red cardinal school'. Of more recent years the sculptor Uli Nimptsh formed a collection of Chinese bronzes of international importance, whilst the painter Edward le Bas formed a collection (which in range and quality resembled the

upper floor of the Barnes Foundation in Philadelphia) which was shown in the Diploma Galleries of the Royal Academy.

The artist at work in the studio of necessity wears special clothing. For the painter a smock over ordinary clothes is adequate, but for sculptors, working clothes must be more substantial and even protective. When working in stone a sculptor needs a hat to prevent the hair from being clogged by dust and to provide some protection on a building site. Heavy boots are a further precaution against falling masonry or large 'gallets'. The image of the sculptor in sandals, like so many other popular notions of an artist's appearance, is in general a creation of the nineteenth century and it is one that some practising artists have served to confirm. Certainly Eric Gill (1882–1940) wore an outlandish garb including lightweight, and therefore dangerous, pumps. For him, clothes were related more to his socio-political and religious convictions than to the practicalities of his trade.[14] Even so, he observed the necessary custom for the stone-carver of wearing a hat, either a beret or the traditional folded newspaper, the standard disposable headgear of artisans in the nineteenth century. Tenniel shows the carpenter in *The Walrus and the Carpenter* wearing just such a hat. When Granet visited Canova in 1809 he found the sculptor '*habillé comme ses ouvriers, le bonnet*

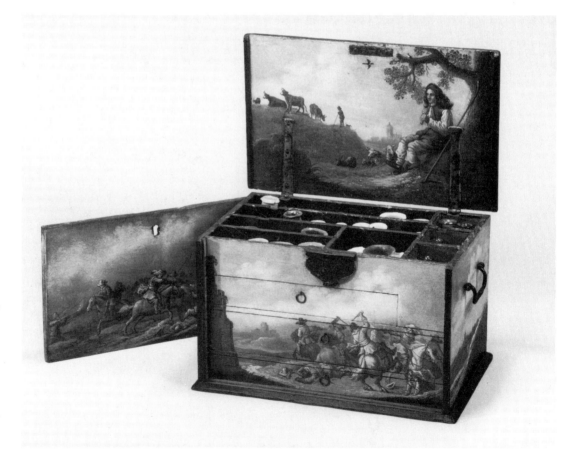

61 Painter's cabinet, the exterior painted by A. J. Croos (1606–after 1662). *Rijksmuseum, Amsterdam*

OPPOSITE
62 John Ballantyne (1815–97), *Frith in his Studio*. Note the dais which provides a typical plinth for the 'throne' or sitter's chair. *Roy Miles Gallery, London*

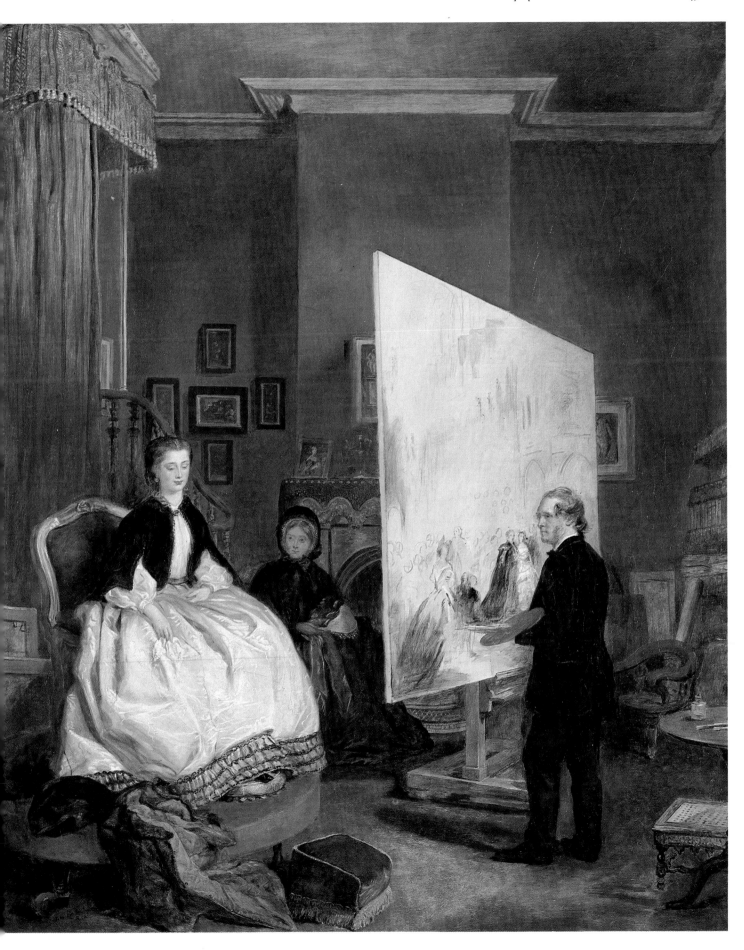

64 A sculptor's banker and turntable, height 32 in. (81 cm.), top 30 × 30 in. (76 × 76 cm.).

de papier, le veste à manche, et des espèces de Grenouilliers en peau, aux genoux'.[15] When in 1820 Lady Morgan was visiting Canova in Rome, she noted his 'nankeen jacket' and 'yellow slippers'; she goes on to describe 'his frail and delicate frame energized to Herculean strength; now striking off from the mass, now finishing some trait so delicate as to escape all eyes, save that of Art.'[16] Since Lady Morgan makes no mention of a hat, the sculptor was evidently working in clay in his yellow jacket and slippers. If not, this is a splendid piece of hyperbole for if he was 'striking off from the mass' in marble he would surely have worn more substantial clothing and footwear.

The dashing attire in which Rembrandt generally appears in his self-portraits (in oils) was at variance with his appearance in the studio, as a few surviving drawings confirm. Bernhardt Keil (1624–87), a pupil of Rembrandt's in the 1640s, remembered his master's appearance 'was careless and his smock was stained with paint all over because it was his habit to wipe his brushes on it'.[17] What painter before and since has not abused a smock in such a way? The attractive simplicity of the smock has some appeal and Sir Thomas Lawrence (1769–1830) painted a portrait of 'Mr West in a gown he only wore in his painting room as more picturesque than a coat and waistcoat'.[18] Outside the painting room the appearance of most artists was very different. Copley's suit of crimson velvet trimmed with gold buttons so impressed Trumbull as to confirm the younger man in his intention of becoming a painter.[19] Another American, Gilbert Stuart, was mortified to find that when he travelled to England in 1775 his 'clothing was half a century behind fashion',[20] This concern with elegant and fashionable clothing was not confined to eighteenth-century colonials. As the prestige of artists increased so dress was treated as a symbol of success, not as a licence for bohemianism. Some like Dello Delli of Florence (1404–53) 'lived

[in Spain] like a nobleman and ever painted from that day onwards in an apron of brocade'.[21] Towards the end of the eighteenth century a number of English artists, including Cosway and Harlow, became so dress conscious as to be ridiculed as fops.[22] In contrast, John Opie's (1761–1807) uncouth appearance was to some extent stage-managed by Walcot on the grounds that 'all curiosity would cease if his hair were dressed and he looked like any other man; I shall keep him in this state for the next two years at least.'[23] The Victorians came to venerate the well-maintained hat and even in the first decades of the twentieth century master carvers arrived at their workshops wearing a finely brushed 'topper'.

In contrast to all this fastidiousness there were of course artists who were either careless of their appearance or had bizarre personal habits or were only too conscious of both to qualify for

65 Model windmill, painted wood, height 22½ in. (57.2 cm.), made for John Constable (1776–1837) by John Dunthorne. *Private Collection*

66 Constable's portfolio stand, walnut, *c.* 1835, height 3 ft. 8 in. (1.12 m.). *Private Collection*

true eccentricity. Alesso Baldovinetti (*c.* 1425–99) for example was believed to have used his cartoons in preference to a table cloth, but surely Vasari is optimistic in suggesting that in Baldovinetti's time there was anything remarkable in sleeping in 'a chest filled with straw and without sheets'.[24] Gerard Soest (*c.* 1637–81) was well known for his slovenly appearance. He 'often went to the door himself and if not in a good humour to draw ... he would act the servant and say his master was not at home: his dress made him easily mistaken.'[25] It was probably the behaviour rather than the appearance of Soest that caused the greater consternation. A century later Joseph Nollekens would also open the street door to visitors himself, 'a vulgarity he was addicted to'.[26]

67 Model of a horse, length 9½ in. (24.1 cm.), made by Gainsborough and later owned and used by Constable. *Private Collection*

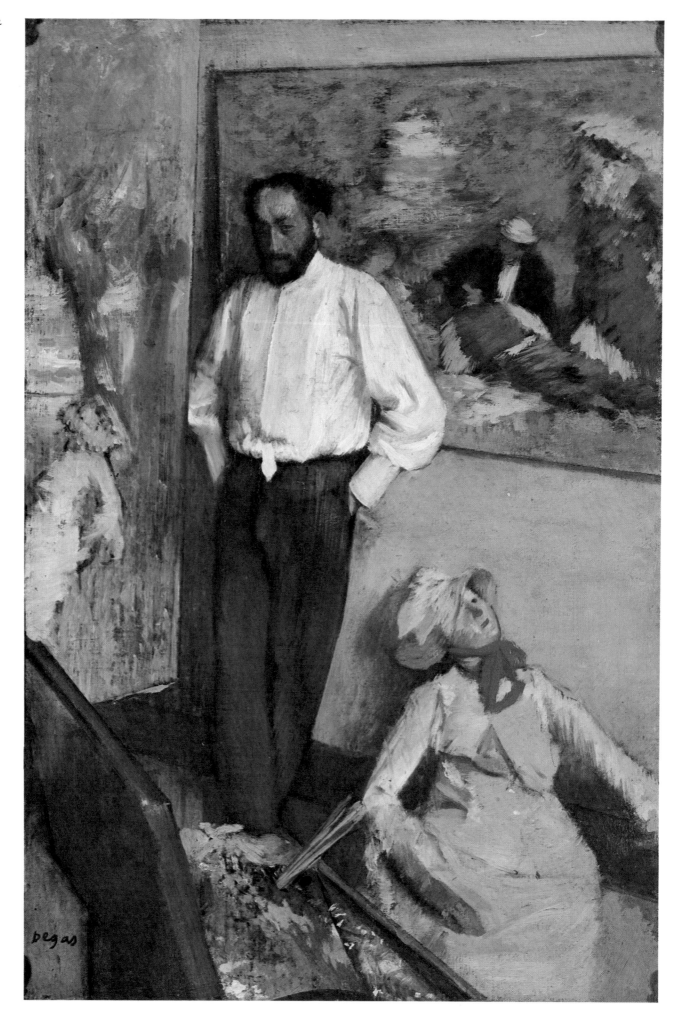

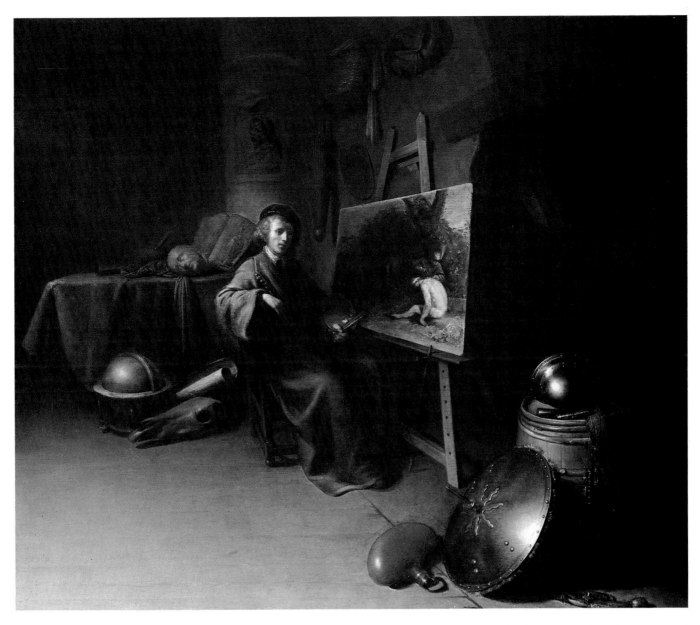

Soest and his type were the exception. It takes a degree of dedication to remain in dirty and perhaps torn working clothes at the end of the working day. For most artists their increased status brought with it certain obligations. This is not to say that artists, poets and other such persons were not permitted a certain latitude – they were. In seventeenth- and eighteenth-century portraits it is these individuals who are most often shown without their wigs. Nevertheless, in these times the advanced but still insecure social position of the artist made it all the more important to keep up appearances – he dressed

well and employed a servant to answer the door. The destruction of the old certainties following the Industrial Revolution, the manufacture of painting materials as well as those products that were for so many artists in direct competition with their work, the destruction of the old systems of patronage – all these contributed to the emergence of the Académie des Refusés and the Bohemian, a word that did not come into use in the English language in this sense until the second half of the nineteenth century.[27] Both the studio and its occupant of popular imagination were a comparatively recent creation.

69 Gerard Dou (1613–75), *The Artist in his Studio*. In the interests of maintaining the purity of his pigments Dou became obsessed with the need for a dust-free studio. *Sold at Sotheby's, London (21 March 1973)*

OPPOSITE
68 Edgar Degas, *Henri Michel-Lévy in his Studio*, c. 1878, oil on canvas, $15\frac{3}{4} \times 11$ in. (40×28 cm.). Note the lay figure discarded on the floor. *Calouste Gulbenkian Museum, Lisbon*

III DRAWING

Drawing, the placing of a mark to represent an idea upon a flat or approximately flat surface, is an activity closely associated with writing. In a metaphorical sense the word is also applied to an artist's ability to see shape as manifest in his work and in that sense is used in relation to sculpture no less than painting.

Materials and Supports

Today we are so familiar with a drawing performed upon paper with a lead pencil (more accurately described as a graphite) that it is an act of historical imagination to conceive of a time when both paper and graphite were unknown and 'pencil' was a word more often applied to small brushes. Our post-Freudian concern with the individual and his emotions has encouraged an interest in drawing. It is in drawing that one is closest to the thought processes of an artist, to his failures and his triumphs. It is in drawing that the unconscious 'signature' of the individual may be 'read' and it was therefore one of the few aspects of studio practice that could not, invisibly, be deputed to others. In the past the obsession with authenticated work by an individual was perhaps less obsessive and drawings were correspondingly of less consequence. In old age, Alesso Baldovinetti put his most valued possessions into a chest and those around him assumed that, since he valued its contents, they were necessarily of intrinsic financial worth. On his death nothing was found but 'drawings, portraits on paper, and a little book that explained the preparation of the stones and stucco for mosaic and the method of using them'.[1] By Raphael's day attitudes were slowly beginning to change since his work could be considered 'so stupendous that even the cartoons are held in the greatest veneration'.[2] As Vasari observed, the sketch in painting, sculpture or drawing often shows 'that fire' which 'finished' works often lack.[3]

The surfaces, pigments, and implements used for drawing have been extraordinarily diverse. Ancient Egyptian artists for example traditionally worked on papyrus, on wood panels covered with gesso, and on flakes of limestone known as ostraca. The preparatory stages of a drawing would be executed in a red ink or pigment with the finalized design being performed in black. The surviving ivory palettes, which are indistinguishable from those used by scribes, incorporate 'wells' for the red and black pigments, as well as compartments to hold the reed brushes used to apply them. To the elder Pliny and his Roman contemporaries the introduction of 'linear drawing' was 'attributed to Philocles of Egypt, or to Cleanthes of Corinth' and the first practitioners were 'Arideices of Corinth, and Telephanes of Sicyon, who still used no colour, though they had begun to give inner markings'.[4] In this one can almost recognize the description of the free and yet precise drawings on Greek vases. The decorators of vases were a group of craftsmen set apart from potters and among them was Execias, the most famous of the black-figure vase painters.

The association between 'drawing' and the caligraphy of the scribe noted in Egyptian work recurs in the medieval 'illuminations' of the 'limner'.[5] The word 'limner' derives from the *minium* or vermilion that was principally used by these craftsmen for initial letters. In general, the surface they worked on was parchment, which was also used by master masons in drawing up plans, elevations and details,[6] but parchment was an expensive item as numerous palimpsests attest. The introduction of paper, which was cheaper and therefore more expendable, freed artists and designers from the inhibitions that must have resulted from the use of parchment. The full-size drawing, as we shall see, was considered essential for architecture, painting, and sculpture. Until paper (which could be pasted together to form large sheets) was generally available, master masons were dependent upon plaster drawing floors for 'set-

70 Ivory palette, Thebes, XVIII Dynasty, *c.* 1400 BC. Ancient Egyptian palettes were provided with two 'wells', one for the red pigment used in the preliminary drawing and the other for the black pigment used to finalize a design. *British Museum, London*

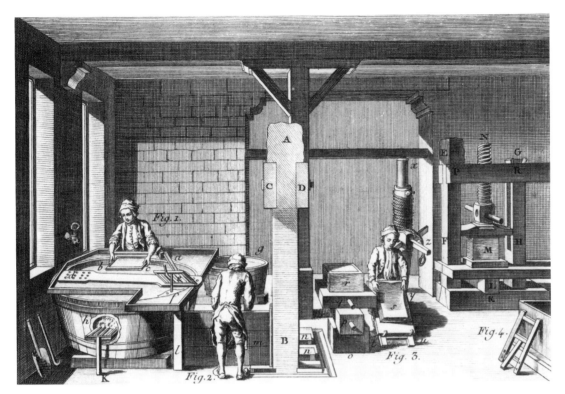

71 Paper making, from Diderot's *L'Encyclopédie*. The main skill in paper making is in the hands of the vatman (at Fig. 1). It is he who dips the wire sieve into the warm pulp and establishes an even thickness of paper in the 'mould'. The emergence of the architectural profession coincided with the development of paper making in Europe, and the growth of watercolour painting in the late eighteenth century was dependent upon an improvement and increase in the varieties of available paper.

ting out', in scribed lines, their full-size drawings. These drawings could be corrected or superseded by subsequent layers of plaster being 'floated' over them. Examples of plaster 'setting out' floors have in recent years been identified at Wells Cathedral and York Minster.

Analogous to these plaster floors was the use of boards covered with gesso (a preparation of whitening and size).[7] As has been shown, this drawing surface was in use in ancient Egypt. Cennini recommends close-grained timber for these boards such as 'old fig wood'. However, such fine timber only grows to a small diameter and with quarter-sawing to lessen the likelihood of splitting and warping, the dimensions were even further reduced (fig. 281). Narrow strips of wood could of course be splined and glued together, and although this was done it was contrary to the medieval traditions of sound construction. For larger drawings larger trees such as oak or lime were essential as hardwood was always preferred. As an alternative to gessoing the panel to be drawn on, Theophilus recommends 'a smooth flat wooden board sprinkled with chalk and water rubbed over with a cloth which when dry could be drawn on with a point made of lead or tin'.[8] Cennini describes a somewhat similar drawing surface made from 'a little boxwood panel, nine inches wide in each direction; all smooth and clean, that is washed with clear water; rubbed and smoothed down with cuttle such as the goldsmiths use for casting.' This was then coated with finely ground calcinated chicken bones, presumably mixed with size, in addition to saliva. Although Cennini

omits reference to size in this connection, for the calcinated bones he does recommend 'the second joint of fowls, or a capon' or 'the thigh bone of a gelded lamb'.[9]

The preparation of parchment required no less attention since whiteness was considered necessary. After the skiving had been stretched on a frame, washed at least three times and dried in

72 Drawing of the medieval masons' tracing floor above the north porch of Wells Cathedral, from the survey by John H. Harvey.

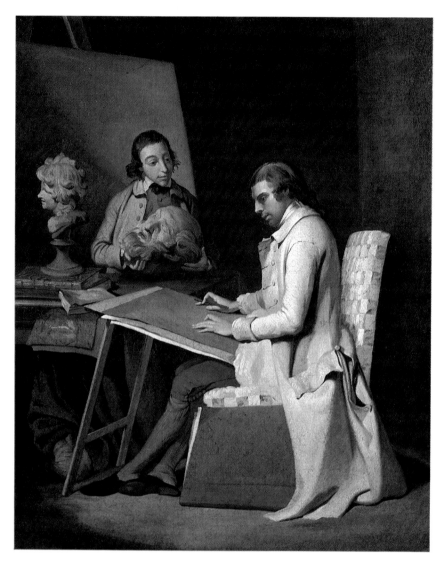

73 John Hamilton
Mortimer (1740–79),
After a Self-Portrait,
c. 1765, oil on canvas,
29 × 24 in. (73.7 ×
61 cm.). The legged
drawing board is of a
type that also occurs in
Rowlandson's *Time and
Death. National Portrait
Gallery, London*

74 Drawing on a gessoed
panel from Thebes,
c. 1400–1000 BC. The
squaring-up indicates
that this is a working
drawing. *British
Museum, London*

75 Drawing of a king
pouring a libation, New
Kingdom, *c.* 1250 BC.
Limestone flakes
(ostraca) were commonly
used by Egyptian artists
for preliminary sketches.
British Museum, London

the sun between each washing, it was treated
with several coats of powdered white lead mixed
with linseed oil – each coat being dried in the
sun.[10] Parchment was generally made from
several mammals although sheep was the most
common. Vellum was of course made from calf
skin.

The eastern origins of paper are implied by
Theophilus' use of the term 'Byzantine Parch-
ment'.[11] It was both imported from Constan-
tinople and manufactured by the Moors in
southern Spain in the twelfth century. By the
fourteenth century paper was extensively made
in the district of Ancona in Italy and its manufac-
ture spread throughout Europe, white paper
being made in England by 1495.[12] Cennini cate-
gorically states 'you may also draw on sheep
parchment and on paper'[13] and the *Libro dell'
Arte* gives instructions on the tinting of paper
with watercolours.[14] With reference to tinted
papers Vasari notes that they provided the
draughtsman with 'a middle shade' and refers to
the use of darker and lighter chalks to provide
the other two extremes of tone.[15] Cennini also

gives instructions on how to make a 'clear' trac-
ing paper with kid parchment scraped very thin
which, if not sufficiently 'transparent', may be
made clearer with 'fine linseed oil' smeared on
with 'a piece of cotton'. After being allowed to
dry thoroughly for several days it was ready for
use.[16] Sir Hugh Platt gives very similar instruc-
tions in his *Delights for Ladies* (*c.* 1595).

Just as printing was unlikely to develop until
paper was cheaply available, so watercolour
painting (which we will consider in a later chap-
ter) was dependent upon the development of
suitable papers. By the nineteenth century the
range of paper and sizes available was formi-
dable. An advertisement for Ackerman's at the
back of John Cawse's *The Art of Painting* (1840)
lists a large stock of 'Drawing Papers':

Demy	20	× 15¼ in.
Medium	22¾	× 17½ in.
Royal	24	× 19 in.
Super-royal	27¼	× 19½ in.
Imperial	30	× 22 in.
Elephant	28	× 23 in.
Columbia	35	× 23½ in.
Atlas	34	× 26 in.
Double Elephant	40	× 27 in.
Grand Emperor	65	× 47 in.
Antiquarian	53	× 31 in.
Antiquarian, extra large	56	× 38 in.

Bristol Drawing Paper and Card Boards
Vellum
More Cartridge for Landscape
Rough-grained Cartridge
Tinted Drawing Papers for Crayons.

Papers were also available both 'Hot pressed'
(smooth) and 'Not' (i.e. not hot pressed).[17]

Architect's 'linen', a cotton cloth treated with
starch, was much used for technical drawings in
the nineteenth and early twentieth centuries.
Leonardo da Vinci used an apparently similar
prepared linen for drawing on known as 'Rheims
cloth'.[18] In the second half of the nineteenth cen-
tury, tracing cloth made in Lancashire and
exported all over the world was woven from
yarn which was spun from long staple cotton.
This material, similar in appearance to handker-
chief cloth, was then 'bleached and stentered
before being filled with starch to which oils had
been added'. After a series of calendering proces-
ses the material was then ready for marketing
as 'tracing cloth' (to receive ink) or, alternatively,
for further processing and conversion into pencil
cloth. The principal manufacturer of these draw-
ing cloths was the firm of Archibald Winterbot-
tom of Manchester which began production
between 1853 and 1872 and registered its
'Imperial' trade-mark in 1879. The highly glazed

surface of these cloths was such that it would
not readily accept drawing ink unless sprinkled
with chalk dust (often kept in turned ivory boxes
for the purpose) or treated with diluted ox-gall
such as was supplied by P. W. Tomkins in the
early nineteenth century.[19] It was recommended
that the glazed side of the 'linen' should receive
the ink line of a drawing but coloured washes
should be applied to the back. An examination
of drawings in the RIBA Collection suggests that
there were no hard and fast rules.[20]

Among the drawing implements listed by
Vasari are 'the pen, the silver-point, the charcoal,
the chalk, or other instrument whatever nature
has created'.[21] William Salmon in his
Polygraphice (1672) states that 'The Instruments
of Drawing are Sevenfold, viz Charcoals,
Feathers of a Duck's Wing, Black and Red Lead
Pencils, Pens made of a Raven's Quills, Rulers,
Compasses, Pastils and Crions.'[22] The brush
appears to be omitted from these two lists unless
the 'Feathers of a Duck's Wing' is an oblique
reference to a quill-ferruled brush or a feather
used as a brush, either interpretation being
possible.

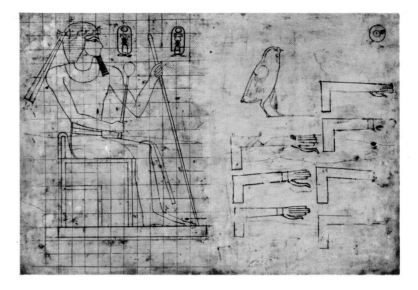

In the introduction to *An Analytical Guide to
the Art of Penmanship* (Boston, 1823) Enoch
Noyes observed that 'Good quills and a sharp
knife are the first things necessary. Quills that
grow on the left wing will better conform to the
hand [of a right-handed person] than those on
the opposite.' The best quills were those that had
been shed naturally since plucked quills had not
'ripened' to a satisfactory hardness, and the
principal sources were geese, woodgrouse,
ravens and swans.[23] Cennini recommends a
goose quill.[24] The cutting of a quill was an art
in itself and one that had to be adjusted to the
user's needs. Once the quill was cut, the natural
oils had to be removed before it would hold ink
satisfactorily. Although steel-nibbed pens are
mentioned in a 1680 advertisement for the
London writing master John Ayres at the Hand
and Pen near St Paul's where 'Gentlemen may
be furnished with the best sorts of Steel Pens,'[25]
they do not seem to have been generally available
until the early nineteenth century. In the 1780s
Harrison of Birmingham made cylindrical steel
pens with the ends shaped like a quill and in 1808
Bryan Donkin patented nibs made from two flat
pieces of steel. It was, however, the machine-
made steel pens introduced by John Mitchell in
about 1822 that ushered in their widespread use.
Many of these advances were of greater signifi-
cance to the swelling numbers of clerks that
industrial evolution demanded than to the less
regimented needs of artists.

The elastic flexibility of the quill pen possessed
a less scratchy quality which the steel nib could
not counterfeit. On the other hand it was the

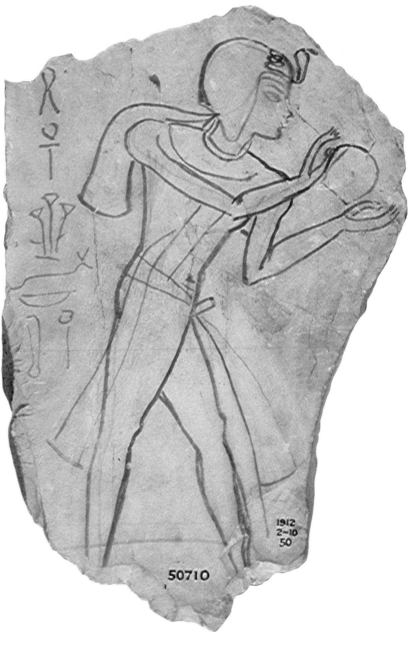

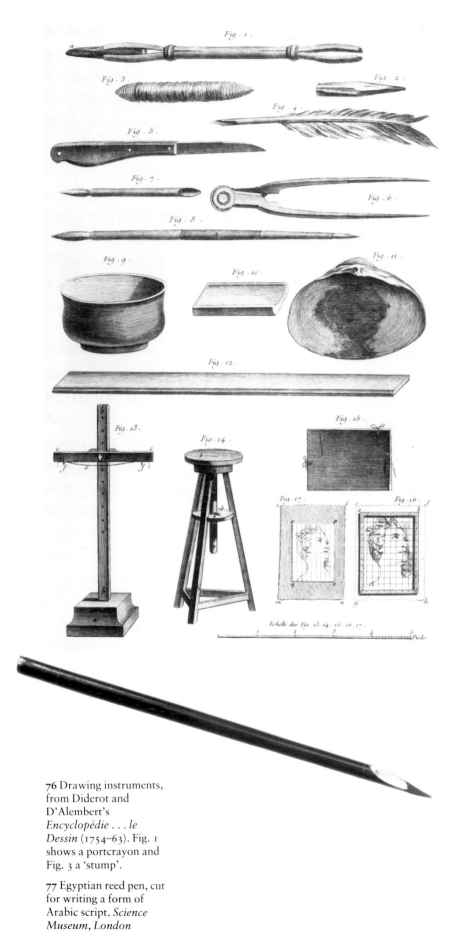

76 Drawing instruments, from Diderot and D'Alembert's *Encyclopédie . . . le Dessin* (1754–63). Fig. 1 shows a portcrayon and Fig. 3 a 'stump'.

77 Egyptian reed pen, cut for writing a form of Arabic script. *Science Museum, London*

coarse stiffness of the reed pen that also appealed to artists like Rembrandt and van Gogh.

In early medieval times the most satisfactory black ink was derived from lampblack or ground charcoal made from grape-vine.[26] Another ink was made from hawthorn wood: on being boiled, presumably in iron vessels, it produced an ink that was effectively an iron tannate or gallate.[27] Washes of bistre (boiled wood soot) were commonly applied to drawings to give them form and drama. Indian ink, which was in fact Chinese, probably reached Europe in the late seventeenth century. In was described in *The Dictionary of Arts and Sciences* of 1754 as follows:

> *Indian* or *Chinese Ink*, is sold, like our mineral colours, though much lighter; it is usually of a rectangular figure, about a quarter of an inch thick, being cast in little wooden moulds. It is ground in a little hollow marble or stone with water in it, till the water becomes a sufficient blackness. It makes a very black shining Ink, which though it sink, when the paper is thin, never runs. It is of great use in designing.
>
> The Chinese make it with smoke-black of different kinds, the best is the smoke of fat pork burnt in a lamp. They mix a kind of oil to make it smooth, and other oderiferous ingredients to take away the rank smell.[28]

The importance of pen and ink is asserted in John Elsum's *The Art of Painting* (1704) in which he argues that a good draughtsman must 'first be a competent penman'. He recommends the imitation of prints. This can be done with 'Pen and Pencil [brush] and is shadowed with Colours, or wrought with Ink and fair Water and shadowed with Ink alone', the last being 'done with black lead upon Vellum or with Pastils upon Paper'.[29]

Of the various metal points or styluses used, silver and lead ('that is a style made of two parts lead and one part tin, well beaten with a hammer')[30] were the most common although copper and even gold were employed. Silver points were perhaps the most usual of styluses. They create a light grey line on the picture surface which oxidizes to a light brown.[31] The surface on which they were used had to be sufficiently abrasive for a mark to be made; gesso must have provided just such a support. The lead pencil, as the words 'lead' and 'pencil' are now understood in this context, is a 'graphite stylus' which came into use in the early seventeenth century. The chief source was the Black Comb Hill graphite mine in Cumberland, noted by Celia Fiennes in 1698,[32] after which the Cumberland pencils and *crayons d'Angleterre* were named. In 1683 the deputy governor of the royal mines reported that the 'Black Lead . . . of late . . . is curiously formed

into cases of Deal or Cedar',[33] a type recognizable today and similar to those manufactured in the early nineteenth century by the family of the American writer and naturalist Henry Thoreau. Graphite adjusted to hardness and softness was not developed until the 1790s when the lack of English supplies persuaded the French chemist Nicolas-Jacques Conté to examine the problem. He found that existing stocks of graphite in France could be extended by grinding it with clay and firing the resulting mixture in a kiln. The more clay that was added to the graphite, the harder was the pencil. Conté patented his invention in 1795.[34]

Among the natural crayons used by artists was chalk and a 'black stone' which Cennini says came from Piedmont and which was soft enough to 'be sharpened with a penknife . . . It is very black.'[35] In addition, Vasari mentions a 'black chalk that comes from the hills of France' and a 'red chalk, which is a stone coming from the mountains of Germany, soft enough to be sawn and reduced to a fine point suitable for marking on leaves of paper'.[36]

Cheapest, and therefore probably most commonly used of all these drawing materials, was charcoal. This was derived from the conversion of various types of wood, but Cennini specifies

> a nice, dry willow stick . . . made into little slips . . . the length of the palm [width] of your hand. Then divide these pieces like match sticks . . . then tie them up in bunches in this way, in three places to the bunch, that is, in the middle and at each end, with a thin copper or iron wire. Then take a brand-new casserole, and put in enough of them to fill up the casserole. Then get a lid to cover it, [luting it] with clay, so that nothing can evaporate from it in any way. Then go to the baker's in the evening after he has stopped work, and put this casserole into the oven, and let it stay there until morning.[37]

If this roasting was insufficient the charcoal was returned in the casserole to the oven.

Among the materials 'for washing or drawing on paper' mentioned by Lomazzo as 'Englished' by Richard Haydocke were: 'For Blackes *Inke*, *black-lead*, *black-chalk*, and the cole of a *willowe*, or *dogge-wood tree*: for Reddes, the red-stone called *apisso*, which was much used by *Le Vincent* [Leonardo da Vinci] and for Whites, *white-lead* or *Ceruse*.'[38] These recommended materials agree with those found elsewhere except for the reference to charcoal made from dogwood and the rather early (1598) reference to black-lead. William Salmon recommends charcoal made from sallow wood[39] and others have used lime tree and spindle tree woods. In general the soft charcoals were made from peeled

78 Stick of Indian ink. 'Indian' ink was in fact made in China. The solid ink would be dissolved as necessary by being rubbed on a close-grained stone mixing-palette with water. Such inks may have inspired the development of watercolour cakes. *Woodbridge Collection*

79 Rogier van der Weyden (*c.* 1400–64), *St Luke Drawing the Virgin* (detail). Before the exploitation of graphite for 'lead' pencils, metal points, especially silver points, were an important drawing material. *Museum of Fine Arts, Boston*

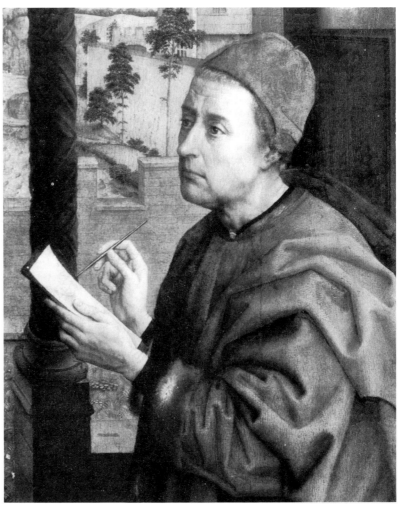

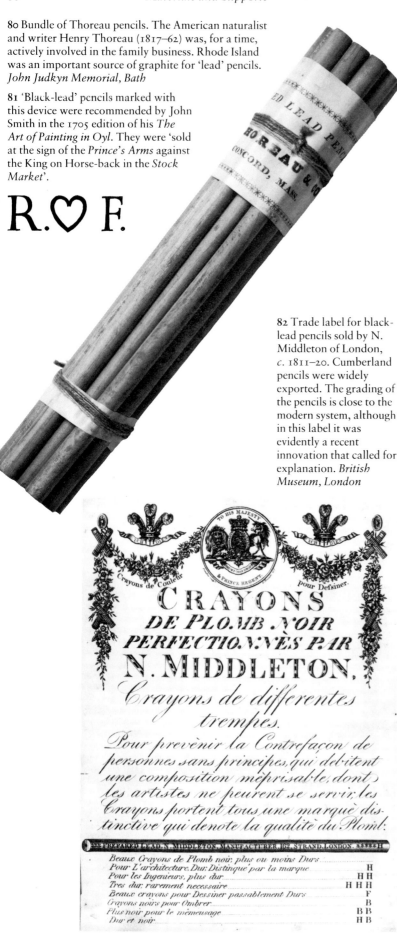

80 Bundle of Thoreau pencils. The American naturalist and writer Henry Thoreau (1817–62) was, for a time, actively involved in the family business. Rhode Island was an important source of graphite for 'lead' pencils. *John Judkyn Memorial, Bath*

81 'Black-lead' pencils marked with this device were recommended by John Smith in the 1705 edition of his *The Art of Painting in Oyl*. They were 'sold at the sign of the *Prince's Arms* against the King on Horse-back in the *Stock Market*'.

R.♡ F.

82 Trade label for black-lead pencils sold by N. Middleton of London, *c.* 1811–20. Cumberland pencils were widely exported. The grading of the pencils is close to the modern system, although in this label it was evidently a recent innovation that called for explanation. *British Museum, London*

twigs, the hard charcoals from split shingles.[40]

The various minerals used to place a mark on paper, parchment or gessoed board were placed in holders. Cennini recommends that in drawing out a design the artist should tie the charcoal to a little cane or stick so as to be able to stand at a distance from the work[41] and Vasari gives similar advice.[42] A quill could also be used as a holder for chalks[43] but by the eighteenth century the portcrayon of brass or white metal was in general use.

As has been seen concerning plaster setting-out floors, corrections could easily be made by scraping back or by 'floating' more plaster over the areas to be adjusted. Similarly, a gesso panel or prepared parchment could be rubbed down and a fresh start made. Paper was less forgiving, the palimpsest is more a feature of parchment, but on all surfaces charcoal seems to have been used for preliminary work and this could easily be erased with the barbs of a chicken or goose feather.[44] This is confirmed by Cennini in his frequent comment, 'draw your figure with charcoal and fix it with ink'.[45] A method of fixing the charcoal was not apparently considered, for once the drawing was 'fixed' in ink the charcoal – such as remained – was swept away with a feather. Before the appearance in late eighteenth-century France of India rubber,[46] freshly baked rye bread was used to erase marks left by charcoal and even silver point.[47] For this purpose the soft interior of the loaf was kneaded to a putty-like consistency. Bread is sometimes still used in this way to remove superficial dirt from old prints. Other erasers have included bundles of leather strips called dolage, cuttlefish bone (still used by sculptors to remove pencil lines from stone and marble), and possibly (and this is a speculation) dried fish skin. For marks that were really reluctant to move from paper, very sharp knives were used. In connection with watercolour painting Winsor and Newton produced specially made scrapers in the 1840s.[48]

Although charcoal is easily smudged, some drawing materials could, to some extent, be fixed on paper with milk. In the course of working up a drawing in chalk the smudge could develop into a high art which was further refined by means of the 'stump', also known as a *tortillon*. These were tight roles of amadou, a prepared fungus, chamois leather or blotting paper, sharpened at both ends and used to blend tones.[49]

A painter's small sketch was usually enlarged to the full-size cartoon or direct to the final work by means of 'squaring-up'. The word 'cartoon' is derived from the Italian *cartone* meaning a large sheet of paper. If the full-size cartoon was to be very large and the first sketch was small, an intermediate-sized drawing was sometimes

made. Until the late nineteenth century most artists favoured the full-size cartoon – but then most would have been working on commissions rather than on speculation. Another explanation for this is provided by Rubens. In the Flemish tradition he favoured luminous shadows through which the brilliant white of a gesso ground could shine. To give this effect an illusion of spontaneity a full-size cartoon was essential, a change of mind a disaster.[50] The method also enabled the Flemish master to depute such mechanical operations to an army of assistants. Vasari describes the 'squaring-up' of drawings 'with the net, which is a lattice of small squares'[51] which in effect provided the 'map reference' from the small sketch to the full-size cartoon. After a rather charming description of squaring-up, John Elsum gives a salutary word of warning: 'But Tis commonly said, that the use of the grate is an evil Practice, and that it weakens the Judgement. I confess there is something of truth in this objection. It must not therefore be used on all occasions, but in great Works only.'[52] Drawings could be squared-up to cartoons of considerable size. Raphael's cartoons in the Victoria and Albert Museum, London, measure no less than 11 ft. $2\frac{3}{4}$ in. × 17 ft. $5\frac{1}{2}$ in. (342.5 × 532.5 cm.). In working on such large cartoons Leonardo is said to have devised a scaffolding which could be raised and lowered as the work progressed.[53]

83 Gainsborough's showbox, oak, late eighteenth century. By facing the lens (left) the viewer could see (in the manner of a television) a back-lit transparency (see fig. 84) within the body of the box. *Victoria and Albert Museum, London*

84 One of Gainsborough's 'transparencies' for his showbox (fig. 83), back-painted in oil on glass. According to Horace Walpole, the Swiss artist Liotard (1702–89) painted similar transparencies 'with surprising effect', but complained that they were 'a mere curiosity, as it was necessary to darken the room before they could be seen to advantage'. *Victoria and Albert Museum, London*

85 Raphael, *An Allegory*, drawing on paper, $7\frac{3}{16} \times 8\frac{7}{16}$ in. (18.2 × 21.4 cm.), showing pin pricks used for 'pouncing' the design through the paper on to a gessoed panel. *National Gallery, London*

86 'Squaring up' a sketch into a full-size cartoon, an engraving from the 1701 edition of William Salmon's *Polygraphice*. A very similar drawing occurs in the John Martin manuscript (1699–1701) in the Soane Museum, London. *Bath Public Library*

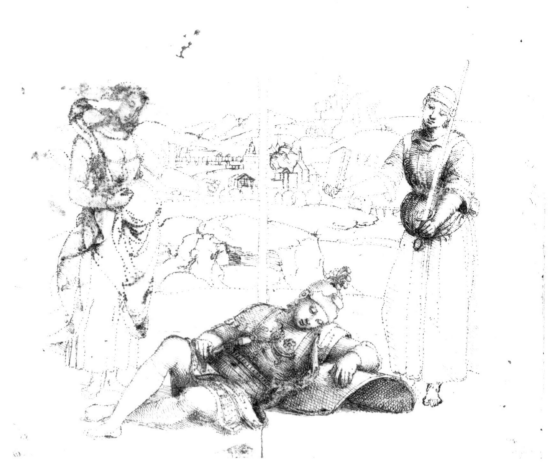

Squaring-up was used mainly for enlarging, but it could equally well be used for reducing, or even distorting a design. The American painter Thomas Eakins with his passion for perspective went so far as to square-up his signature into perspective.[54] It was seldom if ever used for transferring a design of the same size, as 'pouncing' was employed for this purpose. It should perhaps be remarked that when a painter enlarges a composition to (say) twice linear, compared with the original sketch, the area is multiplied fourfold. In sculpture, as we shall see when we come to look at methods of pointing-up, an enlargement of twice linear (as compared with the original three-dimensional sketch) constitutes an eightfold increase in volume. For sculptors, drawing is an important means of 'seeing' even though three-dimensional sketches are of more direct relevance for their three-dimensional work.[55] It was perhaps in acknowledgement of this that Vasari provocatively stated that 'although Jacopo [della Quercia] was only a sculptor, nevertheless he drew passing well.'[56] Another non-painter who 'drew remarkably well' was the eighteenth-century chaser, George M. J. Moser (1704–83). He was the first Keeper of the Royal Academy schools where he taught drawing.[57] It is of course true that sculptors often, but by no means always, omit 'local

n.° XV

colour' in their drawings in monochrome where a painter would usually include it. For sculptors, as for architects, drawings of works of art of the past were records of factual information. Joseph Nollekens's Italian sketch books gave the measurements of the works it included.[58]

Although the comparatively early (fifteenth-century) references to tinted papers suggest a move towards the drawing as a 'finished' product – a 'cabinet picture' – the tonal range offered by such paper, if used in conjunction with two further tones of chalk, would be of use to painters in establishing their tonal 'values'. The true cartoon, in John Elsum's words, was 'subservient to great Works'.[59]

We now come to an important stage in the 'life cycle' of the working drawing – its transference to the final working surface. With the true fresco an area of plaster was floated onto the wall that conformed to a day's work and cartoons were usually cut up along natural 'frontiers' in the design. These irregularly shaped segments of the cartoon were easily and accurately placed in position whilst the plaster itself was more effectively 'keyed' into the previous day's work. It was then simply a question of using a metal stylus to impress the paper which left a trace in the damp plaster of the *fresco buono* beneath.[60] It is possible that the need for these zones of activity encouraged, and perhaps inspired, the use of elaborate architectural backgrounds found in many frescos.

With gesso panels, canvas and other surfaces, the design was more usually pricked through. Cennini gives the following description in connection with work on textiles but the method was used for many purposes:

> Then you prepare your pounce patterns according [to the work to be undertaken] . . . that is, first draw them on parchment [the cartoon]; and then prick them carefully with a needle, holding a piece of canvas or cloth under the paper. Or do the pricking over a poplar or linden [lime tree] board; this is better than canvas. When you have got them pricked, take dry colours [and] . . . pounce with charcoal dust wrapped up in a bit of rag.[61]

This is described as *calking* by Robert Dossie (1764) which 'is performed also in another way by puncturing or pricking the original print or drawing, and producing an outline on a new ground by transmitting a coloured powder through the punctured holes.'[62] Some more recent writers have recommended the use of paper ash as the charcoal used in the 'pounce-bag'.[63]

The basic principles of carbon paper were not unknown to Vasari since he recommends rub-

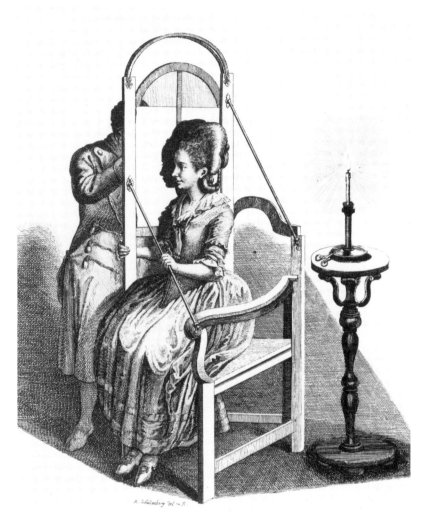

bing the back of the cartoon with charcoal or black powder which will then be transmitted to the surface to be worked on by means of a stylus used on the face of the cartoon.[64] Charcoal was quite adequate on larger-scale work but on small-scale gesso panels the pounce dust or charcoal 'carbon' had a very slight hold on the surface. It was therefore necessary to reinforce the lines thus indicated with silver point or ink. The remarkable drawing on gesso of *St Barbara* by Jan van Eyck shows the extent to which this was sometimes carried. Drawing of this type was often done in ink mixed with water applied with a 'small pointed minever brush'.[65] The use of a metal point sometimes left a slight indentation which, in a raking light, may be visible in the completed work. It is particularly noticeable in geometric elements in a composition where rulers and compasses were used to scribe architectural features and haloes.[66]

Auxiliary Devices

The shadow was the first optical aid available to artists. For some such as Hilliard, 'line

87 Johann Rudolph Schellenberg (1740–1806), *Goethe drawing Frau von Stein*, engraving, $9\frac{1}{2} \times 7\frac{3}{4}$ in. (24 × 19 cm.). Many of the drawing devices developed in the late eighteenth and early nineteenth century were based upon a cast shadow.

88 Sir Joshua Reynolds's camera obscura. The instrument folds down to resemble a book, a typical eighteenth-century conceit, although professional artists do seem to have exercised some discretion in acknowledging the use of such a device. *Science Museum, London*

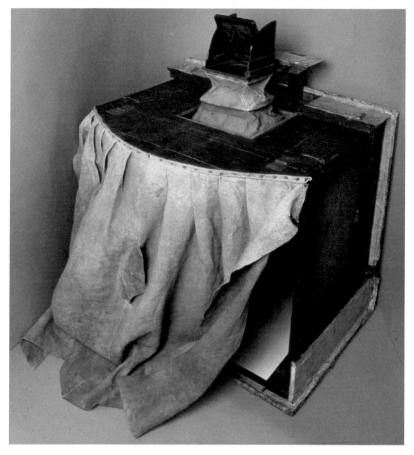

89 Paul Sandby (1730–1809), *The Magic Lantern*, watercolour and bodycolour on paper, $14\frac{3}{4} \times 21\frac{1}{4}$ in. (37.5 × 54 cm.). Artists were in the forefront of optical experiment. Daguerre was a painter, as was J. F. B. Morse who held a franchise on the daguerreotype in the United States. *British Museum, London*

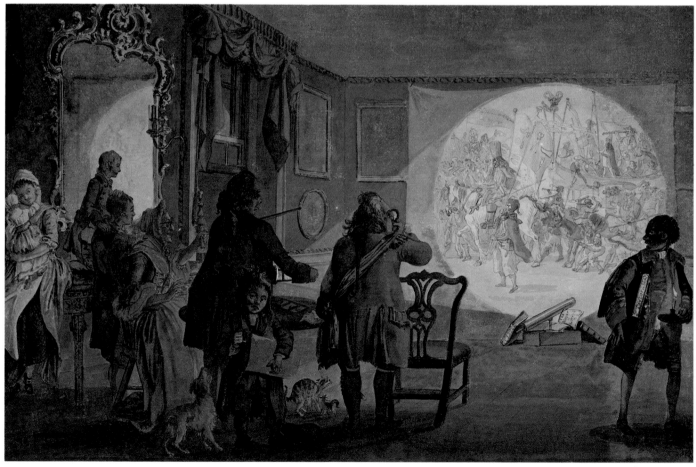

without shadow showeth all to good judgement, but shadow without line showeth nothing: as for example, though the shadow of a man against a white wall showeth like a man, yet it is not the shadow, but the line of the shadow which is so true that it resembleth excellently well.'[1] The recognition of the accuracy of information cast by a shadow was sufficient to encourage the development in the late eighteenth century of many devices that took advantage of this property. Among these was the physiognotrace (1786)[2] and also Schmalcalder's rod, patented in 1806.[3] So numerous had these devices become that by 1807 the Swiss-born artist, David Boudon, advertising in Maryland, was compelled to assure 'the public that his profiles are not produced by machinery but are the effects of his acquirements, from close and attentive application to the study in the best schools of Italy'.[4]

Geometrical perspective was an abstract theory which did much to raise painting to the status of a liberal art. Optical perspective could be a matter of empirical study and to aid artists in this the drawing frame was invaluable. Dürer illustrates a number of these devices showing the way they were used. John Elsum gives a good description of a drawing frame:

> ... take a Square Frame of Wood about one foot large, and on this make a little grate of Thread, so that crossing one another they may fall into perfect Squares about a Dozen at least, then place it between your Eye and the Object, and by this grate imitate upon your Table [picture surface] the true Posture it keeps, and this will prevent you from running into Errors.
>
> The more Work is to be [fore]shortened the smaller are to be the Squares.[5]

Omitted from this description is any reference to the need to divide 'the table' into similar squares. Robert Dossie however provides this information in *The Handmaid to the Arts* (1764), and states that with it 'the eye may be enabled to form and dispose [the subject] with more certainty, on a paper or other ground, divided in a similar number of squares.'[6]

Missing from both Elsum and Dossie is any reference to the need for the eye to maintain a constant position in relation to the drawing frame and the subject beyond it. This may be because, by placing the drawing frame near to the subject but at a distance from the artist, the relationship was less vital. The point is demonstrated in Abraham Bosse's engraving (1659) showing a drawing frame in use. Even here the artist is seated and a plumb line is hung in front of the drawing frame to ensure the accuracy of the 'longitude' no matter what

90 A framed collection of silhouettes by Shepherd of York. The enormous number of silhouettes cut in the decades around 1800 were to some extent inspired by the availability of convenient drawing devices. *York Castle Museum*

latitude occured elsewhere. Drawing frames were of two basic types. The earliest, Alberti's, was provided with a grille (as noted above), but Leonardo describes a later variant where a sheet of glass was substituted for the grille. Both types are discussed and illustrated by Dürer in his *Underweyssung der Messung* (1525). Sir Christopher Wren's perspectograph of 1669, which was illustrated in the Royal Society's *Philosophical Transactions* (no. 45), bore some resemblance to the drawing frame. In the *Anecdotes*, Walpole alludes to Wren as the 'inventor of drawing pictures by microscopic glasses . . . He drew a view of Windsor, which was engraved by Hollar.'[7] Distantly related to the drawing frame, although paradoxically omitting the frame but including the all-important 'viewer', was James Watt's 'Perspective Apparatus' of 1761. Since Watt failed to patent the device it was pirated by George Adams in 1766, and Dr Ree's *Encyclopaedia* of 1819 illustrates 'Mr Peacock's delineator' which appears to be very similar to Watt's design, although far less portable. All these devices have fallen into disuse amongst painters and sculptors. They continue however

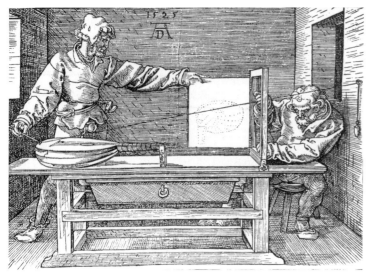

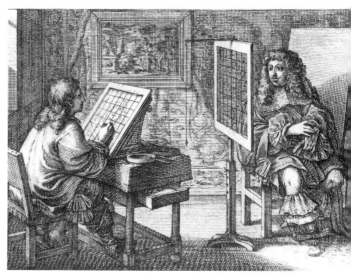

91 Dürer, *The Drawing Frame*, from his *Underweyssung der Messung* (1525). The drawing frame was a means by which an empirical understanding of perspective could be achieved.

92 Abraham Bosse, the drawing frame in use (1637). A plumb-line is suspended in front of the frame as a co-ordinate for all the vertical threads in the frame. In this instance the artist has used a makeshift background to the sitter.

93 James Watt's perspective apparatus of 1761. As with the drawing frame a constant vantage point was essential, hence the eyepiece (top centre). *Science Museum, London*

to use that most basic method of measuring a distant subject – the pencil held at arm's length.

The problems of perspective that so appealed to the sixteenth-century mind found its most distinctive expression in anamorphic painting. The skull in the foreground of Holbein's *The Ambassadors* is a familiar example. Like the distorted signs painted on road surfaces that become legible when viewed at a distance from the seat of a car, these Tudor examples are simply extruded natural forms that coalesce into recognizable images when viewed from the side. By the seventeenth century this visual device had assumed greater complexity and anamorphic images could only be read with the aid of special distorting mirrors which restored abstracted shapes into a two-dimensional reality on a three-dimensional surface. With his interest in optics, Sir Christopher Wren did a

> great Variety of sciographical, scenographical, dioptrical and catoptrical Experiments, which when executed with good painting, and geometrical Truth in the Profile would deceive the Eye with surprising Effects; such, for Instance, was the catoptrick Paint[ing], given to the Royal Society by Bishop Wilkins,[8] on one Side the Paint[ing] appears as if it were altogether rude and irregular, so as nothing can be made of it, but a metalline Cylinder being plac'd perpendicular upon a certain Point of the Table, the Rays are in such sort incident theron, and thence reflected to the Eye, as to represent a Variety of curious Works in Landskip and Figures &c.[9]

The 'perspective box' of the seventeenth century was yet another product of this marriage of art and science. Such raree-shows were composed of a series of two-dimensional panels, often painted with representations of the interiors of houses, which were assembled to form the interior faces of the perspective box.

When viewed through strategically placed mirrors these two-dimensional paintings in three-dimensional space resembled the real world.[10] Samuel van Hoogstraten's perspective box in the National Gallery, London, is a rare survival. All of these 'toys' would have required elaborate preliminary drawings.

Possibly the earliest and most widely used optical device was the mirror, at first a sheet of polished bronze, steel or other metal, later a mercury covered sheet of glass. Although the first recorded, but not surviving, self-portrait is

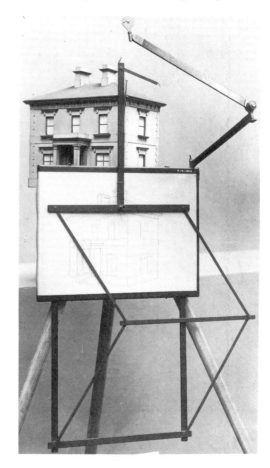

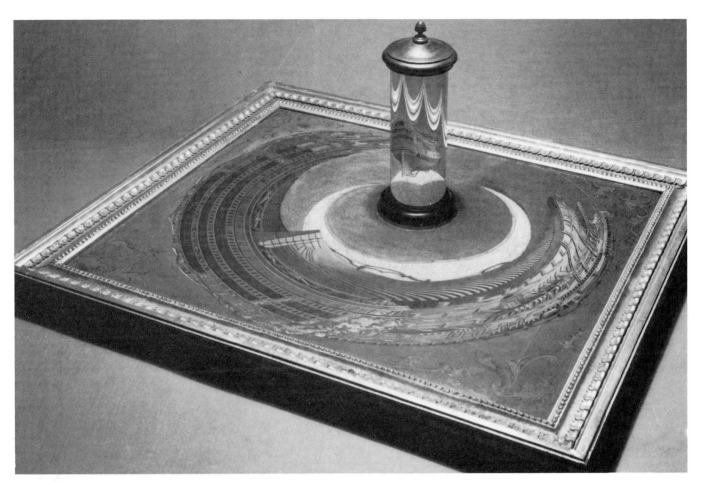

94 Anamorphic painting of a ship, eighteenth century. Christopher Wren's experiments with optics included the creation of anamorphic paintings which resolved themselves (as here) into recognizable forms by means of 'a metalline Cylinder being plac'd perpendicular' on the picture. *Science Museum, London*

95 Anamorphic painting of *The Head of Charles I*, late seventeenth century, oil on panel, 24 × 26 in. (61 × 35.5 cm.), artist unknown. The 'discovery' of perspective was accompanied by a general curiosity in optics and optical effects and illusions. The painting may disguise a celebration amongst Jacobites of 'Charles the Martyr'. *Private Collection*

96 Paul Sandby (1730–1809), *Rosslyn Castle, Midlothian* (detail), *c.* 1770, watercolour and bodycolour on paper, 18 × 24¾ in. (45.5 × 63 cm.). The camera obscura – such as is shown in use here – assisted with perspective but was also recognized as a means of seeing colour. *Yale Center for British Art, New Haven*

97 Camera obscura stamped with Canaletto's name. The image is thrown on to a ground glass plate measuring 7½ × 8¼ in. (19 × 21 cm.). Although the provenance of this instrument is unknown there is little doubt that Canaletto used a camera obscura. *Correr Museum, Venice*

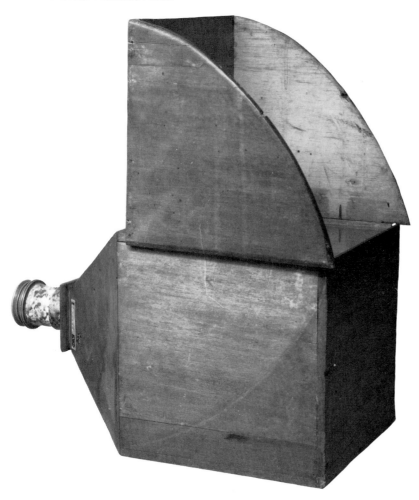

supposed to have been a bronze by the sixth century Samian sculptor and architect Theodorus,[11] it was the proliferation of effective glass mirrors in the modern world that coincided with an increase in the self-portrait and portraiture in general. The flat mirror was a valuable aid to introspection, as the tight inhibitions of so much fifteenth- and sixteenth-century portraiture so precisely, and with a delicious beauty, illustrates. They possess that constricted sense of arrested and self-conscious movement which did not appear again until the early days of photography. In each case, familiarity would in the course of time produce a more relaxed but not greater portrait art.

No less important but certainly less evident in its effects was the use of the mirror by artists to see a reversed version of their compositions. This gave painters and sculptors the chance to renew a jaded vision and again it was later parallelled by Rodin's use of the camera to provide a new insight into his works.[12]

The introspection – the reflective quality – of both the artist and his art, encouraged by the mirror, was at the same time opened out by the convex looking-glass. Details are seldom as dominant as is the convex mirror in Jan van Eyck's *Arnolfini and his Wife* (1434). In this picture the mirror occupies a central place in the composition. In the somewhat later *St Luke Painting the Virgin and Child* by a follower of Quinten Massys, the convex mirror may be physically placed to one side but since it also serves as a halo for the saint it is not insignificant. To late medieval taste the convex mirror must have been close to magic. It was the touchstone that reduced the world to the golden certainties of the illuminated miniature. But the convex mir-

ror was too valuable an aid to be abandoned when tastes changed. The Claude glass, with its less distractingly pretty image, was to be of greater use to painters. This black convex mirror not only reduced and reversed the subject, it also simplified the colour and tonal range. It has been used by painters, especially landscape painters, since the seventeenth century, to examine both subject and canvas. The distortions of the convex mirror were so evident as to be easily allowed for.

More disconcerting was the camera obscura that produced a realism (moving pictures in living colour) that artists were quite unprepared for.[13] Dunlap described 'the glowing pictures of the artificial camera obscura, when every object is illuminated by a summer's sun'.[14] Unlike the reflected image that appears in nature, the camera obscura projected another-worldly reality. The seventeenth-century Dutch painter Torrentius was even accused of witchcraft in connection with his use of a darkened chamber for his painting.[15] It was therefore not adopted with the enthusiasm that might be expected. The evident use of the camera obscura by Vermeer suggests a certain discretion surrounding the employment of such a device.

Vasari mentions a camera obscura in connection with Alberti (*c.* 1457), but it is likely that the earliest examples, used since antiquity by astronomers, were the darkened chambers from which their Latin name derives. The earliest known printed illustration of such a 'darkened chamber' shows a camera obscura used by Reinerus Gemma-Frisius to observe an eclipse of the sun at Louvain on 24 January 1544.[16]

By the late seventeenth century the portable camera obscura was quite commonplace and by the eighteenth century Dossie remarked that 'the portable kind . . . is commonly made by opticians. It is needless, therefore, to give a description of these instruments.'[17] This assertion is confirmed by the trade cards of London opticians like Edward Scarlett (*c.* 1758) at the Archimedes and Globe near St Ann's Church, Soho, and Edward Nairne (*c.* 1763) at the Golden Spectacles, Reflecting Telescope and Hadley's Quadrant in Cornhill, opposite the Royal Exchange. Dossie goes on to say that where a portable camera obscura is not available

and a prospect through any particular window is desired to be taken, an occasional camera may be formed. This is done by boring a hole through a window-shutter . . . and putting one of the glasses, called an ox-eye, into the hole; when all other light being shut out except what passes through this hole, and a proper ground of paper, vellum, &c being held at a due distance from the hole, the reflected

image of the prospect will be found upon the ground . . . yet there is one very material objection to its [the camera obscura's] use. This is, that the shadows lose their force in the reflected image; and objects, by the refraction, are made to appear rounder, or different sometimes, both in their magnitude and site, from what they really are, which being oppugnant to the truth of any drawing, almost wholly destroys the expedience there would be otherwise found in this manner.[18]

This perhaps rather sophisticated disdain does not admit of the probable use of this optical tool by Vermeer and its certain use by artists like Canaletto, Torrentius and the English artists Nathaniel Dance, Paul Sandby, and Reynolds, whose camera obscura survives. Mixed though the reception accorded to the camera obscura was amongst professional artists, it was certainly widely recognized as an aid to amateurs. John Cuff (*c.* 1747), advertising his 'Solar Microscope', describes it as 'a Contrivance for drawing the pictures of [celestial bodies] with great Ease and Exactness, even by those who have never drawn before'. The camera obscura not only gave a clear representation of line, it also provided an 'eye' for natural colour. In the *Critical Guide to the Exhibition of the Royal Academy* of 1796, Anthony Pasquin suggests that 'if Mr Towne used a camera occasionally, he would correct his present manner of colouring.'[19] George Smart, the early nineteenth-century tailor of Frant, near Tunbridge Wells, not only produced charming naïve collages for sale but may have used in their design the camera obscura which features in some of his pictures and which he later opened to the public.

With this existing interest in the camera

98 An interior view of Samuel van Hoogstraten's perspective box (*c.* 1654–62), internal dimensions $22\frac{7}{8} \times 35\frac{5}{8} \times 25$ in. ($58.1 \times 90.4 \times 63.5$ cm.). *National Gallery, London*

99 Two Claude glasses, probably eighteenth century. *Science Museum, London*

RIGHT
100 Camera lucida.
Science Museum, London

obscura amongst some professional and most amateur artists, it is hardly surprising that the subsequent development of the camera proper occurred amongst both groups. It was the use of the camera obscura that led the gentleman amateur painter and mathematician Fox Talbot to invent the first working camera and it was the professional painter Louis J. M. Daguerre (1787–1851) who devised yet another method of taking photographs. The American painter Samuel F. B. Morse became the holder of a franchise of Daguerre's patent in the United States.

In contrast to the camera obscura the much later camera lucida has remained the preserve of draughtsmen. This device was patented by William Hyde Wollaston in 1807, but William Dunlap quotes Benjamin West being shown a camera lucida which Gilbert Stuart dropped, 'his hands being always tremulous'.[20] This must have been before Stuart left London in 1787, never to return. In use the camera lucida enables the artist to look at both the subject and the surface on which he is drawing simultaneously. Varley's 'Patent Graphic Telescope', which was invented by the painter Cornelius Varley (1781–1872) in about 1809 and patented in 1811, combines in one instrument the properties of both the camera lucida and the telescope. The apparatus has since been adapted for use with the microscope.

In general the camera obscura did not produce

101 Eighteenth-century
magic lantern. *Science
Museum, London*

a bright enough image to be of much use in portraiture. William Storer's 'Royal Accurate Delineator' (1778) was one of the very few camera obscuras capable of being used for portrait work. More usual were the various devices that revert to the use of shadow for drawing profiles, of which the physiognotrace was perhaps the best known.

The camera obscura and the camera lucida presented nature in two dimensions, but otherwise in all its overwhelming complexity. Other devices used by artists were less ambitious in their purpose and function. Dividers and callipers were of considerable importance, the latter especially amongst portrait painters and sculptors who, in the interests of their clients, often had these made in wood or ivory rather than the more usual iron or steel. In enlarging or reducing a drawing or other work proportional dividers were much used. Their invention has been attributed to Heron of Alexandria in the first century AD. The earlier proportional dividers were probably made to a fixed proportion 1:2, 1:3, or 1:4. By 1565 Jacques Besson in Lyons illustrates the slotted variety with a movable pivot, the sides calibrated with proportions.[21] Related in principle to the proportional divider and similarly adjustable was the pantograph. An instrument of this kind was devised by Scheiner in 1603[22] and by 1666 Pepys mentions a visit to the instrument-maker Greatorex where he saw a parallelogram which the naval official noted would be of help in preparing charts. Although referred to by Dossie as 'formerly called a parallelogram, and by some at present a mathematical compass',[23] it was for map-making that these instruments were principally used. The unevenly

distributed weights of the conventional pantograph were inadequate for the accuracy demanded in technical drawing. In response to the need for an improved pantograph, Thomas Reid devised a new type of drawing mechanism that was later pirated with improvements by Andrew Smith and named by him the apograph; this device of the 1820s had the advantage that not only did the copying arm move easily from a central point, it was also possible for it to work on the underside of a drawing, thus producing the mirror image so necessary for engraving.[24] The reducing machine for coins and medals (fig. 255) works on the same principle as the pantograph, and so too does the long-arm pointing machine (fig. 217). The latter is very comparable to the W. F. Stanley eidograph.[25]

102 'Mathematical compass', illustrated in the English translation of Claude Boutet's *The Art of Painting in Miniature* (London, 1736). The pantograph was an important drawing device.

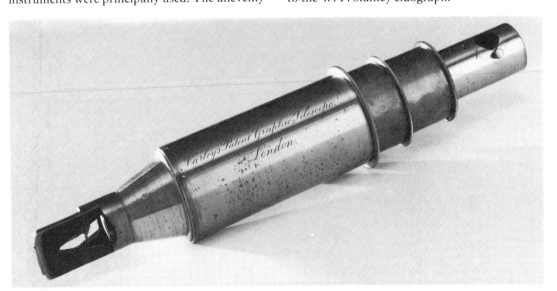

103 Varley's 'Patent Graphic Telescope'. Cornelius Varley (1781–1873) invented this version of the camera lucida in about 1809 and was granted a patent in April 1811 (patent specification 1811 N° 3430). *Science Museum, London*

IV PAINTING

Supports and Grounds

The 'support' to a painting is the backing which carries the surface on to which paint is applied. The intermediate layer of surface preparation or priming (such as gesso), upon which the paint is usually placed, is known as the 'ground'. In murals the support is the wall and the plaster ground is the equivalent of the gesso of a panel painting. Over the last 400 years or so, canvas has become such a familiar support that 'the canvas' is now a synonym for 'the picture'. This may account for the emphasis given to the supports in gallery labels which generally leave us in ignorance as to the nature of the ground. The development of canvas as a support for paintings did much to hasten the standardization of dimensions for both canvases and picture frames. A wood panel could be cut down to any size with ease but the stretcher or straining-frame to the canvas was more difficult to alter.

Murals painted with pigments suspended in a medium of size, casein or lime are common, especially in northern Europe, but since it is the medium rather than the surface that conditions their character we will look at these elsewhere. Wall paintings of this kind were known by the Italians as *fresco secco* in reference to the dry surface upon which they were painted, in contrast to the true fresco or *fresco buono* where the pigments were applied to fresh damp plaster which gives them a certain ingrained or 'dyed in the wool' permanence. In countries bordering the Mediterranean frescoes may even survive out of doors for many centuries. In some senses, the ground in true fresco also serves as the medium. G. Baldwin Brown[1] argued that 'it is better to consider it [*fresco buono*] . . . as a colour finish to plasterwork'; the pigments being mixed with 'nothing but pure water' are held by the plaster.

Damp walls – especially those affected by rising damp – are probably the greatest problem for all types of wall painting. Leonardo da Vinci's *Last Supper* in Milan and the mural in the Loggia at Ham House in Surrey, England,

are two examples that reveal the adverse effects of damp. In northern Europe this was always a greater problem than for the countries of the Mediterranean, which is reflected in the respective treatises written in these regions. In the north, walls that were to receive plaster for murals were sometimes treated with leaf tin or covered with cloth glued onto the wall surface.[2]

For true fresco, the ground consisted of a series of coats of lime plaster. The first layer was a coarse cement of broken brick and lime followed by progressively finer layers of rendering made from lime and sand, culminating in a mixture of slaked lime and marble dust. The resulting calcium hydrate is akin to the chalk used in the *kalkmalerier* of Scandinavia.[3] These layers of lime plaster could total as much as 5 in. in thickness. It was not advisable at any stage to mix gypsum with lime,[4] and if Roman lime, which was made of travertine and white in colour, was mixed with 'pozzolana' (Pozzuoli), a tawny-coloured volcanic dust, the discolouration, slow drying, excess of water when drying, and resulting efflorescence all had to be allowed for.[5] Before 'floating' the lime plaster, the wall had to be keyed and drenched with water so as to reduce suction and slow the rate at which the plaster 'cured'. If it dried too rapidly it would crack and peel off the wall. After the wall had been rendered with the penultimate coat of plaster the general outlines of the cartoon were transferred. The cartoon was then cut up into sections and the wall plastered correspondingly day by day. The dimensions of each section were equal to the area that the artist felt able to complete in one day. This final coat of plaster, known as the *intonaco* and applied bit by bit, was 'worked up' with the 'float' on the wall until it achieved a 'fatty' consistency. John Martin's manuscript (1699–1700) recommends that the final coats 'be very hair'd with ox-hair' and rendered 'very smooth and even, that no roughness, hills, nor dales be seen'; and that the final coat should be 'the thickness of half a barley corn'.[6] This was burnished with the 'float' whilst still damp.

Premeditated though the planning, designing and drawing necessarily were, the final performance was rapid and therefore produced an apparently spontaneous effect. Vasari recognized the worth and virtuosity of fresco on the grounds that 'it consists in doing in a single day that which in other methods may be retouched day after day.' It required a hand that was 'dexterous, resolute and rapid'[7] and 'nimble and free'.[8] The still visible zones in Italian Renaissance frescos attest to the impressive speed at which artists were capable of working. In a raking light it is also possible to see where the artist has used a stylus to impress the drawing from the cartoon into the fresh plaster. These indented lines were finally revised with sinoper, a red earth that originally came from Sinope on the Black Sea but which became the generic name for almost any brilliant and valuable red pigment.[9]

Some experiments at painting in oil on plaster were attempted by Domenico Viniziano (d. 1461)[10] and later by Andrea dal Castagno, as well as by Antonio and Piero Pollaiuolo. The first to succeed in this was Sebastiano del Piombo. His still well-preserved *Christ at the Column* in San Pietro in Montorio, Rome, is painted in oil on plaster. Piombo's secret apparently lay in the lime plaster that he used together with a mixture of mastic and colophony which was melted together, applied to the wall and then smoothed over with white hot mason's trowels.[11]

Although Vasari states that Margaritone[12] (*fl. c.* 1250–75) was the first painter to 'consider what a man must do when he works on panels of wood', many artists before him evidently pondered such matters. Among them were the Romano-Egyptian painters of mummy portraits who continued the Greek tradition of wax encaustic. These were painted at Faiyum and date from the first century BC to the third century AD. They were painted on thin panels of cedar, stone-pine and sycamore covered with muslin and coated with gesso.

In panel painting the selection of timber, its sawing and seasoning were of utmost importance. Hardwoods (deciduous) were preferred, but hard softwoods (coniferous) such as yew were also used. Boards, especially oak boards, cut from a log 'through and through' are very likely to warp since it is the tendency of the annual rings of growth to unwind. In the past this was obviated by quarter-sawing, a method of dividing the log which resulted in more wastage but greater stability in the resulting boards. When cut from the log in this way the annual rings run through and not across the section.

Seasoning is a slower process in large scantlings than in small ones and for this reason is today generally begun after a log is planked. In

the past, hand sawing and high standards of craftmanship encouraged timber merchants to season timber in the log. Although seasoning is colloquially referred to as 'drying' the 'green' timber, an absence of moisture is not the intention of seasoning. It is rather its function to remove the sap from the wood gradually so that cracks are unlikely to develop. Once the log had been reduced to planks and then to panels Cennini advises that they should be submerged in boiling water, a procedure which was designed to encourage movement so as to reduce the likelihood of splitting.

Among the woods recommended by Cennini for panel painting were box and fig for small panels, and for large work, lime, willow and, most favoured of all in Italy, poplar. Both Mérimée and Eastlake, writing in the first half of the nineteenth century, noted that wood supports in Italy were generally of white poplar and in Flanders of oak.[13] More recently a study of 1000 'primitive' western European paintings by Madame Marette of the Louvre[14] confirmed Eastlake's observations. Suitability and availability seem to have been the prevailing considerations. In South Germany fir and lime were

104 Michelangelo's Sistine Chapel lunette *Azor–Sadoc*, the lower illustration dissected to show the joints in the plasterwork, each zone being the extent of one day's work.

most popular; in North Germany beech; in the Netherlands, Northern France and England oak; in Russia lime was preferred, but by the fourteenth century pine was sometimes used and by the seventeenth century was quite common.[15] This empirical attitude towards materials has long been noted in the study of vernacular building, and since that was the product of the workshop experience of masons and carpenters, it is reasonable that in the workshops of picture-makers similar values prevailed. This is not to say that panels were necessarily made and prepared by those who were to paint upon them. John Harvey has pointed out that 'painters' traditionally decorated wood saddle bows made by saddlers, in contrast to 'stainers' who 'stained' canvas hangings made by weavers. This would explain why in Utrecht the saddlers were members of the same guild as the painters and sculptors; it was not until 1611 that the saddlers were ejected.[16] The differing supports distinguished the 'painters' from the 'stainers'. In Cennini's instructions on how to make goat glue there is reference to its use by painters and saddlers which may be explained by the history of association between the two crafts.[17] There is also evidence that medieval joiners worked as painters in the decoration of chests and panelled rooms.[18] The long association between 'painters' (as opposed to 'stainers') and the wood-working crafts suggests that joiners, if not saddlers, continued to make panels for painters down to the seventeenth century.

In Antwerp a special guild developed for the craftsmen who made oak panels for painters.[19] The virtues of quarter-sawing resulted in some difficulty in producing panels of the larger dimensions. Indeed medieval panelling is traditionally composed of a series of small panels or narrow planks, two schemes that were the natural result of quarter-sawing. For large paintings it was necessary to join boards so as to create a larger 'table'. These had to be made in such a way as to respect the flexible nature of wood whilst at the same time providing the permanence that both painter and client would expect.

The organic nature of wood is always present despite the various measures that were taken in the seasoning and sawing to reduce its effect to a minimum. The need of some painters to place the newly painted panels in the sun to dry subjected the wood support to further stresses. 'Giovanni of Bruges' – or Jan van Eyck as we know him – experienced this problem which, so Vasari tells us, encouraged him to experiment with oil paint which could dry safely and slowly indoors.[20] Nevertheless, traditional practice dies hard and even in the seventeenth century, when oil had become the most usual medium, Peter Vlieric placed an unfinished panel painting in the sun which split so badly 'that it required to be again planed and glued'.[21] This could be construed to suggest a weakness in traditional practice but in fact it was found that the sun effectively bleached out the discolouration caused by the use of an oil medium.

105 The back of a painting of the Trinity, Austrian School, fifteenth century, silver fir, $46\frac{1}{2} \times 45\frac{1}{4}$ in. (118×115 cm.). Timber panels were the most common support for moveable paintings until the widespread introduction of canvas. Even when not generally visible, the backs of such paintings were sometimes treated decoratively; this example is painted with a design of green leaves. *National Gallery, London*

106 An example of 'cradling', a system used to prevent a panel painting from warping. The battens that run on the same axis as the grain of the wood are fixed to the panel; the battens that run across the grain are not fixed, which enables the panel to 'move' without splitting. *National Gallery, London*

Wood should always be given a certain latitude to enable it to move, which is why in the framing-up of panels the grooves inserted into the stiles and rails to receive the panel are wide enough to 'give the board liberty to shrink and swell without rending', as William Salmon expressed it.[22] Despite this 'liberty', such framing-up does serve to restrain movement. In thick panels this may be achieved by means of 'keys', a method that was especially favoured for the pine panels of Eastern European icons. The 'cradling' sometimes resorted to by conservationists is similar in principle. In both methods the wood has liberty to shrink in its width (it shrinks insignificantly in its length). For this reason the keys are often slightly tapered, and in cradling only those battens that run on the same axis as the grain of the panel are fixed. Large panels or *tavole* made up from a series of small boards were splined and glued together. Pieter Saenredam's 1648 painting of the interior of the Church of St Bavo in Haarlem measures no less than $68 \times 56\frac{3}{8}$ in. (172×143 cm.). It is painted on an oak panel composed of six thin boards dowelled together.[23] Various glues were used in assembling such panels including fish, cheese (casein) and animal. Both Theophilus and Cennini recommend glue made from a mixture of cheese and quicklime, probably because, unlike animal glues, it was not soluble.

In Antwerp in the seventeenth century, panels were bought by painters from suppliers in set sizes denoted by price rather than dimensions: three-, six-, eight-, sixteen-, twenty-, and twenty-six-stuiver sizes,[24] or a two-and-a-half-gulden panel.[25] The cost of a panel could be quite high in relation to the cost of the painting. The notary Dirck de Haen, who died in 1638, valued his portrait by Willem van Vliet at twenty-nine gulden including five gulden for the panel.[26] Quite why some of Rubens's paintings are on panels made up of a confusion of smaller ones, in different sizes and proportions, may only partly be explained by the artist's need to add onto one side of his picture surface.[27]

Although wood panels were made with considerable care, an understanding of the nature of wood extended also to its preparation with gesso. In this respect the 'ground' is but part of the structure of a panel painting. Once the panel had been planed and scraped and made as free of greasiness as possible, knots were carefully 'killed'. In softwoods the oiliness of such knots is especially difficult, which was one reason why fir was avoided as a support in Western Europe. Cennini recommends that knots and holes be pasted over with a mixture of size and sawdust, so that panels 'may not show fissures and cracks'. A nail, or some such serious fault which might rust and discolour the gesso, was first knocked down into the surface of the wood and then covered with tin foil which was glued in place.[28] Vasari tells us that Margaritone 'used to put over the whole surface of the panels a canvas of linen cloth, attached with strong glue [size] made from shreds of parchment and boiled [heated] over a fire.'[29] This 'marouflage' is a well-recognized procedure with which the Egyptians were familiar. John Elsum in *The Art of Painting* (1704) associates 'Working upon the Table' exclusively with egg tempera, and states that 'Flaws must be stopped with Putty [whitening and a binding agent] or something equivalent, and then sized.'[30] Before sizing, the panel was usually slightly heated. It was then ready to receive the gesso ground. This was composed of a mixture of size and powdered whitening applied in many coats, each coat being made of a progressively weaker size and greater proportion of whitening. The latter could be made of gypsum[31] rather than chalk, but since the gypsum had to be denatured by constant stirring to become in effect chalk there seems little reason for this exercise.

The application of gesso, size, and gauze to one side of a panel inevitably established tensions in the structure of the wood. With the traditional triptych where the flanking panels are painted and therefore prepared on both sides, there is very little sign of warping. Where a panel was prepared on one side only the convex bow of the wood is often considerable. For the mummy portraits of Roman Egypt this was if anything an advantage. To counteract this tendency panels were sometimes prepared on both sides, even where only one surface was painted, so as to maintain a flat plane. In general the bowing of a wood panel was a disadvantage although the Italians, whose work is often warped, do not seem to have responded to this problem as did others. The van Eyck *Arnolfini and his Wife* in the National Gallery, London, is treated on both sides. Panels that remained untreated with gesso on the back could be branded with the owner's cypher (e.g. Charles I's) or with the painter's name (e.g. Cephas Thompson's brand).

The gesso panel presented a perfect surface upon which to draw or scribe a design, and scribe lines often remain visible in the completed work. Sometimes these scribed lines were intended to be visible in emphasizing a halo or some such feature. Related to this was the texture given to the 'ground' by means of scribing and punching with ring punches and other designs. None of these features would be especially visible if it were not for the burnished gilding that gesso grounds were so eminently suitable to receive. More evident were those elements in a composition that were built out in gesso in relief. This

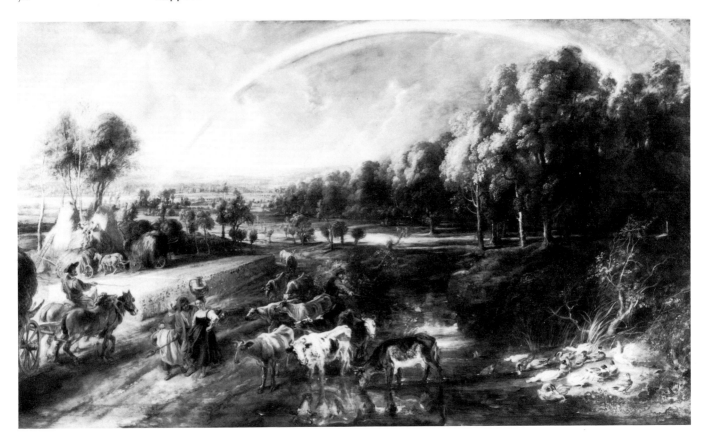

107 Rubens, *The Rainbow Landscape*, 1636–8, oil on panel, 53¾ × 93⅛ in. (136.5 × 236.5 cm.). The irregular composition of this panel (shown by the smaller reproduction) is not easily explained, although the two narrow strips at the bottom were apparently added as an afterthought to provide room for more foreground. *Wallace Collection, London*

was done by modelling in a moist warm gesso. built up layer by layer with a brush and then carved into crispness when dry.

From earliest times gold leaf was applied by a method known as water-gilding. Other methods include oil-gilding, which, being impervious to water, was suitable for exterior work, and the fire-gilding of metal, especially bronze. For purposes of water-gilding the gesso had to be as smooth as possible. This surface was then given one or possibly two coats of powdered red clay (Armenian bole) mixed in a weak solution of size and applied with a brush. Once dry the Armenian bole was dampened with a large soft-haired brush and as the bole began to dry

again the leaf gold was applied with the aid of 'tips' of squirrel hair. After some time it was then possible to burnish the gold with a dog's tooth or agate. A fuller description of gilding will be given in the section on framing. Suffice it to say here that 'working in the white', as scribing, punching, carving and casting gesso is known, is so enjoyable (it was a pleasure experienced by Donatello in his youth) as to inspire labour-intensive treatment. Many of its effects are barely visible 'in the white' and are revealed only after gilding. The handling of water-gilt gesso is therefore surprisingly independent of the individual or period in which it was made. The content may change but the form is constant, from an Egyptian sarcophagus to an Italian gold-ground 'primitive' or an English Queen Anne mirror frame.

There was too, as regards painting, another important influence at work in the use of this ground. The gesso in Cennini's words was 'as white as milk' and as smooth as 'ivory'.[32] In addition, the pigments that were applied to this surface were, as we shall see, obtained and ground with so much effort and care that the paints, no matter what medium was used, were customarily applied so that the gesso shone through to illuminate their brightness.[33] This characteristic was maintained by the Flemish school of painting[34] which persisted with the use of panels although by the seventeenth century the Italians had turned increasingly to painting on canvas.

Bernard van Orley, according to van Mander, painted a *Last Judgement* on a ground covered entirely in gold leaf.[35] Although a silver-leaf ground became quite common in late (i.e. seventeenth-century) Novgorod icons,[36] and silver leaf was used for some details in Western European paintings, it was inclined to tarnish. For this reason tin was substituted or silver leaf was often given a glaze of varnish either to protect it or to counterfeit gold. Even as early as the eighth century the so-called *Lucca Manuscript*[37] mentions a varnish mixed with saffron and orpiment which, when glazed on leaf tin, resembled gold.

In addition to wood, other rigid or less flexible supports were used. Of these much the most common, particularly from the mid-sixteenth to the mid-seventeenth centuries, were copper plates. In contrast to wood panels, copper plates were more stable, and in addition the smoothness that was so lovingly created in gesso on wood was a natural feature of the copper plate – indeed it was something of a liability. Van de Graaf has associated the development of oil painting on copper with the use of copper as a basis for enamel, especially the enamels fired at Limoges.[38] In support of this hypothesis Leonardo mentions the art of painting in enamel on copper which, when fired, rivalled the permanence of sculpture.[39] Another connection may be the appearance of copper plates in the artist's workshop for print making, especially in the Low Countries and Germany. Martin van Valckenborgh's painting of *The Tower of Babel* (*c.* 1595) in the Museum of London is painted on a reused plate from Hogenberg's map of London of about 1560. Another plate that once formed part of the same map (showing the eastern side of the City of London) has also survived reused as the support for a painting by another hand.[40] Vasari mentions that Sebastiano del Piombo's (1485–1547) use of a mixture of mastic and colophony heated together to provide a ground for painting on marble indicated a possible method for painting on plates of silver, copper, lead and other metals.[41] By the seventeenth century John Petitot, working in England, 'generally used plates of gold or silver, seldom copper',[42] and for miniature painting Claude Boutat (or Boutet) advised that 'Your Velom must be pasted upon a little Plate of Brass or Wood.'[43]

At a still earlier period, reverse painting on glass[44] and on gesso panels covered entirely in gold leaf had established certain methods of overcoming the difficulty of persuading paint to adhere to such excessively smooth surfaces. Artists who painted on glass and copper are thought to have found it possible to work without a priming if the surface was first rubbed with garlic

juice. Experience in making the mordants for oil-gilding was also helpful and, as an alternative to garlic, the juice of the fig tree, gum sagapenum, ox-gall and gum arabic (with the addition of honey or sugar to reduce the likelihood of the paint cracking) are all believed to have been used as a preparation for painting on glass or copper.[45] Some painters preferred to prime the copper with white lead, which could be used as an oil size and overlaid with gold or silver leaf which reintroduced the metallic effect. Indeed it was the decline in the use of glazes or the mixed technique of glazes and solid colour in northern Europe in the mid-seventeenth century that deprived the copper support of its

108 Martin van Valckenborgh, *The Tower of Babel*, *c.* 1595, oil on copper, $14\frac{1}{2} \times 19\frac{1}{4}$ in. (36.8 × 48.9 cm.). See fig. 109. *Museum of London*

109 Reverse of *The Tower of Babel* (fig. 108), showing that the painter reused a copper plate which had been engraved by Hogenberg with a map of London (*c.* 1560).

raison d'être – the luminosity that it gave to transparent paint. This would help to explain why Italian artists who painted with solid colour earlier so seldom used a copper support. Among the many artists who painted on copper plates prepared with white lead and overlaid with gold or silver leaf were Elsheimer, Rembrandt in his earlier work, and Claude Lorrain.

Reverse painting on glass, not to be confused with stained glass where the colours are fired in, was a respectable if minor art in late medieval Europe. In this instance the support is, uniquely, on the face of the painting, and again uniquely the first brush strokes are the last visible ones, so that details are painted first and generalities afterwards. Glass, like copper, was a well-known support for oil painting in the Netherlands and Germany. A few eighteenth-century Flemish landscapes and church interiors were painted on a series of sheets of glass thus introducing the reality together with the illusion of depth. These may be distantly related to the use of layers of talc in painting portraits in miniature in the late sixteenth century. The fashion for glass painting continued down to the second half of the nineteenth century by which time it had become a popular or peasant art, though panels of *verre églomisé* were sometimes incorporated in sophisticated eighteenth- and early nineteenth-century furniture.

Another widely used rigid support was the ivory favoured by painters in miniature, but probably because of its great rarity and value sixteenth- and early seventeenth-century miniaturists worked mainly on carefully prepared card or vellum. Norgate's instructions of the mid-seventeenth century read as follows:

> Take an ordinary playing Card, pollish itt and make itt so smooth as possible you can, ye whitt side of itt [hair side], make it evry wheare even and clean frome spots, then chuse the best abortive Parchment & Cutting A peece Equall to yor Card, with fine and Cleane starch past it [flesh side] on the Card wch done Lett itt dry then making yor Grind stone as Cleane as may bee, lay the Card on the stone, the parchment sid downeward, and then Pollish itt well on the backe sid Itt will make much the smother, you must past yor parchment so that the out side of the skinn may be outward Itt being the smothest and best side to worke on.[46]

The difficulty of working in miniature on a smooth surface like ivory encouraged limners to apply their paints with a stippled technique. Improved methods of preparing ivory enabled artists like Joseph Goupy (d. 1765) to imitate 'the boldness of strokes in oil'.[47] The portable nature of miniatures made possible the development of the art in America to a European standard of proficiency – perhaps the first American art to do so and possibly the only one that sought to. One such miniaturist was Benjamin Trott (*c.* 1770–1843) who was described as 'purely an American – he has never been either in London or Paris'.[48] No wonder Dunlap was so distressed that, next to such homespun achievement he (Dunlap) was 'deficient even in the knowledge to prepare ivory for the reception of colour'.[49]

Some Mannerist painters may have followed the outward show of Michelangelo but they also indulged in one novelty that was none the less superficial for being based upon the fundamental matter of supports. By preparing a wood panel with virtually colourless size it was evidently possible to incorporate various features of the grain of the wood, the 'figure', as a coherent and integral part of the composition. This 'figure' in wood is always most visible in quarter-sawn timber so that this highly practical method of dividing a log has also long been recognized for its aesthetic effect. Presumably having discovered the advantages of incorporating wood grain into their pictures, painters turned to the even greater potential in this respect of variegated marbles and alabaster.[50] The conceit was attributed in 1530 to the Venetian, Sebastiano del Piombo,[51] and was especially popular in seventeenth- and eighteenth-century Italy and South Germany. Much the most spectacular marble for this purpose was found in the valley of the river Arno and was known, predictably, as *pietro d'Arno* but more descriptively as *paesina* (landscape marble). The more valuable natural materials used for this purpose were, for obvious reasons, sawn very thin and stuck onto slate with shellac. An example of this is *The Virgin and Child with St John* painted in oil by Hans Rottenhammer (1564–1625) on purple quartz.

Marble will not survive high temperatures which is why when it is used to face the lintel in a fireplace surround it turns 'sugary'. Slate, in contrast, will endure quite high temperatures, and it was therefore slate that was used by the Victorians and Edwardians as the base on which to stove-enamel painted marbling for chimney-pieces in endless terraces of suburban development. It was presumably for similar reasons that Agostino Cornacchini (1685–after 1740) chose slate for his experimental wax encaustic painting *The Infant Christ Asleep, Adored by Two Angels* (1727), since heat is an integral part of this method of painting.

In some ways related to these paintings on such materials as wood, marble and slate are those that use man-made substances such as ceramic tiles.

Rigid supports may be of very different materials, but from the painter's point of view their inert nature in response to the brush makes

their similarities greater than their differences. The introduction of canvas for easel painting, and its gathering popularity, was a very different matter involving a support whose flexibility responded to the resilient nature of the brush. The solidity of the panel contributed to a rigid, delicate and exquisite precision, whereas canvas lent itself, in the work of Titian, to the first expressionistic handling of oil paint. Moreover, canvas was generally only lightly prepared with a coat of size[52] or gesso since many coats would be liable to crack. Consequently the character of the weave of the canvas became a matter for the painter to consider. The freedom that canvas imparted encouraged artists to be less inclined to cover every part of the picture surface with paint. This tendency was rejected for its suggestion of incomplete workmanship by some connoisseurs of the eighteenth century who objected that Kneller 'sometimes, in the haste of finishing left part of the primed cloth uncoloured. This fault, which in Kneller proceeded from haste and rapaciousness, was affectedly imitated by some of the painters who succeeded him.'[53]

In fifteenth- and sixteenth-century Novgorod, canvas was occasionally built up on both sides with gesso and on this fragile surface double-sided icons were painted. In general, painters seemed to have followed the precedent of the 'stainers' in applying colour thinly, but unlike the 'stainers' they also turned to areas of impasto, a contrast in thickness which gave variety to the picture surface and more illusion in relationship to the painting.

The traditional procedures of the 'stainers'[54] were, because of the differing nature of their customary supports, quite distinct from those of the 'painters'. The stainers were of course working on canvas in very liquid distemper – the so-called 'German water-work' as Shakespeare describes the painted hangings that were made in imitation of woven tapestries.[55] Eastlake, however, with reasonable evidence, argues that at least in the fourteenth century this 'water-work' was practised in England on a large scale perhaps before it was introduced as an important industry in Germany and Flanders in Shakespeare's time. The fourteenth-century English recipes of the

110 George Jamesone (1587–1644), *Self-Portrait*, oil on canvas. In Scotland the general transition from panel supports to canvas occurred in the lifetime of Jamesone. The miniature suit of armour served as an important studio 'prop'. The hour glass may have been used to time a model's pose or as a feature in a *momento mori. Scottish National Portrait Gallery, Edinburgh*

OPPOSITE LEFT
111 The Wilton Diptych, Anglo-French, *c.* 1400, tempera on oak panels, each panel 18 × 11½ in. (45.7 × 29.2 cm.): *St John, St Edward the Confessor and St Edmund commend Richard II to the Christ Child.* Possibly by Thomas Litlyngton (chief painter to the crown, 1395–1402) or his master Gilbert Prynce. When closed, only the simple heraldic devices were left visible to identify the royal ownership. The gesso which forms the foundation to the gilding is punched decoratively. *National Gallery, London*

RIGHT
112 Romano-Egyptian funerary portrait of a man, early second century AD, wax encaustic. The ground is gesso on a very thin wood support, cedar being a commonly selected timber. *Staatliche Museen, Berlin*

OPPOSITE LEFT
113 Duccio (active 1278–1319), *Madonna del Voto*, tempera on panel. See fig. 114. *Siena Cathedral*

RIGHT
114 *The Magistracy presents the Keys of Siena to the Madonna del Voto*, miniature on the cover of the city account book for 1483. The use of relief in early Italian pictures was evidently intended to give an effect of reality, as symbolized by the arms that reach out in this representation of the *Madonna del Voto* (fig. 113). *Siena State Archives*

Englishman Theodoric, cited by Eastlake, state that these paintings should be done on a 'closely woven linen saturated in gum water . . . stretched on the floor over coarse woolen and frieze cloths; and the artists, walking over the linen with clean feet, proceeded to design and colour historical figures and other subjects.' By placing the canvas flat on the floor and preparing it with 'gum water' the colours would not run. To prevent pigments 'commonly Tempered with Size' from cracking, Elsum advised that it was necessary to 'bathe the back of the Cloath, with a Spunge dipt in Size to Soften and refresh them'.[56] The importance of 'staining' with a liquid colour rather than painting with a solid colour is emphasized in Theodoric's account: 'Yet, after this linen is painted, its thinness is no more obscured than if it was not painted at all, as the colours have no body.'[57] This emphasis on the transparency of the cloth seems to have been a northern European characteristic and does not appear to have been true of Italian cloths painted in tempera in the sixteenth and seventeenth centuries. Vasari, in his life of Raphael, alludes to a work sent to the Italian master by Dürer 'in watercolours on cloth, which showed transparent lights on both sides'. The insistence on the transparency of the colours in the painted hangings of northern Europe produced a certain drabness that was in marked contrast to the brilliance of effect that Flemish and English 'painters' could achieve on a thick and polished gesso ground. It may be that this provides the explanation for the growing importance of 'painters' and the declining position of 'stainers'. In 1620 a special amendment of the regulations of the Guild of St Luke in Delft excluded painters in watercolour (the size-painters of canvas hangings and cartoons for woven tapestries) from membership of the guild.[58] It would also explain why the northern artists resisted the use of canvas supports since it would occasion a demarcation dispute between the two skills and would associate the respectable profession of the painter with the mere skill of the craft of staining. It was perhaps the Italians, in their freedom from these inhibitions, who first used canvas for the élite purposes of 'easel painting'. Cennini certainly gives very full instructions on how to stretch canvas and prepare it.[59]

The portable nature of paintings executed on canvas was recognized at an early date. Pliny mentions as 'a thing previously unheard of' a colossal portrait of Nero measuring 120 ft. (36.5 m.) in length and painted on canvas for display in public places, presumably because it could be easily rolled up and put away when not in use.[60] Italian artists of the Renaissance may have been obsessed with mural painting but the portable possibilities of canvas were also

exploited by them. Jacopo Squarcione of Padua and his student Andrea Mantegna[61] worked in gum-water colours on canvas as did others associated with the Milanese school such as Corregio,[62] Leonardo, and Luini,[63] who used this support to carry thin but not transparent colours. An early surviving example of the Italian use of the canvas support is the Florentine Paolo Uccello's *St George and the Dragon* (*c.* 1460, 22¼ × 29¼ in., 56.5 × 74.3 cm.). Above all, as Vasari noted, it was the Venetians of the sixteenth century who were exceptional among the Italian schools of painting in favouring canvas. Both Jacopo and Gentile Bellini executed their first works on cloth, and as early as about 1440 a likeness of Pope Eugenius IV was painted on canvas, perhaps by Giachetto Francosco of Filarete (*c.* 1400–*c.* 1469).[64] Even in northern Europe, Dieric Bouts's *Entombment of Christ* (*c.* 1455) is painted in gum on canvas.

In the Venice of Giorgione and Titian, canvas became a standard support. Once the Italians had established the respectability of painting on this material it was gradually adopted by the painters of northern Europe. In 1638 the sculptor Nicholas Stone Jnr., then living in Italy, purchased 'a cloth for my picture to be painted on . . . £2-0-0'.[65] The transition from panel to canvas occurred in the lifetime of the Scottish artist George Jamesone (1587–1644): 'His earliest works are chiefly on board afterwards on a fine linen cloth, smoothly primed with a proper tone to help the harmony of his shadows.'[66] By the seventeenth century de Mayerne refers to an 'Imprimeur Wallon' who was living in London and supplying canvases prepared with a tint.[67] The use of a tint in the ground demonstrates the extent of the revolution in supports. The old notion of a brilliant white ground, traditional and possible with gesso on wood, was rejected as unsuitable for canvas. In place of the thin paints and glazes, solid colour and even impasto make their appearance, and do so spectacularly in the work of Rembrandt. An impasto on gesso would have destroyed the inner reflected light of the ground whereas impasto on canvas maintained the brilliance of pigments which would otherwise be discoloured from the front and, through the canvas, from the back.

Before the invention of the fly shuttle by John Kay in 1733 textiles, with the exception of tapestry where the technique is rather different, could not be woven wider than about 3 ft. (91 cm.). The 'ten-acre' canvases of Benjamin West are, besides much else, a celebration of technical innovation in weaving.[68] Early canvases were made up of strips of cloth sewn together. In paintings the seams were all but invisible, but with floor cloths (canvas decorated with oil paint and used in the eighteenth and

115 Reverse of the *Portrait of Dirck Hendricksz. van Swieten* (fig. 116), 1626, oil on canvas, 29 × 22¾ in. (73.5 × 58 cm.). In this early canvas the picture frame serves also as the stretcher. *Rijksmuseum, Amsterdam (on loan from the Koninklijk Oudheidkundig Genootschap)*

116 *Portrait of Dirck Hendricksz. van Swieten*, artist unknown (see fig. 115).

early nineteenth centuries as a floor covering) a seam produced unsightly wear. In British ports where sailcloth was manufactured, specialist weavers were able to produce canvas in great widths. This wide canvas was used by the manufacturers of floor cloths. It is possible that the first to produce prepared artists' canvases of large dimensions were the floor cloth manufacturers. Certainly many 'trade' painters, such as the eighteenth-century firm of Biggerstaff's and Walsh's, show on their trade labels that they made both floor cloths and easel pictures. Thomas Sharp, 'Indigo Blue Maker and Colourman at the Three Kings in Newgate Street, London', also sold floor cloths.[69] The first pictures that the American painter Dunlap ever saw were in the collection of Thomas Bartow and were painted on 'oil cloth without frames, representing huntsmen, horses and dogs'.[70] Even more extraordinary evidence for the association of the manufacture of oil cloths with artists' materials is John Middleton of Sandys & Middleton who supplied 'oiled umbrellas' in 1781.[71] Jonas Hanway (1712–86) was the first Londoner to carry an umbrella, establishing a fashion which for artists working out of doors became

a necessity.[72] A surviving hatchment in St John the Baptist's Church, Berkswell, West Midlands, was painted by David Gee with the arms of Sir John Eardley Eardley-Wilmot in 1847 on the back of a floor cloth.[73] Dunlap's attempt in 1824 to paint a picture on 'a large unprepared cloth, intended as a floor cloth', which he nailed to the floor to work on,[74] and the painter Rolinda Sharples's careful notes on the manufacture of floor cloths by Hare's of Bristol in 1816[75], provide circumstantial evidence for an association between this industry and painting.

In the late eighteenth century a number of artists' colourmen in London made and sold 'all sorts of Prim'd Cloths'. These firms included William Jones of 103 Leadenhall Street; Sandys & Middleton, 79 Long Acre; Francis Stacy at 'the St Luke the corner of Long Acre'; and William Ward of 66 Chandos Street.[76]

Commercially prepared canvases stretched to standard sizes were, by the closing years of the eighteenth century, stamped or stencilled with the maker's name. The earliest known dated example carries the name of James Poole (est. 1780–90) and occurs on the back of John Opie's *Portrait of Mrs Elliott*. It may be dated by its duty stamp to 1799. By the second quarter of the nineteenth century firms like Winsor & Newton (earliest dated example 1839) and G. Rowney were supplying canvases. The stencilled trade marks of the makers of these supports usually include the address and may be used in conjunction with contemporary trade directories to date a painting.[77]

In America, prepared canvases were sometimes available in the eighteenth century[78] and by the early nineteenth century all but the largest sizes were easily obtained. Dunlap's floor cloth

experiment failed but he was later able to purchase a large canvas from 'Mr McCauley's manufactory in Philadelphia, which proved satisfactory'.[79] The earliest documented commercially produced, prepared canvas in America is for the firm of 'Dechaux & Parmentier, 328½ Broad Way, New York' and was found on the back of A. B. Durand's *Portrait of the Artist's Wife and Sister* which was painted in 1832. Other American paintings bearing this mark and dating between 1832 and 1833 all show the stencil on the centre of the reverse of the canvas. Dechaux & Parmentier moved from 312 Broad Way to 328½ in 1831, and remained there until 1834. Joseph Parmentier seems to have retired to Paris in the 1850s and the firm became in 1866 Edward Dechaux Jnr. & Co., and from 1869 to 1893 it was Paul Dechaux & Co. In all, eleven addresses for the firm appear in the New York *Directories*. Other American companies that sold prepared canvases include Williams & Stevens. John H. Williams was in business selling looking glasses by 1829, and was joined by Linus W. Stevens in 1843; and by 1849 they were selling prepared canvases stencilled with their 'label', a design which they continued to use until 1854 when it was replaced by the more flamboyant 'Williams, Stevens, Williams' mark. Another firm that used a decorative stencil in which the name and address was enclosed by a palette was Reynolds, Devoe & Pratt, which was at 106 and 108 Fulton Street, New York, during 1863–64. English and French canvases were imported into America and occasionally these are found with the stencilled name of both the manufacturer and the retailer.[80]

Although prepared canvas is today sold from the roll, in the past canvas was prepared on the stretcher. However efficiently the 'canvas grips' were used preparatory to tacking the canvas onto the stretcher, the early stretchers were at first morticed and tenoned or half-lapped at the corners which gave no scope for further stretching. It was therefore found expedient to design stretchers or straining frames which could be wedged, thus further stretching a canvas that had become slack. Small canvases were stretched on a simple framework running around the perimeter of the canvas, but for larger works auxiliary struts across the middle or diagonally across the corners were necessary. It was important that the front edges adjacent to the canvas were bevelled to prevent the stretcher's line erupting in the paint surface as sometimes happens when this chamfer is omitted or inadequate. The timber used for stretchers may sometimes indicate the country of origin of a painting. When John Singleton Copley submitted his *Boy with a Squirrel* for the scrutiny of Benjamin West and his brother academicians, they 'were at a loss

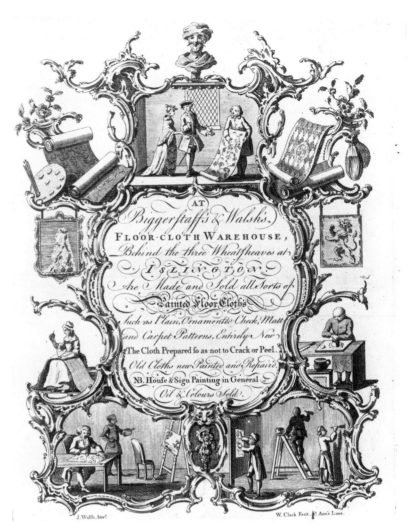

what to say about it in the catalogue, but from the frame on which it was stretched, being American pine, they called the work American. The surmise was just. It was a portrait by Copley.'[81]

In the preparation of the stretched canvas the somewhat irregular weave of the early canvas made it necessary to scrape it down after each priming. Cennini advises that 'the less gesso you leave on, the better' so that 'the interstices between the threads' are filled up. Later painters did not demand such a pristine surface, but they generally did their best to eradicate 'any node or knot in the weave'.[82]

Paper has already been considered as a support for drawings. It was no less important for watercolour painting. Indeed, if suitable paper had not been available to compliment the Reeves' watercolour paints in the late eighteenth century, the whole development of this art would have faltered.

When Thomas Gainsborough saw a copy of a guide to the City of Bath in 1768, it was not the book but the new 'wove' paper on which it was printed that attracted him. This paper was developed by Whatman in 1757 but did not

117 Biggerstaff & Walsh's trade label, mid-eighteenth century. There may have been some association between the production of floor cloths and the supply of prepared canvases for artists, although John Calfe (among others) was supplying 'prim'd Cloths' in the first decade of the eighteenth century. *British Museum, London*

118 Titian, *The Death of Actaeon, c.* 1559, oil on canvas, a detail showing the weave of the canvas left visible, as well as the expressionisitic brushwork, two revolutionary features which the Venetian master introduced. *National Gallery, London*

119 Dutch School, *Interior of a Synogogue*, mid-eighteenth century, painted in oil on four sheets of glass, 12 × 14¼ × 3½ in. (30.5 × 36.2 × 9 cm.). *Private Collection*

120 Dutch School, *Skating Scene*, mid-eighteenth century, painted on three sheets of glass, 11¼ × 14½ × 3 in. (28.5 × 36.9 × 7.6 cm.). Paintings of this kind which combine both the illusion of depth with its reality are extraordinarily rare. *Private Collection*

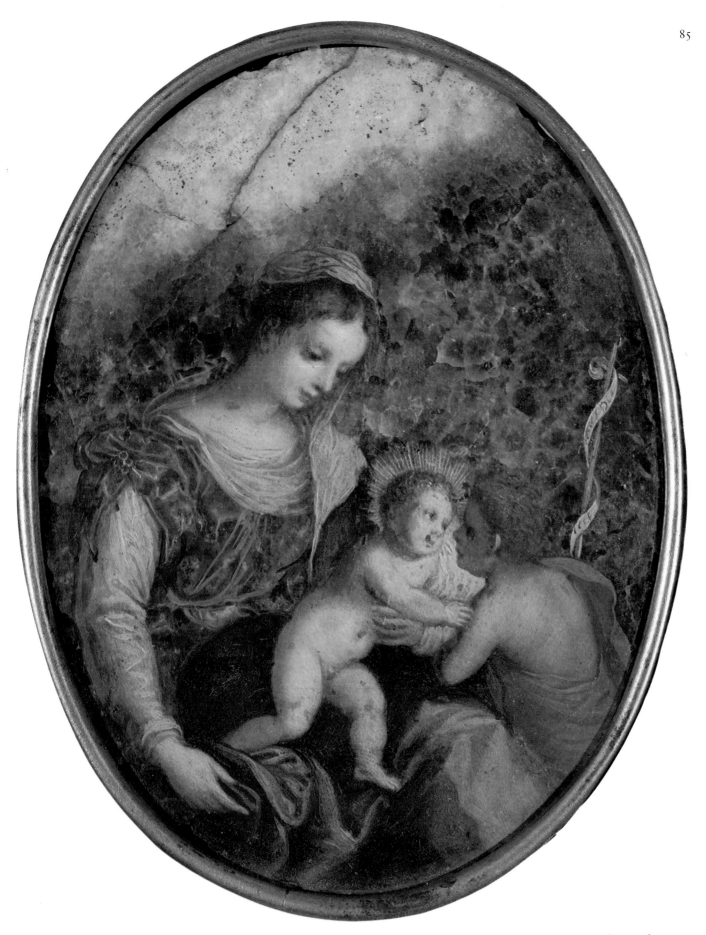

121 Hans Rottenhammer (1564–1625), *The Virgin and Child with St John*, oil on purple quartz, $4\frac{5}{8} \times 3\frac{1}{2}$ in. (11.7 × 9 cm.). The use of various stones and marbles to provide not simply a support but also a background was especially popular in Italy and South Germany in the late sixteenth to the early eighteenth century. *Victoria and Albert Museum, London*

122 Trade label for James Poole. A canvas stamped with James Poole's name was used by John Opie for his *Portrait of Mrs Elliot* in the Walker Art Gallery, Liverpool. This canvas also carries the duty stamp of the year 1799. *British Museum, London*

become easily available until the 1780s. In contrast to 'laid' paper which, for the purposes of painting in watercolours, was disfigured by furrows caused by the brass wire grating which is the papermaker's 'mould', 'wove' paper which was made using fine woven wire moulds was introduced by John Baskerville in 1757. This paper was textured but level.[83] A heavy gelatine size made the paper more forgiving and resilient when the artist was struggling to produce his desired effect. Constable's great painting of *Stonehenge* (1836) is a veritable battlefield of activity and yet the colours have not 'spread' uncontrolled. The importance of the right choice of paper is underlined by John Varley in his *Treatise* of 1816: 'with regard to the painter in watercolours a very great portion of his time is employed in overcoming the peculiarities and defects of paper.' By 1820 the demand for paper specially adapted to the needs of watercolour was sufficient to encourage the commercial development of papers such as Creswick, Harding, Griffin Antiquarian and North's O.W. paper. For best results these watercolour papers were stretched by being moistened and then laid down onto a drawing board and stuck with strips of paper. As it dried and stretched the painter was presented with an immaculate surface on which to paint. Early watercolourists tacked the paper down There is some evidence that in this they were following the tradition for cleaning parchment (or for stretching a canvas) by laying the paper down on a straining frame rather than a drawing board. Confirmation for this hypothesis suggests itself in John Martin's manuscript (1699–1700) which gives instructions on 'How too Strain Mezo-tinto prints on straining fframes'; and in de Wint's watercolour of

Kneeton, Nottinghamshire, the line of peg holes that would have held the paper in place is interrupted at the corners where a mitre may have ruled out the use of a peg.

In addition to the use of paper for painting in watercolours or the coarser sorts used for 'painting' in pastel, the material was also employed, somewhat informally, as a support for oil paint. John Harden (1772–1847) records that Reinagle painted in oil on paper preparing 'the paper with several coats of thickish water colour (oker) by wh. means it absorbs the oils, and dries almost immediately, much sooner than canvas, & lasts equally well'.[84] Such paintings are often subsequently mounted on canvas or panel and thus the paper becomes analogous to the priming or ground rather than being the support.

Pigments, Media and Varnishes

The artist's understanding of materials, like his knowledge of anatomy, is generally superficial, intuitive and intimate, but not necessarily theoretical. Pigments had to be ground and mixed with various media but these processes were undertaken by painters informed, more often than not, by tradition and experience rather than by science.

The grinding of pigments and the preparation of paints with media was one of the most labour-intensive aspects of the painter's workshop. When Sir Godfrey Kneller came to England in *c.* 1674/5 he brought with him a servant whose sole job was to grind pigments and prepare materials.[1] This close association between the painter and his pigments established an empirical understanding of materials to which the condition of the works themselves attest. By the late eighteenth century that position began to change with the wide availability of industrially, or at least commercially, produced pigments and paints. William Williams in his *Essay on the Mechanic of Oil Colours*, published in Bath in 1787, implicitly refers to this change by arguing that an artist should

make himself well acquainted with the qualities and hues of the different pigments in their dry state, that he may judge of the goodness or deficiency of them when ground in oil, it is a pity, but it is true, there are many, and some of much merit, that scarce known the difference of umber and oker in their crude state; seldom if ever seeing them but in bladders.[2]

The scientific and industrial methods of production of the late eighteenth and early nine-

T H E

New BATH GUIDE:
O R,

U S E F U L
Pocket-Companion;

N E C E S S A R Y

For all Perſons reſiding at, or reſorting to,
this antient and opulent City.

Giving an Account of its Antiquity, and firſt Diſco-
very of its Medicinal Waters; the Reality and Emi-
nence of King BLADUD, the firſt Founder of the
Baths; alſo a Deſcription of the City and its Buildings
down to the preſent Time; with a much more correct
Account than any yet publiſhed of the going out and
coming in of the Poſt, according to the late Altera-
tions) Machines, Waggons, Carriers, &c. &c. &c.

With every other Particular worthy Obſervation.

TO WHICH IS ADDED,

The Life, Character, &c. of the late RICHARD NASH,
Eſq. who was Maſter of the Ceremonies at *Bath*
and *Tunbridge* upwards of Fifty Years.

The *Fifth Edition*, with Additions.

BATH: Printed by C. POPE,
For W. TAYLOR, Bookſeller, in Church-ſtreet, King-
ſton-Buildings:---Sold likewiſe byH. LEAKE, and W.
FREDERICK, Bookſellers, in BATH.---[Price 6d.]

teenth century divorced painters from an understanding of their paint and brought about a decline in the craft – in contradistinction to the art – of painting. Curiously enough it was at this time, when artists had less control over their pigments and less experience of their chemical interaction and durability, that sophisticated optical colour theories developed. By the second half of the nineteenth century, when the industrialization of the painter's craft was complete, the notion of 'painterly' handling of paint appeared. It was based not on an understanding of materials but upon the admixture of preservatives in tube oil paints which also gave them greater 'plastic' qualities. Most of these innovations occurred first in Britain. It is in English publications of the seventeenth century that the first references to 'bladder colours' may be found[3] and by the 1760s William and Thomas Reeves had successfully produced watercolour

cakes. By 1841 John G. Rand, an American portrait painter working in London, had patented the collapsible metal tube for oil paints.

From earliest times these pigments were ground with a muller on a ledger[4] or grinding stone. Cennini mentions that these were made of serpentine and marble but especially porphyry, a material also recommended by John Smith[5] and William Salmon.[6] Hilliard listed 'fine *Cristall*, *Serpentine*, *Iasper* [Jasper], or *Hard Porfory*' as suitable materials.[7] The harder and denser the material, the less likely it would be to contaminate the pigment being ground. Cennini states that serpentine was 'not good' for the purpose whilst marble was 'still worse'.[8] In the fourth impression of John Smith's *The Art of Painting in Oyl* (1705) 'the Grindstone and Muller' are described as the first in a series of 'manual utensils' used in the 'Art of Painting'. He recommended 'a hard Rance, Marble, or some other

123 Title Page and Frontispiece of *The New Bath Guide* for 1768. On seeing this book Thomas Gainsborough made enquiries about the new 'wove' paper, which he discerned would make a good surface for watercolour. *Bath Public Library*

124 Paolo Uccello, *St George and the Dragon*, c. 1460, 24¼ × 29¼ in. (56.5 × 74.3 cm.). This mid-fifteenth century work is one of the earliest extant paintings on canvas. *National Gallery, London*

of a close grain of stone', whilst the Muller is defined as 'a Pebble Stone of the form of an Egg'[9] – a large pebble sliced in half to provide the flat grinding surface. These ledgers were either thick enough to have stability whilst in use by reason of their weight, or they were set flush into a sturdy bench (see figs. 122, 131).

Robert Dossie in *The Handmaid to the Arts* (London, 1764) describes 'The operations subservient to the making and preparing of colours [as] *sublimation, calcination, solution, precipitation, filtration* and *levigation*'.[10] John Barrow's *Dictionary* defines pulverization as being 'of two kinds, levigation or trituration and contusion or pounding'. From these accounts it is apparent that whilst the muller and grinding stone may have been the most generally used tools for reducing crude colour to powder, the pestle and mortar was also used. Some minerals, such as the lapis lazuli (used to make ultramarine), were so hard that they were first reduced by pounding with a pestle and mortar which was covered with a cloth to prevent the valuable dust from drifting away.[11]

If, as was most usual, pigments were to be kept for future use as dry powder colours, they were

first ground in water and then allowed to dry. Eastlake argues that Rubens favoured colours ground in an 'essential oil' which was well rectified to avoid discolouring the pigments and to prevent their 'caking' since moisture (water) left in the powder colour would cause difficulties when combined with an oil medium.[12] Effective though the use of such volatile oils must have been they were also more expensive than water and most early accounts relating to the production of pigments mention the use of water, although a trade card of Sandys & Middleton lists 'Colours ground in Spirit [essential oil], in Water, in Gum and Bladder Colours ground in Oil'.[13] Colours, be it noted, were not ground dry any more than marble was polished dry. A few colours such as malachite could become grey if ground too much, but most improved the more they were worked. Verdigris was ground in vinegar.[14] All colours were ground stiffly[15] and therefore had to be further diluted if they were to be purified by filtration. Dossie tells us that filters were extremely important in the preparation of some colours:

125 Jan van Eyck, *St Barbara*, 1434, drawing on gesso-coated panel with some painting, $12\frac{5}{8} \times 7\frac{1}{8}$ in. (32 × 18 cm.). This unfinished painting demonstrates the degree to which artists working in the medieval tradition mapped out in advance every detail of their work. In doing so the colours and glazes could be applied so as to retain the inner light offered by the reflecting surface of the brilliant white gesso. *Musée Royal, Antwerp*

Ioan. Stradanus inuent. Phls Galle excud.

126 *The Painter's Studio*, engraving, *c.* 1600, by Johannes Stradanus after J. van der Stradet. Before the rise of academies and schools of art the studio of the successful 'master' provided apprentices with a valuable training and in return gained assistants to grind pigments and prepare paints.

OPPOSITE
127 Jonathan Adams Bartlett (1817–1902), *Self-Portrait, c.* 1841, oil on canvas, 31⅞ × 27 in. (83.8 × 68.6 cm.). Judging by the presence of the muller, ledger and stone knife in this self-portrait, it was evidently necessary for an artist working in the state of Maine in 1841 to grind and prepare his own paints. *Abby Aldrich Rockefeller Folk Art Center, Williamsburg*

They should be made of pewter in the form of common earthen cullenders, but with more and larger holes; and their size should be such as admits of their interior surface being wholly covered by a sheet of filtering paper . . . called *bloom* or *filtering paper* . . . it is difficult to find in common stationers shops, such as will even moderately well answer the end.[16]

J. H. Müntz in his book on *Encaustic* (1760) warned that in grinding colours on a stone (presumably with water) 'and managing them upon the pallette, care should be taken not to use an iron knife' because 'the steel or iron that grinds off, in mixing with the colours spoils their brightness and vivacity.' Müntz therefore recommended spatulas of wood, horn, ivory or tortoise shell.[17]

Most artists, including van Dyck and Lely, kept their colours dry except for white which was ground in a medium of nut oil and kept under water to exclude the air and keep the paint workable.[18] William Williams does not mention white in this regard but states that prussian blue, as well as scarlet and purple lake, 'must only be mixd when wanted, as in a week they will grow (as the painters phrase it) fat and unfit for use.'[19]

Most colours could be ground with their media and placed in bladders to keep. John Smith remembered

a parcel of Colours given me in the year 1661 by a Neighbouring Yeoman, that were as he said, left at his house by a Trooper, that was quartered there in the time of the Wars about the year 1644. This Man was by profession a Picture-Drawer, and his Colours were all tied up in Bladders . . . and when I opened them, I found them in very good condition – they had remained in this condition about seventeen years.[20]

By the eighteenth century this method of keeping paint had becomed unremarkable and numerous colourmen advertised 'bladder-colours' on their trade labels without need for further explanation. When in use the bladder was simply pierced with a tack, the required colour extruded and the tack replaced. It should perhaps be added that, in addition to paint, snuff was also sometimes kept in this way.[21]

Powder colours were of course easily stored. Theophilus recommends the use of goose quills for the fine pigments used in niello.[22] Norgate mentions dry colour being kept in 'a neat box

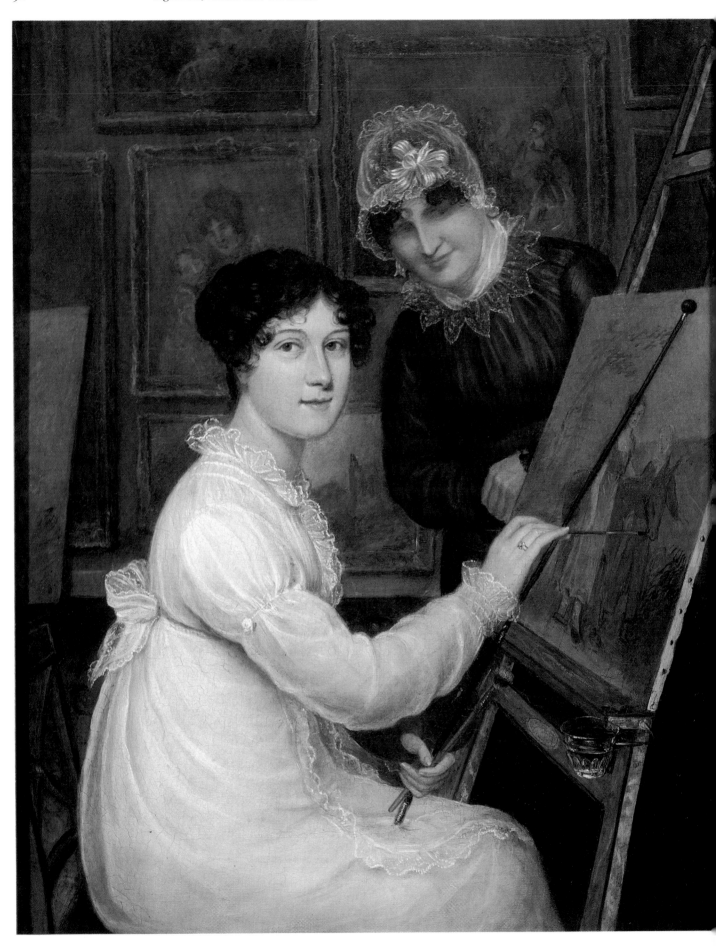

of Ivory'. But by the eighteenth century, glass bottles were the most usual means of storage, although small quantities of ground pigments could also be kept in a twist of paper.[23]

With appropriate reservations Pliny records the tradition that the invention of painting with colour made, it was believed, from powdered potsherds, was due to Ecphantus of Corinth.[24] Whatever one makes of this legend it has the virtue of emphasizing the importance of earth colours in the ancient world. The Stone Age cave painters of Altamira and Lascaux employed red and yellow earth, and lamp black or soot, but white from chalk was probably also available to them. To these basic pigments the Egyptians and Greeks added considerably. By Cennini's day (born *c.* 1370) the number of pigments was far greater than the number of colours required. He lists three basic types of black, two whites (lime white for fresco and white lead), about six yellows (two of which were dyer's colours), three blues (Bagdad indigo, ultramarine from lapis

lazuli, and azurite from Germany). The greens could either be made by mixing blues and yellows, or terra verte, malachite or verdigris were available. Among the colours that were made 'by alchemy' were vermilion, red lead, massicot (a yellow described by Cennini as *giallorino*), orpiment, verdigris, and white lead. The last two, it was urged, should be kept apart 'for they are mortal enemies'.[25]

By the early eighteenth century 'The Principal sorts [of colours] are Seven, of which two [black and white] are Extreams, and are Fathers of the Rest.'[26] William Williams's *Essay on the Mechanic of Oil Colours* (Bath, 1787) provides a short list of no less than twenty-six pigments, many of which are duplicates although the greens are omitted since these could be mixed. For 'setting a palette' he reduces the number to a manageable twelve. Among the colours listed by Williams is a patent yellow which he describes as 'a new invented colour, very bright and durable; dries well'. Judging by the date of the publi-

129 Illustration of a 'colour wheel' and 'softening' brushes in J. H. Clarke's *A Practical Essay on the Art of Colouring and Painting Landscapes in Watercolours* (1807). The development of sophisticated colour theories developed amongst artists when they became less involved with making paint.

OPPOSITE
128 Rolinda Sharples (1794–1838), *The Painter and her Mother*, oil on panel, 14½ × 11½ in. (37 × 34.5 cm.). Rolinda Sharples visited the floor-cloth factory of Hare's of Bristol in 1816. *Bristol City Art Gallery*

cation this was possibly Indian yellow, which appeared around the middle of the eighteenth century. It could not be chrome yellow which was not discovered until 1797 by Vauquelin in Paris. Indian yellow was made from the urine of Indian cows that had been fed on mango leaves and deprived of water.[27]

By the second half of the nineteenth century many new colours were developed, especially those derived from coal-tar. In 1845 William von Hoffman established the possibility of making pigments from coal-tar and in 1856 his student, Sir William Perkin, made the first colours.[28] By 1857 he manufactured mauve commercially. A receipt dated 1804/5 in the Ambrose Heal Collection[29] mentions 'Colours in Coal Varnish' and 'Coal Tar Brown', but these may be a reference to the 'asphaltum' which William Williams mentions in a recipe for 'Antwerp brown'. A related colour was mummy brown derived from grinding up ancient Egyptian embalmed bodies that were rich in asphaltum.[30] Bitumen was much used by Reynolds with disastrous results; no wonder the effect it produced became known as *craquelure anglais*.

In general the earth colours had natural 'body' but the metallic colours (and the coal-tar ones) are in the nature of dyes and were either used in glazes or were given 'body' artificially for use as paints. Today pigments are generally divided into the 'organic' or 'inorganic'. The plant or animal derivatives include purple (the dye of the murex or purpura mollusc), sepia (cuttle fish), carmine (cochineal beetle), and indigo (from plants of the genus *indigofera*). Inorganic pigments include verdigris (copper acetate), ultramarine (lapis lazuli), red lead (lead oxide), and many others.

As we have seen, pigments could either be ground with a temporary vehicle (water or an essential oil such as spirit of turpentine and stored as powder colour) or they could be ground immediately with their medium. In painting, the vehicle is the liquid that acts as the 'carrier' and the medium is the substance that binds the pigments and usually includes a vehicle. A characteristic example is watercolour where the vehicle is water and gum arabic is the medium. Dossie gives a good definition of the media in the dual sense of the word as preparations 'which at the same time, answer the double purpose of reducing the colours to a state fit for being worked with brush or pencil, and cementing them to each other and the ground they are laid upon'.[31] Haydocke in his 'Englished' version of Lomazzo's *Third Booke of Colours*, divides painting into three sorts according to 'those moistures wherewith they are grounde . . . Distemper, *Oile-worke*, and *Frisco*'.[32] Complex as the questions of the pigments were, it was in the

numerous media and varnishes that the real secrets lay. In Williams's book on painting, the recipes for oils and varnishes are printed with spaces in which key ingredients have been written in by hand, no doubt to preserve a measure of confidentiality.[33]

Although the pigments used in antiquity are reasonably well understood, the media and processes used in wax encaustic painting are not. Pliny, when referring to burning wax colours into a painting, suggests the process may have been invented by Aristeides and brought to perfection by Praxiteles although the Roman scholar points out that earlier examples were known. Pliny associates one type of wax painting

ENCAUSTIC:
O R,
Count CAYLUS'S
METHOD of PAINTING
the MANNER of the ANCIENTS.
To which is added
sure and easy METHOD for Fixing of
CRAYONS.

By J. H. MÜNTZ.

NDON: Printed for the AUTHOR; and
. WEBLEY, at the BIBLE and CROWN near
CHANCERY LANE, HOLBORN, 1760.

with the brush (the painting of ships' hulls) but alludes to a second type of painting on ivory by means of a cestrum or sharp point.[34]

Whatever the worth of this often confusing account, it is undeniably a method of painting that is extinct, although some specialists have over the centuries attempted to reconstruct the process or processes. Perhaps one of the most successful experiments was in 1727 when Agostino Cornacchini painted his *The Infant Christ Asleep, Adored by Two Angels* (figs. 134, 135) in wax encaustic on slate – a material that would survive the heat that the method entailed. In 1762 J. H. Müntz (or Muentz), whose principal patron in England was Horace Walpole, exhibited in the Society of Incorporated Artists of Great Britain in Spring Garden 'a landscape painted in encaustic, a process [so Edward Edwards tells us] of which he seemed to have considered himself the inventor'.[35] Between 1757 and October 1759 Müntz made a number of experiments and in 1760 published in London his *Encaustic, or Count Caylus's Method of Painting in the Manner of the Ancients*. The book begins by quoting Pliny and goes on to cite extracts from a letter from the Abbé Mazeas F.R.S. to the Royal Society describing Count Caylus's methods. One of these called for the use of wax and turpentine heated together to form a medium with which the pigments were mixed. However, with this method it was found that the turpentine evaporated too fast. A further system involved the rubbing of a lump of beeswax over the panel or canvas. In this the colours were simply mixed with water, but since the wax preparation would resist such colours the priming was first 'rubbed with Spanish chalk or whitening'. Once the work was complete and the colours dry, the picture was placed near a 'fire whereby the wax melts and absorbs all the colours'.[36] As Müntz points out, these procedures, though in each case involving the use of heat, were either impractical or did not fully accord with Pliny's vague descriptions. More satisfactory, so Müntz considered, was the following method:

> the wax is melted with strong lixivium of salt of tartar, and with this the colours are ground. When the picture is finished, it is gradually put to the fire, which increases the heat by degrees; the wax melts, swells, and is bloated up upon the picture; then the picture is removed gradually from the fire, and the colours do not at all appear to have been discoloured; the colours then become unalterable.[37]

Wax being related to the fats, and alkalis being the means of dissolving fats, lixivium (an alkaline filtrate, such as leached ashes or lye) would be a significant element in the process.[38]

OPPOSITE ABOVE
130 Turned box-wood container, early nineteenth century, holding a nest of ivory mixing-palettes for watercolour.

OPPOSITE BELOW
131 Hard stone muller on a ledger, height of muller 6 in. (15 cm.). *Private Collection*

LEFT
132 Title Page of J. H. Müntz's book on wax encaustic (1760). *British Library, London*

From the Thames side
at Kew.

F

F. Similar to E. From the
Woulds near Ashby de la Zouch
Leicestershire.
G. The Asperula or Woodroof of which
there are two species wild in England.
The root of this yielded a red colour to
Aluminates. H the same in Flower.

Colour prepared
from the Root
in 1804.

134 Agostini Cornacchini (1685–after 1740), *The Infant Christ Asleep, Adored by Two Angels*, 1727, wax encaustic on slate, 10½ × 5½ in. (27 × 14 cm.). See fig. 135. *Victoria and Albert Museum, London*

135 Reverse of Cornacchini's *The Infant Christ Asleep* (fig. 134), showing the artist's experiments and notes on wax encaustic painting, dated 1727, in which he claims the technique as a 'new invention'.

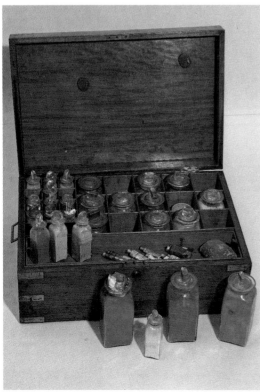

136 Mahogany box containing glass jars of dry pigment, early nineteenth century. Artists travelling from one commission to the next were equipped with such boxes for their materials. *Victoria and Albert Museum, London*

137 Romano-Egyptian funerary portrait of a woman, second century AD, wax encaustic on panel. In modern experiments with wax painting on a rigid support, resin was added to the wax to give greater strength and flexibility. *Musée du Louvre, Paris*

OPPOSITE
133 *The Madder Plant* from George Field's notebook (1804). Many plants and minerals supplied raw materials for pigments. *Winsor & Newton, London*

The method appears to resemble Leonardo da Vinci's notes on 'secco' wall painting in which he describes a medium composed of wax, white lead and distilled water. In using this preparation he advises that the colours should be ground with the medium on a warm stone.[39]

Amongst the three methods of which he gives details, Müntz includes a variant of the system for painting on canvas where the wax is rubbed onto the back of the picture. For this he advises the use of two 'straining frames', one for the picture while it is being worked and the other smaller stretcher for the completed work. For painting solid surfaces he recommends the emulsion using lixivium. Since it was necessary to have the colour constantly heated, Müntz refers to the use of a charcoal 'brazier ambulant'. He recommends both beeswax (especially for larger works) and virgin wax and advises painters to prepare a trial strip of canvas painted with wax colours to record the tonal and chromatic value of the pigments when mixed with wax. Neither Count Caylus nor Müntz seem to have carried out their experiments with the benefit of surviving examples of early works in encaustic to guide them. The discovery of the mummy portraits, especially in the cemetery at Hawara in Fayoum, Egypt (1899–1901), provides evidence of the appearance of this type of painting from about the time of Pliny (AD 23/34–79) to the third or even fourth century AD. These examples indicate that Cornacchini may have successfully rediscovered the secrets that eluded others. It is also possible that he had access either to the so-called Lucca manuscript (or a copy of it) which describes painting on wood with colours mixed with wax, or to some surviving tradition, a tradition that long persisted on Mount Athos.[40] A good description of modern experiments with wax encaustic painting may be found in Kurt Wehlte's *The Materials and Techniques of Painting*.[41]

Wax emulsion paint in water is if anything less familiar than encaustic. The emulsion is composed of water with the wax emulsified in it by means of a catalyst such as ammonia.[42] This was the material principally used to polychrome carved-wood sculptures in medieval times. Although usually applied on a gesso ground, wood-carvings treated in this way will take a gentle polish which does something to reinstate the sense of the wood that underlies the pigment and the gesso ground.

In addition to wax many other emulsions or temperas have been used including the natural emulsions (which incorporate an aqueous and non-aqueous material) such as fig-tree sap, milk and, best known of all, egg yolk. A 'Liquor made of the Yoke of an Egg, beaten up with the Milk of a Figg Sprout, well ground together' was described by William Aglionby (1685).[43] John Elsum (1704) states that for egg tempera 'Colours must be mixed with the Yolk of an Egg, except Blews'.[44] This was because, as in other yellow media, blue could easily become green and was therefore generally mixed with size to circumvent this difficulty (even with pictures that were otherwise worked in oil paint). Alternatively, a coat of white lead ground in oil of spike (lavender – an especially clear vehicle) was applied as a mordant and dusted with blue pigment which was then held with a clear varnish of white of egg, isinglass or size. The white of the egg or 'glair' served as a gold size on manuscripts. It could also be used as a rather brittle and therefore temporary varnish.[45] Casein tempera (like glue) made from cheese was also important. Vasari quotes Uccello being so full of cheese that he was afraid he would be made into glue,[46] and in Rome in 1640 Nicholas Stone Jnr. noted a recipe for a glue (for sticking marble) made from 'prouaturo, a certaine cheese made of buffles milk'.[47] Nollekens recommended Gloucester cheese as the basis for a cement for sticking marble.[48]

John Martin's manuscript (1699) recommends the use of colour ground in 'Lime-water, milk or whey, mixed in size colour pots' for wall painting, in other words, the distemper used by house painters. Size painting was also the basic medium used by the stainers for their painted wall hangings.

Until the recent appearance of acrylic, which in many ways represents a return to the use of emulsion temperas, oil was for centuries the dominant medium. The enthusiasm for its use almost knew no bounds. John Elsum (1704) had no doubt that 'Colouring in Oyl is the most Perfect and excellent of all others, and has superceded the ancient Practice of Dry Painting.'[49] Despite such assertions, oil as a medium has not been without its critics. In the sixteenth century Domenica Beccafumi tried it and then reverted to tempera observing that oil did not preserve the freshness of the colours. Beccafumi was of the opinion that the works in oil by Luca da Cortona and Pollaiuoli had deteriorated compared with those by earlier masters in a tempera medium.[50] Writing in the eighteenth century Müntz, whilst not wishing 'to depreciate oil painting', expressed the hope that the likes of 'Reynolds, Ramsey, Scott or Lambert' would at least consider the possibilities of wax encaustic.[51] (It is not without interest that both Reynolds and Raeburn may have incorporated some wax in a number of their works in oil.)[52] Of recent years Ivar Lissner in his extraordinary book *The Living Past* offered the opinion that if the Japanese 'were familiar with oil paints they were wise enough not to use them'.[53] The great

138 Cima da Conegliano (d. 1517/18), *Virgin and Child with Saints*, oil and tempera (unfinished). This transitional work shows the persistence of egg tempera techniques in early oil painting. The initial stages are carried out in the old medium and the final stages in the new. *Scottish National Gallery, Edinburgh*

difficulty with oil paint, and one not shared by the more stable temperas, is that pigments tend to sink and the oils to rise. This produces a yellowing of the paint which is why the early masters in the Low Countries placed their works in the sun to bleach out the oils.

Although a couple of centuries have passed since Horace Walpole disposed of the erroneous notion, apparently perpetrated by Vasari, that van Eyck invented oil painting,[54] there can be little doubt that the Flemish master was the first to use it with such evident success – and judging by the superb condition of his surviving works he might also be considered as the last. The strength and durability of his work owed every-

thing to his methods and materials. Van Eyck and other Flemish and Dutch painters respected the gesso ground by making careful, premeditated designs and underpainting with pigments in a tempera medium followed by a complicated series of oil glazes. In this the house painter's good practice of starting with 'lean' paint (flatting) and concluding the work with 'fatty' paint was achieved. In contrast to the Dutch, the Italians used the *alla prima* or direct method of painting in oil. This resulted in the inevitable *pentimento* (alterations), the use of toned grounds and solid underpainting, which have tended to deaden the brilliance of the pigments and narrow the tonal range.

140 *Rhoda Astley* by an unknown artist, *c.* 1755, 30¼ × 27 in. (75.5 × 67.5 cm.), showing this highborn lady 'painting' in pastels. *National Portrait Gallery, London*

OPPOSITE
139 Jan van Eyck, *The Arnolfini Marriage*, 1434, oil on oak panel, 32¼ × 23½ in. (82 × 59.7 cm.). Although Vasari's assertion that van Eyck was the inventor of painting pictures with an oil medium is insupportable, he undoubtedly brought the technique to levels that have never been surpassed. *National Gallery, London*

The most usual oil medium used by medieval painters was linseed but it was found that greater clarity was maintained with poppy oil, also known as olivette. Other oils used included oil of spike (lavender), rosemary and, the most familiar of all, turpentine, which was derived from various conifers. In recommending that house painter's work should be costed on the 'running measure' like the 'honest Joseph's profession' of carpentry, Sir Balthazar Gerbier observed that painters 'do but spend the sweat of Wall-nuts (to wit oyle) the Carpenters that of their browes'.[55]

With glutinous media, wine and even beer were used as dilutants.[56] Skinned walnuts[57] produced a good clear oil for light-coloured pigments as did poppy seeds. The latter however was a slow dryer although this could be improved by being placed in a pewter vessel in the sun and covered to prevent evaporation.[58] Presumably the lead content of the pewter provided the necessary drying agent and may explain the use of lead colour pots by some medieval painters.[59]

Although fig-tree juice could be used to retard the drying of oil paints, it was an improvement in their siccative quality that was more eagerly sought. In this, the development of mordants (literally to 'bite hold of') for oil gilding probably preceded their use as 'dryers' by painters. These 'dryers' included a solution composed of verdigris or white coperas of calcinated bones in an oleo-resinous medium. The resulting mixture was gently heated to a moderate temperature gauged by a dove's or hen's feather which curled when the solution reached the appropriate temperature. The 'dryers' was then strained through a linen cloth for use.[60] Van Dyck, who insisted that his dryers should be made in his studio and never kept longer than a month, used a recipe consisting of a pint of nut (probably walnut) oil gently heated with $1\frac{1}{2}$–2 oz. of white lead. The resulting mixture was then clarified 'by straining and repose'.[61] In the use of oil paint it was possible to work on wet underpainting, but if the earlier layer or layers had dried, Elsum directs that 'you must anoint that place you intend to cover, with Nut Oyl well clarifyd, and very Thin, and rubb it in with the Ball of your Hand and afterwards wipe it well.'[62]

In addition to the oils listed above, hempseed oil was used as a substitute for linseed.[63] Leonardo da Vinci used either a mixture of mustard seed pounded and pressed with linseed oil or cypress oil distilled (a turpentine) and mixed with juniper gum.[64] Vehicles composed exclusively of an essential oil evaporated leaving a paint surface resembling pastel and one that, like pastel, required 'fixing'. The distilled essential oils included spike, turpentine and, as early as the sixteenth century, petroleum (from Parma and Bologna – also known as naptha or *olio di saso*).[65] These deposits still exist, at least in small quanities, in the districts around Parma and Modena. The first seeps of this natural naptha were near the town of Barigazzo, and, when ignited spontaneously, were known as the *fuochi di Barigazzo*.[66] Mérimée commended Persian naptha, which was much used in the manufacture of varnish.[67]

In general the natural affinity between distilled turpentine and the gum or mastic (exudant) of the fir tree combined to produce both successful media and varnishes. Varnishes were of course used to coat armour and prevent rusting. They also provided a finish for furniture. The cabinet-makers of seventeenth-century Amsterdam introduced oil of spike as a 'dryers' in vernice liquida (amber) and this varnish was especially favoured by the Cremonese musical instrument makers. In Gentileschi's day (1563–1639) the colour shops kept stocks of the amber varnish used by the lute makers.[68]

Painting in pastels, or crayons as they were known in the eighteenth century, seems to have reached Britain in the seventeenth century from the Continent. One of the first to advertise crayons for sale in London was 'De la Cour . . . At the Golden Head in Katherine Street in the Strand' whose trade card was engraved by R. White in about 1743 (see fig. 141).[69] Of the important artists in pastel, the Swiss Jean Étienne Liotard (1702–89) is probably the best known. One of the foremost manufacturers of crayons in the late eighteenth century was Galliards of the Black Bear, 227 Piccadilly (previously of Noel Street) whose 1784 trade card announces that they sold 'Galliards Original Swiss Crayons for which the Society for the Encouragement of Arts Manufactures & Commerce granted a Bounty to Pache and Galliard'.[70] Their product must have been of some importance since a couple of years later G. & I. Newman of Little Chelsea, Bridge Row, Ranelagh, felt compelled to advertise their 'Crayon Pencils Equal to the Swiss'.[71]

In making pastels the pigments were ground in a medium, usually gum tragacanth and, depending on the colour being prepared, varying quantities of filler, usually pipe clay.[72] On the other hand Müntz, in his book on *Encaustic* (1760), includes a section on 'crayons their preparation and use' in relationship to wax in which he rejects the use of such 'fillers'. 'In composing any new tint it will be well to leave out fullers earth, pipe-clay, chalk, and other calcarious matters which are generally used in the common way; the former – to bind the looser colours; the latter to keep up the flake white and white lead, which otherwise would turn black.'

141 Trade label of De la Cour, engraved by R. White, *c.* 1743. *British Museum, London*

The oxidation of colours was a perennial problem but one which, when they were 'locked up' in a tempera or oil medium, seldom arose. As for the use of fillers, Müntz reaffirms his objections in a footnote. Unfortunately, the author of these opinions does not give much information on how to make 'crayons' but simply directs artists to 'Mr Sandys, colour merchant in Dirtylane, Longacre, of whom perfect sets may be had; and as the author has communicated the *recipe*, for binding the most difficult colours, for the benefit of art, without fee or reward whatsoever, those crayons will be sold at the usual price.' So devious is Müntz regarding the recipe for his crayons that he audaciously adds that 'If this treatise should meet with such approbation as to require a second edition, the recipe for the composing of crayons will be inserted at full length.'[73] Charles Sandys the colourman later went into partnership with Middleton and their trade card of *c.* 1780–90 states that from their premises at 79 Long Acre they 'Make & Sell all Sorts of Crayons'.[74]

Another eighteenth-century artist in pastel, John Russell (1745–1806), was no less secretive, writing his recipes in Byrom's shorthand.[75] A number of his 'secrets' may relate to those of Müntz; although Russell does not mention chalk as a filler, he does refer to whiting. He frequently states that the pigments should be ground in a vehicle of spirit of wine or turpentine to which a resin was added as a 'binder'. Many of his recipes have a peremptory note appended to them addressed to his daughter who evidently worked as his assistant: 'Nancy, use no water here.' In some recipes the pigments were ground

in water, but for quicker evaporation that would speed the process of casting the sticks a volatile oil was preferred. The amount of resin used in the medium influenced the hardness of the resulting crayons and at one point Russell advised that 'none that are wise will want it more hard'. Some of his recipes mention as little as $\frac{1}{15}$ resin by weight, though in relationship to what (colour or essential oil) is unclear.[76] Russell was by no means the only eighteenth-century artist to make his own crayons. George Moreland's father of Chapel Street, Wardour Street, 'was also a maker of most excellent crayons which went by his name.'[77]

The surface for pastels was usually a thick, tough paper with a strong tooth. Some artists in the eighteenth century prepared their paper with gum water and smalt (a blue pigment made from ground cobalt glass) to improve this quality. With pastel, 'fixing' is an important part of the process. In some ways it is a retrospective medium that binds the colours after their application. The stronger the fixative, the greater the loss of brilliance and charm of the colour. A frequently used fixative was skimmed milk which, as a natural casein, held the colours reasonably securely. Fixatives were generally applied at intervals as the work progressed, thus consolidating each layer of pigment. In 1850 pastels were described as simple to make by *The Ladies Companion* which recommended 'the art largely to female artists and amateurs'.[78]

There is perhaps something in the collective personality of English artists that contributed to their liking for, and achievement in, working in watercolours – on paper, vellum or ivory. No doubt the damp climate helped, but so too did an innate sense of restraint that enjoyed the precision of working 'in little'. This sense of restraint occurs at many periods in English art. Whatever the explanation, English artists have been outstanding in the use of both solid and translucent watercolour. From the medieval limner to the jewels of Hilliard and his contemporaries, the English watercolour made its triumphant appearance in the translucent washes of Sandby and Turner. That achievement was closely linked with the development and manufacture of watercolour cakes and watercolour paper, two innovations in which eighteenth-century England led the world. Inevitably it came to be known as 'The English Art'.

In the preparation of all colours for use by artists a method of storage for future use was one of the principal concerns. A fifteenth-century manuscript in the public library at Strasbourg quoted by Eastlake describes colours for illuminating which were stored by steeping small pieces of linen cloth in the liquid colour and then

drying them.[79] When the colour was needed for use a small portion of the 'clothlet' (*rüchlein varwen*) was cut off and soaked in a little water overnight. Although water was the vehicle, these medieval artists used glair (white of egg) as the medium. The clothlet represents a precursor of the watercolour cake and an occasional reference in the Strasbourg manuscript to 'London practice' suggests that craftsmen in the English capital were in the vanguard of their development. Clothlets were convenient to store and also to trade. Cennini mentions 'certain colours which have no body, known as clothlets, and they are made in every colour'.[80]

The pre-Reformation illuminated manuscripts, like the miniatures of Hilliard, his contemporaries and later artists who worked 'in little', employed solid colour (gouache or body colour as it is also known). Cennini's reference to clothlet colours lacking 'body' has considerable importance and indicates the use of translucent watercolours at an earlier time than is usually recognized. The materials used in the late sixteenth and early seventeenth centuries are described by Hilliard with a sparkling delicacy that somehow reflects the quality of his work:

> ... the watter wel chossen or distilled most pure, as the watter distilled frome the watter of some clear spring, or frome black cherize [cherries] which is the Cleanest that euer I could find, and keepeth longest sweet and cleare, the goume [gum] to be *Goume Aarabeeke*, of the whitest and briclest [brittlest] broken into whit pouder, one [on] a faire and cleare grinding stone, and whit suger candy in like sort to be keept dry in boxes of *Iuory* the grinding stone of fine Cristall, Serpentine, Iasper, or Hard Porfory ...[81]

These ingredients remained constant, since well over a century later Robert Dossie lists 'the substances used for rending water a proper vehicle for colours': gum Arabic, gum Senegal, size, sugar candy, starch ('sometimes used instead of sugar candy') and isinglass ('a glue from the cartilages of large fish'). Sugar candy was added with the intention of preventing 'colours from cracking when mixed with gum Arabic; which the sugar prevents by hindering that perfect dryness and great shrinking which happens on the use of gum Arabic alone, and also to make the gum water more kindly with the pencil [brush].'[82] Similar details will be found in William Salmon's book in which he defines limning as 'an Art whereby in water Colours, we strive to resemble Nature in every thing to the Life'.[83] The definition is important since it shows that at the time Salmon's book was first published (1672) the word 'limning' retained its original meaning. By 1766, when *The Vicar of Wakefield*

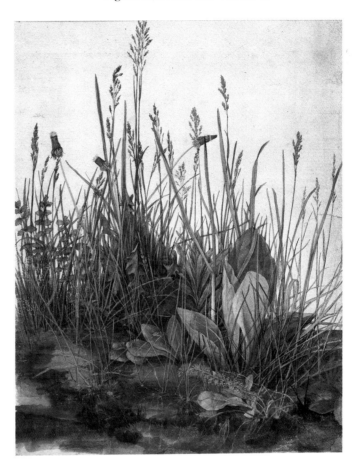

was published, the precision of the word had been lost. Goldsmith's itinerant limner worked on a large canvas and by implication painted in oil producing 'likenesses for fifteen shillings a head'. To save confusion the word 'limning' was now replaced by the term 'painting in miniature'. In his chapter on the subject Dunlap confines his remarks to 'those only who painted in watercolours and on vellum, paper or ivory; that is what is now called "miniature-painting".'[84] From 1781, when William Reeves in partnership with his brother Thomas were honoured by the Society of Arts for their watercolour cakes – and the coincidental development in the transparent handling of watercolour in the eighteenth century – the definition was important. It was a definition that the redundant and therefore misused word 'limner' no longer provided. Although artists had regularly used bistre washes and 'Indian' ink (see pp. 58–9) in translucent washes to give their work greater tonal depth, the use of colour washes was rare until the late eighteenth century. This transition may be seen, for example, by comparing the drawings of Hogarth, which are dramatized by means of monochromatic washes, with those of Rowlandson, whose repertoire of techniques included the use of colour washes.

The portable nature of gouache and watercolour had long been recognized. The medium

143 Dürer, *Piece of Turf*, 1502, watercolour study. *Albertina, Vienna*

OPPOSITE
142 Charles Wilson Peale (1741–1827), *Portrait of James Peale painting a Miniature*, oil on canvas, 30 × 25 in. (76.1 × 63.5 cm.). The easel is remarkably similar to the one illustrated in fig. 144. *Mead Art Museum, Amherst College, Massachusetts*

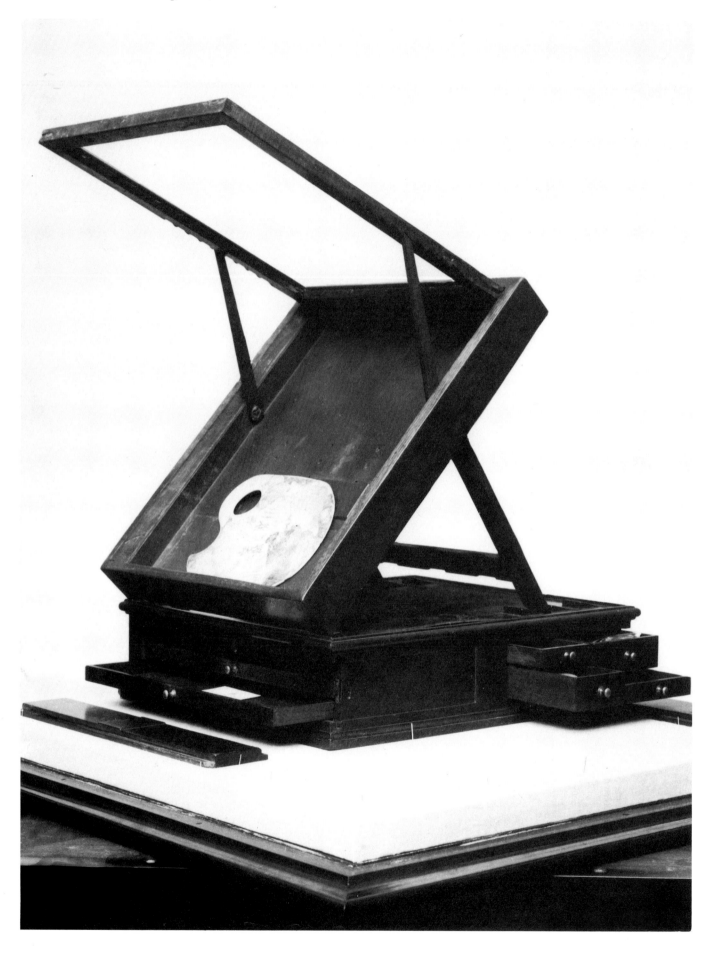

was used by Dürer for his charming landscape studies made on his travels to Italy (*c.* 1495) and it was used by the artists who accompanied various expeditions of exploration and discovery from John White's records of the Indians of Virginia (1585–90) to the paintings by the naturalist Sydney Parkinson, who sailed on Captain Cook's first voyage (1768). Most of these artists used solid colour in the manner of the medieval limners. Isaac Smith, who sailed on Cook's first voyage as a midshipman and on the second voyage as Master's mate, took with him a colour box supplied by the Reeves brothers on both voyages. By the time Captain Cook's third expedition sailed in 1776 a quiet revolution in technique had taken place – John Webber, the official artists on that voyage, used the avantgarde method of transparent washes of colour. The first painters who regularly used transparent washes were those who tinted printed maps. In this instance such a handling of watercolour was essential if the details recorded in such engravings were not to be obliterated. Although Dunlap accords the English artist Jeremiah Myers 'the merit of first painting in transparent colours',[85] Prince Hoare, in common with most later commentators, was of the view that Paul Sandby

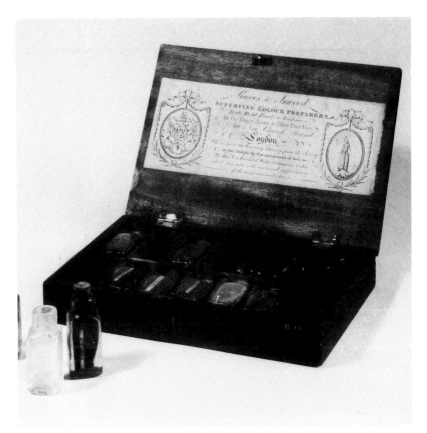

'was the inventor in England of that style of water-coloured drawing in Landscape, which has since been carried to so singular a degree of beauty and expression of nature [that] . . . seeing others advance far beyond himself . . . was his reward.'[86] Among these 'others' was Edward Dayes (1763–1804), pupil of Girtin, and of course J. M. W. Turner, who was also influenced by Dayes. Remarkably, Sandby in his late work was quite prepared to use passages of body colour – a great sin amongst purist watercolourists. The accepted procedure was either to work colour and tone directly and simultaneously, or to work first tonally and then by successive washes chromatically. These systems are paralleled in oil painting. In theory, whites could only be created by the paper itself and some artists such as Gilpin used spirit varnish as a 'resist' which could subsequently be removed with spirits of wine. In Constable's *Stonehenge* the white highlights were created by scraping back to the paper, and this, together with additional strips of paper, make the painting a splendid battlefield over which the artist fought and triumphed. The use of solid white gouache would have been a soft option indeed. In the late nineteenth century the use of solid watercolour became common and was encouraged by the new watercolours made by Reeves which used virgin wax in place of gum to provide the necessary hygroscopic characteristics which kept the paints moist and usable over many years.[87] In addition to the use of solid col-

145 Mahogany box holding liquid watercolour in glass bottles, by Reeves & Inwood (after 1781). Transparent watercolour was first generally used for tinting maps and prints. *Museum of London*

OPPOSITE
144 Miniature painter's easel, walnut, late eighteenth or early nineteenth century, 16 × 13 × 8 in. (40.5 × 33 × 20.3 cm.). The ivory palette is only 4 inches across and enabled the artist to mix his colours on a surface, and at a scale, appropriate to his work (see fig. 142). *Victoria and Albert Museum, London*

146 Drawing of a paint box in Richard Symonds's notebook on painting (1650–51/2). This drawing may indicate an early concern with painting out of doors. *British Library, London*

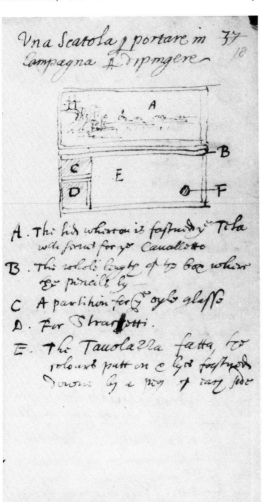

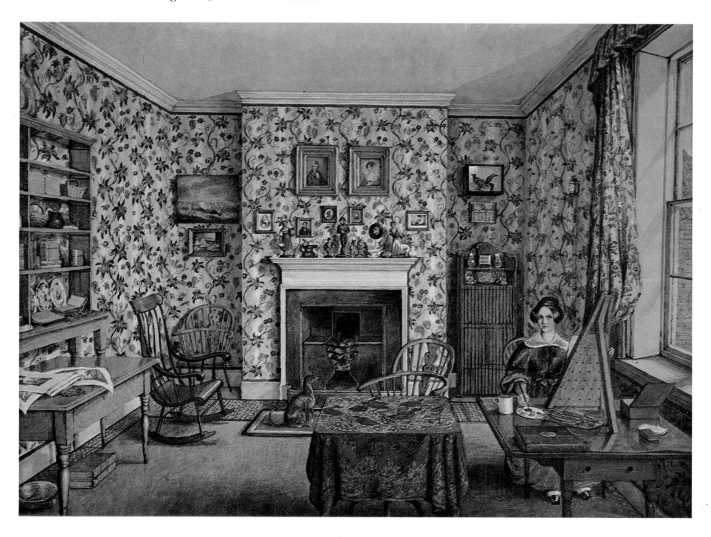

147 Mary Ellen Best
(1809–91), *The Artist in
her Painting Room,*
watercolour on paper.
York City Art Gallery

OPPOSITE
148 Claude Lorraine
(1600–82), *Landscape
with a Goatherd,* oil on
canvas, 20½ × 16⅛ in.
(52 × 41 cm.). In John
Constable's opinion
much of this picture was
painted out of doors from
nature. If correct, this
would be one of the first
plein air landscapes.
*National Gallery,
London*

our many ornithological artists of Thorburn's
generation varnished the eyes and scaly legs of
their subjects for greater verisimilitude. In many
ways these artists had returned through the needs
of their subject matter to the methods and
splendours of the limners of the sixteenth
century.

According to Sandby's early biographer, the
painter encouraged 'Middleton the colour maker
to prepare them [watercolours] in somewhat like
their present state and which are now brought
to so great a perfection by Reeves, Newman and
others'.[88] If this report is correct it suggests that
it was the art that inspired the industry rather
than the industry which supplied the means to
an end. Furthermore, it was Middleton's who
briefly employed William Reeves and introduced
him to the colourman's trade.[89] As we have seen,
watercolours were available long before water-
colour cakes were invented, but their develop-
ment, whilst not creating an art, certainly
increased its number of adherents. The diffi-
culties of painting in watercolour are indicated
by the *Method of Painting in Water Colour*
(1730).[90] The author goes to great lengths to des-
cribe the many sources of colours and their

preparation. It was a job that only dedicated pro-
fessional artists could undertake. From 1781,
when William Reeves in partnership with his
brother Thomas was awarded the 'Greater Silver
Pallet' of the Royal Society of Arts for their
watercolours in cakes, the number of artists,
both amateur and professional, who used water-
colours increased rapidly. So too did the rival
manufacturers, and in their train the associated
instruction manuals and armies of drawing mas-
ters listed in the trade directories of early
nineteenth-century England. The supreme
achievements of Turner and Constable in the
medium, and the admission of watercolours in
1812 to the annual exhibition of the Royal
Academy, demonstrate the high esteem in which
their new art came to be held. The Great Marlow
Military College, which later moved to Sand-
hurst, made painting in watercolours part of the
training for army cadets and numerous con-
temporary books on female education confirm
that it was considered an important 'accomplish-
ment' for young ladies.[91] The prodigious num-
bers of amateur artists are reflected in the
following letter quoted in Mrs Sarah Uwins's
Memoir of Thomas Uwins, R.A.

gara] and made drawings which I carefully coloured in the open air.'[93] So new was this experience to him (he had lived in England as a student of Benjamin West) that he felt compelled to describe in considerable detail his 'artist's three-legged stool resembling a club'.[94]

The introduction of watercolour cakes began a revolution that was not completed until the invention of collapsible metal tubes for oil paint in place of the more cumbersome, messy and less efficient bladders. An early attempt to improve on these was made by James Harris who submitted 'a syringe for the purpose of preserving oil paint' to the Society of Arts in April 1822. Brass syringes of this type were priced at £4-10s per dozen and tin at £3-10s per dozen. Queen Victoria's colour box of c. 1837 is furnished with metal syringes of paint made on the same principle. In 1840 William Winsor, who with Henry Charles Newton had founded in 1832 the business that continues to bear their name, patented glass syringes as 'Preservers' of oil paint. *The Art Union* (London, 1841) anticipated that these glass syringes would do much to make oil painting 'a more general female accomplishment'. Despite these innovations, bladder colours remained general, largely because they were cheaper. As early as 1804 the colourman Rawlinson devised a bladder with a wooden stopper and by 1841 Waring & Dimes of 91 Russell Street, London, were advertising their 'Anti-tube bladders of oil colour' which were fitted with a cap.

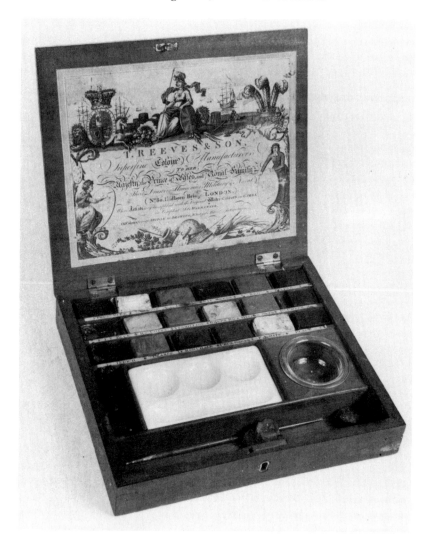

149 A box of watercolour cakes by T. Reeves & Son, c. 1793. The introduction of these easily used paints did much to promote the 'English art' of painting in watercolour during the last decades of the eighteenth century. *Winsor & Newton, London*

150 Artist's folding stool – open and closed – late nineteenth century, birch and canvas, length 21 in. (53.4 cm.). Painting in watercolour did much to promote working from nature out of doors, for which sketching stools were important. *Private Collection*

Naples 7th May 1830

Dear Severn – What a shoal of amateur artists we have got here ... I am old enough to remember when Mr Swinburne and Sir George Beaumont were the only gentlemen who condescended to take brush in hand, but now gentlemen painters rise up at every step and go nigh to push us off our stools.

Gainsborough, himself a landscape painter, quite deliberately avoided painting out of doors. In preference, he worked from table-top models which he constructed from sand, clay, moss, twigs, rocks, and mirror glass. These scenes were inhabited by miniature horses, cows and human figures which he modelled for the purpose. Gainsborough asserted that Paul Sandby was the first artist to paint 'real views from nature'.[92] Watercolour cakes certainly made it easier for professional artists to make objective studies of landscape in the open air. Even so, the experience of working in this way was sufficiently novel in about 1815 for Dunlap to state: 'I remained four days at the Falls [of Nia-

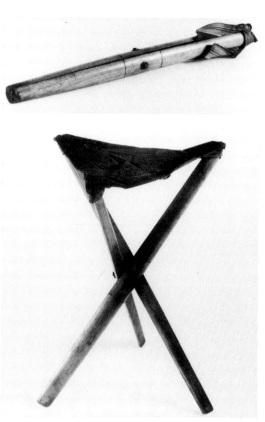

In the same year George Rowney & Co. of 51 Rathbone Place were promoting their 'Preserving Envelopes to supersede the use of the Bladder for Oil Colours'.[95] There was evidently a need for an alternative.

The most momentous and indeed revolutionary development was the invention, by a now obscure American portrait painter John G. Rand (1801–73), of 'metallic collapsible tubes for oil colours' in March 1841. Rand lived in London *c.* 1836–48 and his British patent No. 8863 was granted for 'Improvements in Preserving Paints and other Fluids'. In September 1841 he took out a similar patent in the United States. It was many years before the wider use (e.g. for toothpaste) of the invention was to be fully adopted, but by 1846 Winsor & Newton had introduced moist watercolours in tubes. The metal used for these early tube paints was tin, an inert material that did not harden and fatigue with constant bending.

The significance and therefore importance of these innovations has been obscured by the more easily understood influence of photography, the development of which occurred in the same decade. It would be a mistake to suppose that watercolour cakes and tube oil colours inspired *plein-air* painting. As we have seen the initial inspiration for watercolour cakes came from a landscape painter and not from a colourman, whilst oil paints preserved and dispensed in flexible metal tubes were the invention of a portrait, rather than a landscape, painter. Furthermore, photography, watercolour cakes, and oil colours in tubes had their predecessors – the camera obscura, Chinese inks, and bladder colours. It was nevertheless the development of convenience paints, no less than the introduction of photography, that ushered in a revolution in painting by influencing the way we see and the way we apply the observations so made.

Painters' Supplies

There were a number of trades that furnished painters with the basic needs of their craft; these included the brushmaker, the oil and colourman, and the framer and gilder. A painter might sometimes be self-sufficient in one of these, but in general such services were provided by others.

HAND TOOLS

Palettes and Palette Knives
Almost as intimately associated with the painter's craft as paint itself are the painter's hand tools. One of these, the artist's palette, in addition to its practical service as a tool, has become a metaphor for the colours used in particular pictures. Terms like a 'restricted palette' refer to a restricted range of colours employed in a painting.[1]

Many of the paints used in the past incorporated media that could not easily be handled. Furthermore, most of these had to be kept warm for use. The animal fats used to bind and carry the pigments used by Stone Age man, the wax encaustic methods of the Classical Mediterranean, and the many emulsions employed by medieval painters encouraged artists to use a series of small vessels each of which contained a different colour. Related to these difficulties was the use of cross hatching for tonal modelling and glazing for colour variations. Tonal and chromatic effects were made on the painting so that a preliminary mixing surface was of less importance than it subsequently became.

The palettes used by the scribes and

151 Thomas Hearne (1744–1817), *Sir George Beaumont and Joseph Farington sketching a Waterfall*, 1777 (?), pen and ink and wash on paper, $17\frac{1}{2} \times 11\frac{1}{2}$ in. (44.5 × 29.2 cm.). The excitement of painting out of doors is very evident in this drawing. Hearne was one of three judges appointed by the (Royal) Society of Arts to examine Reeves's watercolours with a view to presenting the colourmen with the 'Greater Silver Palette'. This award was finally made on 11 April 1781. *Dove Cottage, Grasmere*

153 Brushes from Thebes, XVIII Dynasty, *c.* 1450 BC. A group of ancient Egyptian paintbrushes of palm fibre and twigs, the latter frayed at one end to create the brush. *British Museum, London*

154 Cornelis-Norbertus Gysbrechts (active *c.* 1659–78), *A Painter's Easel*, oil on canvas, 89 × 48⅜ in. (226 × 123 cm.). *National Museum, Copenhagen*

OPPOSITE
152 John Singleton Copley, *The Death of Major Peirson* (detail), 1783, oil on canvas, 97 × 144 in. (183 × 246.5 cm.). Until the widespread adoption of more convenient paints many outdoor subjects reveal the contradictions of indoor lighting, hence the theatrical effect of the light in this picture. *Tate Gallery, London*

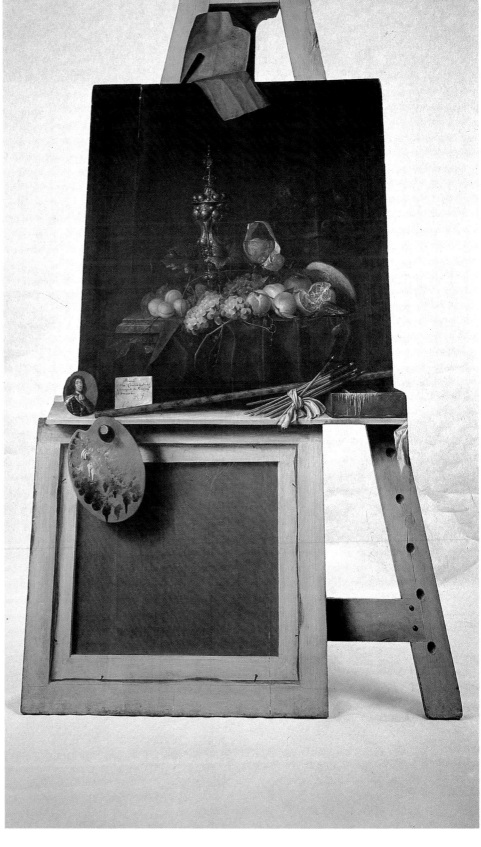

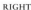

RIGHT
155 Queen Victoria's colour box, exotic woods and tortoiseshell, *c.* 1840, $20\frac{1}{2} \times 15 \times 6$ in. (52 × 38 × 15.2 cm.). The metal syringes were designed to hold paints. *Royal Academy of Arts, London*

OPPOSITE ABOVE
156 The storage of oil paint, from the pig's bladder of the seventeenth century to the collapsible metal tube, which was first introduced in 1841. *Winsor & Newton, London*

OPPOSITE BELOW
157 *St Matthew*, from a manuscript Gospel probably painted at Rheims in about AD 830. The cow-horn container was used for both ink and paint, its shape ensuring that heavy impurities sank to the tip. *Municipal Library, Epernay*

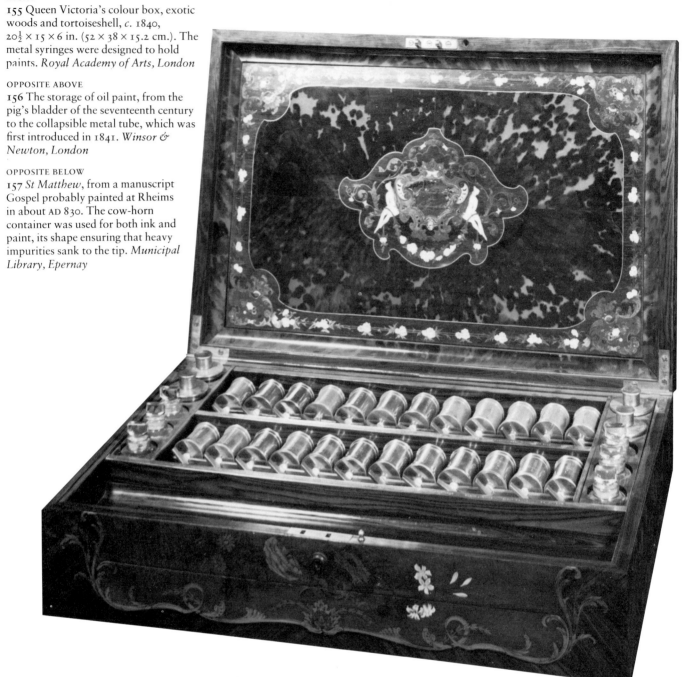

draughtsmen of Ancient Egypt incorporate separate hollows to receive the red (for under drawing) and black (for finalizing) pigments.[2] Others were made with up to a dozen such depressions to contain a sequence of different colours and these resemble the watercolour boxes of the early nineteenth century. Somewhat similar in this respect are the modern aluminium palettes designed for egg tempera. Aspertini of Bologna eccentrically wore a girdle round his waist to which were attached pots of colour.[3] A natural receptacle much used by missal painters was a cow horn and so successful were these in collecting the sediment and thus purifying the paints that in later periods reference is sometimes found to 'a horn of glass'.[4]

In the late seventeenth century the tradition of a series of small vessels for pigments was standard procedure in some crafts related to painting, such as varnishing, japanning, and gilding. William Salmon mentions that

Fine, smooth, middle-sized Horse Muscle-shells are fittest for these Occasions; of which you ought always to have 2 or 3 hundred in a readiness, for mixing your Metals or Colours in, as need requires; not that you will need the 10th part of them at once, but that you might not be to seek for them when you want them.[5]

The use of mussel shells for this purpose is perpetuated in terms like 'shell gold' (a powdered gold) and 'shell-lac' (shellac).

Even in the late eighteenth century William Williams in his *Essay* (1787) recalled an 'old gentleman' living in a remote district unacquainted with artists, who painted exquisite pictures of butterflies 'with a patience that would have surmounted any difficulties, [and] collected a multitude of shells of colour of every various tint.' Although Williams seems oblivious to the fact, this 'old gentleman' was evidently using a very traditional technique.[6]

The palette, as it is understood today, began its evolution in the early fifteenth century as a small, wooden, bat-like surface (as its French name implies) upon which artists could work up a few colours prior to their application.[7] Their size is reflected in the diminutive form of the word, and their shape (though without the long handle) was once very similar to the baker's 'peel' which was also known as a 'palette'. The small size of these early palettes may be accounted for by a tentative change of method. It reflects the procedures of egg tempera painting and the tradition for 'finishing' small areas bit by bit. The growth in the size of palettes coincides with the development of oil painting. The bat-like, 'English' palettes continued to be used occasionally throughout the eighteenth century until they were finally displaced by the ovoid

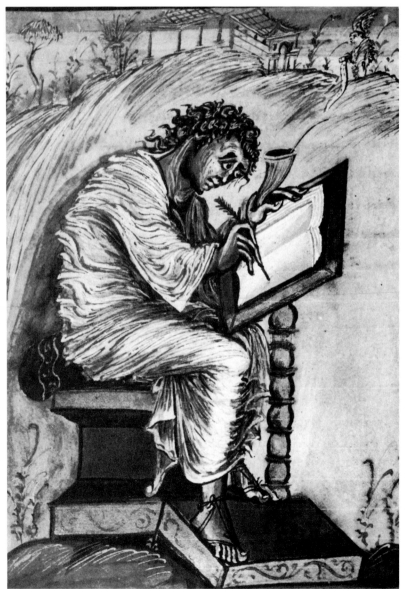

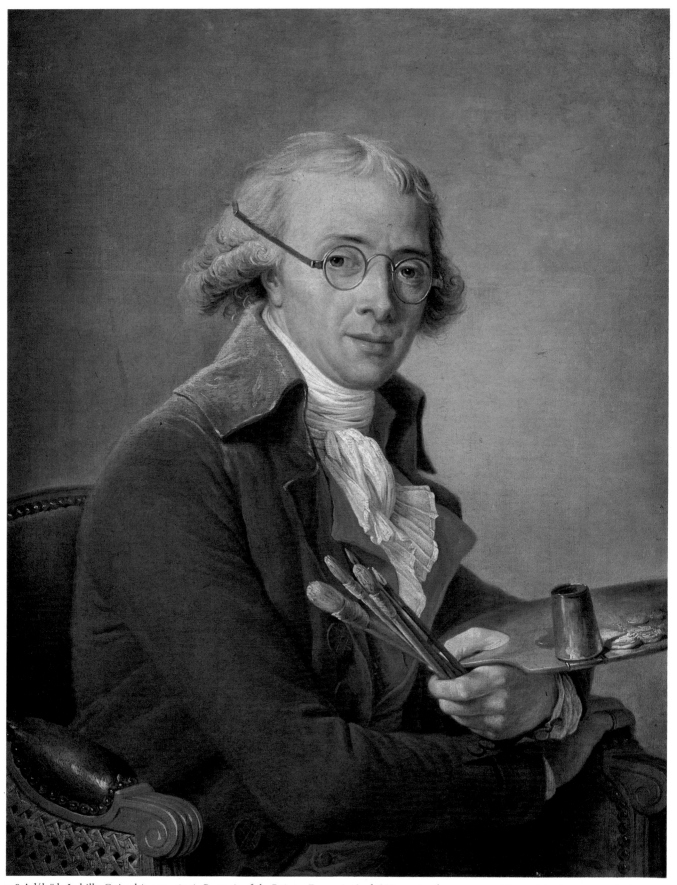

158 Adélaïde Labille-Guiard (1749–1803), *Portrait of the Painter François-André Vincent*, oil on canvas, 28¾ × 23¼ in. (73 × 59 cm.). A container for medium was, and still is, customarily attached to the palette. The painter is holding 'brushes', in which the hair is bound in twine rather than being held in a quill, as was general for the smaller 'pencils'. *Musée du Louvre, Paris*

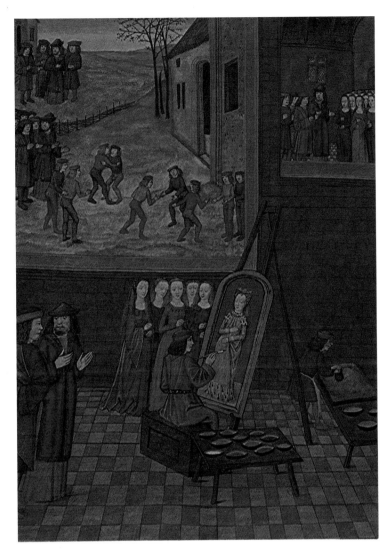

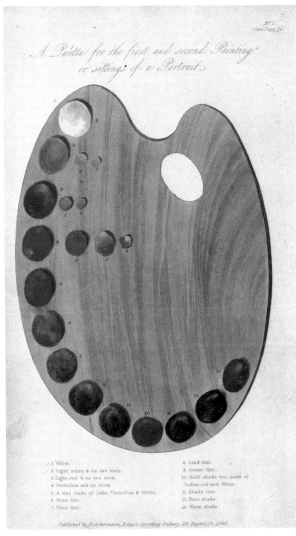

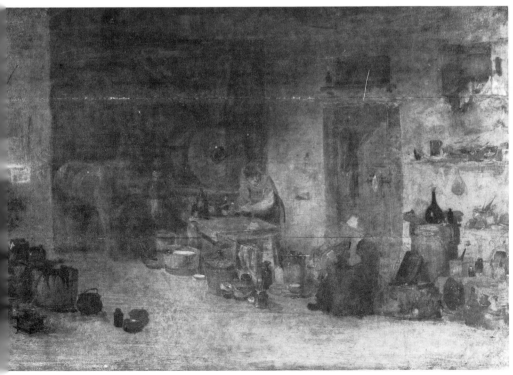

159 *Zeuxis painting Girls in his Studio* (detail), Netherlandish, late fifteenth century. This watercolour miniature illustrates the use of a series of individual pots for each colour, a necessary feature of painting with egg tempera and one that reduced the need for a palette. This encouraged an almost heraldic use of colour, with tonal variations worked by cross-hatching. *Bibliotheek der Universiteit, Ghent*

160 *A Palette for the First and Second Painting or Sittings of a Portrait*, from John Cawse, *The Art of Painting* (1840). Numerous theories were published from the mid-eighteenth century onwards on how to 'set' a palette. (See fig. 165.) *Victoria and Albert Museum, London*

161 J. M. W. Turner, *An Artist Colourman's Workshop*, c. 1807, oil on pine panel, 24½ × 36 in. (62 × 91.5 cm.). Turner has here depicted a horse mill of the type used by the Emertons (see fig. 182). *Tate Gallery, London*

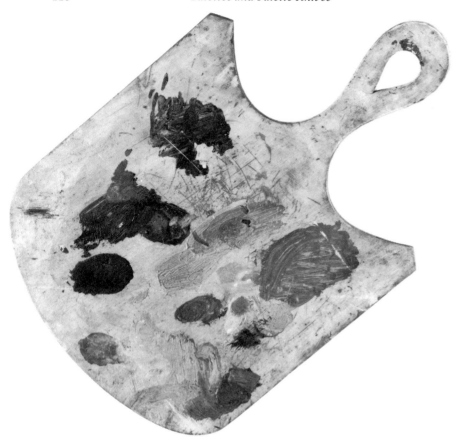

and sometimes rectangular form with thumb hole and brush 'bay'. In this shape the palette occurs in countless allegorical representations as an attribute of 'the arts'. Throughout the eighteenth century palettes remained relatively small.[8] It was in the nineteenth century that they grew to the remarkable proportions of those that surround the council room at the Scottish Royal Academy in Edinburgh as trophies of Presidents past. In *The Art of Painting* (1704) John Elsum warns the artist to 'Value your time above the cost and price of your Colours, and spare not to waste the latter to gain or save the former, 'Tis no good Husbandry to starve a Picture to save charges; besides thin Painting is neither Beautiful nor holding.'[9] That such a warning was necessary is of considerable importance. The high cost of paints in earlier periods would have kept palettes small and the rapid increase in their dimensions in the nineteenth century follows the introduction of cheap, industrially produced tube oil paints.

Palettes were usually made of a close-grained hardwood such as pear, walnut, mahogany or rosewood. Writing in the late seventeenth century when they were evidently not generally available at retailers but had to be made on

162 An 'English palette' of peel form and eighteenth-century type – birch, overall size $21\frac{1}{2} \times 14$ in. (54.6×35.5 cm.). The thickness varies from $\frac{6}{16}$ in. (10 mm.) at the handle to $\frac{1}{16}$ in. (1.6 mm.), in the interests of balance. *Private Collection*

163 Martin Lambert, *Portrait of the Brothers Henri and Charles Beaubrun*, 1675. The palette, palette knife and mahlstick are clearly represented. *Château de Versailles*

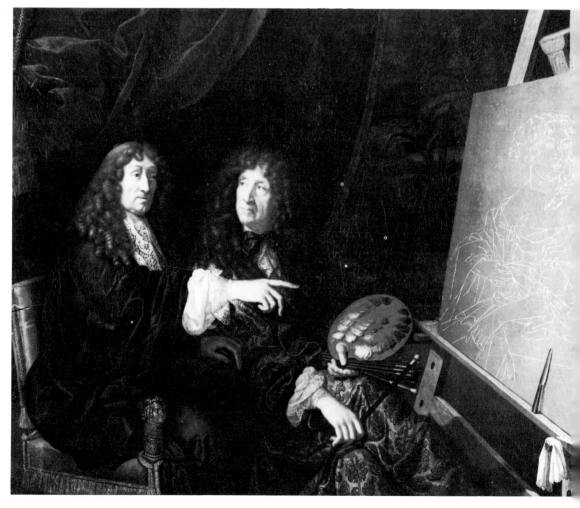

request, John Martin suggests that a painter should 'have two or three, flatt palletts made of olive-wood, or walnut-tree wood and made very smooth, of an oval fashion, one bigger than another'. Balance was an important consideration, the more so with the 'bat' than with the oval or square forms, since the latter types rest along the painter's arm. In addition to a 'sleeve guard'[10] a lead weight was sometimes added as a counter-balance and palettes of all types were often shaved to varying thicknesses in the interests of balance.

The ivory or porcelain palettes used by painters in miniature remained small, indeed minute. The materials out of which they were made was consistent with the surface upon which the paint would finally come to rest. Their dimensions too were, for both practical and psychological reasons, no less consistent with their purpose. *The School of Fine Arts*, published 'by and for' William Cole, lists the necessary tools: 'The chief materials in painting with water colours are gum arabic, pencils, a palette, commonly made of ivory; but a Dutch Tile, or any other well-glazed surface, of a light colour, will serve the purpose; an ivory palette knife, because iron or steel injures the colours.'[11]

The 'setting of a palette', the arranging of a series of paints in a definite sequence of colours and tones, has long been considered a basic need of the craft. This is not to say that the sequence has remained unchanged through history or that individual artists in a generation agree as to the form it should take. The history of this long and important subject has been very well examined by F. Schmid in his book *The Practice of Painting* (1948), which is largely confined to this question.[12] Of the many arrangements that have been recorded both within the pages of instruction manuals and in portraits and self-portraits showing artists at work, I shall quote William Williams's system by way of example:

Place the white next to the thumb, or to the right end of the pallet as it is held, patent yellow next, ranging them in the following order; next to the patent yellow, ditto oaker, Siena earth, vermillion, red oaker, purple brown, lake, burnt umber, Antwerp brown, black, prussian blue.[13]

Williams goes on to advise that, at the end of each working day, the colours should be removed and 'placed on a glass or pot [pottery] pallet, in the same order, and put into a clean

164 John Faed (1820–1902), *Portrait of Thomas Faed*. The subject is shown holding an ivory palette of the type used by painters in miniature (see fig. 142). *Scottish National Portrait Gallery, Edinburgh*

165 John Cawse (c. 1779–1872), *Self-Portrait*. Cawse was the author of *The Art of Painting* (1840), a plate from which is illustrated as fig. 160. *Private Collection*

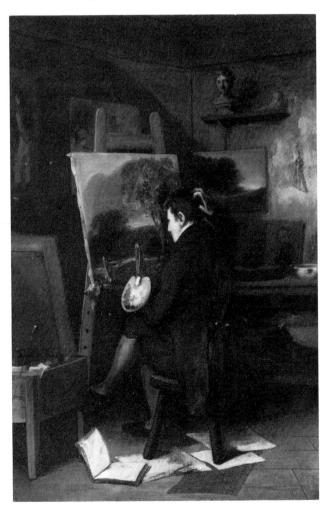

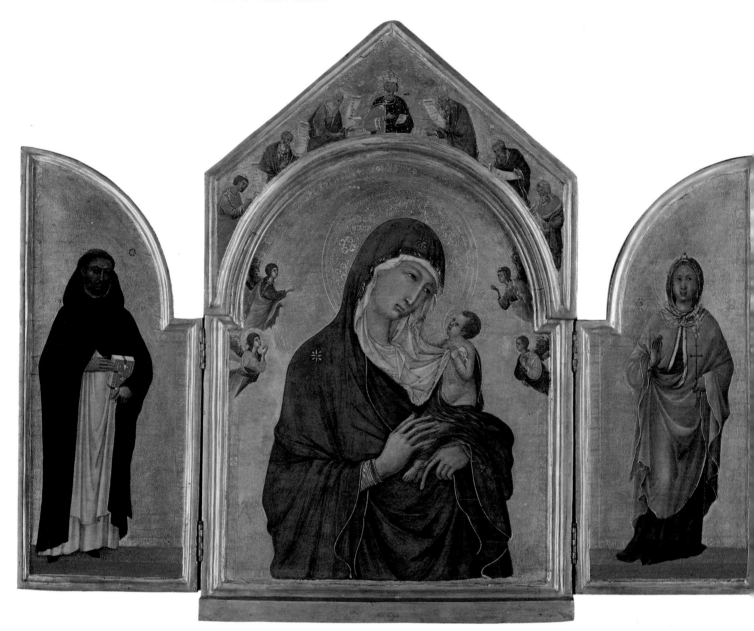

166 Duccio (active 1278–1319), *The Virgin and Child with Saints*, tempera on panels, central panel 24⅛ × 15⅜ in. (61.3 × 39.1 cm.). *National Gallery, London*

167 One wing of the Duccio triptych in fig. 166, shown closed. By being prepared with gesso on both sides the panels of such triptychs remained very stable.

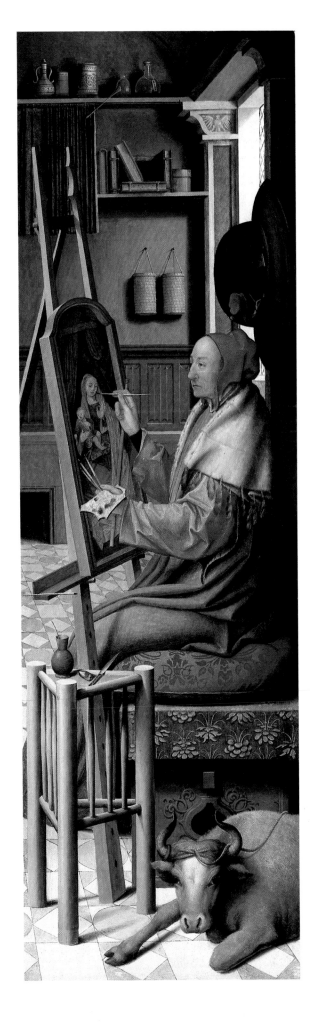

168 School of Quinten Massys (1465–1530), *St Luke painting the Virgin and Child*, tempera on oak panel, 44¾ × 13¾ in. (114 × 35 cm.). Until the development of the self-portrait in the modern world, the depiction of the patron saint of painters provides the best visual evidence for the tools and equipment used. *National Gallery, London*

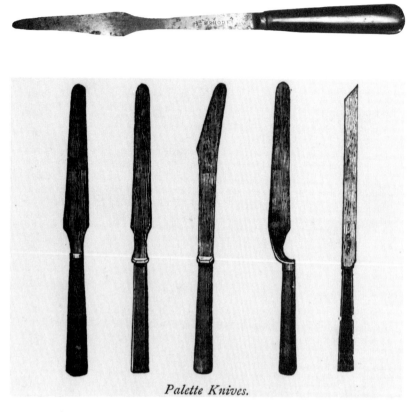

Palette Knives.

blade . . . very plyable [and] it must have noe adg [edge] but Made very blunt and smooth [so as not to] spoil your pallets'.[17] Numerous varieties (of type B) were available by the late nineteenth century and despite the views of earlier writers who recommended (as did J. H. Müntz) palette knives of ivory, horn, tortoise shell or wood, these were usually made of ferrous metal. Eastlake, doubtless aware of the views of past authorities, used a palette knife with 'a very flexible ivory blade' and added that painters should use 'several such, varying in the breadth of their extremity from an inch to almost a point'.[18] The 'stone knife' illustrated in some late nineteenth-century catalogues was doubtless for use in 'working up' paints on the grinding slab; this was the basic shape (type B) of which there were numerous permutations.[19] The trowel-shaped palette knife of steel seems to have been a nineteenth-century innovation and one which some have attributed to Courbet, although a knife of this type was used by Constable (fig. 169). When such instruments are of fine, well 'drawn out' steel, they are capable of extraordinary flexibility and serve as brushes in the application of paint on the support with a rich impasto. They are known as painting knives.

Brushes and Mahlsticks

Although brushes made from bundles of twigs and from palm fibre have come down to us from ancient Egypt, very few of the artists' brushes used in the more recent past have survived. In the nature of things they were expendable items. Documentary and pictorial examples as well as the inferences that may be drawn by close examination of painted surfaces are the main sources of evidence.

Paint was sometimes applied to the picture surface with the fingers and Pliny makes reference to the sponge, which was normally reserved for cleaning brushes, being brought into use in place of them.[20] As we have seen, those who worked in wax encaustic used small, heated metal tools to manipulate the warm, wax-bound pigments. This is just one of the features that gives to Faiyumic portraiture its 'modern' look; those 'painterly' qualities resulting from the use of paints with a rich 'body' handled with a second- or third-century AD precursor of the painting knife.

Many small mammals have been used to furnish hair for artists' brushes. Theophilus recommends that painters should make them out of 'the tail of a martin, badger, squirrel, or cat [polecat?] or from the mane of a donkey'.[21] The implication from this, as from other pre-seventeenth-century sources, is that painters made brushes for themselves. The recommendation that they could be made from the mane is

169 Painting knife, steel with a horn handle, *c.* 1820–30, 8½ in. (21.6 cm.), stamped by the maker E. Rhodes, and with the cipher G.R. Both this implement and the brush in fig. 171 were owned by John Constable and they emphasize that he was an early exponent of the use of the flat brush (which metal ferrules made possible) and the painting knife. *Private Collection*

170 Palette knives of various types, illustrated in Brodie & Middleton's catalogue of *c.* 1880.

pan of water' to preserve the colours for future use. 'For gentleman practitioners who are often obliged to break off abruptly,' Williams suggested that 'the pallet itself with the colours downwards may be put upon the water. The pallet should be well seasoned with oil both upper and under part, to prevent the water having effect on the wood.'

The palette was the surface upon which a painter could rehearse the consistency, tone, and colour of the paint that he intended to apply to the work in hand. Richard Wilson recalled that on a visit to the landscape painter George Lambert, it was possible, by looking at his palette, to see 'the cow, and the grass she was going to eat'.[14]

In transferring paints from the grinding slab to the palette, and in 'working them up', palette knives were essential. These were made in two basic types: (A) those where the blade was set at right angles to the handle[15] and (B) those where both handle and blade were on the same axis (see fig. 170). The tool used 'to clear off the Colours from the Stone when ground, and also to keep them together in the time of grinding when it spreads too much' is appropriately described in *The Art of Painting in Oyl* (1705 edn.) as 'a Voider, being no other than a Lanthorn Horn, about three Inches one way and four the other'.[16] John Martin describes the 'temporing knife, which you must have made one [on] purpose' as being 'about Eight Inches Long in

of interest since the tail has generally been considered to provide the most suitable hair – and the coat the least appropriate. This is one reason why artists' brushes are, and have long been, expensive. In mid-seventeenth-century Holland a year's board and lodging for an apprentice was estimated to cost twenty-two gulden, with a further three gulden for brushes and paints.[22]

In his *Polygraphice* Salmon asserts that 'the longest haired Pencils are the best'.[23] This is an oversimplification. By the nineteenth century, when the variety of brushes available to artists was probably greater than at any time before or since, there were three basic types of 'pencil' (brush) with variations within each type. There was the standard shorter-haired brush and there were two long-haired varieties known as 'writers' and 'stripers' (see fig. 173). The 'striper' was very long-haired, whereas the 'writer' was not quite so long and the hairs came to a point. Another long-haired brush was the 'rigger' named after the rigging in the nautical subjects that it was used to paint.

Sixteenth- and seventeenth-century manuals list hair from numerous types of mammals as suitable for brush making, the most commonly mentioned being *miniver*, although reference is also made to *calaber* or *caliver*. Neither of these has so far been identified with certainty but some authorities have associated the word miniver with ermine. Hair drawn from the tails of ermine, stoat and weasel certainly provide a soft texture combined with the resilience necessary for pointed 'pencil' brushes.[24] On the other hand, Marshall Smith (1692) states that ermine provided the best 'fitches' – square-tipped brushes which were round in section.[25] The word 'fitche' is presumably derived from 'fitchew' or 'fitchet' which is an alternative name for polecat. The source of calaber or caliver hair is uncertain but by the mid-eighteenth century seems to have been used synonymously, but not necessarily accurately, with camel hair. Salmon mentions camel hair as being 'very soft' and suitable for varnishing pencils.[26] By the late eighteenth century sable brushes were the most sought after for fine work. John Payne in his *The Art of Painting in Miniature on Ivory* (2nd edn., London, 1798) does not mention sable brushes as such, but does argue that the best were made from the tail hair of several species of Asiatic red mink.

In making a brush, bunches of hair were snipped from the tip (but not including the tip) of the tail, working up the tail bunch by bunch sorting the hairs for length. The insertion and arrangement of these hairs in the barrel of the quill with the roots within the quill, and the shaping of the point of the brush by arranging the lengths of hair, was a highly skilled procedure. House painters in medieval England, in common with 'image painters', made their own brushes.[27] By the sixteenth century artists purchased their brushes from specialists. John Smith suggests: 'In chusing Pencils . . . put them into your mouth, and moisten them a little, then draw them forth between the Toung and the Lip, and if they come out with an entire sharp point without cleaving in twain they are good.'[28]

Cennini, and later writers, divided brushes into two sorts: those which were made of soft but stiff and flexible hairs held in a quill barrel known as '*pencils*', and the stiffer-haired, larger '*brushes*' (for which the word was reserved) which were bound onto a wooden shaft with waxed thread. This distinction should however be treated with caution since Martin's late seventeenth-century manuscript advises artists to have between '3 or four duzon of pencils of all sorts, as pencils pinteed [pointed], fitches great and small and another sort of pencils made of hogs hair'.[29] The transition in the meaning of the word pencil to signify a 'lead' (graphite) pencil occurred in the course of the eighteenth century. On De la Cour's trade label, engraved by R. White in about 1743, reference is made to the availability of 'Lead and hair Pencils'.[30] For the larger 'brush' Cennini recommended

William Lyon, *Bruſh-maker*,

AT the Sign of the *Black Boy* in St. *Michael's Crooked-Lane*, Maketh and Selleth all Sorts of *Bruſhes*, Wholeſale and Retale, at Reaſonable Rates.
Money for Hogs-Briſtles and Horſe-Hair.

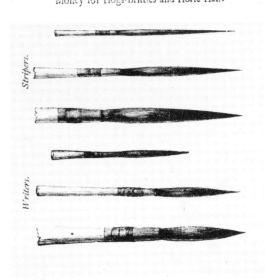

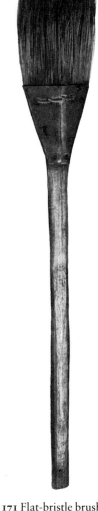

171 Flat-bristle brush, the metal ferrule 'sewn' with copper wire, length 11 in. (28 cm.). See fig. 169. *Private Collection*

172 Trade card of William Lyon of London. *Museum of London*

173 Writers and stripers, illustrated in Brodie & Middleton's catalogue of *c.* 1880.

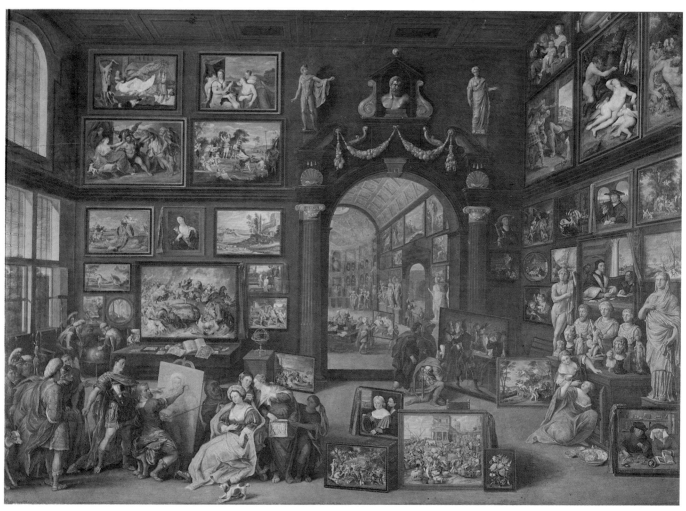

174 Tobias van Haecht
(1561–1631), *The Studio
of Apelles*. Among the
many details shown here
are pictures furnished
with curtains (see
fig. 191). *Private
Collection*

175 Detail of a painted
frame, *c.* 1620.
Mouldings painted to
simulate carving are
described by Sir Balthazar
Gerbier in his *Council
and Advice to all Builders*
(1663). *Estate of the late
Earl of Berkeley*

bristle from the domestic white hog rather than
either wild or black hogs. For the 'pencils' he
recommends the quills of vulture, goose, hen,
and dove.[31] Salmon gives, in descending order,
swan, 'greater and lesser' goose, duck, crow, and
swallow quills.[32] The quills of waterfowl were
preferred since they survived better when
immersed in the various media. In general the
quills of the non-aquatic birds mentioned were
for the smallest brushes and indicated the size
of the quill rather than its true source. The dis-
tinction between the two types of brush noted
by Cennini provided to some extent a demarca-
tion between the easel painter and the house
painter. In seventeenth-century Holland the
latter was known as a 'broad-brush' painter
(*kladschilder*).[33]

Although silver ferrules occasionally appeared
in the seventeenth century, the widespread use
of metal ferrules in the nineteenth century made
possible the creation of brushes with a flat sec-
tion. At first these brushes were used in oil paint-
ing as 'blenders' (fig. 178)[34] and their flat section
was also used in watercolour painting where the
double-ended, fan-shaped brush was used for

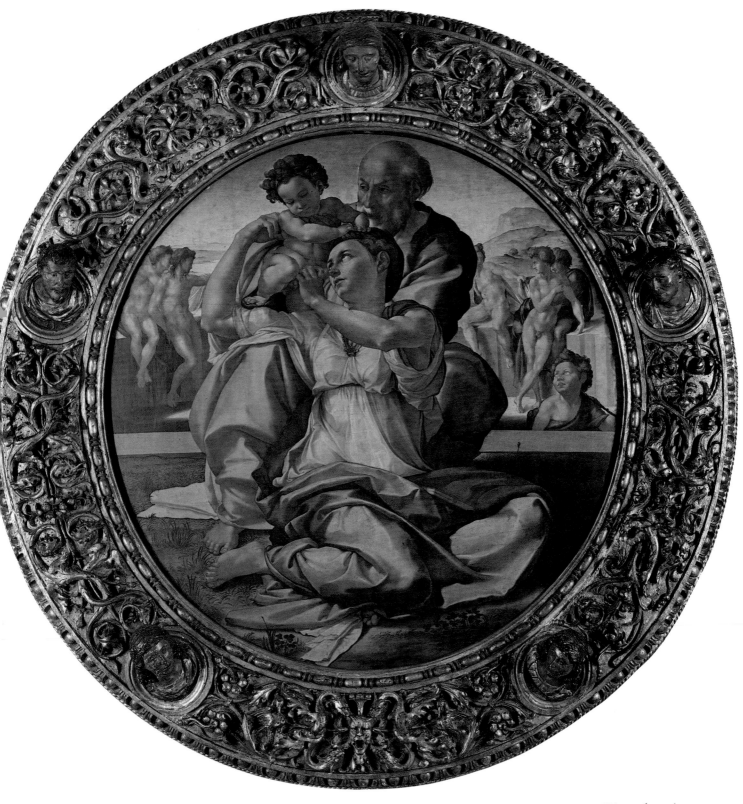

176 Picture frame by
Antonio Barile, coeval
with, and designed for,
Michelangelo's *The Holy
Family* – the 'sight'
measurement (the visible
part of the picture) is
46¾ in. (118.7 cm.). *Uffizi,
Florence*

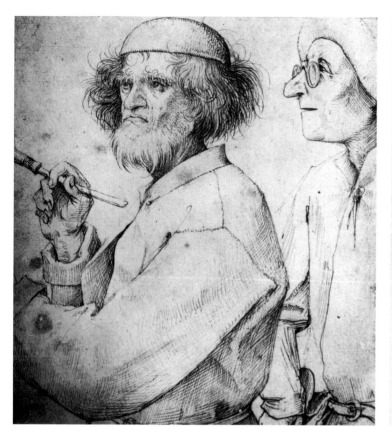

177 Pieter Bruegel the Elder, *Self-Portrait*, *c.* 1565, pen and ink drawing. Bruegel has shown himself holding a brush of the type in which the hairs are tied on to a stick. Larger brushes were invariably of this type, and until the early eighteenth century the term 'hair pencil' was generally used for the smaller kind in which the hairs are held in a quill ferrule. *Albertina, Vienna*

178 A series of metal ferrulled brushes, illustrated in a Winsor & Newton catalogue. Such brushes with a flat section made possible a new type of brushwork.

'softening off' (fig. 129).[35] Such brushes subdued the hard edges that the capillary attraction of the water vehicle otherwise resulted in. The most important effect of the metal ferruled flat brush (hair or bristle) was the brushwork that it spawned. Cézanne is probably the most obvious example of a painter for whom a new type of brush provided the potential if not the inspiration for a new vision.

For preserving brushes for use the following day, artists' cabinets were fitted with a zinc liner with an inclined well, one end of which could hold oil or a cleaning fluid such as turpentine. J. T. Smith mentions that Nollekens used clay slip to wash himself with in place of soap.[36] It is a helpful cleansing agent with a slightly abrasive quality suitable for the initial removal of oil paint from brushes.

Various gadgets were available for use with brushes and these included the brush rest and the mahlstick. The latter became so inextricably associated with the work of the painter that a columnist in the *Leeds Mercury* in the early nineteenth century was given the by-line 'Maul Stick'.[37] The word 'mahlstick' literally means 'paint stick' from the Dutch *maalstok*. Even in the late seventeenth century the interesting root of this word was evidently forgotten since Martin spells the word 'Mol-Stick' and describes it as

a small straight smooth stick not so week as

it may bend but pritty strong about three foot and a half long, tied with a piece of Leather at one end of it, round like a little ball, which is to keep the one end of the stick from scratching the colours off when you paint. And this stick is to rest your hand on, that it may not shake, when you paint any picture.[38]

ARTISTS' OIL AND COLOURMEN

The production of oils and varnishes and the grinding of pigments and their combination with media in the making of paints was, until the advent of mechanization, a labour-intensive part of studio practice. Upon it depended the whole basis for the apprenticeship system in painting, and without it art education shifted inexorably towards academies and schools of art. Only the large-scale production of paints could sustain any serious degree of mechanization. Of course, even from quite early times, the basic pigments were obtained from colourmen; it was their translation into paint that was a studio responsibility until the sixteenth and seventeenth centuries. Richard Campbell, writing in the mid-eighteenth century, described the colourman as 'the Apothecary to the Painter'.[1] Certainly, many colours could only be produced by alchemy. With earth colours it was inevitable that certain geographical areas became known for possessing valuable minerals that could be converted into pigments. The black earth commonly used by

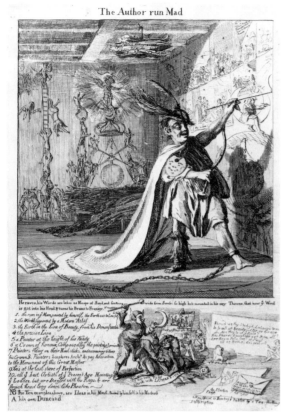

The Author run Mad

Venetian painters and known as *nero di Verona*[2] is one such example and Oxford ochre another. Oxford ochre was ground until about 1900 in two windmills that stood adjacent to the ochre quarry at Wheatley (see fig. 180), but 'Oxford' ochre was also ground at Shotover, Cuddesdon, Little Milton, and South Weston.[3] Outside Oxfordshire, ochre was found in Cumbria, Anglesey, Devon, and Cornwall where it was often found in association with copper ore. The basic yellow ochre may be calcinated and this oxidizes the iron content and turns the material into red ochre – further calcination making Siena earth.[4]

On 20 April 1785 John Morgan of New York City announced in the *Independent Journal or the General Advertiser* that he had 'erected a mill for the sole purpose of grinding colours' but unfortunately he does not indicate the type of mill.[5] In addition to the mechanization offered by windmills, water-mills were also important at this time, an example being the cochineal mill that operated on the river Wandle just above Wandsworth.[6] A horse-powered mill is illustrated in the trade label of Joseph Emerton whose son-in-law Thomas Etteridge continued the business from about 1744 to 1753. Another colour merchant was Joseph Emerton's brother Alexander, who died in 1741 and whose widow, Elizabeth, carried on the business. It was this business that later in the century became Emerton & Manby whose trade label makes

such a feature of the horse-mill first illustrated by Joseph Emerton.[7] It is a paint-mill of this kind that Turner recorded in his painting *An Artist Colourman's Workshop*, *c.* 1807 (fig. 161). Mechanization presented a considerable threat to the well-being of the traditional craftsmen in paint, both to the suppliers who were not equipped with machinery and to house painters whose chief secret lay 'in grinding, mixing, and compounding the Colours'. *The London Tradesman* (1747) continues: 'as to the laying them on it requires no Art, but an even Hand and to carry the Brush up and down according to the grain of the Wood.' Campbell goes on to voice Luddite fears that the trade is 'at a very low Ebb' due to some 'Colour-Shops who have set up Horse-Mills to grind Colours and sell them to Noblemen and Gentlemen ready mixed at a low Price, and by the Help of a few printed Directions, a House may be painted by any common Labourer at one Third the Expence.'[8] This is undoubtedly a reference to the Emertons, either to Joseph or more likely to his widow Elizabeth who carried on the business from about 1741 or to Thomas Etteridge their son-in-law who continued it from about 1747. All three used a horse-mill to grind pigments and supplied printed instructions with their paints.[9] The responsibility for the innovation is squarely placed by William Salmon in his *Palladio Londinensis* (1755) on Alexander Emerton, and Salmon asserts 'that several Noblemen and Gentlemen

have, by themselves and Servants, without the Assistance or Direction of a Painter' decorated their houses.[10]

The inflammable nature of the trade of the oil and colourmen made fire insurance important. In 1725 Alexander Emerton took out policy no. 36897 with the Sun Insurance Company to cover his premises at the Bell, Arundel Street in the Strand, London.[11] *The London Tradesman* emphasizes the toxic nature of white and red lead and states that the mills for preparing these two pigments were situated in Whitechapel and other suburbs where the labourers were 'in a few Years to become paralytic by the Mercurial Fumes of the Lead; and seldom live a dozen years in the business.'[12]

Although colourmen are mentioned as early as 1391 when Richard de Welton is listed as a colourmaker in York,[13] much of the early trade in both pigments and media must have been carried on through what John Michael Montias, in the language of the economist, has described as 'backward linkage'. In other words, it was quite common in seventeenth-century Holland for stonemasons to deal in marble, frame-makers in ebony, and painters in lacquers and paints.[14] A remarkably early example of such 'backward linkage' occurred in 1353 when the Flemish painter Lonyn de Bruges supplied white varnish for St Stephens Chapel, Westminster.[15] Montias cites a number of early to mid-seventeenth-century examples including the Rotterdam painter Michiel van de Sande and Louis Elsevier.[16] Rotterdam, it seems, became a centre for such trade. It was very well situated for not only did it stand on the eastern banks of the Rhine near the North Sea but the canal systems of Holland with their horse-drawn barges provided a cheap and, by seventeenth-century standards, swift means of transport.[17] It was that infrastructure, coupled with the remarkably high demand for painting over a surprisingly wide social spectrum in Holland, that encouraged the development of the trade in colours in seventeenth-century Rotterdam. Other early centres of the trade were Venice and Montpelier.[18]

The English portrait painter Mary Beale (1632/3–97) seems to have conducted quite a business in colours, for the notebooks kept so assiduously by her husband include frequent references to such sales – for example, 'several parcels of Lake of my own makeing which he [Lely] sent for 17 August 1671 ... In August [1674] Mr Lely had one ounce of Ultramarine, the richest at £4 10s per oz in past payments betwixt us.'[19]

By the second half of the seventeenth century instruction manuals make passing references to the various colours that are 'to be met with in the Colour-shops'.[20] John Martin's manuscript

182 Joseph Emerton's trade label, illustrating his horse mill. *British Museum, London*

OPPOSITE
181 Picture frame, lime-wood, school of Grinling Gibbons, late seventeenth century – the sight measurements are 28 × 25 in. (71.1 × 63.5 cm.). *Private Collection*

183 John Calfe's trade label, engraved by John Savage (active 1680–1700). St Luke was the patron saint of painters, and the saint's symbol, the bull, is here shown as a calf, a rebus on the name of the colourman. The use of French on this label may have something to do with the many Huguenot craftsmen who came to England in 1685, following the revocation of the Edict of Nantes. *British Museum, London*

was apparently written (1699–1700) by a craftsman who specialized in decorative painting. It was prepared as an instruction manual for amateurs and in it Martin advises his readers that 'Most of the Collours a foresaid you may Buy in Little Bladders and the rest in powders with oyles, Shilles [shells] and varnish att Mr Coopers at the sign of the three pidjohns in Bradford Street, a print shop.'[21] As we have seen, colour vendors are recorded in medieval England and the long association of medicine and painting through the patronage of St Luke was doubtless invaluable to a more scientific understanding of pigments, media, and varnish. One of the earliest colourman's cards preserved in the Heal Collection is for John Calfe whose sign was St Luke with the patron saint's bull shown as a calf – a rebus on the colourman's name (see fig. 183). The card was engraved by John Savage who was active in the last two decades of the seventeenth century. It is evident that whilst for the sake of brevity Calfe described himself on his card as a 'Colour Seller', he sold much else besides, including oils. These were of course also stocked in the eighteenth century by oilmen. The designation had several meanings. It could be the equivalent of today's delicatessen, or alternatively a perfumier selling balms and powder for wigs, or even a hardware store, a meaning which to some extent 'the oilman' retains. *The London Tradesman* alludes to 'The common Colour-Man [who] generally sells Oyls, Pickles, and several Things that are sold in what are properly called Oyl-Shops. But the Colour-Man properly confines himself to painting,'[22] both easel and house painting. The same source also refers to 'Shops called Dry-Salters, who deal in Colours; but they chiefly deal with Dyers and Stainers.'[23] The traditional sign for oil shops was an oil jar but a popular though rare sign was the 'Good Woman'. It may derive from the parable of the seven foolish or heedless (headless) women who had no oil in their lamps.[24] The sign was used by Jos. Pitcher who is listed in the London *Directories* for the years 1768–70 at St Giles Church, London. Later, the same premises were used by the oil and colourman Thomas Waddell & Son (*c*. 1783–93), by which time it was necessary for the Waddells to state that they operated from the sign of 'the Original Good Woman'.[25]

Colourmen were identified by signs which specifically alluded to painting, such as the St Luke's Head or the Golden Palette, and also by devices that were quite unrelated to their trade – a common feature in eighteenth-century London.

By the mid-eighteenth century a number of firms in London, in addition to the Emertons' two shops, had emerged as important suppliers of painters' materials. These included Nathan Drake of the White Hart in Long Acre who described himself as the 'Successor to Mr Robert Keating' and sold 'Keatings fine Varnish formerly calld Coopers Picture Varnish'. The late Ambrose Heal considered Keating to have been one of the earliest recorded colourmen in London, and Campbell states that he knew 'but one [shop] in London viz. Mr Kateing [*sic*] at the White Hart in Long Acre' which was confined 'to what relates to Painting'.[26] Northcote, however, in his *Life of Reynolds* was of the opinion that the servant that Sir Godfrey Kneller brought with him to England and whom Sir Godfrey later established in business, was the first colourman in London – an insupportable claim. More interesting is J. T. Smith's reference to the colourman Edward Powell of 96 Bedford Street, Covent Garden, who, in the late eighteenth century, occupied what Smith considered the oldest surviving premises for the trade. The shop was then one of the very few surviving in London where the shutters slid in grooves. The large room in the house occupied by Powell and his family was used by Hogarth as the setting for one of the episodes in *The Rake's Progress*.[27]

By the late eighteenth century the numbers of colourmen in London had increased dramatically and it was from among these tradesmen that the national and even international importance of their products became evident. These firms included Sandys & Middleton, James Newman, J. Pool, and William & Thomas Reeves. Of these, it was William Reeves who was to make the significant breakthrough, with a consequent impact on the history of English art. It was, however, the art and not the science that was mother to the invention. An early biographer states that,

> For many years after Mr [Paul] Sandby commenced landscape drawing no colours were in general use except such as were peculiarly adapted for the staining of maps and plans, and indeed it was himself who set Middleton, the colour maker, to prepare them in somewhat like their present state and which are now brought to so great perfection by Reeves, Newman and others.[28]

Even after the introduction of watercolour cakes, colourmen such as William Jones of 103 Leadenhall Street, London, continued to advertise 'Liquid Colours in Bottles for Prints, Maps, Plans &c.'.[29]

The inspiration for forming colours in soluble blocks evidently came from the so-called Indian inks, a version of which Thomas Reeves would by 1784 describe as 'Reeves British Ink'. In 1780 the Reeves brothers, who founded their business in 1766, submitted samples of their watercolours formed in cakes to the Chemistry Committee of

the Society of Arts (later the Royal Society of Arts). The samples were forwarded to the painters Mary Black, Hendrik de Meyer, and Thomas Hearne for practical trials. All three were impressed and Meyer drew attention to their potential 'usefulness on travels or voyages'. After due consideration the Society of Arts awarded the Reeves brothers the 'Greater Silver Palette' on 11 April 1781, a trophy regularly mentioned in their advertisements thereafter. To this distinction the Reeves were soon able to add the royal patronage of George III and other members of the royal family, and their appropriate arms and badges were used, together with an engraving of the blue coat boy (the uniform of the famous school which the brothers attended) to embellish their trade cards. The greyhound, the family crest of the Ryves family of Dorset with which the Reeves claimed kinship, does not generally figure on the trade cards, but was used to stamp their early watercolour cakes. In

December 1783 the Reeves brothers' partnership was dissolved with some acrimony and the present firm is descended from that of Thomas Reeves (see Appendix 3). William, the younger of the two brothers, continued in business and became a member of the Society of Arts. Thomas Reeves prospered and his firm received the patronage of Queen Charlotte and the Prince of Wales in 1790. Oddly enough, it was in that same year of success that the *Morning Herald* (12 October 1790) reported an incident in the firm's history that is both comic and tragic:

> Yesterday an overdrove ox ran into the shop of Mr [Thomas] Reeves, Colourman to her Majesty, Holborn Bridge; broke the windows of the shop and knocked down near the whole of the colours and stock; he was at last secured and taken to the slaughter house. He tossed two women in Holborn and bruised them in so dreadful a manner that they were conveyed to an hospital without hope of recovery.[30]

184 Watercolour cake made by Newman's of Soho Square, London – $1\frac{1}{8} \times \frac{5}{8} \times \frac{1}{4}$ in. (29 × 16 × 6 mm.).

185 Mould and die for watercolour cakes. *Winsor & Newton, London*

186 The sign of St Luke used by Sherborn's of London. Most trade signs were made by specialist firms based in Harp Alley, Shoe Lane, off Fleet Street. *Museum of London*

Thomas died in 1799 and it was his son William, in partnership with William Woodyer, who developed the trade with fashionable schools and military academies which resulted in a great demand for their products amongst the members of the British East India Company resident in the sub-continent. As early as 1784 the *Calcutta Gazette* included advertisements for artists' materials and by the 1830s Latta & Co., the Calcutta silversmiths, were making silver boxes to contain watercolour cakes (fig. 188).

Among Reeves's competitors were Rowneys, George Blackman (who advertised that he could undersell his father-in-law, William Reeves, by 20 per cent), and James Newman, Blackman's pupil. By 1832 William Winsor and Henry Charles Newton founded at 38 Rathbone Place, London, the firm that would rapidly became Reeves's most serious rival. Both Winsor and Newton were painters but it is supposed that Winsor had the greater knowledge of chemistry.[31]

Following the development of watercolour cakes, the next most important innovation was a metal syringe dispenser for oil colour as an improvement on the traditional but inconvenient bladder colours. A design for such a syringe was submitted to the Royal Society of Arts in 1822

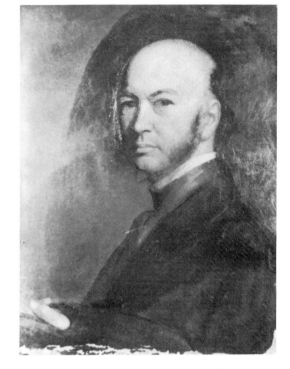

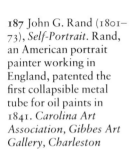

187 John G. Rand (1801–73), *Self-Portrait*. Rand, an American portrait painter working in England, patented the first collapsible metal tube for oil paints in 1841. *Carolina Art Association, Gibbes Art Gallery, Charleston*

188 Silver watercolour box, made *c.* 1830 by Latta & Co. in Calcutta for the English market there. *Hobart House Antiques, Connecticut*

by James Harris and was succeeded by a glass syringe patented by Winsor & Newton in 1840.[32] In 1841 John G. Rand, an American portrait painter working in London, patented the first collapsible tube. These were first marketed by Thomas Brown of 163 High Holborn and known as 'Brown's Collapsible Tubes', but by 1842 Rand had granted a franchise to Winsor & Newton among others.

The importance of London-based colour makers and retailers in the late eighteenth and early nineteenth centuries was founded on their considerable technical innovations and entrepreneurial aplomb. G. and I. Newman in a trade card of 1786 advise potential customers that 'Their Prepar'd Colours in Boxes may be had in every Principal Town throughout England'[33] and S. & J. Fuller in the 1820s, 'Preparers of Permanent Superfine Water Colours' at their Temple of Fancy at 34 Rathbone Place (a few doors from where Winsor & Newton were to set up shop), advised that 'Merchants, Captains and Traders [were] supplied Wholesale and for Exportation'.[34] In the provinces, William Bewick was first instructed by and then obtained his materials and colours from an itinerant house, sign and herald painter known as Dick Tinto.[35] The larger cities of the early nineteenth century boasted retailers such as Cranefield's Fancy Stationers in Bristol which sold drawing and watercolour materials, whilst S. Bedford stocked 'primed cloths, bladder colours, brushes, velvet scrubs, crayons, chalks and everything for painting and drawing'. In Liverpool, a chemist named Strachan actually manufactured paints for sale, a rare provincial attempt. Carvers and gilders

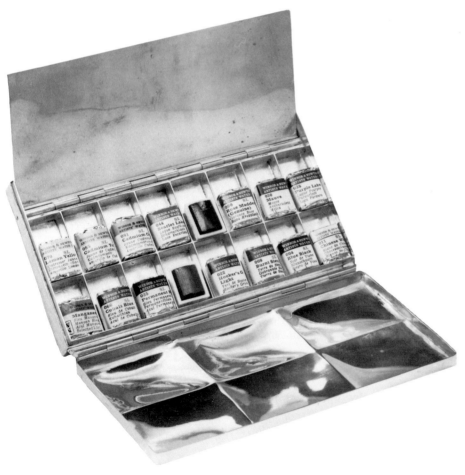

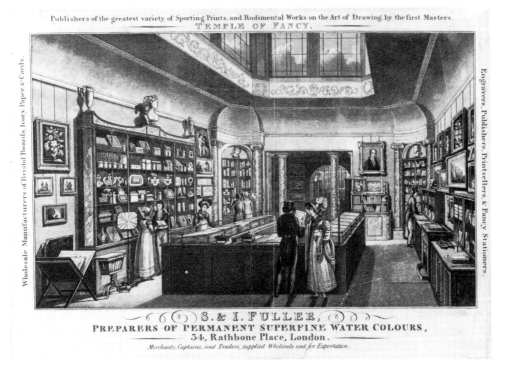

Publishers of the greatest variety of Sporting Prints, and Rudimental Works on the Art of Drawing, by the first Masters.
TEMPLE OF FANCY.

Wholesale Manufacturers of Bristol Boards, Ivory Paper & Cards.

Engravers, Publishers, Printsellers & Fancy Stationers.

S. & I. FULLER,
PREPARERS OF PERMANENT SUPERFINE WATER COLOURS,
34, Rathbone Place, London.
Merchants, Captains, and Traders, supplied Wholesale and for Exportation.

such as William Fawcett in Leeds and the Free-mans in Norwich sold artists' materials in addition to frames and prints. In colonial America Dunlap exclaimed 'Colours were to be found at the colour-shops, and inspiration – heaven knows where!'[36] By the next century these American colour shops were regularly selling English watercolours to the more sophisticated inhabitants of the new republic.

From William Williams' *Essay on the Mechanic of Oil Colours* (1787) it is evident that colourmen were not always to be trusted. Accordingly, many artists preferred to deal with one colourman. Cosway and Richard Wilson used James Newman at the sign of the Golden Palette (17 Gerrard Street c. 1790–1800, and thereafter in Soho Square),[37] Gainsborough used John Scott of 417 Strand,[38] and Reynolds and Romney used James Poole of 163 Holborn.[39] The hazards of not using a reliable oil and colourman are graphically described by Williams in his account of 'the use of a bad oil procured from a colour shop, the pictures never dry'd ... but ran down in tears, whether from the folly of the artist or the knavery of the colour-man history says nought.'[40]

FRAMING

Medieval Europe was primarily concerned with painting as a fixture.[1] More often than not, painters worked *in situ* on commissions and their work was 'framed' by the architectural environment. This was inescapably the case as far as murals were concerned. Although the speculatively produced canvases of the stainer were often cut to fit the available space, the large panels of the painter were very much designed for the position they were intended to occupy permanently. The relatively few small panel paintings were very much made to travel and it was their portable nature rather than aesthetic considerations that conditioned the way in which they were housed. The sumptuous Wilton diptych is evidently a travelling piece which, when closed, reveals nothing but the arms of its owner – luggage labels for identification. In this instance, the identification is so beautifully worked that it was doubtless furnished with a travelling case. Nevertheless, the Wilton diptych maintains the tradition for the reverse of the leaves to be of a secondary character; where figure-work occurs it is often painted in grisaille.

Cennini makes reference to both the *tavola* (panel without mouldings) and the *ancona*. It is the structural integration of the frame and panel and their preparation with gesso that characterize the *ancona*.[2] For this reason, the construction of the frame preceded the production of the picture, if not the drawing of its cartoon. It was not a question of a frame being selected to suit a picture; it was on the contrary a situation in which the painter responded, consciously or unconsciously, to the visual influences of a pre-existing, and indeed gilded, frame. It was in this context that the following inscription was painted on a frame in fourteenth-century Italy:

SIMONE CINI, THE FLORENTINE, MADE THE CARVING; GABRIELLO SARACINI OVERLAID IT WITH GOLD; AND SPINELLO DI LUCA OF AREZZO PAINTED IT IN THE YEAR 1385.[3]

189 Leaflet advertising S. J. Fuller's Temple of Fancy, 1823. By the early nineteenth century watercolour painting had become a popular genteel accomplishment and stationers were regularly supplying the necessary materials. *British Museum, London*

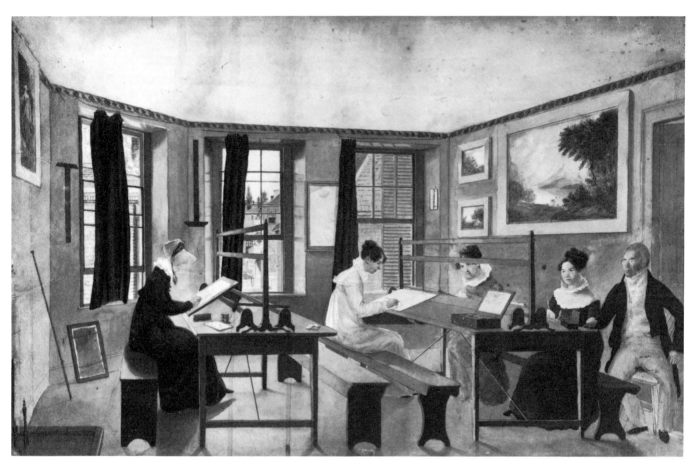

190 *The Watercolour Class*, artist unknown (New York), *c.* 1815–20, watercolour on paper, 14¼ × 22 in. (36.5 × 56 cm.). *Art Institute of Chicago*

This healthy attitude persisted into the Renaissance. In one instance Leonardo da Vinci was commissioned to paint a Madonna and two angels, but only after Giacomo de Maino had finished carving the altarpiece into which the painting was to be set.[4] Under these circumstances it is not especially remarkable that the names of the carvers of such frames should have been preserved. The frame that surrounds, and was designed for, Michelangelo's *Holy Family* in the Uffizi in Florence was carved in about 1503 by Antonio Barile.[5]

Although the medieval multi-panelled folding picture may have originated as a portable focus of worship, the arrangement, once established, became a form, whose complexity, size and weight made it immovable. The full splendour of the housing of the polyptych depends for its effect mainly on the repetition of standardized elements. In detail the mouldings may have been rich in section but they are also simple in appearance. At this stage in its development the frame may scarcely be said to exist. The mouldings that surround these pictures like the leaves which enclose them simply serve to protect the painting. Liberale Veronese was commissioned to paint the doors that were specifically added to protect an early Madonna in S. Maria della Scala at Verona which, so Vasari tells us, had been injured by the candles on the altar.[6] The risk was

real. Much later, in England, Garrard recorded that Charles I was so concerned with the possible damage to some of his pictures that a temporary building was constructed out of timber for a masque, 'Because the King will not have his pictures in the banqueting house burnt with lights'.[7] Undoubtedly, the English court at this time was familiar with alternative protective measures. When Cromwell's Parliament sold the works of art in the Royal Collection, one item was described as 'from Windsor a picture of Edward III with a green curtain before it £4',[8] and the royal inventories show that most pictures in the early seventeenth century were curtained with sarcenet. One such was described as being of 'white and yelawe sarcenette paned together' – which is a reference to a patchwork curtain.[9] In domestic circumstances a curtain was sometimes drawn across a painting to preserve it from scorching by primitive lighting devices or to protect the spectator from the influence of an erotic picture. By the eighteenth century, curtains in front of a picture certainly provoked such an expectation. In the Thornton/Hogarth exhibition of signboards of 1762, items 49 and 50 consisted of a pair of pictures entitled *The Curiosity* and its companion, with the following admonition: 'Ladies and Gentlemen are requested not to finger them, as blue Curtains are hung over in purpose to preserve them.' Behind the curtains

on one of these 'pictures' was written Ha! Ha! Ha! and on the other He! He! He![10]

Coincidental with the Renaissance and the decline in ecclesiastic building in those countries affected by the Reformation, a demand developed amongst the rising middle classes not only for secular paintings but also moveable ones. It was at this time that the frame began its development as a more significant barrier which served to isolate the picture from surroundings, the character of which could no longer be predicted. The frame was now expected to contain a violent or dramatic painting, or distance a fragile subject from an overbearing interior. The simple frames of the past were eventually found inadequate for this often conflicting role. Contrary to popular belief, simple frames may prove, in the event, to be both too meagre for their function and distracting *because* of their simplicity. Elaborately carved frames were found to be more effective, and when covered with burnished gold or silver leaf they could respond sympathetically to any environment by reflecting the colours around them. Not all clients could afford such opulence. According to Sir Balthazar Gerbier's *Counsel and Advise to all Builders* (1663), carved and parcel-gilt frames 'fifteen Inches broad, the ground a fair white colour cost five shillings a foot', whereas those that were painted 'in white and gold upon flat moulding, and set off with shading, like carving, one inch broad, and a foot long is worth four pence or five pence a foot.'[11] Very few of these cheap frames with simulated carving have survived, which makes the example illustrated in fig. 175 both a valuable document and an enjoyable object.[12] Among the frame carvers who worked in England in the second quarter of the seventeenth century, Zachary Taylor was probably the best known.[13]

In most major towns and cities, such as London and Rotterdam, the making of picture frames, as opposed to their embellishment with carving, was undertaken by the joiners.[14] This is not to say that the carpenters did not have some claim to be frame makers. In London the conflict between the two guilds was resolved in favour of the joiners in 1632.[15] In small towns the frame makers were not necessarily members of the joiners' guild. In Delft, Anthony Gerritsz. van der Wiel joined the painters' guild of St Lucas but he may well have done so because he owned some pictures which he wished to sell and for this, membership of that guild was essential.[16] The importance of the joiner as an influence on the design of picture frames has probably been underestimated. In contrast to cabinet makers, the joiners remained closer to the sound principles of construction which the more substantial needs of the building trade demanded.

Even as late as the early seventeenth century, many joiners eschewed the use of the mitre. This joint is peculiarly unsound since it depends upon glue which does not adhere readily to the 'end grain' of a mitre – a deficiency which in high-class picture frames is compensated for by various means including the use of a 'key'. In addition, Evelyn 'observ'd that *Oak* will not easily *glue* to other *Wood*; no not very well with its own kind; and some sorts will never cohere tolerably, as *Box* and *Hornbeam*.'[17] It was partly for these reasons that early frames retained the use of the mason's mitre which, with its architectural connotations, served also to make the frame and its picture a 'window on the world'. This notion found a parallel in the cornice and plinth of the no less 'architectural' frames of the Italian Renaissance.

By the seventeenth century the mitre had become the standard – one might almost say the definitive – joint used in the construction of picture frames. It was in this century that the Low Countries became a conduit for the flow of design ideas to Britain from Italy and France. A further and exotic element was added to this mix through the Dutch East Indies and the importation of ebony and other precious materials. Simulated ebony was certainly used in the late sixteenth century but the real thing was extra-

191 Hook attached to a frame of *c.* 1644 for a picture curtain rod (see fig. 174).

192 Oak picture 'ring' on a simple 'box frame', surrounding M. van Mierevelt's *Portrait of Frans Dircksz. Meerman* (*c.* 1620). Note the use of small dowels to attach the hanger to the frame; the use of expensive metal is kept to a minimum. *Deutzenhofje, Amsterdam*

ordinarily rare. Benvenuto Cellini mentions in his autobiography a mirror frame carved in ivory and black bone.[18] By the following century, as John Montias has shown, many inventories in Delft list frames made of whalebone and ebony with a gilded inner slip.[19] Although the Dutch continued to use white pine[20] and other woods for their carved frames, they became well known for ebony frames machined with a wriggle moulding and which occasionally incorporated panels of tortoise-shell, features that were sometimes used in furniture.[21] These Franco-Dutch frames are alluded to in Félibien's *Principes* (1699) which also mentions the 'waving machine' – '*machine qu'on appelle un outile en ondes*'.[22] Vermeer's brother-in-law Anthony Gerritsz. van der Wiel was a picture dealer, but his main occupation centred on the making of ebony frames of this type.[23] A remarkable description of the mechanism used to make machined ebony frames occurs in Joseph Moxon's *Mechanic Exercises* (1683–4). Although the account which is both illustrated and lengthy is not very intelligible, it was probably written on the basis of personal observation since Moxon, though an Englishman, learnt his trade as a

printer in Holland from his father James Moxon. He describes 'the Waving Engine' in part as follows: 'And as the Rounds of the Rack rid [ride] over the round edge of the flat Iron, the Rack and Reglet will mount up to the Iron Q, and as the Rounds of the Waves on the under side of the Rack slides off the Iron on edge, the Rack and Reglet will sink, and so in a Progression.'[24]

Another characteristic Dutch frame of this period was carved in a series of flattish auricular scrolls, a type that became most popular in England after the Restoration and Charles II's return from exile in Holland. Frames of this type are sometimes described as being in the Lutma style after the Amsterdam goldsmith Johan Lutma.[25] It was in the third quarter of the seventeenth century that a fashion developed for some exceptional furniture to be overlaid with silver plate. At a less opulent level, the fashion was continued late in the century with frames covered with silver leaf.

From the late seventeenth to the early eighteenth century a group of carvers within the orbit of Grinling Gibbons, and therefore under Dutch inspiration, carved frames of the type that Celia Fiennes recorded in her journals in about

193 Detail of the Gibbons frame in fig. 181, showing the way in which each layer of carved vegetation was separately applied.

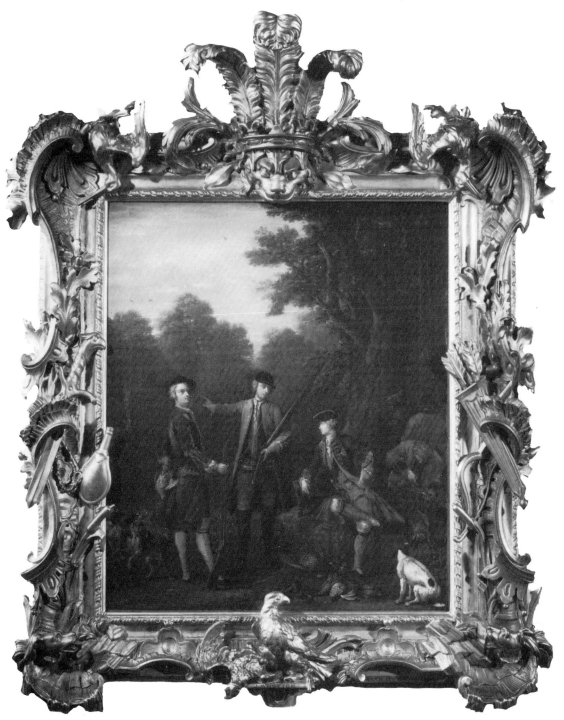

194 Picture frame carved by Paul Petit in 1746 for John Wootton's *The Shooting Party* – the canvas measures $35\frac{3}{8} \times 29\frac{1}{8}$ in. (88.9×74 cm.). *Royal Collection, Windsor Castle*

1694 and which remain where she saw them in the Ashmolean Museum. Frames of this sort, bearing a cornucopia of fruitfulness, were quite evidently the exception and it was therefore natural that they should often incorporate features which make direct reference to the subject of the picture. This conceit appeared before the time of Gibbons (as with some of the 'auricular' frames mentioned above) and it will be found in later periods, but it was perhaps in the late seventeenth century that such embellishment most frequently occurred in the highest quality

frames. The frame that surrounds Wootton's *The Shooting Party* is festooned with trophies of the chase. It was carved by Paul Pettit who was paid £21 on 1 February 1746 for his labours. By this date such flights of fancy were exceptional. The explanation may well be due to the rising power and influence of architects as regards interior decoration. In formal rooms in the seventeenth century, pictures were sometimes arranged in symmetrical groups and although at this time some picture galleries evidently attempted to frame all pictures in the same way,

many Dutch genre paintings attest to the wide-spread practice of placing pictures in a haphazard way in frames of quite different types. The underlying trend seems to have been to give every consideration to the picture rather than the interior decoration. If a painting was hung high it was tilted forwards to make it more visible.[26] By the early nineteenth century this method of hanging was deprecated by Prince Hoare on the grounds that it had the effect of distorting the verticals represented in the painting.[27] The chains and wires from which pictures and mirror frames were suspended in the seventeenth century were often treated decoratively and masked with silk ribbons and bows, although the overall arrangement of pictures on a wall was of less importance than it was to become in the eighteenth and nineteenth centuries. In contrast to the seventeenth century when special frames were made for particular pictures, the eighteenth century saw special frames being made for exceptional rooms. The shift of emphasis is remarkable since it runs counter to the generally high and growing social position of painters at that time. In their person they may have been on a level with the gentry but in the presentation of their work in important houses it was subsumed in a wider architectural context, a position with which medieval craftsmen would have been familiar.

At a less exalted social level, paintings and mezzotints with their very different qualities and framing were promiscuously mixed and hung arbitrarily, if symmetrically, over the stiles and rails of panelling – at least this was true of some provincial houses. By the nineteenth century even small groups of family photographs were orchestrated on the wall – the sense of symmetry was maintained and only the influence in the twentieth century of the balance and counterbalance found in the paintings of Mondrian would disrupt it.

Some writers asserted that certain rooms in a house demanded paintings whose subject was appropriate to their use. William Salmon devotes considerable space to the 'Disposing of Pictures',[28] a notion that derives from Giovanni Paolo Lomazzo's book which was 'Englished' by Richard Haydocke in 1598 as a *Tracte Containing the Artes of Curious Paintinge, Carvinge and Buildinge*. This book promises in the index that the sixth and last book (which is omitted) will list the subjects suitable for churches, 'Princes Pallaces', and even 'for places of torture and execution' (chapter 23).

Fine picture frames were always expensive and so they have remained. They often represented a high proportion of the cost of the painting they surrounded. A portrait painted by Gerard Soest in 1667 at a fee of £3 was framed at a cost of sixteen shillings.[29] In 1825 John Constable spent about £20 each on the 'rich frames' for two pictures which he priced at 130 guineas for the pair (frames included).[30] These two pictures were offered by Constable to Francis Darby of 'Coal brook dale' who eventually purchased them. To assist him in coming to a decision Constable gave Darby the overall dimensions of the frame – the space it would occupy on a wall – rather than the 'sight' measurements of the canvas. There were of course ways in which painters could circumvent cash transactions. When Michlaer Huysman of Mecklin (*c.* 1637–1707) arrived in England, he 'brought two large landscapes which he kept to shew what he could do; for these he had frames richly carved by Gibbons and gave the latter two pictures in exchange.'[31] Another painter who was even better placed was B. Flesshier, a frame maker himself.[32]

For paintings by artists whose work appeared in less opulent surroundings, frames were available from the late seventeenth century in more modest materials which were worked more simply. In 1688 Stalker and Parker recommended

195 The visual distortion caused by hanging pictures tilting forwards, an illustration from Prince Hoare's *Epochs of the Arts* (1813). *Bath Public Library*

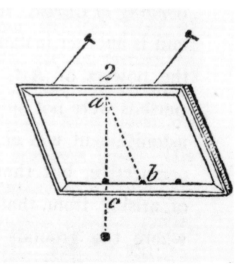

pear wood frames painted to simulate ebony. They emphasized that such frames were composed of 'narrow mouldings for little pieces, which increase in breadth as the size of your picture does in largness'.[33] Ebonized frames with narrow mouldings, or the wide bolection or similar sections made in New England by William Faris,[34] remained popular on both sides of the Atlantic throughout the eighteenth century for minor works. Frames with narrow mouldings were especially apt for prints and it is likely that one specialist maker of these was J. Ayton, the frame maker and printseller of 'No. 73 Next Door to the Coffee Mill in Berners Street, Oxford Road'.[35] The larger-scale ebonized frames used to contain oil paintings were made by, among others, George Yardley of Noble Street, near Aldersgate, London, who specialized in picture frames of all sorts, 'either Black or Carv'd and Gilt'.[36] These frames invariably incorporated a narrow, carved and gilded 'slip' (somctimes more pretentiously known as a Marie Louise) adjacent to the canvas to enliven them and to provide the greater neutrality that only a burnished gilded surface affords. The carving of the moulded 'slip' and the sanding of the flat surface or 'fillet' that customarily ran alongside it, suppressed any tendency of the gold to glint distractingly.

Overmantel, overdoor and other 'furnishing pictures' were of course framed by the styles and rails of the panelling in which they were set – in the late seventeenth and early eighteenth centuries this would have had a bolection section, carved or uncarved, painted, grained or marblized. Not all such paintings were framed by panelling. The 'chimney-board' (so called even when painted on a canvas support) was not framed at all except by the chimney-piece in which it was set.

Carvers and gilders maintained their monopoly over all manner of frames that demanded their skills although the basic framework continued to be made by joiners. This is confirmed in *The London Tradesman* (1747) which describes 'a set of Joiners who make nothing but Frames for Looking-Glasses and Pictures, and prepare them for the Carvers'. These frames would have been soundly constructed but rough in appearance, which led Campbell to seriously underestimate their quality since he supposed that they required

> but little Ingenuity or Neatness, as they only join Deals roughly plained, in the Shape and Dimensions in which they are required. If the Pattern chosen for the Frame is to have any large Holes in it, these they cut out in their proper Places, or, if it is to have Mouldings raised in the Wood, they plain them on, but

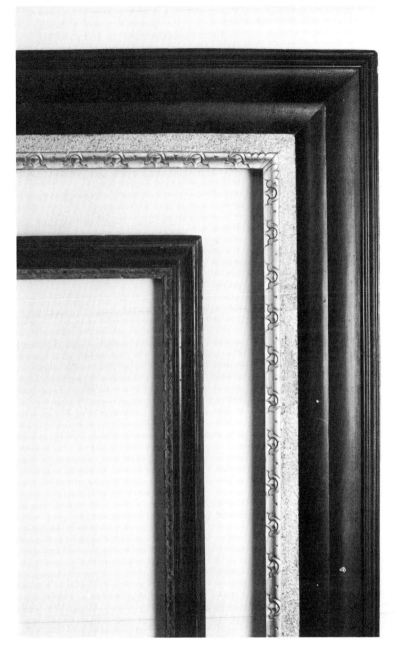

they leave the Carver to plant on the rest of the Figures. But we have said enough of this Trade, who is no more than a cobbling Carpenter or Joiner.[37]

The majority of trade labels advertise these craftsmen as 'Carvers and Gilders'. In practice, few men seem to have developed both skills to an equal level of proficiency although most such carvers were able to do some gilding and vice versa. This makes Thomas Field (of King Street, St Ann's, Soho) something of an exception since in his trade card (*c.* 1760) he simply and honestly describes himself as a 'Carver'.[38] The frame carvers worked both in the wood and also 'cut in the white', or carved and punched the gesso that would have been prepared and applied by the gilders. The interrelationship of the two crafts

196 OUTER: A simple ebonized frame, with a carved and gilded 'slip' – the overall measurement across the moulding is $4\frac{1}{8}$ in. (10.5 cm.). For much of the eighteenth century these frames were the cheap alternative to the more elaborately carved and gilded ones. INNER: A so-called 'Hogarth' frame – the overall measurement across the moulding is $1\frac{1}{2}$ in. (3.9 cm.). The frame is made of pearwood, stained to resemble ebony (see fig. 205). *Private Collection*

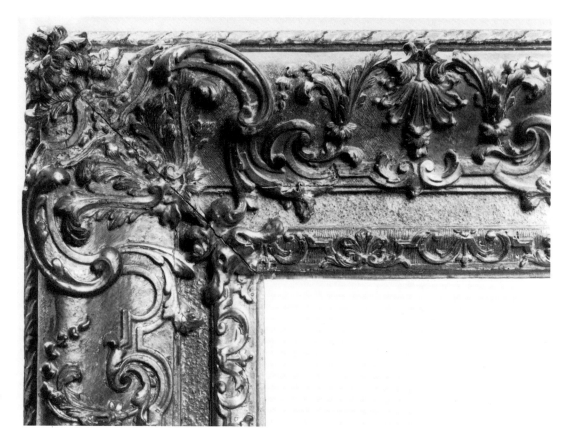

197 Detail of a Louis XIV frame. In this photograph only part of the Victorian overgilding (in oil) has been removed to reveal the original water-gilding and the elaboration of the 'cut-in-the-white' gesso. *Private Collection*

198 Gilders at work, from Diderot's *L'Encyclopédie*.

was such that it was necessary for a carver to employ a gilder or a gilder to employ a carver and this would explain the association of the two on surviving trade cards. In contrast, eighteenth-century London gold beaters worked independently; men like Gervas Snape (at the Golden Hammer in Long Acre) and Thomas Bateman (of 5 Chiswell Street).[39]

In 1758 Thomas Johnson began to publish his

Designs for Picture Frames, Candelabra, Ceilings etc in 'Monthly Numbers . . . for the better accommodating the Price to the Circumstances of every Purchaser'; it was his fellow carvers that he had in mind. In the preface to his designs, which were drawn by Johnson and engraved by either James Kirk or B. Clowes, the carver asserts that if 'honoured by the Hand of the skillful Workman . . . they give entire Satisfaction.'

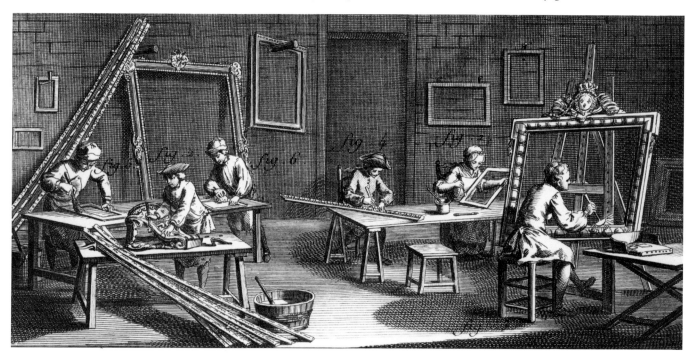

199 Gold-beater's sign. *Museum of London*

200 Design for a picture frame by Thomas Johnson, Plate 17 in his *Designs for Picture Frames, Candelabra, Ceilings . . .*, which was issued in London from 1758 in monthly numbers. *Victoria and Albert Museum, London*

Many of the designs have a distinctly French look although the volume is dedicated to his 'Brother' member Lord Blakeney, 'Grand President of the Antigallican Association.' It is possible that Johnson occasionally framed Hogarth's work since both men were endowed with similar prejudices and influences. Certainly the sinuous line of many of Johnson's designs would have conformed well to Hogarth's notions of a 'line of beauty'. In one edition of the work, Johnson states that 'the designs may all be performed by a Master of his art . . . as I am well satisfied they can be executed by myself.'[40] Ignoring the self-congratulation, some authorities have doubted the extent to which such a high level of skill percolated down to the provinces in Britain. Certainly very little elaborate carving was produced in colonial America where picture frames were noticably simpler than in Europe and where elaborate mirror frames furnished with the labels of American retailers were almost invariably imported. There was, too, the problem of translating a two dimensional drawing into three-dimensional reality. Some light is thrown on this conundrum by the accounts for Holkam Hall, Norfolk, where one pier glass in the Ante-Room is believed to have been carved by Whittle of London, whilst the pair to it in the Dining-Room was made by James Miller, a local man who did much else in the house.[41] In this instance, of course, Miller simply had to transpose an existing carved frame rather than

interpret a drawing of one.

Aside from the fire gilding applied to bronze, carved wood could be either oil or water gilt. John Smith in the 1705 edition of *The Art of Painting in Oyl*, a book designed for 'Vulgar Painters' (house painters), explicitly states that gilding 'on any oyly size [is] the usual practice of Painters'. The procedures involved in water gilding were simply too lengthy and demanding to be carried out by any but specialist craftsmen.[42] Their work was expensive. In 1633 Nicholas Stone Jnr. was charged £2 for the gilding of a frame that surrounded a landscape of London costing £7.[43]

The preparation in a double saucepan or *bain marie* of the whitening and size, and the application of a dozen or more coats of this 'gesso' in varying degrees of strength, followed by two coats of Armenian bole, were matters of great importance for successful gilding. The whole process involved considerable skill, experience, and knowledge. No wonder the preparation of the 'bole' was 'kept a profound Secret', though *The London Tradesman* gives the following recipe for 'Burnish Gold Size':

Take one Pound and a Half of the best Pipe Clay,
Half an Ounce of Red Chalk.
One Quarter of an Ounce of Black Lead.
Forty Drops of Sweet Oyl.
Three Drams of the best rendered Tallow.

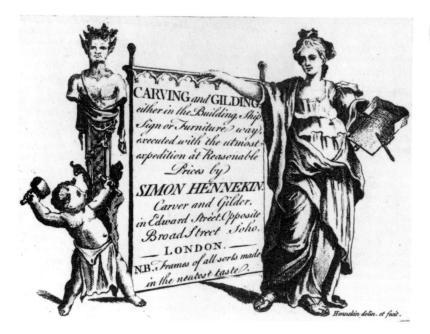

201 Trade label for Simon Henekin, the London carver and gilder. The right-hand figure is holding a gilder's 'cushion'. *British Museum, London*

202 A 'tip' for lifting gold leaf from the 'cushion', illustrated in Brodie & Middleton's catalogue of *c.* 1880.

203 A 'cushion', knives and burnisher, illustrated in Brodie & Middleton's catalogue of *c.* 1880.

Grind the Clay, Chalk, and Lead, with Water all separate, as fine as you can; then mix them with Oyl and Tallow, and grind all together to a due Consistance. This Size is scarce fit for Use till it has stood two or three Years; if it stand twenty it is still the better . . .[44]

Before the gold size was applied it was usual to 'open the veins of the Carved work which [the] Whiting has choakt and stopt up' with a gouge 'no broader than a straw'.[45] The gesso was then smoothed over with very fine fish-skin or Dutch rushes,[46] neither of which, unlike glass or sand paper, would leave a gritty deposit to disrupt gilding or blunt carving tools. Finally, a linen rag was placed over the index finger and with the aid of some spittle the gesso was given its final surface for the reception of the 'bole'.

Two coats of 'bole' were applied and permitted to dry, at which point the degree of suction necessary could be tested by touching the surface with the moistened lower lip of the mouth. Some gilders then burnished the bole at this stage, but this was not essential.[47] A soft-haired, full-bodied brush was then used to apply a weak solution of parchment size to the work and as this ran into the surface of the bole the suction of the underlying gesso held the gold leaf in place. An intimate understanding of the process is revealed by Stalker and Parker in the section on gilding in their book *A Treatise of Japaning and Varnishing* (Oxford, 1688): 'you'l perceive how lovingly the gold will embrace it, hugging and clinging to it, like those inseparable friends, Iron and the Loadstone.'[48] Few seventeenth- and eighteenth-century descriptions of gilding seem to have been written with this note of personal experience. The loose leaf (as opposed to transfer) gold that was used in this work was cut

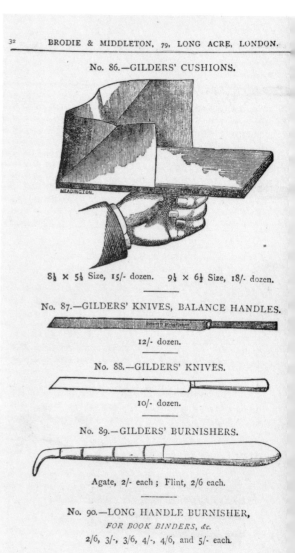

on a 'cushion' with a smooth but unsharpened steel knife. The steel 'case-knife' is referred to in the 1705 edition of John Smith's *The Art of Painting in Oyl* as second only to a 'cane-knife' made from 'a slip of the hollow Spanish Cane'.[49] The tradition of using such cane knives has completely died out although in the 1676 edition it is the only type of knife that Smith considered suitable for the job.[50] The 'cushion' was 'made of Leather, Stuft very evenly and smoothly with fine Tow, and strained on a Board 14 inches one way and 10 inches another'. To prevent the valuable leaves of gold floating away with the slightest draught, 'Gilders commonly border this cushion at one end, and 4 or 5 inches down each side, with a slip of Parchment or Velom 2 inches high, to be as a Fence to keep their Leaves of Gold from Wind and Air.'[51] In addition to gold, leaf silver and tin[52] were used and sometimes these were later given a coat of yellow varnish so as to resemble gold. For the purposes of economy, the 'backing off' of a carved frame was not gilded but given a coat of 'backing yellow' (yellow ochre).

Once cut on the 'cushion' the leaf gold was lifted into place with the 'tip' (fig. 203) by means of static electricity in the hairs. If this was found insufficient the tip was passed across the gilder's head where it collected just enough grease to enable it to pick up the leaf gold. In the seventeenth century, when the 'palette' was not so exclusively associated with painters, a tool known as a 'guilding pallat' was used to pick up leaf gold. The implement consisted of 'a flat about three Inches long, and an Inch broad, upon which is to be glewed a piece of fine woolen Cloth of the same length and breadth; upon this Pallat do but breath with your Breath . . . then if you clap it down gently on the Gold that is cut out and may from thence be readily conveyed to the work . . .'[53] Probably transitional between the gilder's 'pallat' of the seventeenth century and the 'tip' which followed it (and remains in use), is the 'Pallet' defined by William Salmon (1672) as 'the end of a Squirrels Tail, spread abroad and fastened to a flat Pencil-stick, which is broad at one end and split, much like an House-painter's graining Tool . . .It serves for taking up and laying on whole Leaves of Gold or Silver at a time.'[54] The gold, once applied to the dampened Armenian bole, was allowed to dry somewhat and then tapped down with 'the hinder foot of a Hare or Coney'.[55] Once the underlying bole was considered sufficiently hardened, burnishing could begin. This involved a nice judgement and years of experience to 'cop it mellow', as a craftsman I once knew so accurately expressed it. The burnishing was done, according to most early accounts, with 'A Dogs Tooth put into a Pencil-stick' and Salmon

204 A 'swept' frame by Richard Fletcher, mid-eighteenth century, overall size 23 × 25 in. (58.5 × 63.5 cm.). See fig. 205. *Judkyn/Pratt Collection*

205 Richard Fletcher's trade label, on the back of the frame in fig. 204. Among the frames made by Fletcher were 'black Peartree & Deal Frames for Maps, Prints or Drawings' (see fig. 196).

206 Late eighteenth-century fruit-wood mould, carved inside-out; it is shown here with a 'squeeze'. Composition or 'compo' provided a cheap alternative to expensive carving, not only for picture frames but also for plaques and other embellishments on chimney pieces. *Private Collection*

OPPOSITE

207 Charles Wilson Peale (1741–1827), *The Staircase Group*, 1795, oil on canvas, 89 × 39½ in. (226 × 100.4 cm.). To give a greater sense of reality, three sides of the frame are provided by the architrave, and the fourth by the bottom step of the stairs. So convincing is this deception that George Washington is said to have bowed to the two young gentlemen shown in the painting. *Philadelphia Museum of Art (gift of George W. Elkins)*

goes on to say that 'of late [1672] they are made of Agates and Pebbles ... These Pebble Burnishers are worth 5s. apiece, and much to be preferred to Dogs Teeth.'[56] Numerous mammals involuntarily provided teeth for burnishing water gilding: Theophilus mentions beaver, bear or boar;[57] Cennini gives in addition to dogs' teeth, those of lion, wolf, cat 'and in general that of any animal which feeds decently upon flesh';[58] and Hilliard used for his work 'in little' the teeth of ferret and stoat.[59] It is on such homespun wisdom that many of the secrets of the crafts are based. The fundamental skills of craftsmanship may not be effectively communicated by words but are primarily acquired by observation and dogged application over many years. The use of oil gilding, the importance of skewings, the virtue of double gilding and even the significance of the climate in terms of temperature and humidity have been omitted here through lack of space.

The continuous carved mouldings that characterize so many of the simpler frames of the seventeenth century gave way in the middle decades of the following century to a variation of emphasis where the corners and centres dominated. The fluid lines of these 'swept' rococo frames required a level of skill from the carver which the more sober tenets of the Classical Revival of the late eighteenth century would not demand. Nevertheless, it was in these years that alternatives to expensive carving were used to any extent. A composition of sawdust and glue was in use in Italy by the sixteenth century[60] and instructions on its preparation and use appear in English publications in the late seventeenth century.[61] A type of composition, or

'compo' as it became known in England, was made of glue (7 lbs), water ('seven half pints'), white resin (3 lbs), and raw linseed oil (3 pints) melted together and combined with 'a large quantity of whitening' which, when mixed to the consistency of dough, would keep for some time in cool damp conditions.[62] This substance could then be pressed into carved wooden moulds and the resulting cast glued onto picture frames or other surfaces such as the plaques used to punctuate a chimney-piece. In contrast to carved picture frames, 'compo' ones were inevitably cheaper. The only highly skilful and labour-intensive part of the 'compo' process was the carving of the original mould. This was the secret of the commercial success of substitute materials which included, in addition to compo, papier mâché, carton pierre, cast pewter, and lead. Stamped brass picture frames were a later variant. Duffour was one of the earliest carvers and gilders to use 'Papie Machie' which he refers to on his trade label of *c.* 1760.[63] The moulds that were carved in boxwood in reverse are in themselves works of art that were made in the eighteenth century by specialists like Thomas Wall.[64]

The cheap and counterfeited grandeur that was possible with 'compo' spelt decline. Some remarkable frames were produced in the nineteenth century but these were tailor-made to fit not only the dimensions of a particular picture but also to augment its content. For this purpose the mass-produced 'compo' elements were unusable. One example of a custom-made frame is that which surrounds *Francesca da Rimini* from Dante's *Inferno*. It was designed by the artist Ary Scheffer (1795–1858) and incorporates relief

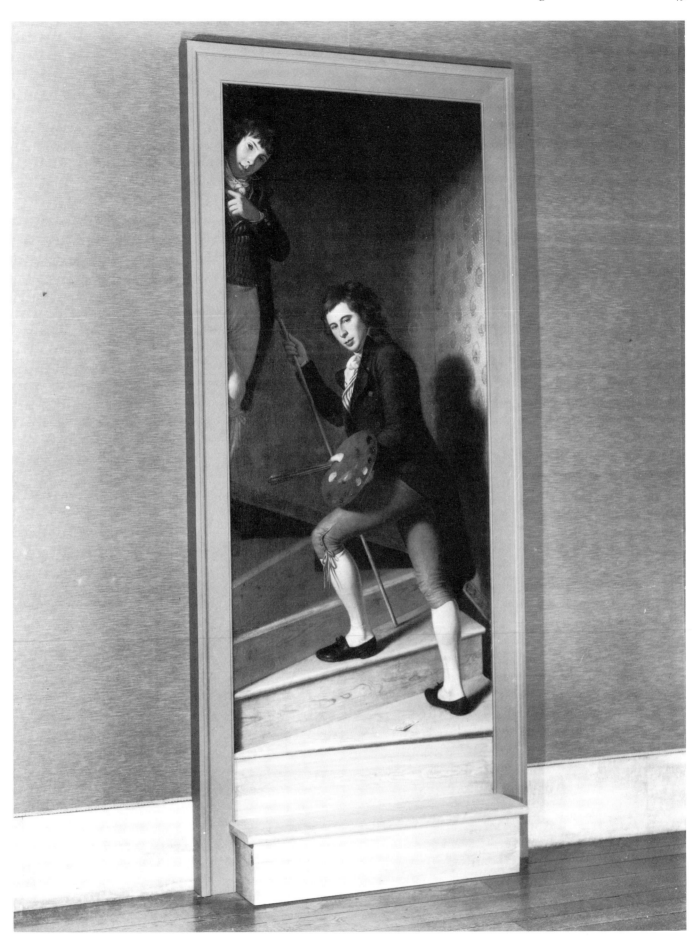

medallions which illustrate Dante's text. Other examples include the frames that were painted by Edward Hicks, Thomas Eakins, and Georges Seurat. Perhaps the most amusing is the 'frame' that was used by Charles Wilson Peale (1741–1827) for his *Staircase Group* (fig. 207).

With the development of watercolour painting in England in the late eighteenth century, simple frames with beaded, husked or gadrooned mouldings became widespread. The Royal Academy's dilemma of how to respond to the growth of watercolour painting was no doubt echoed in the frames. Some painters varnished their watercolours[65] and described them as tempera, or glazed them with glass and grouped them with drawings. In the late eighteenth century, watercolours were generally close-framed without a mount (or mat as it is known in the United States). This position was at first maintained in the early nineteenth century probably because the exhibiting societies introduced rules to discourage wide mounts which would limit the number of pictures they could hang.[66]

By the late eighteenth century most trade directories for provincial towns in England list at least one carver and gilder. They were no doubt capable of making the simple frames suitable for watercolours and needlework. They included men like A. Hunt of Liverpool, William Fawcett of Leeds, William Tucker of Exeter, and Tijou, who seems to have worked in both Birmingham and London.[67] Some, like John Thirtle who opened a framing business in Norwich in about 1800, had trained in London;[68] others were supplied with mouldings by Samuel Farnworth of 'the Pavement, near Finsbury Square', London.[69]

Ogee frames veneered with maple were in general use for minor pictures by the mid-nineteenth century and these continued a somewhat earlier but co-existing tradition for frames that were cross-banded in rosewood or mahogany. These were usually fitted with 'German gold' slips. By the closing decades of the century 'Oxford frames' of oak were considered 'suitable for sacred subjects, mottoes, views of the Holy Land, &c.'.[70]

Whatever type of presentation is used for a picture, the frame is, in the Italian phrase, 'a pimp for the painting'.[71] The importance of this was apparently not understood by William Dunlap who objected that the keeper of a second rate academy was usually 'some trustworthy mechanic, who never thought of a picture but as something made valuable by a frame.'[72] In contrast to this view many painters have had a close association with their framers. This was true of Vermeer whose framer (and brother-in-law) was Van der Wiel; it was also true of John Crome and his frame makers Jeremiah and William Freeman, one of whom accompanied the painter on his visit to Paris in 1814.[73]

208 Stamped brass frame, c. 1830–5 – the sight measurements are 4 × 3⅛ in. (10.2 × 7.9 cm.). *Abby Aldrich Rockefeller Folk Art Center, Williamsburg*

209 American frame (c. 1825) painted to simulate curly maple with mother-of-pearl inlay – the sight measurements are 7³⁄₁₆ × 6 in. (18.3 × 15.2 cm.). *Abby Aldrich Rockefeller Folk Art Center, Williamsburg*

V SCULPTURE

In his *Sculptura*, published in London in 1662, John Evelyn states that those who have considered 'Technical notions seem to distinguish what we commonly name *Sculpture* into three several Arts; and attribute specifical differences to them all.' Evelyn identifies these as the plastic (modelling), the toreutic (metal working), and the glyptic (carving, especially stone) arts. He concludes that only those processes which involved 'cutting' may 'in Propriety of speech be call'd *Sculpture*'.[1] It is in this sense of the word that Evelyn goes on to discuss engraving in copper at length, and it was in this sense that engravers attached 'sculpt' to their signatures. In fifteenth-century Florence the masons, carvers and carpenters belonged to the same guild – they were all 'sculptors'.[2] So entrenched did the word become in relation to engraving that Campbell in *The London Tradesman* (1747) considered it necessary to state that sculpture differed from engraving 'in that the Figures in that art [engraving] are sunk or cut into the Materials; whereas in Sculpture the Figures rise from the stone.'[3]

The precision with which Evelyn used the word 'sculpture' was more profound than may be explained by the benefits of a good classical education. In small-scale and simple economies all men were close to the land and craftsmanship. In these conditions and in much the same spirit John D. Case (1598) divided painting and sculpture into the three arts of 'Painting, Carving and Plasticke'.[4] The following sections will be concerned with the plastic and toreutic arts as well as with carving in both wood and stone.

In comparison to painting, few books were published on the techniques of sculpture. This was probably partly because in its various departments sculpture is less conducive to the efforts of the amateur. It was also less capable of being translated into a series of recipes. Training was by example rather than via the written word. These chapters will therefore contain fewer early accounts of methods used. Again in contrast to painting, the tools, like the works they were used to create, have survived in greater numbers. These tools and the way in which they continue to be used, together with a close examination of the surfaces of existing sculptures where these tools have left their mark, provide evidence of the sculptor's methods down through history.

The handling of tools, like the manipulation of a golf club, has as much to do with the way in which they are held as with the quality of the implement concerned. As J. R. Kirkup has observed in relation to surgical instruments,[5] hand tools fall into three distinct categories:

(1) unimanual control (e.g. modelling tools)
(2) bimanual control (e.g. bow and drill)
(3) double unimanual control (e.g. hammer and chisel).

Painters seldom use tools requiring anything but unimanual control (e.g. paint brushes), but since sculptors regularly use all three categories of manipulation they will be considered together with the sculptor's tools.

The degree to which in the past sculptors, working in clay, stone, marble or wood, used full-size preliminary models is a matter of speculation. They were probably used more than is generally supposed since an unfired clay model would last a sufficient time as a point of reference but would rapidly disintegrate after, and even during, use. The labour of producing a plaster cast would not always have been considered necessary although successful nineteenth-century sculptors with their armies of assistants invariably used a full-size plaster model. Surviving procedures and Cellini's allusion to the use of a full-size model 'in the manner of a good sketch'[6] tends to support this hypothesis. This said, it is evident that many sculptors were content to work from small maquettes which were inevitably less constricting than the full-size models from which Canova and many others are known to have worked.

The basic measuring instruments used by sculptors are calipers, the curved legs of which reach round a form to measure it at the widest

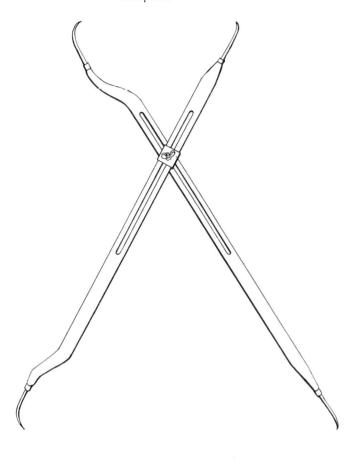

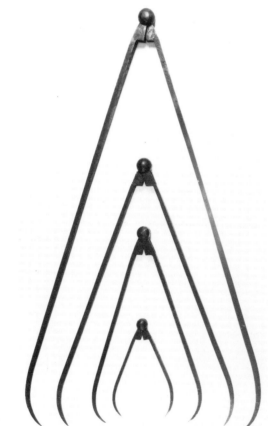

210 Proportional dividers. The wing-nut is movable to vary the proportion.

211 Set of calipers, eighteenth century (?), overall height of the group 36 in. (91.5 cm.). A very similar set is illustrated in fig. 212. *Private Collection*

point. This the straight-legged dividers could not do. Calipers were available in varying sizes, and for portrait work, wood or even ivory ones were less of a hazard for the sitter (fig. 211). Proportional dividers were in use at least as early as the first century AD.[7] They were important in enlarging (or reducing) from the model to the final sculpture. By changing the position of the nut on which such dividers pivot, the ratio of their span at one end changes in relationship to the other end. Less well known than proportional dividers but of enormous assistance are the three-legged dividers by means of which a point in space may be established in relationship to two other points. For relief work, sculptors used a simple depth gauge in the form of a batten of wood with a nail driven through it to the required depth. It is a primitive but important means of gauging a constant depth or (in modelling terms) height of relief.

In marking up lines for a lettered tablet, a 'stick of inches' was avoided. Dividers were used (in conjunction with a ruler) to establish consistent letter heights and line spacing, and marks were made on strips of paper which were then transferred to tick off the corresponding intervals on the other side of the tablet. Like the mason's trammel, such methods reduced the likelihood of mathematical error and stressed the visual rather than the theoretical basis of decision making.

All these methods of measuring permitted the eye to remain the final arbiter. More accurate, in a mechanical sense, were the various methods of 'pointing' which could be used to enlarge or reduce or to transpose a sculpture at the same scale. The earliest system, or a variant of it, is known as the chassis method of pointing and this was later joined (possibly by the eighteenth century but certainly by the nineteenth century) by the 'three point' and the 'long arm' pointing machines. All three depend on the mathematical proposition that when two or more points lie on one plane a further point in space may be accurately calculated. Pointing was the sculptor's means of navigation.

The simplest device consisted of a square or circular board placed over both the model and the ultimate sculpture from which plumb lines could be hung. These provided vertical locations from which horizontal measurements could be taken from the plumb line to the model or final sculpture, thus establishing a 'point' in three-dimensional space. The unfinished figure of a youth (first century BC) from the island of Rheneia[8] was evidently made using some such simple method. The chassis system of pointing was a development of this where the sketch and the material to be worked on were each placed in a timber cage. A movable tee square was

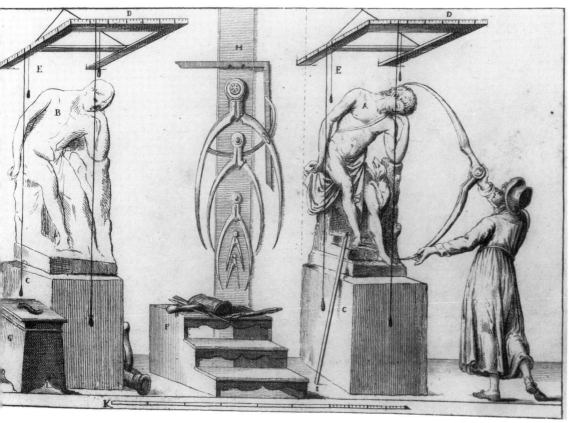

212 Method of copying a modello in marble, illustrated in *Istruzione elementare per gli studiosi della sculptura* by Francesco Carradori (Florence, 1802).

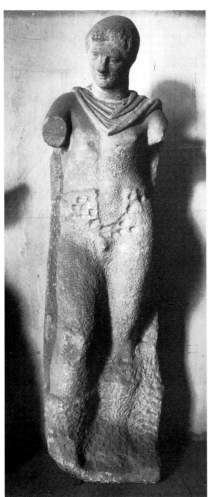

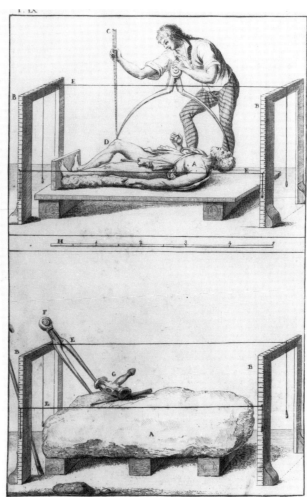

213 Unfinished marble figure of a youth, from the island of Rheneia – first century BC, height 5 ft. 9 in. (1.75 m.). Judging by the series of depressions around the middle of this figure it was evidently 'pointed' from a clay original. Most of the form has been achieved with the exclusive use of the marble point (see fig. 257). In early Greek work finishing was achieved with abrasives. *National Museum, Athens*

214 An illustration from Carradori's *Istruzione elementare* showing the method of pointing in fig. 212 set up in a horizontal position.

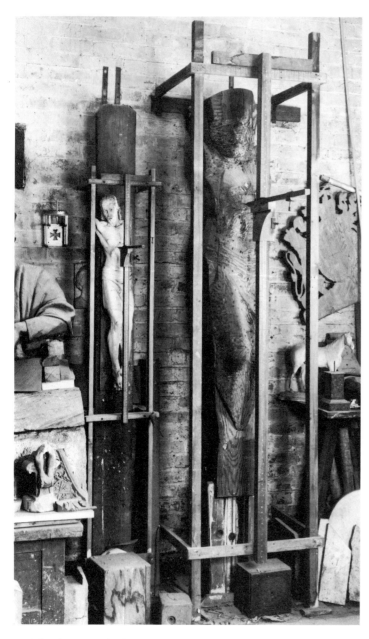

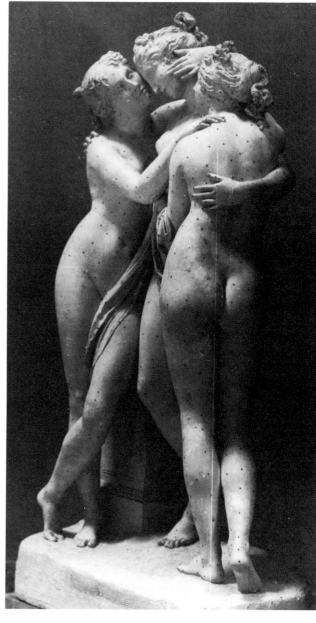

215 The chassis method of pointing. Two chassis, one for the original model, the other twice linear, are used. The top horizontal battens of the chassis, the vertical leg of the T-squares and the horizontal pointers are all calibrated. *Private Collection*

216 Antonio Canova (1757–1822), *The Three Graces*, 1813, plaster, height 65¾ in. (167 cm.). Canova's works in marble were transformed from full-sized plaster models; this surviving plaster model shows the pointing marks. *Gipsoteca, Possagno*

suspended from the outer battens of the timber cage. This tee square was furnished with a box that could be fixed at any point in its vertical movement by means of a wing-nut, and within this box a pointer could be moved back and forth and similarly arrested at a given point. The horizontal battens of the cage (the chassis), the vertical arm of the tee square, and the horizontal 'pointer' were all graduated. One cage with its dependent tee square surrounded the model and another cage and tee square built to the desired scale surrounded the sculpture to be worked on. If a work was being pointed-up in clay, the clay was added at the individual points just short of the final surface (although shrinkage was often considered sufficient for this purpose) and marked with wooden pegs. With carving in either wood or stone, the points which were marked with pencil were placed ⅛ in. above the

anticipated final surface. Even so, pointing marks may often be found on completed sculptures, as, for example, Hiram Powers's *Greek Slave* (1847) at Raby Castle, Co. Durham. Powers began his working life as a Yankee mechanic in Cincinnati and was evidently totally seduced by the skill of his Italian assistants in reproducing his works in marble with the mechanical aid of a pointing machine. His contemporary Thomas Crawford began his training in a New York stone yard and the more incisive qualities of his works in marble may well be attributable to this background.[9]

It was an impractical version of the chassis pointing machine, in which both the model and the final sculpture were completely encased by boarding, that Leonardo described in his *Notebooks* and Cellini in his *Treatises*.[10] The more convenient open cage was the system that was

used by Canova's assistants in producing the full-size model from the master's maquette and in translating the resulting plaster into marble. It was this process that Charlotte Anne Eaton recorded in 1818: 'a [plaster] cast is taken from it [the full-size model] by his assistants, which is dotted over with black points at regular intervals to guide the workman.'[11] Hugh Honour has suggested that Roman sculptors, so familiar with copying, 'repairing' and, for that matter, faking classical statuary, may have reintroduced Hellenistic methods of pointing to the modern world.

In England a widespread interest in the various methods of pointing coincided with the Classical Revival. On 19 March 1771 the Royal Academy 'Resolved that the apparatus for the use of the Academy according to a Design delivered by Mr [Augostino] Carlini [d. 1790] be carried into execution and that Mr Carlini be desired to order and superintend making the machine.'[12] This probably resembled the chassis system 'improved upon by Chantrey', in which it was recommended that the points on the plaster model should each be marked with 'small pins in all the leading angles or surfaces'. Chantrey sent a drawing of his device to Canova in 1818.[13] It was, as M. Digby Wyatt explained, a system that enabled the sculptor 'to substitute a sliding graduated vertical scale for the line and plummet of the mason, together with a graduated pointer working at right angles to this graduated moving upright'.[14]

Towards the end of his life, the engineer James Watt conducted a long correspondence with Chantrey concerning the pointing machine; it was the 'long arm' system that Watt developed which was similar to Cheverton's Sculpture Machine and analogous to the pantograph. In much the same way, the chassis machine was akin to 'squaring up' in two-dimensional work (see pp. 148–50).

The third and probably most recent method of pointing-up was by means of the 'three point' machine. This was suspended frontally from three points and the sliding pointer was dependent upon the universal ball and socket joint which could be tightened section by section. The frontal approach made possible the Hellenistic or Michelangelesque method of 'excavating' sculpture on one face. Despite the frontal attachment of the three points, the ball and socket joint of the pointer was so flexible that it could reach out and around the back of the work to complete it fully in three dimensions.

A version of the chassis was employed for the so-called 'section-method' of modelling. In this system the living model was placed within the cage and the vertical timbers notched at regular intervals of, say, 1 in. A thread was stretched

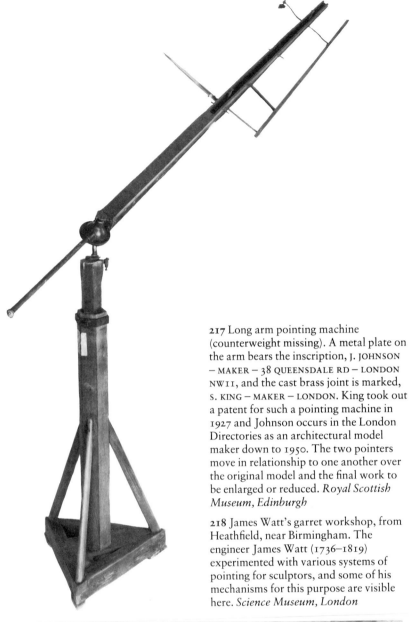

217 Long arm pointing machine (counterweight missing). A metal plate on the arm bears the inscription, J. JOHNSON – MAKER – 38 QUEENSDALE RD – LONDON NW11, and the cast brass joint is marked, S. KING – MAKER – LONDON. King took out a patent for such a pointing machine in 1927 and Johnson occurs in the London Directories as an architectural model maker down to 1950. The two pointers move in relationship to one another over the original model and the final work to be enlarged or reduced. *Royal Scottish Museum, Edinburgh*

218 James Watt's garret workshop, from Heathfield, near Birmingham. The engineer James Watt (1736–1819) experimented with various systems of pointing for sculptors, and some of his mechanisms for this purpose are visible here. *Science Museum, London*

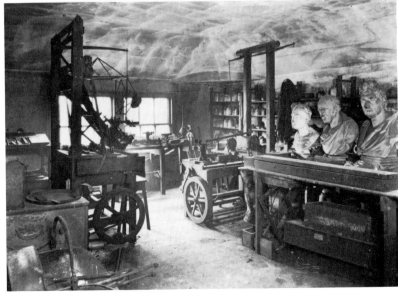

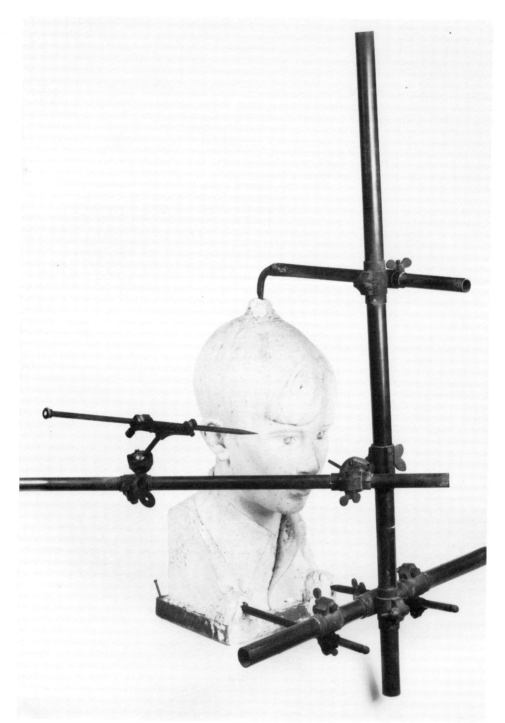

219 Plaster cast of the *Portrait of Paul* in the process of being transferred to wood (at the same scale) by means of a three-point 'pointer'.

220 Arthur J. J. Ayres (b. 1902), clay model for the *Portrait of Paul* – life size.

221 Arthur J. J. Ayres, *Portrait of Paul*, 1954, English walnut, life size. *Escott Collection*

round the framework and held in these notches to establish a regular and horizontal plane. To prevent undue movement, the living model was constrained by a series of horizontal battens attached to the chassis. Salient points were then marked on the model's skin with ink and the measurements to each point were taken from two or more corner posts with dividers. Using dividers these points were then struck on a sheet of card that corresponded to the plan of the chassis. In this way a series of sections could be drawn which gave the exact section of the living model at regular intervals. The English sculptor (James)

Harvard Thomas (1854–1921) was a great exponent of the section method. The last examples of the use of this system in England are the bronze figures on the Guards Memorial, Whitehall, which were modelled by Gilbert Ledward following the Great War.[15]

It was the pointing machine that enabled the sculptor to become an administrator of a substantial studio producing large numbers of almost identical works. For Nollekens, 'according to the theatrical phrase', his 'stock-pieces' were the busts of Pitt and Fox. The notion of sculpture as the unique product of an exceptional

mind and hand was not so much rejected as simply forgotten. When, following Nollekens's death, the Earl of Egremont purchased the plaster model for one of the sculptor's Venuses, 'He engaged Mr Rossi the Academician to execute it in marble [although the actual carving was done by "Mr Williams" – probably Thomas] with strict instructions that no alteration whatever, not even an improvement upon the model, should be attempted . . . for if improvements had been made, it could no longer have been esteemed as a production of Nollekens' mind.'[16] Such a slavish use of the pointing machine was not only capable of embalming the work of living sculptors, it also gave them the possibility of work after death.

THE PLASTIC ARTS

Modelling

In the most literal sense 'sculpture' refers exclusively to carving and 'the plastic arts' are confined to modelling. In practice the 'plastic qualities', in the sense of 'modelling', may appear in any 'sculptural' material. The way in which these terms are used interchangeably produces much confusion. This is no pedantic quibble; it is more than a question of semantics. Modelling and carving are not simply different, but the anti-

thesis of one another. Modelling in clay or wax is a process of addition which is at the same time sufficiently fluid to allow for the complete revision of the work in hand. By contrast, carving in wood, stone, or marble involves irreversible and therefore inflexible methods of subtraction. These characteristics of the plastic and the glyptic arts condition and inform the result. Modelling is akin, in its permissive receptiveness and its response to a fickle or fecund imagination, to drawing. As with drawing, spontaneity is more easily achieved in clay than in the more demanding and time-consuming processes of carving.

It was these ductile qualities that encouraged many sculptors to produce their sketch models in clay and wax. The elder Pliny records the plaudits awarded to a modeller like Pasiteles and the view that modelling was the mother of sculpture. He notes that terracottas could be of such a high quality that it was no shame to worship deities of clay, that clay was more 'innocent' (*innocentiora*) than gold or silver and that 'gable ornaments in clay are still to be seen even in Rome as well as provincial towns.' Elsewhere, the *Historia Naturalis* states that artists would pay more for clay models by Arcesilaus than 'the finished works of others'.[1] This reflects the general Western European view that the plastic

222 'Sectional modelling' uses many of the features of pointing, but is based on the living model.

223 *Athena modelling a Horse*, attributed to the so-called 'Painter of Pan' – red figure pitcher, after 470 BC, height 8½ in. (21.5 cm.). *Antiquarium, Berlin*

224 Articulated armature, *c.* 1900, mild steel, height 13 in. (33 cm.). *Private Collection*

225 School of Michelangelo, *Torso* – clay sketch, repaired with wax, probably for the Julius monument. *British Museum, London*

arts were a means to an end – to 'sculpture' in marble, stone, wood, or bronze. As the ultimate material, clay was considered only suitable for the minor arts.[2]

Generally speaking, the sculptor, and occasionally even the architect, translated the modelled work into metal, stone, or wood in much the same way as drawings were transmuted into paintings.[3] The emergence of modelling as an art in itself is closely paralleled by the burgeoning interest in drawings amongst the *cognoscenti* of Renaissance Italy. This rebirth of Classical values, and the growing status of the artist, were anachronistically combined with Christian tenets in which 'God himself' was seen as 'the first Plasticke worker who, taking some of that virgine elementary earth . . . made man who was the first statue'.[4]

Modelling begins from within, from the skeleton, the armature, and whilst many who worked in clay or wax sought the monumentality of wrought stone or marble, the slender febrile quality of the underlying armature is often present.[5] For a free-standing figure the armature was constructed of wood or lead piping and supported on a 'figure iron'. The English sculptor John Gibson, working in Antonio Canova's studio in Rome in 1817, overheard the Italian master remark to his foreman 'Signor Desti' that Gibson evidently knew nothing of 'skeleton work'. Gibson's armature proved so unsatisfactory that 'a blacksmith was called in, and the iron work made, with numerous crosses of wood and wire [butterflies]. Such proceeding I had never before seen. One of his [Canova's] pupils then put up the clay upon the iron skeleton and roughed out the model before me, so that it was as firm as a rock.'[6] According to Antonio d'Este's *Memoire* the use of the iron skeleton to support a large clay model was indeed an innovation of Canova's.[7] Ferrous metals were coated with Brunswick black or something similar to inhibit rusting which would discolour the clay and mar the modeller's vision. In very large works an armature of timber is often constructed which is carefully scaled-up from a small sketch. In 1759, when Pietro Bracci began work on the central group of Neptune attended by Tritons for the Trevi fountain in Rome, he prepared a sketch model of four palmi (88 cm.) and from this a full-size model 26 palmi (5.72 m.) in height was made. It was from the plaster cast of the full-size group that the carvers worked.[8]

Portrait heads were modelled on a simple 'head-peg' and reliefs were worked up in clay on a back-board into which nails were driven or blocks of wood attached to 'key' the surface and hold the clay. Sir Richard Westmacott (1775–1856) recommended that large reliefs should be modelled upon a slab of slate since wood was

'objectionable . . . from its liability to shrink and to be warped by the action of damp or moisture'.[9] Like the free-standing figure, the modelled relief, even when subsequently translated into bronze, betrays its origins. The carved relief is cut back into the pre-existing surface of the slab. When used architecturally the glyptic methods naturally and appropriately tend to produce results which conform to the plane of the buildings in which they are set. An awareness of this property of the carved relief seems to be present in *The London Tradesman* (1747) when Campbell describes 'Bass Relievo' as 'the highest raised work of this kind: The Image seems ready to fly from the Compartment and touches the Plain of the Building but insensibly.'[10] In contrast, a modelled relief may all too easily advance from the back-board which is its only discipline. Such reliefs, worked in a 'plastic' material, may undulate casually and for this reason were long considered inappropriate for architectural purposes. M. Digby Wyatt in his *Fine Art* (1870) described how the modeller should work within 'the parallel planes of the back of the bas-relief and a plane parallel to it, beyond which it is prescribed that none of the parts of the bas-relief should project'. In addition the forms within a relief should be adapted to an eliptical section consistently deployed. It is this that Digby Wyatt referred to when he wrote that the sculptor should 'flatten every part in strict obedience to a scale of parts obtained by laying out upon a straight line the full dimensions of the depth of every part of the living model proposed to be introduced in the basso-relievo'. In other words, a relief is, in architectural terms, more akin to a pilaster than to an attached column.[11]

In many ways clay and wax may be used to create light and shade rather than form, and undisciplined reliefs are, in effect, grisailles where the tonal range is sculptured with shadow. Such works are completely dependent upon their lighting for effect. Terracotta clay, with its seductive colour and elastic properties, was especially prone, in both reliefs and free-standing works, to the effervescent charms of light. In Rodin's early work this feature achieves its maximum effect. His portrait of *Une Jeune Fille au Chapeau Fleuri de Roses* (before 1871) contrives to suggest the lustrous dark eyes of the young woman, the yellow of the straw hat and even the pinkness of the lips. All this is achieved by the twin accomplices of light and shadow and has little to do with form. It may be objected that a truth to materials is absent from such a portrait head. In fact, Rodin's early terracottas were faithful to the virtues of clay, and when fired in the kiln, clay they remained. It is his later, more monumental works that are divorced from the materials in which they were conceived.

To keep the clay pliable – plastic – it was

227 'Head peg'. Portrait heads are modelled on such an armature; the 'butterfly' (not strictly necessary here) is a traditional way of carrying weight in a clay model.

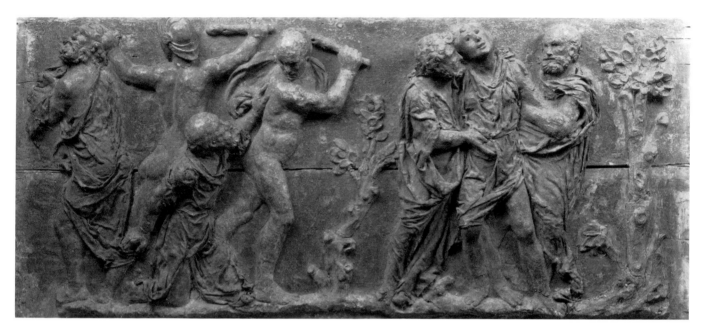

necessary for it to be dampened at regular inter-
vals and covered up when not being worked on
so as to inhibit evaporation. The damp rags
which covered the model could cause some loss
of crispness in the modelling and a wooden cage
was usually constructed upon which these cloths
were hung. Water was scattered on the surface
of the clay either by shaking a water-charged
house painter's distemper brush at the work or
by squirting jets of water from the mouth, a pro-
cedure that some sculptors such as Nollekens
developed with no little skill. Others like John
Bacon RA (1740–99) found it more polite to use
a silver syringe.[12] When first dampened the sur-
face of the clay is sticky and unworkable and,
probably for this reason, Nollekens made it his
practice to begin his working day by first
dampening his models and then retiring to have
his breakfast.[13] Working in the damp conditions
necessary for clay modelling was especially
uncomfortable in winter and for the old and
infirm. Luca della Robbia kept his feet warm by
standing in a basket full of wood shavings.[14]

The tools used for modelling in clay fall into
two categories, both of which involve unimanual
control. These are the spatulas and other tools
designed to apply clay, and a second group
designed to remove it. In the application of clay,
tools made of a close-grained wood or, even
better, ivory are used (fig. 231). Richard Deakin
in his *Flora of the Colosseum of Rome* (1855)
describes the wood of the spindle tree as 'fine-
grained, compact and pliable, and is much used
for the purpose of making modelling instruments
used by sculptors'.[15] The cutting tools were
either made of wood but given a serrated edge,
or made of thin rods of metal (often brass) spiral-
led round with wire (fig. 231). These provisions
effectively limited any tendency for the tools to

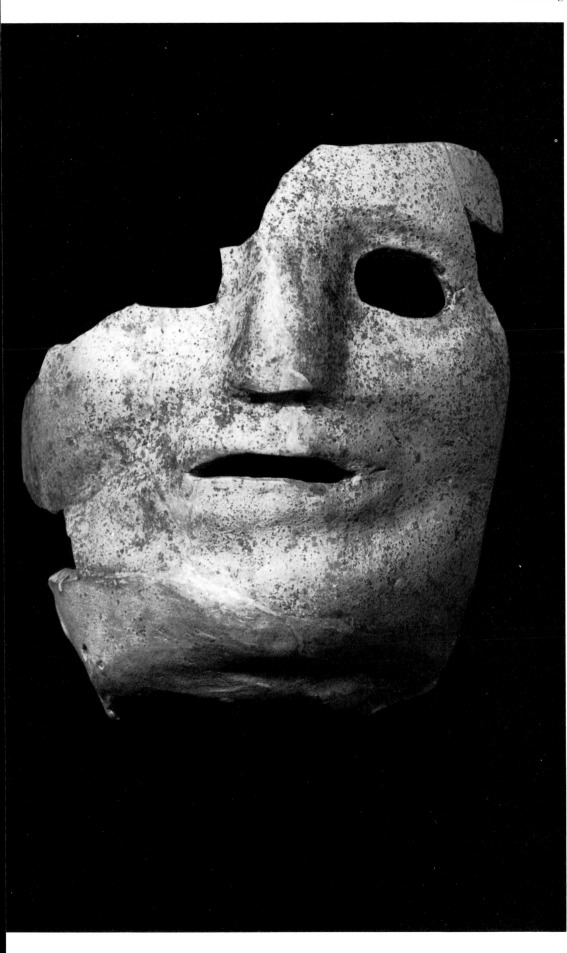

228 Jacopo Sansovino (1486–1570), *The Story of Susanna*. Although reliefs were commonly modelled on timber backboards, Richard Westmacott the Younger (1799–1872) preferred a slab of slate, as wood was liable to warp and split. *Victoria and Albert Museum, London*

229 August Rodin, *Une Jeune Fille au Chapeau Fleuri de Roses*, before 1871, terracotta. The 'local colour' of the dark eyes is achieved with shadow and has nothing to do with the 'form'. *Musée Rodin, Paris*

230 Actor's mask, clay, Romano-British, second century AD. The elastic qualities of clay are remarkably visible in this work. *Warrington Museum and Art Gallery*

ride over the varying consistencies of the clay. By using such a tool first in one direction and then again across the axis of the previous movement it was possible to create a deliberate form in which the modeller's intentions were not deflected. In many ways these tools were paralleled, and for similar reasons, by the claw tools used by carvers and masons on marble or stone.

From the following glimpse of both Joseph Nollekens (1737–1823) and John Flaxman (1755–1826) at work, it is evident that many modellers also used their fingers. 'Nollekens's time was employed in modelling [rather than carving] and in consequence of his great practice, he acquired such dexterity with his clay, that he brought a bust wonderfully forward with his thumb and finger only. Flaxman principally employed himself in modelling; but though not so dextrous as Nollekens, he kneaded the clay in a rough manner with the hand under the influence of a great mind.'[16]

If a modeller intended to give permanence to his work by firing it in a kiln, the basic design was either worked up as a hollow structure, or it was modelled on a simple armature and then, when 'leather-hard', dissected so as to remove the armature and hollow out the work. Once hollowed out, the segments of the work could then be reassembled by giving a 'tooth' or texture to the joints and by means of clay slip a rub-joint held the pieces together. With reliefs it was advisable to cover the back-board with paper which could act as a parting agent.[17] Italian Renaissance portrait busts in terracotta often appear to retain the simpler shapes of the 'built' clay wall. Only in the smallest terracottas was it possible for them to be fired solid; the small Tanagra figures are hollow simply because they were 'slip-cast'. In larger works the tensions created by the shrinkage of the varying volumes of solid clay were such as to split and crack the clay as it dried and when it was fired. It was also necessary that the clay be well tempered with an aggregate of 'grog' and 'wedged' to mix the two together and expel air pockets – otherwise this 'fixed air' would cause the terractotta to 'fly in the kiln'.[18]

By the early nineteenth century if not before, sculpture was no longer so precisely defined as a synonym for carving. Charlotte Anne Eaton, whilst at first supposing that all sculptors worked direct in marble, was evidently oblivious to these niceties when writing of her visit to Canova's studio in 1817 or 1818. 'A sculptor begins upon a much more ductile material than marble, he forms his models in clay of his own hands [which] ... when finished a [plaster] cast is taken from it by assistants.'[19] This of course introduces questions as to the authenticity of a

231 Group of modelling tools, maximum length 15 in. (38 cm.). From the left: the first seven are cutting tools, of which the first five have serrated edges; these are followed by a metal spatula, three boxwood and two small ivory modelling tools.

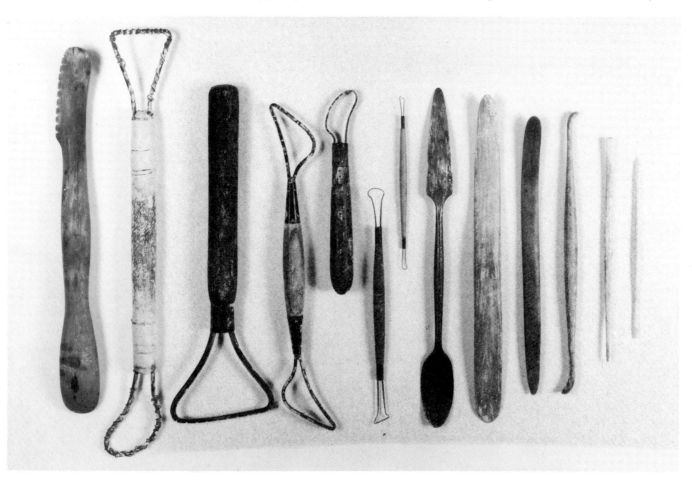

232 Ionic pilaster capital,
Coade stone, overall
width 18 in. (45.7 cm.).
Very few examples of
Coade stone are signed
and dated as this one is.
Private Collection.

work of art – questions with which previous generations do not seem to have been much concerned. J. T. Smith was quite forthright and explicit in writing about 'the classic sculptor of high fame whose mind must necessarily be engaged upon his designs' in clay or wax.[20]

The development of this outlook in the second half of the eighteenth century coincided with the appearance of various new materials which could be used as substitutes. Luca della Robbia, among others, recognized that terracotta was more cheaply worked than bronze or marble,[21] but it was in the eighteenth century that this potential was fully exploited. By 1772 the carver and gilder Duffour of Berwick Street, Soho, London, was advertising that he was the 'Original Maker of Papie Machie'[22] and John Jaques of Grays Inn gate, Holborn, London, was promoting himself as a 'Composition Ornament and Chimney Piece Maker'.[23] In addition there was 'Adam's composition' in which Ceracchi modelled a bass relief for Robert Adam. The material was described as 'a mixture of cement with oil, which is now called mastic'.[24] Of all these substitutes Coade stone was much the most important. It was evidently a form of terracotta which was 'hardened by the vitrifying aid of Fire' which made it impervious to 'Frost and Damps' which had 'no effect upon it'.[25] Mrs Eleanor Coade (1708–96) established her enterprise in London in 1768 or 1769,[26] although the process was probably originated by Thomas Ripley and Richard Holt who were granted a patent for a 'compound liquid metall, by which artificial stone and marble is made by casting'. Coades were soon making mass-produced sculpture and architectural ornaments for a world market, sending pieces to North America, the West Indies, Poland, and Russia. These distant customers would have been dependent upon the various catalogues issued from 1777 by 'Coade's Gallery or Exhibition in Artificial Stone, Westminster Bridge Road'. Coade stone ceased to be made in 1840.

The use of terracotta, or for that matter Coade stone, in an architectural context demands a considerable knowledge of the shrinkage of clay as it dries and when it is fired. It is also dependent upon a consistent firing temperature. Waterhouse's Natural History Museum in London is a monument to that knowledge and skill. Despite the variation in the dimensions and volume of the constituent parts of that structure, the jointing is accurate and the mouldings run true.

Like many late eighteenth-century 'sculptors', Joseph Nollekens worked in clay (and collected terracottas)[27] but made his reputation in marble. In contrast to such a personality were other lesser figures well known in their day as modellers. Such an individual was Crispe, who had a china factory at Lambeth.[28] One of his apprentices was John Bacon RA (1740–99, he with the silver syringe) who later worked for Mrs Coade as her principal modeller. Another was James Cundy (1793–1826) who was employed as a modeller by the silversmiths Rundell & Bridge.

Like clay, wax could either be used as an end in itself, or as a means to an end. For small sketch models it was an ideal material which could be built up and changed without the interference of any significant armature which would impede the modeller's thought processes. For larger figures, armatures were of course necessary. Orsino, the Florentine worker in wax, assisted Verrocchio in preparing armatures for three life-size figures. These were constructed of wood interwoven with split reeds and covered with waxed cloths as a basis for modelling.[29] Wax was much used for modelling in low relief, as for example the medals by Pisanello. Capitsoldi and Voyers used wax in modelling the ornaments on a wooden model of Joseph Wilton's design for George III's state coach.[30] In both instances the

233 School of Gaetano Giulio Zumbo, *A Damned Soul*, late seventeenth century, coloured waxes. *Victoria and Albert Museum, London*

was more easily examined but also hardened the wax and gave it a pleasant colour.[32] The use of polychrome waxes which, as a mirror of the natural world, were capable of achieving not only natural colour but also the translucence of flesh or flower petals, is a conceit which goes back to Classical antiquity.[33] Instructions for making cast wax fruit and flowers appear in Alexander Browne's *The Whole Art of Drawing* (1660).[34] In portraiture, the resemblance of these coloured waxes to life (or death) were put to morbid effect in the necrophiliac works of Gaetano Giulio Zumbo (1656–1701). Less emotionally charged were Madame Tussaud's wax portraits of members of the *ancien régime*, despite the sense of urgency that the guillotine gave to her work, and the funeral effigies by, among others, the American wax worker Mrs Patience Lovell Wright (1725–86). The startling reality of wax portraits was such that Vasari considered they lacked nothing 'but the spirit and power of speech'.[35] Horace Walpole was moved to remark on the 'surprising perfection' of the wax likenesses by 'Mr Gosset and his nephew' (Isaac Gosset 1683–1744 and Isaac Gosset 1713–99).[36]

In addition to wax and clay, other traditional plastic materials included stucco and various related substances. Vasari describes a stucco composed of marble dust mixed with a lime made from either travertine or marble.[37] It has been used successfully for architectural work since Roman times when it was handled by modellers with enviable freedom. In the preface to William Aglionby's *Painting Illustrated* (London, 1685), 'Stucco-Work' is described rather loosely as 'Figures of all sorts, made in a kind of Plaister, and employed to Adorn a Room'. Christopher Wren, as one would expect, was more precise when he described the spandrels between the arches on the cupola of St Paul's as being 'invested with *Stucco* of Cockle-shell Lime, which becomes as hard as *Portland* Stone'.[38] In Britain the work of the foreign *stuccatori* was frequently overlapped by that of the 'parjiter' who also worked in plaster, men such as John Abbot (1640–1727) of Frithelstock, Devon,[39] and John Cooke of Gloucester (*fl.* 1748–63).[40] The confusion between plaster and stucco is confirmed by an advertisement of 1772 for William Roberts, a carver and gilder who was also a 'stucco plasterer and slater'.[41] These craftsmen were 'properly a Branch of Sculpture' since, as Campbell observed, their work required 'Judgement and Education'.[42] Undoubtedly their skill in handling plaster or stucco to run a moulding or turn a section was of value to other sculptors especially in the preparation of sketch models for schemes where the sculpture was integrated with architectural members. Close though the association between

layer of modelling material would have been so thin as to make clay completely impractical. With the development of various patent modelling materials such as Plasticine, the use of wax declined – except of course for the lost-wax process of casting.

The tools used in working wax were much the same as those employed on clay except that metal spatulas were found to be an advantage since they could be warmed to make the wax more malleable.

Although wax is well suited to small works, it is, as we shall see, an essential part of the lost-wax process for casting in metal or glass. For this reason many sculptors have chosen to model in wax on a 'core' – a hazardous procedure which in the lost-wax process could mean the total loss of the work. This however was the method often used in ancient Egypt and it was still in use in the sixteenth century when Benvenuto Cellini worked in wax on a 'core' in this way when creating his lunette *The Nymph of Fontainebleau*.[31]

Various measures such as the introduction of a little animal fat were found to make wax more pliable and the addition of pitch or red earth not only reduced the translucency so that the form

the plasterer, stuccoist, and sculptor could be (and the plasterer John Cooke was the father of the sculptor James Cooke *fl.* 1800–36), they generally seem to have remained distinct areas of expertise.

Falling somewhat between the use of clay and stucco was a composition of clay, paste glue and shearings of woollen cloth used by Jacopo della Quercia (*c.* 1374–1438).[43] This resembles a mixture of plaster and straw known as 'staff' which was extensively used to make (in 1892) large impressive though impermanent Michelangelesque groups for the Columbian Exposition of 1893.[44]

Casting in Plaster

The concern with social position and rank at the expense of the characteristics of the individual declined in the late medieval period and portraiture grew in significance so that death masks became an important part of the trade of the image maker. Verrocchio, using a type of plaster derived from burning a soft stone found in the area of Volterra and Siena, made numerous casts from life of hands, feet, knees, legs, arms, and torsi which he, like many sculptors since his day, used for visual reference.[1] Confirmation that Verrocchio did indeed use a type of plaster of Paris is found in Vasari who writes that Girolamo della Robbia (the grandson of Luca), when working for King Francis near Paris, used a material 'like Volterra gypsum but of better quality'.[2]

In England in the course of the seventeenth century the recumbent effigy gave way to the commemorative figure showing the late-departed subject standing or reclining as if in life. By the following century such work formed the basic source of income of most sculptors. When Joseph Nollekens read of the death of a great personage he ordered his assistants to have plaster and tools made ready so that they could respond immediately to any request to take a death mask – the standard preliminary to producing a posthumous portrait for a monument.[3] Life masks were most often taken in connection with portrait busts destined for a country house rather than a church. Benjamin Rackstrow (d. 1772) of the Sir Isaac Newton's Head in Fleet Street advertised in 1738 that he took 'off faces from the Life & forms them into Busts to an exact likeness & with as little trouble as sitting to be Shav'd'.[4]

A life or death mask was inevitably a frontally conceived 'fossil'. To take a cast of a piece of sculpture 'in the round' with 'undercutting' was a more complicated procedure and one which in Pliny's day was thought to have been invented by Boutades.[5] It is not my purpose here to go into details; suffice it to say that it was necessary

for the mould to be divided into sections. This could either be done in stages by a clay wall (essential if taking a mould from life, marble, stone, wood, etc.), or by barriers of thin brass shim inserted into the clay model which could be removed after the mould was complete. If the mould was intended for the production of one plaster cast, it was necessary for a layer of coloured plaster to be used adjacent to the clay as a warning to the craftsman when he subsequently chipped away the mould to reveal the plaster cast (fig. 235). If a series of plaster casts was intended, or a wax cast needed as a stage towards bronze casting, it was necessary to make a piece-mould. This is a mould divided into so many sections that it was necessary to number

234 A clay portrait head being prepared for casting in plaster with a clay wall.

235 The plaster 'waste-mould'. In creating the mould the clay model must be divided by brass shim or a clay wall to enable it to be separated and cleaned. These sections are then reassembled and plaster poured into the mould, which is later chipped away – 'wasted'.

them and to create an outer mould that would hold them together for use. In all these stages a parting agent, usually olive oil, was important.[6]

The preparation of a mould and the production of a plaster cast is not so much a skill as a technique. Neither does it involve aesthetic judgement. For these reasons, casting could be sub-contracted and a highly successful sculptor would employ a specialist to take casts for him in his studio. The sculptor James S. de Ville (1776–1846) began his career in this way in the studio of Joseph Nollekens.[7] Among the sub-contractors who undertook this work in addition to doing some sculpture on their own account in eighteenth-century London were the 'figure makers' David Crashlay, John Flaxman Snr., Matthew Mazzoni, Francis Pillgreen, Sarti, and Vevini.[8] Some, such as Genelli of 33 Cock Lane and B. Papera of 16 Marylebone Street, were in addition prepared to hire casts out.

Although plaster of Paris is brittle, it survives well indoors and may be given a reasonably long life outside if the cast is boiled in oil and painted, as was done with some of the figures on the Nash terraces in Regent's Park, London. John Deare (1759–98) in a letter home to his father in Liverpool (27 June 1784) refers to 'The job I . . . put up in the country, was a bas relief in plaster of Paris, oiled and painted, twenty-one feet long for a pediment of a gentleman's house . . . I have pleased him vastly with it.'[9]

THE TOREUTIC ARTS

Casting and Chasing Metal

If to Rodin, the accomplished modeller, clay was life, plaster death, and bronze resurrection,[1] it was only to be expected that he would have little to do with the divine matters of the bronze founder. The fact was that for Rodin bronze was little more than an embalming process that gave physical permanence to works that remained, in both a technical and a spiritual sense, plastic. It was not always so; quite the contrary. An Italian bronze such as the late fifteenth-century *Arione with his Violin* (fig. 236) evidently emerged from the bronze foundry in such a rough condition that the subtleties of form were created in the metal, giving the resulting work an identity with its material that made it a work 'of' bronze and not one that was casually 'in' bronze. This identity of material and method is ultimately made, not by the master pattern or by the casting; it is the creation of the 'chaser'.

The simplest method of casting in bronze, and one used since the Bronze Age, was to reverse-carve a mould in some suitable stone that would sustain the heat of the molten metal. Sand casting and the lost-wax process were later innovations and these two methods remain in use. Although

the production of simple solid cast forms is not too difficult, the ability to hollow cast bronzes, important to minimize weight and to economize on the quantity of metal used, was a very skilful and technically difficult matter. The achievements of the Benin metal founders of West Africa in the seventeenth century and earlier are characterized by their thin, lost-wax bronzes which, though beautifully chased, often show signs of patching. At a later period, when bronze became more plentiful as a result of trade, these West African founders generally favoured thicker, and therefore more reliable, if heavier, castings. In all methods of casting the quality of the alloy and the provision of runners (along which the bronze runs) and risers (through which the gases escape) is vital and their number, positioning and gauge depends upon good judgement and experience – too few and air pockets would disfigure the cast, too many and the chaser would be involved in unnecessary work.

Bronze is an alloy which consists principally of copper with the addition of tin in varying proportions – one pound of copper to two ounces of tin was quite common. The word 'bronze' has been etymologically associated with the root of the word 'brown';[2] the mixture is therefore, to some extent, confined within that colour range although, by natural and artificial patination, many colours from black through red to pale green have been superficially achieved.[3] In the past, many bronze sculptures were cast from melted down cannon or bells but such economies were resisted in the late nineteenth century on the grounds that 'the proportions and quality of their ingredients' were unknown. No wonder Michelangelo, on being congratulated on the quality of the casting of his figure of Pope Julius II, acknowledged that he owed as much to that Pope who gave him the bronze as painters owe to the chemists from whom they obtain their colours. By the late nineteenth century, when the finest founders such as M. Collas were located in Paris and its environs, high-quality bronze was made from the best 'English or Straits [of Malay] tin, and very pure South American copper, which latter was purified by liquation'.[4]

Until the early nineteenth century, sculptors regularly worked closely with their founders even if they did not always work direct in the metal themselves, although Chantrey built his own foundry in Eccleston Place, London. In contrast to this, the materially successful sculptors of late Victorian Britain had little to do with the processes of casting their work, but they would visit the foundry dressed in their finery of silk hat and frock coat to witness the 'pouring'. On these occasions, as a form of sculptural 'largesse', they would toss a gold sovereign into the crucible in the belief that the bronze would

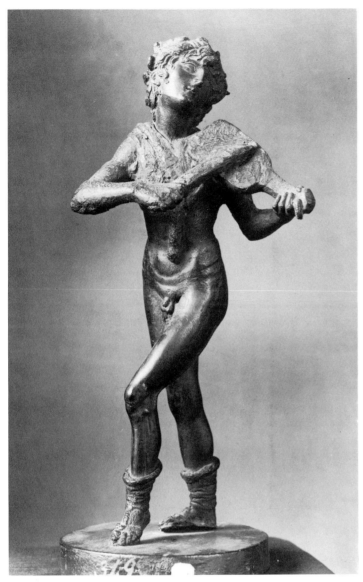

run more smoothly.[5] The notion went back to antiquity when it was believed by the Romans that the Greeks alloyed their bronze with gold or silver.[6] Even in the sixteenth century the Mannerist goldsmith and sculptor Benvenuto Cellini describes in his autobiography the harrowing details of the casting of his *Perseus*. In this instance, after the 'gates' had been opened and the bronze began to run, disaster struck – the metal cooled. To rescue the situation Cellini gathered together all the pewter vessels in his house and threw them into the molten bronze.[7] The addition of gold, silver, or alloys like pewter would have had the effect of lowering the melting temperature and increasing the fluxion of the bronze.

In all forms of casting, in bronze, gold, iron, glass, or for that matter plaster, the positive form, the master pattern, must be translated into a hollow space enveloped by the mould, the negative. Into this the material to be cast is poured in its molten or liquid state to produce

the cast, the positive. Simple examples of the process are the Wealden firebacks of Sussex. At first these were made by impressing various objects, such as rope, into a sand-filled tray – this was the mould that received the molten iron. Later the process was slightly refined by the use of carved-wood patterns that were impressed into the sand.

For elaborate three-dimensional casts the moulding boxes for sand casting are constructed of cast iron bolted together. Special sands or loams are used in sand casting. Leonardo da Vinci mentions 'river sand' but does not tell us which part of which river,[8] and Benvenuto Cellini makes reference to founder's tufa earth but reserves special praise for the sand which is found in the bed of the River Seine at Paris, especially that found by the hard at Sainte Chapelle.[9] In late nineteenth-century France two types of sand were in use, both of which came from Fontenay des Roses near Paris,[10] and in Britain green sand found in Somerset was preferred. All these

236 *Arione with his Violin*, unfinished bronze, Italian, late fifteenth century. Most of the significant subtleties in the modelling of this figure were worked directly in the cold metal (annealed at intervals) by the chaser. *Museo Nazionale, Florence*

237 Benin bronze head, West Africa, mid-sixteenth century, life size. Hollow-cast bronzes, such as this early Benin example, demonstrate remarkable technical skill by the foundry. *British Museum, London*

sands are somewhat oily to the touch, a property which helps the mould maintain its precision. For 'facing sand' this feature could be improved by the addition of a mixture of potato starch and ground charcoal,[11] and Cellini recommends smoking a sand mould with a candle.[12] Despite the care that these 'tricks of the trade' imply, sand casting retains less detail than other methods based upon a mould made of a fire clay such as a mixture of brick dust, plaster, and refractory clay in equal parts by volume. For this reason large figures are sometimes sand cast with the heads produced separately by the second method. The British bronze founders Morris Singer cast Epstein's *Archangel Michael* for Coventry Cathedral in this way. When one piece of sculpture is cast in separate sections it is advisable for both the sculptor and the founder to make allowance for the differing shrinkage of the two or more parts – the greater the volume, the greater the shrinkage. For preference the jointing of such a bronze should be obscured by drapery or some such camouflage in anticipation of any discrepancy. In such circumstances the method, the medium, will condition the design.

Hollow cast metal sculptures of any size require considerable technical accomplishment. The Egyptians were able to produce such bronzes, especially with smaller work, by means of the lost-wax process. At times they incorporated as part of the 'core' the mummified remains of the subject of the bronze – a falcon

or a cat. Benvenuto Cellini seems to have had a similar veneration for the 'core' which he refers to as the 'anima' or soul.[13] Larger figures, such as the ram-headed deity (fig. 238) were cast solid but in sections. The earliest surviving hollow cast Greek bronze of any size is the Kouros from Piraeus which stands 6 ft. 3 in. (1.90 m.) in height and dates to about 530 BC.[14]

Many of the techniques for hollow casting large figures were apparently lost in the Byzantine, Romanesque, and early Medieval periods. It is difficult to be certain on this point since so much was later melted down.[15] The effigy of Blanche de Champagne, duchesse de Bretagne, who died in 1283 must once have resembled a large bronze casting but is in fact composed of a series of copper plates tacked onto a wooden effigy.[16] It was probably made at Limoges and its poor condition makes its method of production quite evident. A related figure, probably also from the same workshops, is the monument to William de Valence at Westminster Abbey. This effigy, which dates from 1290–1300, is in such a miraculous state of preservation as to demonstrate the remarkable resemblance to bronzes that assembled repoussé work could achieve. Such effigies relate to those that were carried in

238 Ram-headed deity, Egyptian, 750–600 BC, height 36 in. (91 cm.). This figure is a primitive sand-cast bronze, produced in three solid sections. *British Museum, London*

239 Visual notes by Leonardo da Vinci showing the armature to support his bronze horse for the *Sforza Monument* (1491–3). *Royal Library, Windsor Castle*

a funeral procession and which were either themselves used as a memorial to the deceased or were later translated into marble, stone, or bronze. This technical and historical association is confirmed by James Hales, 'le imaginator', who in about 1507 made the wooden effigy of the Earl of Derby as the pattern for the bronze figure which was the Earl's memorial in Burscough Priory, Ormskirk, Lancashire.[17] A technical conundrum occurs in Vasari's description of Donatello's bronze doors for the Baptistry of S. Giovanni at Siena for which the sculptor made a wood 'core' and then the wax shell.[18] It is more likely that the 'core' was in fact the master pattern, such as was made by Hales.

A reference to the lost-wax method of casting occurs in Pliny as a result of his visit, at some point in the third quarter of the first century AD, to the studio of Zenodorus, who was then engaged upon a colossal figure of Nero, $119\frac{1}{2}$ ft. in height. Pliny was not only excited by the quality of the likeness but also by 'the slender tubing' – evidently a reference to the runners and risers (described below) which were necessary for bronze casting. A thousand years or more later Theophilus gives one of the first detailed accounts of the lost-wax process in relation to the casting of the handles for a chalice.[19]

The great difficulty with hollow cast works was to suspend the 'core' or inner mould equidistant from the outer mould at all points so that the resulting cast would be of an even thickness. The thinner the cast, the less room for error. In the lost-wax process the technique, in essence, was as follows. The wax was either modelled on the core or the sculpture was hollow cast in wax and this was filled with a heat-sustaining clay. Heated iron nails were then driven at right angles through the wax into the core and left projecting. Pre-cast rods of wax were then bent and attached to the wax sculpture. These would eventually form runners and risers. This part of the operation required considerable experience and judgement. The arrangement of the runners was designed to deliver the molten bronze in successive layers to particular areas in such a way as not to create or trap air pockets. It was the function of the risers to facilitate the escape of any such bubbles or pockets of gas. Once these details had been achieved, the mould was made with a heat-sustaining material and this completely enveloped not only the sculpture but also the wax runners and risers. The core and outer mould were made of various components mixed

240 A sculptor's workshop and foundry, from a Greek bowl of *c.* 480 BC. *Staatliche Museen, Berlin*

together and allowed to dry like a cement. The *New Universal Dictionary of Arts and Sciences* (1754) recommends 'a mixture of clay, horse-dung, and hair, or a mixture of parget and brick dust'. The concoction was given further stickiness by using old crucibles pounded to dust and combining this with urine or water and the whites of eggs, which the *Dictionary* aptly describes as 'this incrustation'.[20] Once the 'investment' was dry, the whole was placed in a kiln and the wax melted out. It is this stage which lends its name to the process. The pins that had been driven through now supported the 'core' in space within the mould, and the rods of wax formed runnels and tubes. The bronze would occupy all these spaces. In pouring the bronze, or other metal, the mould was heated once again. This served to prevent the bronze cooling prematurely but it also erradicated any moisture that, in conjunction with the molten metal, could cause a dangerous explosion and the destruction of the work. With very large bronzes it was

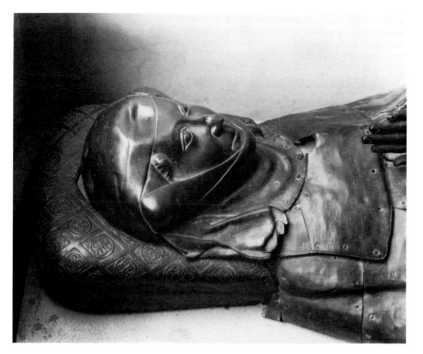

241 Effigy of Blanche de Champagne, Limoges, late thirteenth century, gilded and enamelled copper on wood. When first made, such life-size effigies may well have resembled bronzes. *Musée de Cluny, Paris*

242 Casting a large equestrian group, from Diderot's *L'Encyclopédie*, showing the investment (or mould), the armature (supporting the core within the outer mould), the runners and risers, and the kiln ready for pouring the bronze.

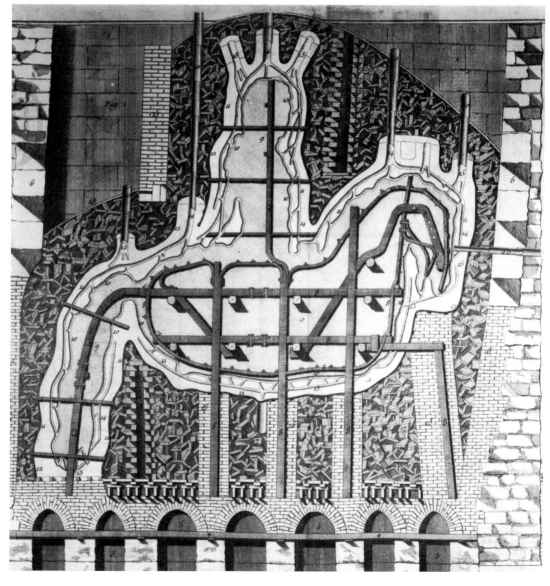

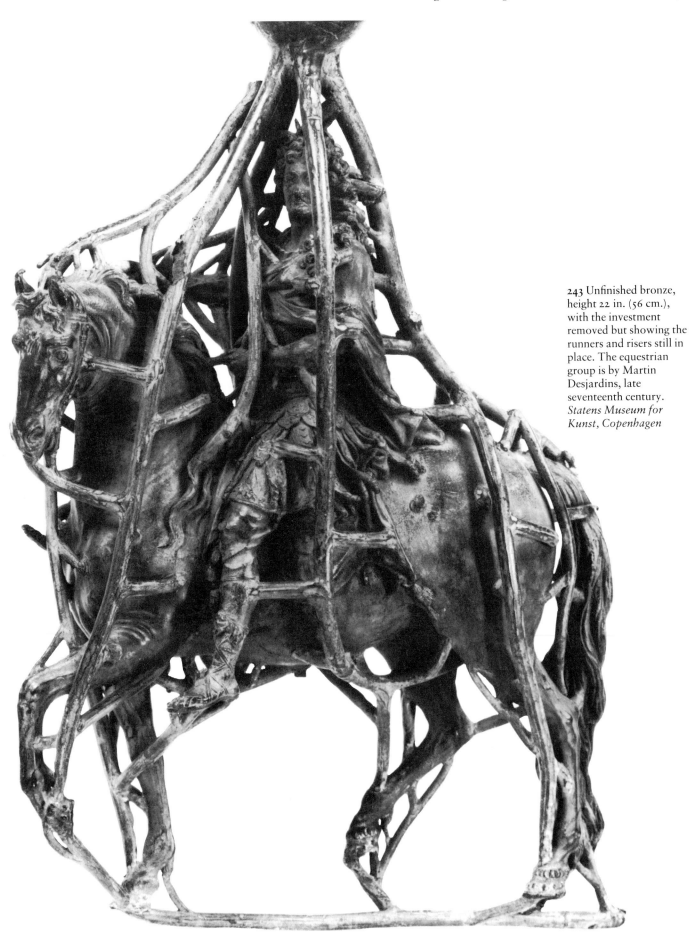

243 Unfinished bronze, height 22 in. (56 cm.), with the investment removed but showing the runners and risers still in place. The equestrian group is by Martin Desjardins, late seventeenth century. *Statens Museum for Kunst, Copenhagen*

necessary to bury the mould in the ground (known to Vasari as the 'casting pit') and build a furnace beneath it. In these circumstances Leonardo da Vinci recommended that the outside of the mould should be given a coat of pitch to minimize rising damp.[21] More effective was the method shown by Diderot in his *L'Encyclopédie* in which the entire mould was built into a furnace (fig. 242).[22] The casting in one piece of Bouchardon's great equestrian statue of Louis XV in 1758 was such a colossal undertaking that the City of Paris decided to publish an illustrated record of the event by Pierre-Jean Mariette, who based his account on the detailed notes made by Lampereur.[23] In 1778 Étienne Falconet (1716–91) personally directed the *cire perdue* casting of his mounted figure of Peter the Great.[24]

The various methods of casting in bronze outlined above could also be applied to casting in other metals and even in glass – a method much used by Lalique. Donatello's *Chellini Madonna* is a remarkable example that combines both (fig. 244). Lead melts at a very low temperature and this, together with its considerable weight, made lead casts cheap. For these reasons sculptors like van Nost, Andries Carpentière, and Henry Cheere virtually mass-produced such sculptures as garden ornaments.[25] For large figures an iron armature was necessary, however, since lead, unlike all but the largest bronzes, is not capable of supporting its own weight. Lead

requires less technical knowledge than bronze and at least one sculptor, William Brodie (1815–81), began his career as an apprentice plumber casting small figures in lead in his spare time; the sculptor John Bushnell was the son of a plumber. His death is recorded at Paddington where the Parish Register records, 'May 15th 1701. Buried John Bushnell, an image-maker', which demonstrates the persistence of a medieval term and, one suspects, attitude to sculptors and sculpture at least among clerics. These examples go some way to explain John Devall's (1701–74) business, which combined the skills of the mason, the plumber, and the sculptor.[26]

Cast iron probably reached the zenith of its possibilities in Prussia in the first half of the nineteenth century when foundries such as those at Gleiwitz (now Gliwice, Poland) and Berlin employed sculptors like Leonard Posch (1750–1831) and Frederick Ludwig Beyerhaus (1792–1872) as pattern makers.[27]

In the Italian Renaissance many sculptors, among them Michelangelo and Donatello, employed bell and cannon founders to cast their work but others, such as Ghiberti and Cellini, undertook it themselves. Vasari goes so far as to ascribe Verrocchio's death in 1488 to the sculptor's overheating when engaged on casting his *Bartolommeo Colleoni da Bergamo* in Venice.[28] By the late eighteenth century, founders such as Francesco Giardoni were providing specialist services.[29] Whether the involvement was direct or indirect is of little consequence for although bronze casting involves remarkable skills, it remains in essence a technical matter. The crude casting of the *Arione* (fig. 236) shows how coarse such castings could be. Vasari contrasts Ghiberti's early and disastrously badly cast bronzes with his later castings,[30] and speaks with wonder regarding the secrets that Bonaccorso had inherited from his grandfather, Ghiberti, concerning bronze casting, 'so that they came out very delicately',[31] or the castings of Jacopo Ciciliano which were 'so delicate and smooth they hardly need polishing'. Even Cellini, who as a goldsmith and sculptor was skilled in such matters, refers to bringing out a 'bronze as clean and perfect as the clay'.[32]

Casting in metal was therefore a highly technical skill, whereas chasing by any standards was an art. The cleaner the cast, the less work it rquired, but at a minimum the rods that formed the runners and risers had to be sawn off and worked over, and the iron pins that once held the core in position had to be removed and the resulting hole plugged with bronze and chased over. John Barrow's *Dictionary of Arts and Sciences* (1754) alludes to the 'picks, puncheons, scrapers, great and small chisels, and round and

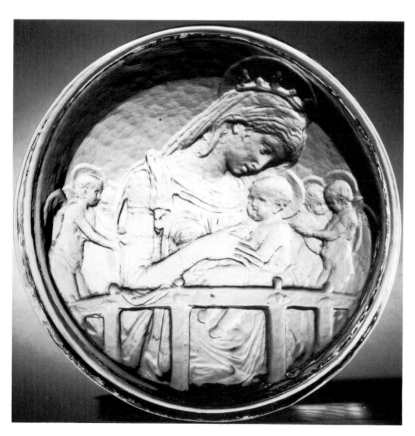

244 Donatello's bronze relief tondo, known as the *Chellini Madonna* (before 1456), is hollow-cast, so that the back is an echo of the front. The 'negative' back was elaborately chased to provide a mould for glass casts. The example illustrated here is a modern cast in glass – diameter 11¼ in. (28 cm.). *Victoria and Albert Museum, London*

sharp gravers' which were used to 'clense' the cast after which it was passed to the sculptor for 'the finishing strokes'. In a casting like the *Arione with his Violin* the subtleties of sculpture could be said to begin with the chasing.[33] For this reason, many sculptors reserved this important stage for themselves or their immediate assistants. Among those who are reported to have worked direct in the metal in this way were Francesco di Giorgio of Siena[34] and Masolino da Panicale of Valdelsa.[35] These sculptors were following the medieval outlook that saw making and creating as synonymous. It was with this understanding that 'image makers' such as William Torel and others supplied the triple skills of sculptor, bronze founder, and chaser for the series of effigies in Westminster Abbey. Another example was the later medieval craftsman Peter Vischer of Nuremberg.[36] Masolino was considered to be Ghiberti's best finisher in working on the Baptistry doors in Florence where his punches and chisels made 'with all the more dexterity certain soft and delicate hollows, both in human limbs and in draperies'.[37] From that description it will be evident that chasing was not simply a question of ironing out little irregularities resulting from the casting process with files and rifflers. Chasing was not just a matter of surface, it was matter of substance, of creation. It was an art that involved the removal of metal, making it akin to carving, and it was also an art that involved the manipulation of metal rather than its removal. In this way sculptural reliefs could be created direct in the cold metal. In short, the chaser was a sculptor. Individuals like Diederich Nicolaus Anderson (d. 1767) and Charles Magniac (*fl.* 1740–69) were known as chasers and modellers,[38] as was George Michael Moser, the first Keeper of the Royal Academy and its teacher of drawing.[39] Another eighteenth-century London chaser, Henry Pars, later ran Pars Drawing School (101 The Strand) which prepared students for the better known St Martin's Lane Drawing School.[40] Moser's early speciality had been the making of elaborately chased cane-heads and watch-cases, and in this his work relates to the ormolu mounts used in French furniture which were made by the *foundeurs-ciseleurs*, the most famous of whom was Pierre Giouthière (1732–1813/14). So important were these sculptural elements in this aristocratic furniture of eighteenth-century France that one *ébéniste*, Charles Cressent (1684–1754), was trained both as a sculptor and as a furniture maker. The *ciseleur* Jacques Caffieri (1678–1755) came from a long line of sculptors, and Louis Dubois (1732–90) abandoned furniture making in favour of sculpture, being admitted to the Académie de Saint-Luc in 1768.[41] In London such work was under-

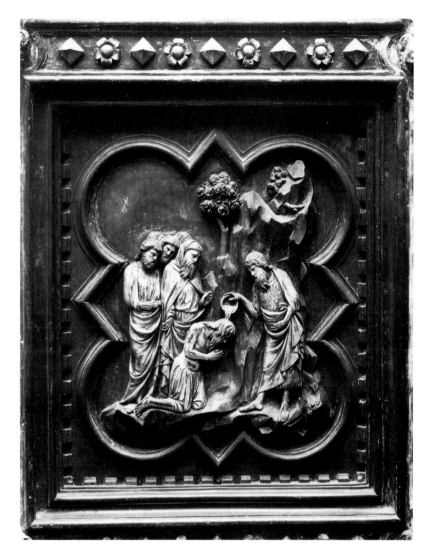

245 Andrea Pisano, one of the quadrilobe panels of the Baptistery Doors, Florence, 1330 – bronze, parcel gilt.

246 Detail of the chased and gilt bronze (ormolu) mounts on the 'Dragon commode' by Charles Cressent (1684–1754). Cressent trained as both a sculptor and a furniture maker. *Wallace Collection, London*

247 Mr J. E. Clark, the chaser, at work on the Moss Bros. Trophy in 1950.

248 Trial silver panel, $6 \times 4\frac{1}{2}$ in. (15.2 × 11.5 cm.), used by Mr J. E. Clark preparatory to working on the Moss Bros. Trophy (see fig. 247). The chasing was done direct in the cold metal, which was backed by pitch. *Private Collection*

taken by John Giles and Shadrach Mulliner who advertised themselves as 'Cabinet Founders and Ironmongers'.[42] Later, Matthew Boulton in Birmingham supplied not only the British but also much of the foreign demand.

As long ago as 1877 C. Drury E. Fortnum in his book on *Bronzes* remarked that 'Unfortunately the processes of finishing are now too frequently delegated to other hands, dexterous perhaps in the manipulation of tools, but having neither the experience nor ability to comprehend the spirit of the sculptor's model.'[43] Perhaps the last chaser capable of working to eighteenth-century standards was the late J. E. Clark, who died in about 1955 (fig. 247).

Die-Sinking

The work of the chaser was in many ways related to that of the die-sinker who also worked direct in metal to produce the dies that would strike coins, medals, tokens, and seals. The relationship between the two skills is amply demonstrated by Benvenuto Cellini who was accomplished in both. There were of course differences between the two arts. The die-sinker, although working metal, was not handling the final material in which his work was to appear. Nevertheless, coins and medals struck with dies cut direct in the steel necessarily share the toreutic nature of the original dies. They were, moreover, created at the size they were intended to appear. This gives a fundamental harmony to the results where both the dimensions and the material are in keeping, one with the other. In these respects Pisanello's medallions, which were modelled in wax and cast rather than struck, fall outside the traditions of medals and coins, which may explain the quarter-century delay before his designs influenced coinage.

Before the Industrial Revolution die-sinkers were appointed directly by the monarch in whose service they worked in the production of dies for relatively small and numerous mints. In the early modern world the die-sinker was, for an all too brief period, an artist in the service of the Crown. He was not, as he later became, a wage-slave working in an industry administered by a civil service which could not understand a body of craftsmen who were not identified as an élite by a white collar. When Sir Isaac Newton was appointed first as Warden (1694) and then to the top post of Deputy Master of the Royal Mint (1697) he occupied a position of profit under the Crown – a position that was then one of relative equality with that of the chief die-sinker.

The personal patronage which was the prerogative of the ruler is evident in the case of Thomas Simon and the Rottier brothers. In Britain Cromwell maintained his responsibilities as head of state in this respect and appointed 'the inimitable Simon', as Walpole so rightly described him, as his chief die-sinker. After the Restoration, Charles II was less than inclined to confirm Simon in his post. Besides, during his exile Charles had promised his goldsmith banker, Rottier, that he would appoint his sons to the post. Accordingly, at the Restoration John and Joseph Rottier 'were immediately placed in the mint and allowed a salary and a house, where they soon grew rich, being allowed £200 for each broad seal and gaining £300 a year for sending great numbers of medals abroad.' Simon of course remained the superior artist and his famous 'petition crown', which was addressed direct to the king, re-established his position at the mint without dislodging the Rottiers.[1]

Members of the Rottier family were also heavily involved with the Paris mint and in 1682

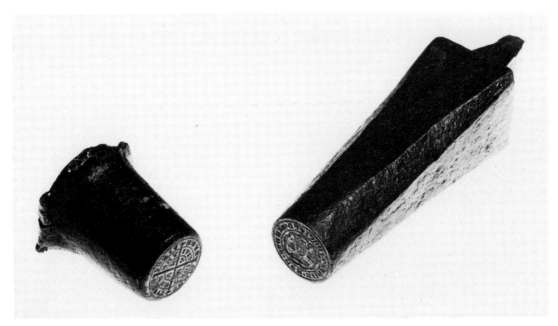

249 A pair of dies for a groat of Edward III (1327–77). *Royal Mint, Llantrisant*

250 The die-sinker Jean Varin showing an antique medal to the young Louis XIV, *c.* 1644, oil on panel. Die-sinkers, like other artists, worked under the direct patronage of the monarch. *Musée Monétaire, Paris*

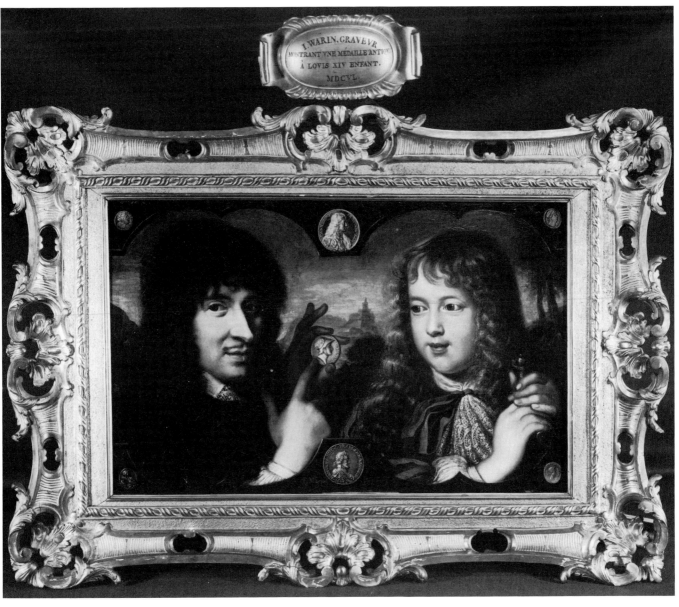

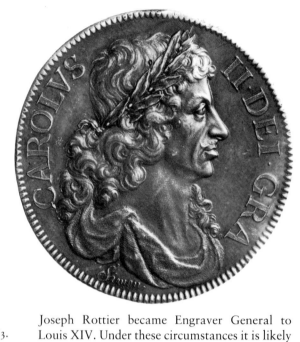

251 Thomas Simon's 'Petition Crown', 1663. Simon submitted this crown to Charles II in order to persuade the King to reinstate him as die-sinker to the Royal Mint. *Ashmolean Museum, Oxford*

Joseph Rottier became Engraver General to Louis XIV. Under these circumstances it is likely that the Rottiers were at least as much employers as makers of dies. The administrative position of chief die-sinker continued at the London mint when a man named Harris was appointed to succeed the Rottiers. Harris, who was apparently 'incapable of the office, employed workmen to do the business.' Fortunately in this case, Harris's chief 'workman' was 'Mr Croker who afterwards obtained the place'.[2] These early instances of 'official' die-sinkers sub-contracting the actual work mark the beginning of the declining status of the die-sinker and, since they were no less subject to vanity than anyone else, a decline in the quality of their work. On the other hand, it was perhaps inevitable that as mints became mechanized so they would evolve from simple workshops concerned with quality to complex factories preoccupied with unit costs and in which the die-sinker would have little place. The die-engraver would inevitably lose his position as an artist operating under the direct patronage of the head of state. In the twentieth century, coins and medals have been all but forgotten as an avenue for patronage in the visual arts. In contrast to this, the great Elizabethan limner Nicholas Hilliard towards the end of his career became less concerned with the craft of limning and more preoccupied with the art of the medallist.[3] To Vasari, as to Evelyn and Walpole,[4] medals and coins were quite naturally reviewed as an art form and so they remained at least down to the time of the Wyons and Pistrucci, who between them dominated the work of the Royal Mint for the first three quarters of the nineteenth century. They were all practical die-sinkers but it was their genius that rose above the 'advantages' of industrialized methods of production. In this the two Thomas

Wyons, father and son, had the advantage of having been employed in the industrialized conditions of Matthew Boulton's commercial mint in Birmingham – they understood the system as well as the craft.[5]

The dies for the coins and medals of Classical antiquity were evidently worked direct in softened steel which was later hardened for use. The high relief of these early coins gave the dies a very short useable life and they were regularly recut. In sixteenth-century Italy this wasteful and expensive system was adjusted and die-sinkers turned to the production of 'positive' dies of elements in a coin or medal (such as heads, lettering, or beading). These were then used to strike an intaglio (or negative) die which was employed in the actual production of the coins but which could easily be reproduced by striking a fresh intaglio die from the assemblage of the constituent positive dies. Cellini in his *Treatises* confirms this procedure:

> The men who did the best work in coining always did the whole of the work upon either the punches or the matrices, and never touched up the dies with either gravers or chisels, for that would be a great blunder as all the various dies necessary for making many impressions of the same coins, would be a bit different.

This system explains Cellini's remark that the *punzoni* 'are the mothers that may be said to beget the figures and all other things you fashion in the die'.[6] By the seventeenth century, most dies were cut in their entirety in the positive master die which was the definitive authority from which many identical intaglio dies could be struck.

These technicalities go some way to explain Walpole's account, no doubt taken from Vertue, of the die-sinker 'Martin Johnson [who] was a celebrated engraver of seals and lived for a time with Thomas and Abraham Simon, the medallists. He was a rival of the former, who used puncheons for his graving, which Johnson never did, calling Simon a puncher, not a graver.'[7] In other words, Johnson used the outmoded method of working in intaglio in the final die without producing positive master 'puncheons'. The Walpole/Vertue account is, as Mr Walter J. Newman (for many years the principal die-sinker to the Royal Mint) has pointed out, an oversimplification.[8] Die-sinkers work in three basic stages: (i) the Master Matrix (a negative); (ii) the Master Working Punch or 'Puncheon' (a positive); and (iii) the Production Die. Die-sinkers regularly work with punches, in the manner of chasers, on positive dies and with gravers in negative dies. In addition, Vasari mentions the use of small grinding wheels such as

252 Coin press, from Diderot's *L'Encyclopédie*.

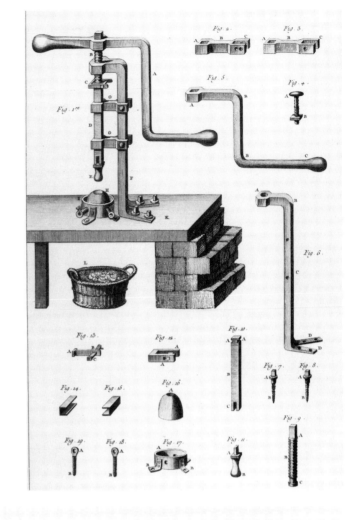

253 Bronze medal by Küchler, diameter 1⅝ in. (40.2 cm.).
OBVERSE: A portrait of the great industrialist Matthew Boulton.
REVERSE: Shows the relationship between the diameters of coins and medals and their rates of production. The inscription, in French, states that Boulton introduced a steam press for striking coins to his Soho (Birmingham) mint in 1788 and added further mechanization in 1798. *Birmingham Museum and Art Gallery*

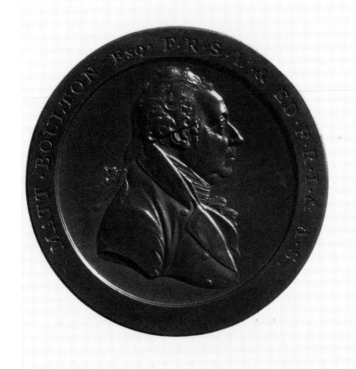

those used to cut seals in precious and semi-precious stones.[9] The use of the drill for making dies is confirmed by the marble memorial to P. Licinius Stolo, *c.* 15 BC, which includes a representation of a die-cutter's bow drill. Where repetition occurs, as for example in a series of stars, a small positive punch in the desired shape is used to punch into the intaglio die. Work on the production die is kept to a minimum for the reasons given by Cellini. The superfluous metal surrounding a die should, as Cellini makes clear, be filed off with a very low-angled bevel to minimize the weakness of a feather-edge which would soon snap in use.[10] At various stages the matrix, the puncheon, and the production dies are tried in lead. When completed, the dies are heated to a 'cherry red' and plunged in cold water to harden them for use.[11] Once the production die became worn, the die-sinker reverted to the authority of the master matrix.

Separate dies were of course necessary for the obverse and reverse of a coin or medal. To Cellini, the lower die which was the obverse was known as the *pila* and the reverse die was known as the *torsello.*[12] Since the obverse and the reverse are, as dies, two separate entities, two different die-sinkers could be commissioned to provide the designs, an eventuality that Cellini condemns in his *Autobiography.*[13]

The production of coins and medals, no less than the creation of dies, has also had its impact upon design. The simple 'hammered' coins of medieval Europe are low in relief and generally fairly small in diameter. The similarly produced coins of the Greeks and Romans may be high in relief but they too are small in diameter. High relief coins and medals of a large diameter were more difficult to produce especially in harder metals like bronze (silver and gold are more malleable). Cellini circumvented this problem by

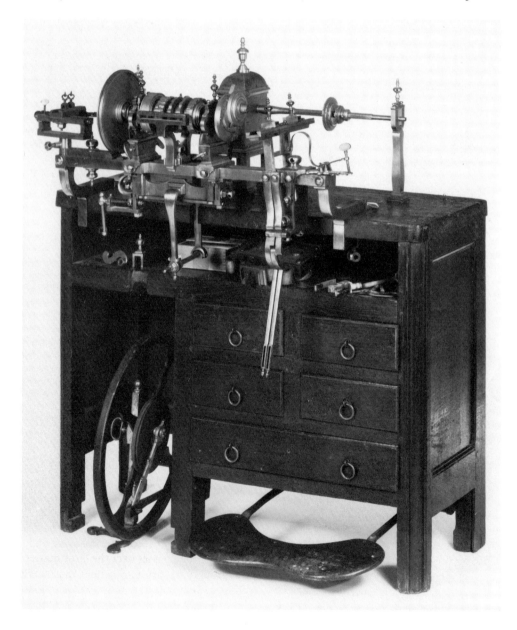

254 Medallion lathe, once the property of Prince Charles of Lorraine, Governor of the Belgians – French, 1760–90, brass and steel mechanism mounted on an oak bench. These lathes could both enlarge and reduce coins in positive and negative. The reducing machine (fig. 255) was a development of this type of lathe. *Sold at Sotheby's, London (19 May 1983)*

devising coin presses and also by initially sand casting his coins and medals before striking or pressing them.[14]

The German and French mints were using presses for coins and medals from the mid-sixteenth century, and later in the century they were introduced to the London mint by the Frenchman Eloi Mestrell. However, either because of the primitive nature of these presses or because of the resistance of the guilds, their use was largely confined to medals whose larger diameter and greater relief demanded their use.[15] Once Peter Blondeau had been given his 'letter of denization' in England on 3 November 1662 he received a grant from the Commonwealth government as the chief engineer at the mint in the Tower of London where he used 'his new invention for coining gold and silver with mill [for rolling metal for "blanks"] and press'.[16] Associated with the widespread introduction of the 'mill and press' in western Europe in the mid-seventeenth century was the use of milling to discourage clipping. Evelyn refers to 'the *Mill'd Moneys*', an innovation that depended upon 'the Contrivance of the Circumscription about the Tranche . . . and its inventor (who ever he were) worthy the Honor of a Medal himself; whether due to Monsieur *Blondeau*, our Industrious *Rawlins*, or to *Symon* . . . [or] Monsieur le Blanc'. Evelyn refused 'positively to determine' these rival claims since some ascribed the invention of a machine that '*Stamp'd*, *Cut* and *Rounded* Money by one Operation only' to a mint in Venice.[17]

All these developments and the capital investment which they signalled led to the demise of the once numerous provincial mints. When Celia Fiennes visited Norwich in 1698 she noted that 'Here was also the Mint which they coyn'd at, but since the old money is all new coyn'd into mill'd money, that ceases.'[18]

The relation of relief, diameter, and the life of a die to the rate of production of coins and medals was well understood by Matthew Boulton who commissioned Küchler, his die-sinker at the Soho Mint in Birmingham, to produce a medal demonstrating that relationship. Perhaps inevitably the great pioneer eighteenth-century industrialist possessed sufficient vanity and entrepreneurial skill to have his own portrait placed on the obverse of this medal whilst the reverse, marked with varying diameters and their rates of production, is inscribed, in the interests of a healthy export trade, in French.

The greatest and indeed the most devastating innovation was the introduction in the late eighteenth century of the reducing machine. This was a development of the medallion lathe, which was a fashionable toy of the time. Matthew Boulton owned such a lathe and his partner

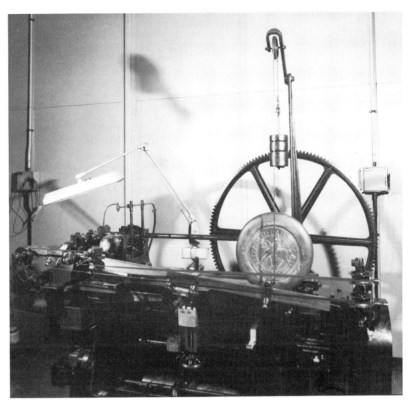

255 Reducing machine. These machines first came into use in the late eighteenth century. *Royal Mint, Llantrisant*

James Watt was much involved in various methods of reproducing sculpture in the round at different scales. In 1789 Boulton instructed his Paris agent Foucault to recruit a mechanic to make a reducing machine capable of reproducing a die from a steel master. In 1790 Jean Baptiste Barthélémy Dupeyrat (1759–1834) was commissioned to design and produce such a mechanism and install it in Boulton's Soho works in Birmingham. This early reducing machine was dispatched in the same year although, doubtless in the interests of trade secrecy, its arrival in Birmingham seems to have gone unrecorded.[19] Before the introduction of such machines, dies for coins and medals had been made both direct in the steel and of the size they were destined to be. After centuries of achievement that tradition was disrupted. Coins could now be modelled in wax, cast in plaster, and reduced by machines to the scale and the steel of the master matrix. The die-sinker was all but redundant, his work being confined to cleaning the master matrix and the subsequent stages down to the production die. No longer was there a limit to the amount of detail. Medals that had once been created with the discipline of the 'Art of the Possible' could now indulge an art of the seemingly impossible.

The reducing machine is in effect a pantograph that is capable of recording both line and relief. A blunt probe passes over the large master relief design and a sharp tool echoes that movement on a smaller scale and cuts the master matrix as it revolves (fig. 255).[20]

One of the more unusual demands for good quality coin designs was alleged to have come, so Prince Hoare avowed, from a need to avoid counterfeiting. If, so the argument ran, a die was engraved with 'a superior degree of excellence', it would 'set at defiance the imitation of ordinary workmen'.[21] Ultimately, coins and medals depend not only on the individual sculptor but also upon his working direct in the dies to produce toreutic qualities at a size and scale appropriate to them. In the absence of such a basic requirement these miniature relief sculptures too easily become not simply small but trivial.

THE GLYPTIC ARTS

In common with so many of the books published before the Industrial Revolution, John Barrow's *Dictionary of Arts and Sciences* (London, 1754) conveys a tactile understanding of materials which was widespread before machinery intervened between man and his products. Barrow defines sculpture as 'an art which, by means of a design or plan and of solid matter, indicates the palpable objects of nature. Its matter is wood, stone, marble, ivory; different matters as gold, silver, copper; precious stones, as agate and the like. This art includes also, casting or founding.' As we have seen, the word sculpture originally related to the process of cutting and in Barrow's day the word apparently retained this sense since casting and founding appear as something of an afterthought. The following pages are therefore concerned with sculpture in the original and primary sense of the word.

Both wood and stone have been used by simple societies since earliest times. Except in treeless regions such as the Arctic, wood has been the most widely used material. Apart from the use of surface boulders the exploitation of stone requires considerable social organization. Against this, and in marked contrast to it, wood, if it is to be carved to its maximum potential, demands much greater skill of the individual than stone or marble.

Stone, marble, slate, and granite each have their peculiarities as do the species of materials that fall under each generic name. The heat-formed materials of marble and granite require a 'skinning' technique which distinguishes them from most types of stone (except those that have a marble-like texture). The characteristics of stone and marble are in fact so distinct that different (if related) tools are used to work them. For this reason no sculptor would refer to stone and marble synonymously.

Many outside 'the trade' naturally view wood and ivory as quite unrelated materials and yet to a wood-carver holly and ivory are so close in quality that the same tools may be used for both. Curiously, stylistic comparisons between sculptures in wood and ivory have been made by art historians without any apparent awareness of this association between the two materials.[1]

The craftsman of the pre-industrial society was in touch with both the source of supply of his raw materials and in daily contact with the smiths who made his tools. In sculpture this resulted in carvings worked from carefully selected stone and appropriate and well-seasoned timber which was worked with tools subtly adjusted to the requirements of the individual craftsman and his material.

Carving in Stone and Marble

Until the twentieth century, quarrying was generally such a small-scale activity that the presence of disused workings are often obscure to all but the practised eye. A great crater such as that at Delabole, Cornwall, was the exception. The presence of a quarry is generally most noticeable by its influence on the buildings in a district. An abundance of a material and its use in exceptionally large scantlings indicates its local availability.[1] Such a natural resource inevitably created a highly skilled workforce to exploit it, where knowledge was passed down the generations by example and by word of mouth. Among the heirs of such wisdom were the sculptor Angelo Bienaimé (*fl.* 1829–51), who was born at Carrara and studied under Thorwaldsen; Wren's chief mason Christopher Kempster, who was born at Burford and was therefore familiar with Taynton stone; and in this century the Haysom brothers of the Isle of Purbeck. In the latter case so much of the so-called Purbeck 'marble' (it is in fact a limestone that is capable of being polished) had been worked out in early medieval times that the Haysoms' local knowledge was necessarily encyclopaedic in locating the few surviving quarries that held the narrow beds of this always rare and now virtually extinct material.

In general, stone is a sedimentary substance in contrast to marble and granite which are the result of the metamorphosis brought about by volcanic activity which destroys the fossil material. It is the latter which so often gives stone its character, whilst its colour and colour variation may, as in marble, be attributed to chemical staining. Because stone was laid down geologically in sedimentary deposits it is important that it is used 'on bed' – that is to say, used with the stratification of the successive sedimentary layers running horizontally. If this rule is not observed the rain and frost will penetrate the 'end grain' and split the stone. It is this very property that is put to such good effect to split stone roofing 'slates' such as Collyweston.[2]

Monks Park, Claverton Down, and West-wood all produce fine building stones; they are know collectively, especially outside their point of origin, as Bath stone, but locally each is known for its particular strengths and weaknes-ses. In a letter from John Deare (Rome, *c.* 1785) to his father in Liverpool, the sculptor remarks that 'In the quarries about Siena, they reckon there are thirty-two different sorts of marble.'[3] The same is true in most quarrying districts. In addition to the white marble the quarries at Car-rara once produced black, red, and grey marble. Since the Renaissance the white marbles of the quarries at nearby Seravezza (near Pietrasanta) have been even more important than those of Carrara.[4] Despite this, the quality of a stone or marble is not only influenced by the location of the quarry but also by the depth at which it is extracted (unless the 'bed' is tilted by a geological fault). In general, the better stones and deeper seams are found at greater depths, which is why the Bath stone 'quarries' are so often in fact stone 'mines'.

In cutting the stone in the quarry in the tradi-tional way it is sawn with 'frig bobs' and drilled and split with wedges and 'feathers'. In soft-stone districts it was often sufficient to chase a groove with a pick (also known as 'jadd' or 'racer') and then drive a series of small wedges known as 'gads' into the groove.[5] In freestone districts where stone is soft and therefore freely worked, double-headed axes may be used to 'dress' the blocks.

The men who worked freestone were free-masons but the term also held significance in relation to the freedom granted to associations of masons who held their own assemblies under the 'Constitutions' which gave them in English law a position comparable to the Tinmen of the Stannaries in Devon and Cornwall, or the Free Miners of the Forest of Dean.[6]

Once the block of stone or marble was detached from 'the living rock', much skill and ingenuity was then applied to moving it away from the quarry face by means of rollers or sturdy waggons. The moving of stone was solved by Ralph Allen in Bath by means of a tramway and the Kennet and Avon Canal was similarly inspired by the need to transport stone. To lift the unworked block from the quarry various windlasses and, by the fifteenth century, jib cranes were used. The man-powered treadmill provided a traditional motive force and a few such treadwheels survive in the towers of Canter-bury and Salisbury Cathedrals, at Beverley Min-ster, and at St James' Church, Louth.[7] Lifting tackle was most effective if geared to minimize the power necessary to hoist the often consider-able weights involved. By means of wheels and counter-weights Brunelleschi contrived to lift a block of stone with one ox where previously six had been insufficient.[8]

Upon their arrival at the masons' 'lodge', the rough blocks were worked by the 'mason hewers', as they were known in the Middle Ages to distinguish them from the 'mason layers'. In modern English these craftsmen are known as 'banker masons' in reference to the block of stone that serves as a mason's bench, and 'fixing masons'. Until the Industrial Revolution pro-vided an effective transport system it was somewhat an optional question as to whether stone should be worked at the quarry so as to reduce transport costs (as was the case with Pur-beck marble) or whether the unworked stone should be sent to the site where the hazards of the journey would not place months of work in jeopardy. In London something of a compromise was arrived at. The unworked stone was carried by water (later by rail) to numerous stoneyards which until recently were located on the south bank of the Thames. In these yards the stone was worked and then carried the relatively short dis-tance across the river to various prestigious building undertakings. Otherwise, most pictures showing pre-industrial building operations in progress suggest that stone was most often worked *in situ* where measurements could be checked. Purbeck marble was probably an exception to this rule because the hard fossils in their relatively soft matrix make it a peculiarly difficult material best handled by specialists. The tradition for masoning on the site has continued

256 Monolithic turned Bath-stone urns (*c.* 1748) on the gate piers of Prior Park, Bath. The local availability of material is often evident by its abundant use.

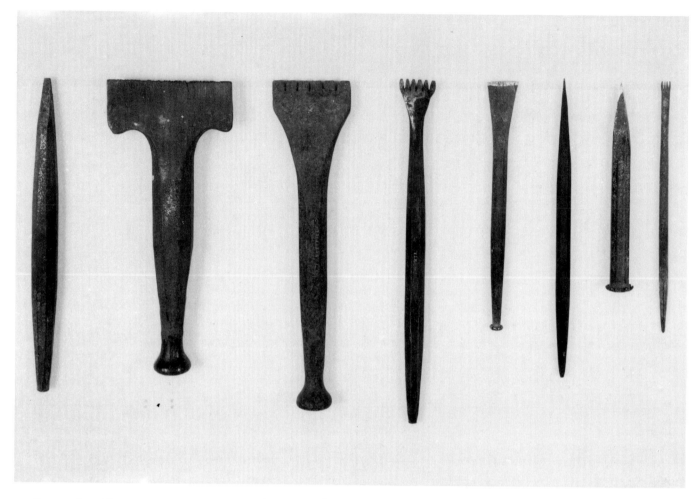

257 Stone and marble cutting tools, maximum length 9 in. (23 cm.). From the left: a stone punch, a bolster and a clawed bolster (both mallet-headed), a stone claw and a chisel, two marble points and a marble claw.

258 A pitcher and a pitching hammer – the head of the pitching hammer is 5¾ in. (14.5 cm.) long. The cutting edge of the pitcher is bevelled to a little more than 85 degrees.

to some extent into the twentieth century, as at East House (opened 1929), Leys School, Cambridge, and this remains the usual practice for restoration work.

In medieval times most stone was waterborne, that is to say it was transported, often over considerable distances, by sea, river, and quite small streams and brooks. Following the Grand Tour and the fashion for alien marble in England and elsewhere the materials extracted from the regions of Carrara and Polvaccio were transported to many northern European countries. For this reason, fashionable sculptors such as Roubiliac, Wilton, and Nollekens kept large stocks of marble in their yards.[9] By the eighteen century, Italian marble was sometimes available in London in substantial blocks and by the end of the century it was commonplace though, as J. T. Smith emphasized, it was expensive. Chantrey worked on a block 'weighing many tons, for which he paid about the sum of six hundred pounds'.[10]

In contrast to a sculptor, a mason is trained to remove larger quantities of stone at a greater speed than is usual amongst carvers. For this purpose masons use heavier tools which are generally employed with the full swing of the extended arm to give greater power. The

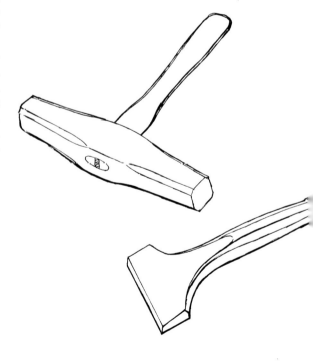

mason's banker is therefore low, about 30 in. in height. Although masons may be employed to give finishing surfaces to building stones, such as a 'batted' face (produced with a 'bolster') or a rusticated treatment, their principal work involves reducing an irregularly shaped block to the required dimensions and form, and the working of geometric sections. It is in the former capacity that a mason produces a roughed-out shape for a sculptor from a 'boasting drawing'.

In this work the first tool after the axe and saw (including the toothless grub saw) is the 'pitcher' which is used in combination with the pitching hammer to shear off large gallets of stone. Once a 'face-side' has been established it provides a constant reference point from which measurements may be taken and templates or 'moulds' used. These moulds provided the necessary information for the working of building stones and for mouldings. The mason's moulds were traditionally made of wooden boards, and may thus be related to the templates used by furniture makers and other craftsmen.[11] In medieval England thin sheets of 'Estrichbord' (Baltic oak)[12] were commonly used and in eighteenth- and nineteenth-century France pine battens were sometimes framed up to produce the required profile.[13] Sir Balthazar Gerbier in his *Counsel and Advice to All Builders* (1663) argued that 'all Surveyors ought to cause the wooden Moulds . . . to be tryed by lifting them as high as the stone . . . is to be placed; to see how it may please the Judicious Eye; which is the best Jury and compass.'[14] Elsewhere he states that 'Master-work-men may receive Instruction by way of Draughts, Models, Frames &c. ' and the latter may refer to framed-up moulds such as those used in France.[15] Moulds of wood or occasionally sheet lead were at first superseded by sheet iron and then by zinc. The use of sheet iron masons' moulds in Italy is recorded by Nicholas Stone Jnr. in his *Diary* for 12 June 1638.[16] The moulds were cut from sections established in the 'setting out', as the full-size drawings are known. It was at this stage that the

mason's emblems of square and compass were used. Reference has already been made to surviving medieval 'setting out' floors (pp. 54–5). Although working and therefore thinking in the two dimensions of the setting-out drawing and the moulds, the mason had to anticipate the problems of the three-dimensional reality which he would himself create. Since he was responsible for the realization of a scheme in 'the round' he was well qualified to achieve this. One has only to consider the complex shape of each and every stone in a fan vault to appreciate the sophisticated solid geometry of which such men were capable. No wonder Brunelleschi found it necessary to chop a shape out of a turnip as a model for a segment of stone for use in the cupola of the Duomo in Florence.[17]

Once the mould has been placed on a level and smooth surface it is drawn or scribed round and the profile chased-in with a chisel. Where it is necessary to remove large gallets of stone the pitcher and pitching hammer are employed. The area to be pitched away is first carefully and lightly worked round with the pitcher to produce a line of fracture. The pitcher has a working edge 'set' at an angle of about 85 degrees (see fig. 258) which does not so much cut the stone as shock it into submission. This traumatizing instrument is aided and abetted by the harsh staccato knock of the steel pitching hammer, the shape of which is designed to exaggerate these necessarily brutal characteristics. The pitcher and its hammer are manipulated with a blunt precision and a loose-limbed series of movements. With the broad outlines established and the main areas of surplus stone removed, the 'punch' or 'point' are now brought into play. The punch is another blunt instrument used in 'roughing out'. It is distinguished from the marble point (which is literally pointed and known in Italian as the *subbia*) by having a narrow chisel end (see fig. 257). Carl Bluemel has shown convincingly that the early Greek sculptors, like the Egyptians before them, did most of their work with a bronze point and relied on abrasives to produce the final form

259 Two timber-mason's 'moulds', for the 'voussoirs' or keyed stones of an arch, in this case a flat arch. *Musée des Artes et Traditions Populaires, Paris*

and surface.[18] A bronze point used at anything much less than an angle of 90 degrees to the surface would not have been viable as it would bend. This conditioned the early Greeks' manner of working and their sculpture. Chisels were however used to some extent, and for letter cutting and incised details such as hair they were essential. Compared with Hellenistic and Roman sculptors, the early Greeks evidently used chisels sparingly – a feature of their working methods which in the early nineteenth century Richard Payne Knight had the perspicacity to note.[19] The steel punch is used on stone in conjunction with an iron or steel club hammer – two and a half pounds being a weight in common use amongst carvers.

From this stage on, the mason uses a mallet and the carver a mallet, dummy, or hammer. The tools are therefore necessarily divided between the mallet-headed and the hammer-headed, the latter being mainly reserved for marble, granite, and the harder stones, and the mallet and mallet-headed tools for the softer freestones. For exceptionally soft freestones, tools with wooden handles similar to those for wood-carving are used. In roughing out, the harsh knock of a mild steel hammer is desirable but as the work approaches areas of subtlety the more sympathetic action possible with a soft iron or bronze hammer or a dummy of lead and zinc becomes more and more necessary.

In producing the rough 'boasted'[20] shape in which the forms are proud of the final surface which the carver or sculptor intends, a mason might stop at the punched stage or proceed to the use of the wide claw tools and bolster. Alternatively, all these stages could be undertaken by the sculptor. Michelangelo certainly recognized that the personality of a sculpture appears in the first moments of its materialization. Because this formidable individual was involved in every stage of his work the act of creation, especially in his later works, is very evident and gives them a power akin to life. As 'incomplete' or 'unfinished' statements, Michelangelo's works are not fully determined and the spectator's thoughts are opened to many possibilities. An understanding of the importance of the early procedures in producing the spirit of a sculptural work in stone or marble occurs in R. Campbell's *The London Tradesman* (1747). In this book, which was designed to provide advice for 'Parents and Guardians', the art of the image maker and the statuary is discussed.[21] Campbell shrewdly observes that 'Besides Genius, this Art requires some Strength' especially in 'Blocking out' which 'is done by the Workmen of the greatest Skill in the Shop', in contrast to 'the finishing; which is done by Hands who have not so much skill in the general Disposition of the Parts.'[22] Against this view, or the fluid relationship between the roughed-out volumes and areas of 'finished' emphasis in Michelangelo's works, was the arrogant notion (no doubt encouraged by too great a reliance on assistants) of the 'finished' sculpture of the period of the Classical Revival. Too often, these sculptures are so suffocated by their 'finish' as to have the finality of death. For the successful sculptor of the nineteenth century the roughing out was done by nameless assistants, but once the Work presented 'a likeness to the sculptor's original model . . . it is at this point that the mason's labour ceases and that of the highly educated carver commences.'[23]

The carver's claw consists of two or three or more prongs, each of which (like the point or punch) is pointed for marble and chisel-shaped for stone. All these tools are mentioned by Vasari in his chapters on technique in which the narrow two-pronged claw is known as the *calcagnuolo* and the wider three-pronged claw as the *gradina*.[24] It was and remains the function of the claw tool to work over the inconsistencies of a natural material and thus establish a true and deliberate form without the carver being deflected by variables such as fossils or strata. To reinforce this characteristic the tool was used in successive and opposing directions. In many ways the claw is analogous to the toothed modelling tool which similarly disregards differences in the consistency of clay. It should be added that claw tools produce a texture that traps shadow and may be used to 'paint' areas of tone and emphasis – it is a flattering implement. In contrast, the chisel in unskilful hands will ride out of control and if handled insensitively may all too easily destroy rather than create form. Stone and marble chisels were made in varying widths, but, in contrast to wood-carving, gouges were seldom used except on very soft stone, since a fluted or hollow form could be created with a bull-nosed tool. All these tools were 'fire-sharpened', which is to say they were tempered in a charcoal-fuelled forge by a whitesmith.[25] The sharpening as such was done on a grit-stone with water (to prevent overheating and loss of temper) which in due course wore down the temper and the tools were returned to the smith to be 'drawn-out' and 'fire-sharpened'. The mid-twentieth century innovation of tungsten steel-tipped tools has resulted in the use of carborundum sharpening 'stones'. In these tools the expensive tungsten tip is sweated into a conventional steel tool. Although they retain their edge much long than the traditional 'fire sharps', they are much clumsier.

On large building undertakings such as a cathedral a smith would be employed full-time in drawing out the masons' and carvers' edged

tools. Even where this was not the case there was, until the Industrial Revolution ruptured such avenues of communication, a close relationship between the maker and the user of tools. With fire sharps this condition persists in that even after its initial manufacture such a tool may be 'corrected' in the course of drawing it out. In these circumstances tools were made that responded to the specific needs of a particular individual working in a given material. Canova has been credited with inventing special tools[26] but in the past most craftsmen probably did just that. Cellini mentions that Francesco del Tadda of Fiesole devised and made special tools with which to work porphyry – a notoriously hard material.[27] In a quite different medium Dunlap records that the engraver John Roberts (1768–1803) 'made engraving tools, and even invented new to answer the exigencies of his work', and that for his engraving after Trott's miniature of George Washington 'he invented a new mode of stippling, produced by instruments devised and executed by himself'.[28] Neither was Roberts an exception even if it was unusual for an engraver to be capable of making tools. Alexander Lawson (1773–1846) got a 'blacksmith' to make an engraving tool based on a book illustration but on finding the resulting implement a 'clumsy affair' that 'worked very stiffly' the artist and the smith worked together to correct its faults.[29]

Many tools, especially the commercially manufactured ones, are stamped with the maker's name, whereas the tailor-made tools are generally stamped with the initials or name of the user. This emphasis on the user with individually made tools is of great importance. In the past only bad workmen blamed their tools for poor workmanship since, if the tools were not adequate, good craftsmen could and did do something about it.

With the exception of the pitcher, which is held loosely, all stone carving tools were grasped with the thumb resting on top of the tool – this gives a degree of leverage which enhances manipulation by varying the angle of attack. A right-handed person naturally holds the hammer in the right hand and the chisel in the left but some stone-carvers may alternate between both hands, especially those who have also been trained as wood-carvers where it is something of a necessity (because of the grain of the wood) to be ambidextrous. In stone and marble this is not essential but it is an advantage in creating a continuous form or line and when working *in situ* on a building where a scaffolding standard may be an obstruction. Moreover a mason or sculptor must always carve *into* a block and *away* from the edge to prevent 'flushing' the arris. In carving a large relief composed of many blocks of stone, and especially when carving

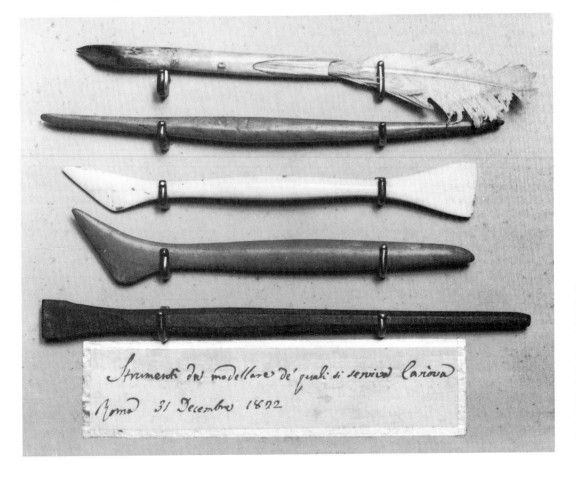

260 A quill, three modelling tools and a carving tool once owned by Antonio Canova (1757–1822). The carving tool bears Canova's initials but is not a very subtle piece of smithing, which suggests that Canova was at some distance from 'the cutting edge' of his art. *Chatsworth Collection*

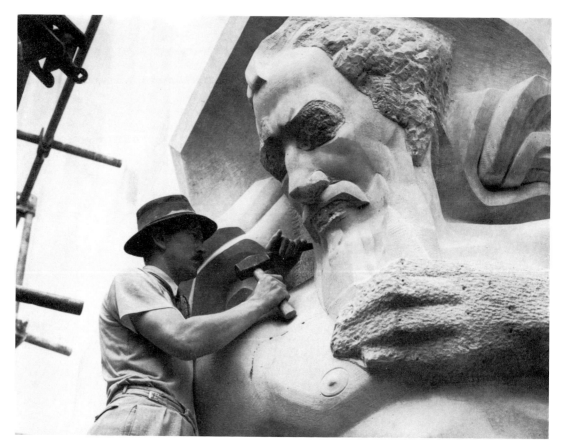

261 The sculptor Arthur J. J. Ayres at work *in situ* on a three-times life-size figure in stone (1933). The thumb of the hand holding the chisel (in stone carving) is placed above the tool for greater leverage.

262 Arthur J. J. Ayres, *Prometheus*, 1935, carved brick – Electricity Offices, Municipal Buildings, Hornsey, London. The relief was carved *in situ*. Carved brick has been in use in England since Tudor times.

brick with a multitude of joints, this necessitates many changes of direction and is more easily accomplished by the ambidextrous carver. A number of early representations of sculptors at work record this in showing carvers holding the hammer in the left hand and the chisel in the right.[30]

Although to some extent stone and marble tools were interchangeable, the distinctions that I have drawn between the two are generally true since stone is worked by means of bursting the waste material clear of the form, a procedure that in marble would bruise its translucence. To the early Greeks, whose sculpture was painted, the bruised and matt surface resulting from using primitive bronze punches at right angles to the surface was an advantage. It is this 'bloom' or bruising that all but persuades one that their statuary is in limestone rather than marble. Hellenistic and Roman marbles which were worked with steel tools retain their translucence and are capable of a high polish.[31] Accordingly, marble is worked by a process of peeling away the unwanted material, an approach implied by Cellini's reference to the *penultima pelle*, the penultimate 'skin'.[32] It would be wrong to suggest, as some have, that marble is harder and more difficult to work than stone.[33] In reality every stone and marble has its characteristics and whilst some may be worked more quickly than others, generalities concerning their hardness or

263 Front and back of an unfinished male figure from Naxos showing the marks of a bronze 'point' in the marble – height 3 ft. 4 in. (1.02 cm.). *National Museum, Athens*

264 Predella (after 1410) carved in marble relief by Nanni de Banco for the church of San Michele, Florence.

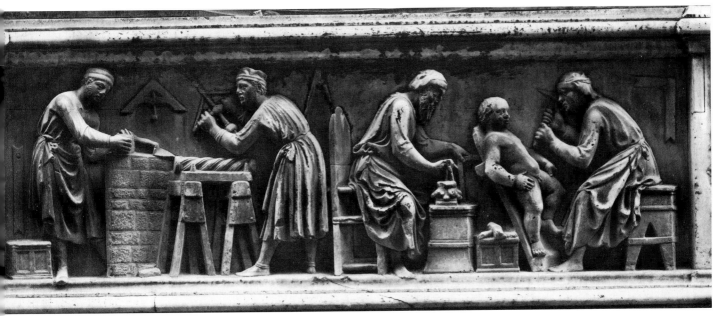

softness in working are not possible. Freshly quarried stone is certainly more easily worked than the same material once it has been given time to 'season' when the 'quarry sap' (the silica) comes to the surface. At this stage freestones like Bath may be worked with speed and ease and 'drags' of various kinds such as cockscombs may be used extensively. Some of these stones are so soft that it may seem remarkable that they ever survive the elements in the open air. Cellini describes a material found near Paris which, though when first quarried was soft enough to work with notched wood-carving tools, 'in the course of time, hardened almost like marble, especially its external surface'.[34] Christopher Wren, in discussing the disastrous use of Caen stone by the French builders of Westminster Abbey (which does not 'case harden' sufficiently and therefore 'spalls') contrasts the French material with the 'good stone [which] gathers a Crust, and defends itself, as many of our *English* Free-stones do'.[35] A similar assertion appears on the trade card of L. Gahagan of Bath in which he commends the local freestone for 'the peculiar Quality of its becoming hard and durable when exposed to the

Weather'.[36] Once the quarry sap had formed a hard crust it was often considered inadvisable to break through this natural surface protection. Sir Balthazar Gerbier advised 'that the Mason must work no stone with Sandy veins, or that which (having been taken out of the Quarry) hath been exposed to Rain, Snow or Frost'.[37] Evidently an appreciation of these effects of weathering existed long before a scientific explanation of the cause was known. The worked stone could be given additional protection by means of a coat of linseed oil (as was used in 1421 by the chief mason at Calais)[38] and similar protection was afforded by the limewash that so often formed the undercoat for polychrome decoration. In her description (1698) of the façade of Bretby Park, Derbyshire, Celia Fiennes remarks on 'something surprising in it its all of free stone which is dipt in oyle that adds a varnish to its lustre as well as security to its foundation'.[39]

In addition to cutting stone by means of a saw or with a hammer and chisel, the drill is an important weapon in the sculptor's arsenal. Perhaps the most ancient and universal type is the bow drill.[40] It was once (and in many third

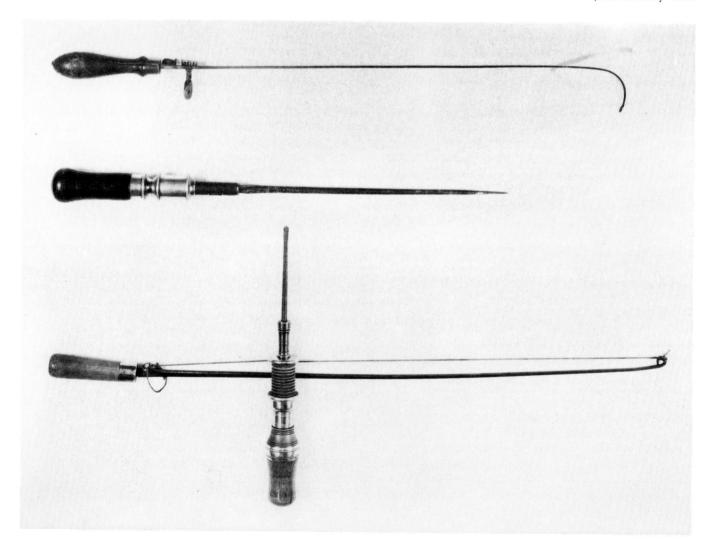

265 Two early nineteenth-century bow drills, wood, brass, steel, and cat gut. The upper example (not threaded for use) has rose-wood handles; those of the lower example are boxwood. The bow of the latter measures 30 in. (76.2 cm.) in length (including the handle) and is stamped 'Solinger'. Fencing foils were sometimes used for the bow, which demands high quality steel. *Private Collection*

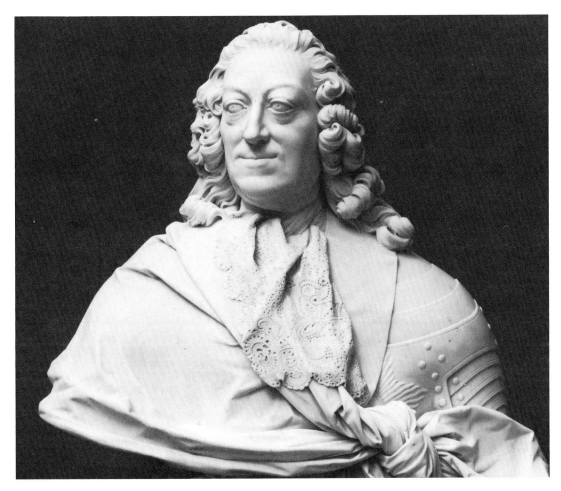

266 Louis François Roubiliac (1705–62), *Bust of George II*, marble, height 31 in. (79 cm.). The use of the bow drill (fig. 265) is clearly shown on the lace cravat. *Royal Collection*

267 Tragic mask, Roman, third century AD, marble, $6\frac{7}{8} \times 10\frac{1}{2}$ in. (17.5 × 27.7 cm.). The bow drill (fig. 265) was an important tool for sculptors, but seldom is the effect of its use so evident, which suggests that this mask was originally intended to be placed at a considerable height. *Fogg Museum, Cambridge, Massachusetts*

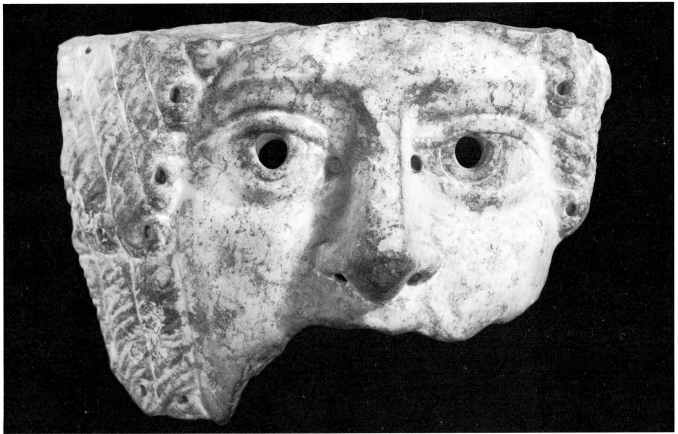

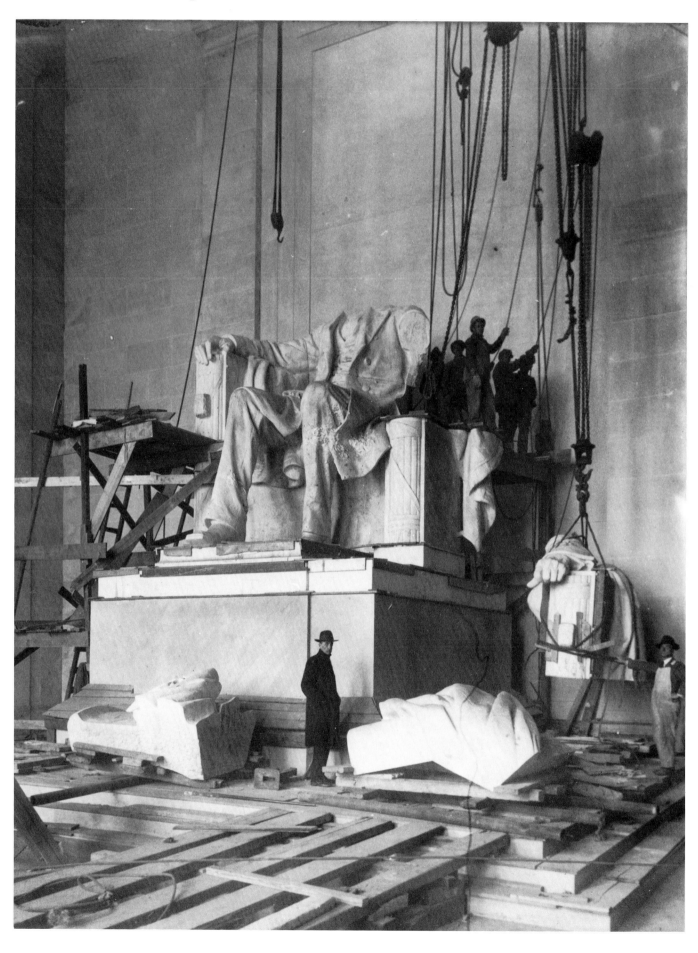

world countries continues to be) used on all manner of materials but in the West its use is now confined to stone and marble carving for which the electric drill does not provide a complete answer.[41] The bow drill has many advantages over more modern instruments, one of which is the way it revolves in alternate directions, clockwise and anti-clockwise, thus freeing the 'scarf' or loose chippings and dust. In addition the bow gives enormous control over speed whilst the revolutions per minute are never so great as to establish a polish that will repel the cutting action of the drill. Above all, the bow drill, especially if used without the bow (when the chuck is revolved back and forth by an assistant with a length of cord) reaches areas inaccessible to most other tools. In its action the 'jumper' falls half way between a drill and a chisel but its less predictable effect make it best used in quarrying or in drilling for internal dowels far from the face of the work.

The bow used for these drills was best made of fine steel and many eighteenth- and nineteenth-century bows were created out of reused fencing foils. Vasari states that the drills themselves were available in varying sizes ranging from twelve pounds to twenty pounds in weight. Drills of this size may well have been used for quarrying but in my experience most drills used for carving were a matter of ounces in weight. The visible evidence of the use of drills in existing sculptures indicates that a drill with a diameter of about $\frac{3}{8}$ in. was commonplace.

In the long, narrow and deep folds so consistently used by the Greeks the bow drill, in conjunction with the 'quirk', was essential. It was also much used in the opulent curls of the wigs on portrait busts of the seventeenth and eighteenth centuries. At times the drill was employed with no attempt to camouflage the drill holes – a feature that may sometimes be explained by the great distance at which a work was designed to be seen. It was probably the blatant use of this tool that Chantrey had in mind when he spoke to J. T. Smith 'in rapturous terms, particularly as to the animated manner in which [an] artist had used a drill in finishing the mane [of a lion]; for this tool when judiciously introduced in hair certainly gives wonderful vigour and depth of touch.'[42]

By the second half of the eighteenth century, English sculptures worked in imported marble were, as we have seen, carved quite literally from monoliths. An early nineteenth-century example is Flaxman's *St Michael Overpowering Satan* at Petworth House (1820).[43] Nevertheless, the earlier practice of assembling large sculptures from segments of marble persisted and for exceptionally large works remained essential (fig. 268). The great disadvantage of jointing up

a three-dimensional figure was that the joints themselves could show, and the cramps used could discolour the marble or stone or at worst cause it to burst apart.[44] With a draped figure the jointing could be relatively easily hidden. In his wish to keep expense to a minimum Roubiliac used a somewhat inferior marble for his life-size standing portrait of Shakespeare commissioned by Garrick and now in the British Museum. The client did not like the effect of a 'birthmark' caused by the blue veins in the marble on the face and Roubiliac consequently replaced the head with one carved in superior statuary marble.[45] The joint is virtually invisible – it could be done. The carver who worked the figure of Sir William Pitt for Nollekens (in the Senate House, Cambridge) contrived to drill out a lump of marble from between the legs that was large enough to use for the head of the statesman.[46] Metal clamps presented a serious problem. Vasari mentions the use of iron painted green and fixed into lead,[47] and elsewhere refers to the use of clamps of polished copper fixed with lead to prevent the marble discolouring.[48] To cement marble together Agnolo Gaddi used a preparation of mastic and wax which was said to survive in the open air.[49] In the repair of antique statuary, and no doubt in the assembling of new works, Nollekens made a cement composed of the dust of the marble he was working on, mixed with grated Gloucester cheese, plaster of Paris, the grounds of porter, and yolk of egg.[50]

There were, as we have seen, few difficulties involved in lifting and moving unworked stone from the quarry to a mason's yard, a sculptor's studio, or direct to a building site. An unworked block with no fragile and valuable arrises may be simply held by 'nippers' or slung in a chain. Moving a worked stone with fragile arrises was a greater problem. Rollers, barrows, and sampsons (fig. 269) were constructed of wood not only for reasons of cost but because wood was less likely to 'flush' an edge. Quantities of 'softing' (old sacks or straw) were also used. Leverage was important for small adjustments in moving a stone. The crow bar (necessarily of

OPPOSITE
268 Installation of the marble figure of Abraham Lincoln at the Lincoln Memorial, Washington, DC (c. 1920). Colossal sculptures not carved in the 'living rock' were seldom monoliths. *Photo: National Archives, Washington, DC*

269 A typical sculptor's 'sampson', 30 × 20 × 7 in. (76 × 51 × 18 cm.). The two central wheels are set at a lower plane to the others to enable the sampson to turn.

iron) was always separated from a valuable worked stone by a batten of wood. The whole procedure was taken step by step and in its emphasis on brain-power rather than muscle-power resembled a game of chess. The moving of large blocks of masonry or sculpture demanded the educated experience of the fixing mason. The 'lewis' provided the essential ring to which the lifting tackle could be attached. Vasari, in his life of Brunelleschi, describes how the architect of the Duomo in Florence prepared himself for that great undertaking by carefully studying not only the architecture of Classical antiquity in Rome but also by examining individual blocks of stone and marble. In doing so Brunelleschi discovered 'a hole hollowed out under the middle of each great stone, [and] that this was meant to hold the iron instrument, which is called by us the *ulivella* wherewith the stones are drawn up; and this he reintroduced and brought into use afterwards.'[51] Quite how much credence may be given to this story is of little importance – the lewis is an ancient device and the timeless magnificence of its shape recalls the flail or crozier. The one disadvantage of the lewis is the labour-intensive dove-tail-shaped mortice that must be cut to receive it. In this century the use of power drills has given rise to new versions of the ancient lewis, which, whilst much less beautiful in appearance, involve far less labour (see fig. 270).

In the known portraits of Joseph Nollekens the English 'sculptor' is not shown holding a carving tool. In Beechey's portrait and even in Rowlandson's caricature he is shown with modelling tools – an exception is Rigaud's portrait in which he is depicted with a port-crayon. It is quite possible, and the portraits support this view, that Nollekens was not able to carve marble or stone. This is not to say that for the sake of a client who found a feature in a portrait too large Nollekens would not fake the carving action and pretend to remove or reduce the offending detail. According to J. T. Smith this was common practice and 'the deception of cutting away [was] effected by the help of a little stone-dust, which the sculptor allows to fall gradually from his hand every time he strikes his chisel or moves his rasp.'[52] In Nollekens' day the use of assistants to do all the carving was not so common as it was to become amongst Victorian 'sculptors'.[53] The Classical Revival, being founded on Greek and Roman precedent, drew much of its inspiration from the use of marble. It was this that gave sculptors their dominant position in the late eighteenth and early nineteenth centuries and it was therefore in marble that their reputations were created. 'The carver's powers' were consequently 'absolutely requisite to the fame of the designer and modeller; for, without his tasteful finishing the most exquisite

270 Examples of the 'lewis', a ring attachment used in lifting large blocks of worked stone. The example at the top is the earliest type, but was labour intensive because of the dove-tailed slot that had to be cut to accommodate it.

model may be totally deprived of its feeling.' The use of such 'ghosts' was an acknowledged fact. 'What an acquisition, then, an excellent carver must be in the studio of the classic sculptor of high fame, whose mind must necessarily be engaged upon his designs; and whose hand had it once been master of the tool, for want of practice, could not manage it with so much ease as that of the artist who is continually employed on the marble only.'[54] This arbitrary separation of inspiration and execution may have been consistent with the prevailing attitudes of the industrialization of Britain and in tune with the Classical inheritance which despised manual labour, but it was scarcely in harmony with the needs of sculpture. It was inevitable that a reaction would set in. By the early twentieth century a number of sculptors turned to 'direct carving'. Among these was Ernest Cole who carved in this way many of the keystones that ornament the façade of County Hall, London,[55] and A. G. Walker who exhibited a portrait head in the Royal Academy Summer Exhibition of 1927 which was worked direct in marble under the title *A Cut Direct but Still My Friend*. Best known today for 'direct carving' is Eric Gill, who raised the need for a truth to materials to the level of an article of moral faith. The proposition is more profound than that. No manifesto can compete with the empirical needs of an art practically put into effect. The soapy forms of a marble sculpture bearing the name of Rodin reveal the hand of the carving assistant and the absence of the revising processes of its alleged author. J. T. Smith may have objected that many of the works in marble that bear Nollekens's name are disfigured by ankles which are too thick but evidently Nollekens's assistants were given a free hand to revise the modeller's works into a form that was practical in marble – thick ankles and supported legs being essential if a free-standing figure is not to snap at this point. A sculpture that is not made *by* its material as well as being made *out* of it may be weak structurally as well as aesthetically. Besides this reality, Gill's 'truth to materials' was an absurd route to an important fact. Not that there was anything especially new about 'direct carving' as it was so self-consciously known in the early twentieth century. Unpremeditated carving has been done throughout history; it was commonplace in medieval Europe. The Danish-born sculptor Cibber was thought, probably erroneously, to have carved the figures of *Raving* and *Melancholy Madness* (1680) 'at once from the block, without any previous drawing or model whatever'.[56] Despite their obvious reference to Michelangelo's marble figures of *Night* and *Day* on the Medici tomb, these two works by Cibber emerge from the Portland stone in the lively way

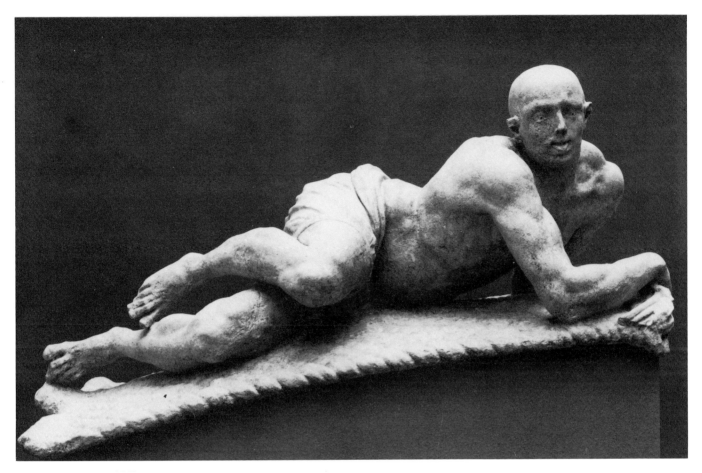

271 Caius Gabriel Cibber (1630–1700), *Melancholy Madness*, Portland stone, length 67 in. (170 cm.). J. T. Smith was of the opinion that this figure, and its pair *Raving Madness*, were worked direct in the stone without a preliminary sketch model. It is more likely that Cibber used a small sketch, which would have preserved some measure of spontaneity whilst giving assurance of a satisfactory outcome. *Victoria and Albert Museum, London*

so typical of the spontaneity and risk of 'direct carving'. Notwithstanding J. T. Smith's evidence to the contrary, these large and important figures of *Madness* were probably worked up to their final size on the basis of small sketch models. Cellini makes reference to this approach which was used by 'many strong men', including Donatello and Michelangelo who both worked direct in marble from 'a small and well designed sketch'.[57] The use of a small sketch model allows room for innovation (and error) but it is a method that has probably had a long and distinguished, if largely unwritten, history. Mistakes could be reduced to a minimum if the carving was approached gradually and frontally – provided sufficient unworked stone or marble was left at the back of the work into which the sculptor could advance to eliminate mistakes. This method was employed in Greece as a number of unfinished works demonstrate. In a passing reference to this method Cellini compares it to working on a relief that gradually resolves itself into three dimensions.[58] The longer and better known description of Michelangelo's similar method given by Vasari is worth quoting in full. His account directly relates to some of his figures of captives:

> ... which serve to teach us how to carve figures from the marble by a method secure

from any chance of spoiling the stone, which method is as follows. You take a figure in wax or some other solid material and lay it horizontally in a vessel of water, which water being by its nature flat and level at the surface, as you raise the said figure little by little from the level, so it comes about that the more salient parts are revealed, while the lower parts – those, namely, on the under side of the figure, remain hidden, until in the end all comes into view. In the same manner must figures be carved out of marble . . . first laying bare the more salient parts and then little by little the lower parts.[59]

It was a method that also drew attention to the sections of forms.

Carving in Wood

Although carving, in contrast to modelling, is a process of subtraction, the working of wood was distinct in quality and technique from the very different requirements of stone and marble. From a purely practical standpoint, carving in wood is more difficult than in stone. Whilst this assertion is generally accepted within the craft, it may strike 'outsiders' as such a sweeping and provocative statement as to demand less ephemeral authority than oral tradition and the experience of the author.

There can be no doubt that the carving of
wood and stone were seen as separate skills.
Eighteenth-century trade directories and labels
advertise 'Statuaries' or 'Masons and Carvers'
who worked in stone and marble,[1] and 'Joiners
and Carvers' or 'Carvers and Gilders' who
worked in wood. In London, 'Statuaries' such as
Nicholas Stone (*c.* 1587–1647) were members of
the Masons Company whereas William Emmett
(*fl.* 1680–1700, born 1641?) the wood carver,
who preceded Grinling Gibbons in his Royal
Appointment, became a liveryman of the Joiners
Company in 1666 and Warden in 1698. Wood-
carving was clearly seen as being allied to a
woodworking trade rather than to carving in
general. In these circumstances it is understand-
able that a craftsman like James Boyle of the
Golden Eagle, Great Pultney Street, Golden
Square, London, should advertise in the 1760s
that he undertook 'All Manner of Carving . . .
in WOOD or STONE'.[2] The explanation for
Boyle's diversity could be that he simply
employed others to provide a wider range of
skills, but it is just as likely that he himself com-
bined both. This was certainly true of the English
carver William Emmett (cited above), Benjamin
King (*fl.* 1744–83), Luke Lightfoot (*c.* 1722–89),
Jonathan Maine (*fl.* 1680–1709), Thomas Paty of
Bristol (1712/13–89), James Richards (1671–
1759), and many others.[3] In his account of
Giuliano da Maiano (1432–90) Vasari categori-
cally states that this sculptor worked in both
wood and marble but began as a wood-carver.[4]
The same was true of Grinling Gibbons,[5] Sir
Thomas Banks (1735–1805, who served an
apprenticeship to a wood-carver named William
Barlow, *fl.* 1733–54 who also worked in stone),[6]
and even Sir Francis Chantrey (1781–1841, who

made his reputation in works in marble but
began his training apprenticed to a Sheffield
wood-carver and gilder named Ramsay). Such
men, it will be noted, began their careers work-
ing in wood and evidently translated their skills
with little difficulty to marble or stone. There is
in contrast scant evidence for carvers trained in
working stone graduating to wood-carving on
any significant scale. It may therefore be inferred,
as the trade generally accepts, that wood-carving
is the more difficult of the two skills and that
it is consequently a relatively simple matter to
move from wood-carving to stone-carving but
not vice versa. This would serve to give a second-
ary meaning to Vasari's account of Donatello
striving to imitate an old wood-carving, appar-
ently to please a client but perhaps also to satisfy
himself.[7]

In the early 1960s a carved wooden crucifix
was identified as the work of Michelangelo.
Although the sculptor is known to have created
such a work in wood, the attribution has
remained controversial, but if confirmed it serves
to demonstrate how the ability to handle wood
with expressive freedom was denied to that
titanic figure who was trained to cut marble
rather than wood.

Wood-carving then, is the most difficult craft
amongst the range of skills that have been
employed in the creation of sculpture. In general
softwood was more difficult to work than hard-
wood due to the need for sharper tools but also
because the sheer lack of character in most soft-
woods offered little inspiration. Despite, and in
many ways because of the difficulties of working
a vigorous piece of English oak, it was a sought-
after material. It was no doubt in this sense that
Evelyn recommended elm (the swirling grain of

which makes it liable to warp and difficult to work) for the carver 'by reason of the tenor of the *grain*, and toughnesse which fits it for all those curious works of *Frutages*, *Foleage*, *Shields*, *Statues*, and most of the Ornaments apertaining to the *Orders* of Architecture'.[8] Despite all these difficulties, the emphasis that Classicism has generally given to marble (and by extension, stone) has had the effect of depreciating the importance of wood. In 1747 Campbell in *The London Tradesman* noted that 'Carvers in Wood are not so esteemed as those in stone.' It is the purpose of this section to indicate the difficulties faced by the wood-carver, and to demonstrate the achievements of those sculptors who worked in that material.

The association between quarrying, masonry, and stone-carving was reinforced by the related crafts that they employ. This position was not paralleled in the timber trades where forestry was a science far removed from the skills of the timber yard, the carpenter, the joiner, the cabinet maker, and the carver. Against this it should be said that carvers did on occasion demand timber that had grown in a particular way – forest timber for the straightness of its grain, parkland timber for its greater 'figure', or town-grown timber which lacks strength but contains interesting impurities as does diseased timber. Holly that was not grown on the appropriate side of a hill lacked the desirable ivory-like whiteness and closeness of texture.[9] The role of the fixing mason was paralleled in some particularly busy ship-building centres where the carvers deputed the responsibility of fixing their work – figureheads and the like – to specialist craftsmen known as 'head builders'.[10]

As we have seen in a consideration of the woods used in panel paintings, there were four zones in Europe in which locally available woods were found to provide suitable supports: poplar in Italy, lime in Southern Germany, walnut in parts of France, and oak in much of northern Europe. These timbers were also favoured by wood-carvers in their respective regions but other timbers were used and from a quite early date were traded over considerable distances. Reference has already been made to 'Estrichboard' (Baltic oak) being used for masons' 'moulds' at Canterbury in 1175.[11] By the seventeenth century Sir Balthazar Gerbier describes the 'Yellow Fur (called Dram)' and goes on to identify these imported timbers by reference to their places of origin including 'Esterrund, Westbeele, Longlonnd, Laurwat, Landifor, Tonsberry, Holmstrand, Dram, Christina, Swinsound, Frederick-stadt and Stavenger'. Homegrown hardwoods were available but, as Gerbier pointed out, 'Good Oaken Timber is bought in some parts of the Country for thirty three shil-

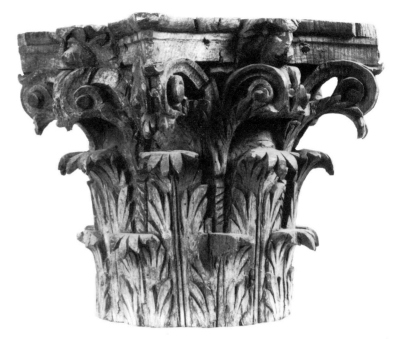

273 Corinthian capital, English, late seventeenth century, elm, height 10 in. (25.4 cm.). Although elm is a very coarse wood, the diarist John Evelyn recommended it for carving 'most of the Ornaments apertaining to the *Orders* of Architecture'. *Private Collection*

lings per load consisting of fifty foot, in and about London for forty three shillings.'[12] The excessive demand for oak by the Royal Navy and the consequent importance of imported hardwoods as well as softwoods like 'yellow Deal' was acknowledged by Sir Christopher Wren: 'Our sea service for Oak, and the wars in the North-sea, make Timber at present of excessive Price.' Wren then added, with remarkable prescience, 'I suppose 'ere long we must have recourse to the *West Indies*, where most excellent Timber may be had for cutting and fetching.'[13] More detailed information is found in John Evelyn's *Sylva* which included 'the propagation of Timber in His Majesties dominions' (1664). Evelyn, however, knew of no wood that could compete satisfactorily with English oak for 'native *spring* and *toughness*' and he makes special mention of 'some pannells [which] are curiously vein'd of much esteem in former times, till the finer grain'd *Norway* Timber came amongst us, which is likewise of a whiter colour'.[14]

By the mid-eighteenth century a timber merchant in London was 'properly' defined as 'the Importer of Timber from abroad in his own Bottoms' and not simply a 'man who keeps a Timber-Yard' which 'especially at the Court End of the Town, are kept by Carpenters and Master-Builders'.[15]

The carpenters claimed, with justification, that their skill was senior to all other branches of the trade which were variants upon the basic craft. In London the Carpenters Company did not receive its charter until 1477, but was evidently well organized long before that since carpentry was recognized as an independent craft in 1307.[15] The joiners and ceilers (*junctura*

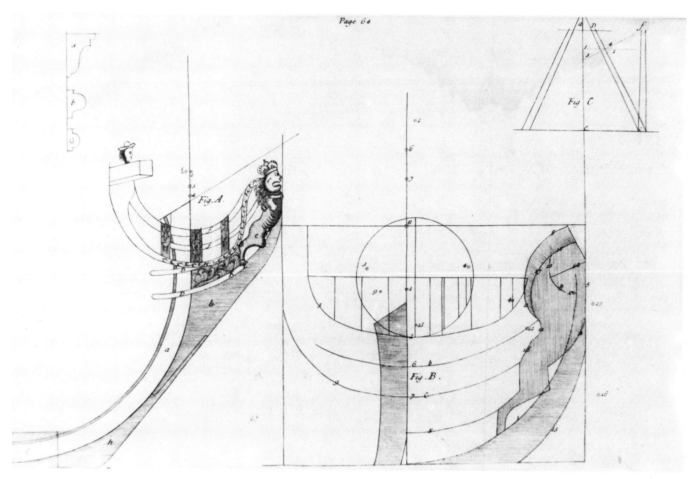

274 A 'boasting drawing'
for a ship's figurehead,
from William
Sutherland's *The Ship
Builder's Assistant* (1711).
Bath Public Library

et celum) did not receive their charter until 1570 but as early as 1428 a craftsman named John Hewet (a surname evidently derived from his trade) was described as a 'joynour'. Demarcation disputes between carpenters and joiners were inevitable. In 1632 the London Court of Aldermen arbitrated between the two trades and listed those skills that 'doe pperly belong to the Joyners'.[17] Item 19 of that arbitration states that joiners should be responsible for 'all carved works either raised or cutt through or sunk in with the grounds taken out being wrought and cutt with carving Tooles without use of Plaines'. As 'ceilers' (makers of panelling) the joiners often required carved relief work for friezes and chimney surrounds in a scheme of panelling. By 1672 the regulations had to be reasserted although the carpenters argued 'that aswell the Joyners as Carvers, Wheelers, Cartwrights, box makers, Instᵣumᵗ makers &c, were formerly but limbes, members, & a part of the Carpentry & Branches taken from them'.[18]

The notion that a craft may be defined by the tools that it employs is demonstrated in the example given above in which joiners were not permitted to use planes.[19] Similarly, the chisels and gouges used by 'makers' (carpenters, joiners, cabinet-makers, etc.) are quite different in character from those used by either turners or

by carvers.[20] In A. Félibien's *Principes de l'Architecture . . .* (Paris, 1676)[21] chisels with parallel-sided blades are illustrated and described as *ciseaux* (the type favoured by 'makers'), whereas those with blades that taper to the handle are known as *fermoirs* (favoured by carvers). In Joseph Moxon's *Mechanic Exercises* (from 1678 new style)[22] both 'chisels' and 'formers' (or 'firmers') are described and illustrated in his chapter on 'Joinery'. The distinction between the chisel used by 'makers' and the 'firmer' used by carvers is confirmed in Charles G. Leland and John J. Holtzapffel's book on *Wood Carving*.[23] Although there is some confusion in Moxon's account (and his illustration) as to the distinction between chisels and firmers, he is quite clear about the important question of the bevel given to 'maker's' tools and adds that in use they should be placed on the wood 'a little without the scribed Stroak with its *Basil* [bevel] outwards, that it may break, and shoulder off the chips from your work, as the Edge cuts it'. In other words, the bevel and sharpening of the tool occurred only on one side as is still the practice for 'maker's' and 'turner's' chisels and gouges. James Smith in his *Panorama of Science and Art* (*c*. 1815–16)[24] describes gouges with a bezeled edge on the inside curve being used by millwrights which enabled them to make a per-

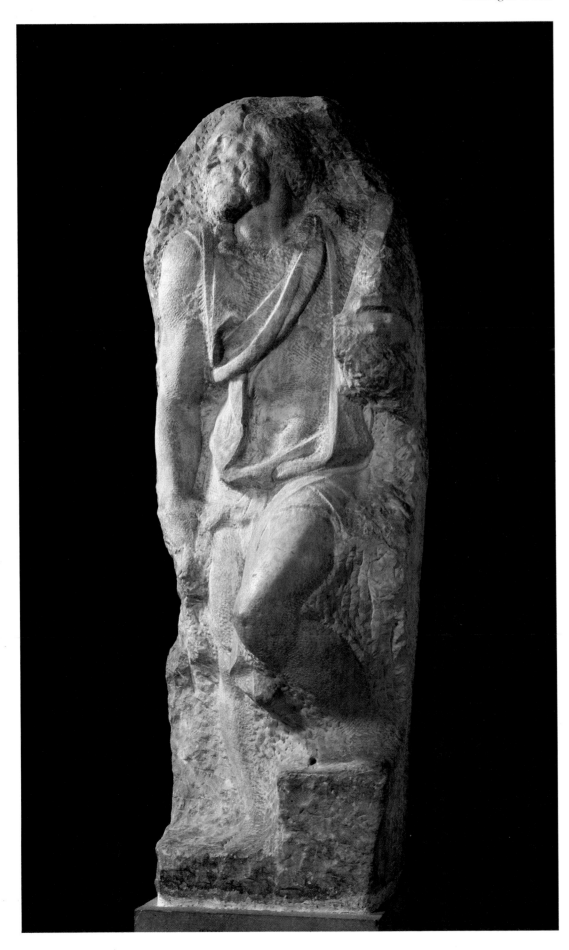

275 Michelangelo, *St Matthew* (unfinished), begun 1506, marble. The methods revealed in this figure accord closely with Vasari's description of Michelangelo's procedures (see p. 189). *Accademia, Florence*

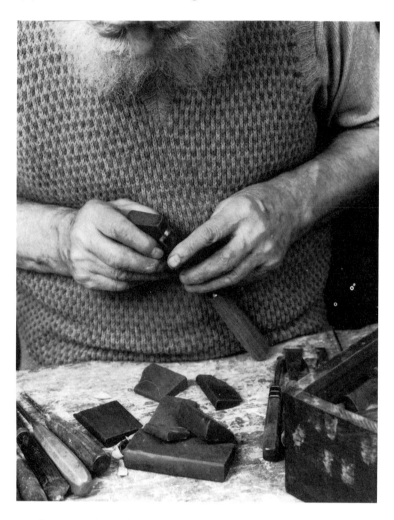

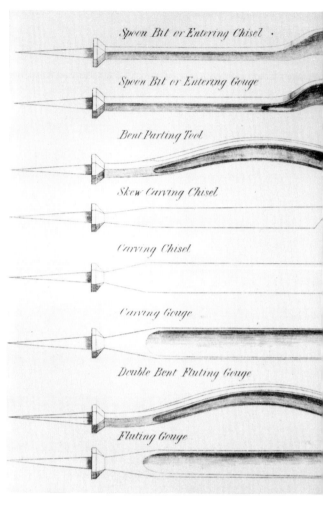

276 Sharpening the inside bevel of a gouge with an oil-stone 'slip' of the same section.

277 A series of wood-carving tools from William Bemrose's *Manual of Wood Carving* (1862).

pendicular cut in wood. Such exceptions are of interest but the salient point was that the bevel and sharpening occurred on only one side where mechanical accuracy was demanded. For the expressive requirements of the wood-carver, the bevel occurs on the outside of the tool but the sharpening occurs on both the inside *and* the outside. An exception to this otherwise widespread practice is found amongst the Florentine ornament carvers who, so as to achieve their pierced and papery forms, followed the practice of the 'makers'. Further expressiveness was also possible by tapering the tool to the handle in contrast to the parallel and shouldered shafts of the 'maker's' tools. The 'Skew-Former' illustrated by Moxon demonstrates this feature. Indeed Moxon states that the 'Skew-Former ... is seldom used by Joiners'.[25] The purpose of the 'corner firmer', as it is now known, was to work more sympathetically across the 'end grain' of the wood.

For the wood-carver, unlike the worker in stone or marble, the sharpening of the tools made of steel brought to a high temper is a time-consuming process and one which takes years of practice to perfect. For stone and marble tools, a simple grinding on a wet-stone is adequate and,

furthermore, the tools themselves are of simple, easily sharpened sections. For the wood-carver only the initial grinding of the outer bevel may be performed on a wet-stone – thereafter close-textured oilstones are used. These include simple flat oilstones which are used not only to sharpen tools that are flat in section but also to sharpen the outer edge of gouges – a feat that is performed with a rocking motion by rubbing the tool, sideways-on, back and forth over the stone. In addition, oilstones known as 'slips' which are shaped to the numerous sections of the many tools employed are used to sharpen the inner edge of gouges and related tools. Among these the 'gouge', 'fluter', 'veiner', and the 'V' or 'parting tool' are reasonably difficult to sharpen but by the nineteenth century the 'Macaroni', 'Fluteroni', and 'Backaroni' were even more of a challenge. Finally, stropping on the specially prepared leather is necessary to remove the burr (a narrow strip of swarf which, if not removed, will dull the edge almost as soon as it is achieved). Curiously enough, the softer the wood, the sharper the tool has to be to cut it 'sweetly'. For this reason, it is usual to 'try' the tool by working it across the grain of a softwood such as best yellow pine. Where the shaft of the

tool is bent to facilitate access to otherwise inaccessible parts of a carving, the problems of sharpening at each of these stages is even greater.

Although the use of glass or sandpaper was eschewed by good wood-carvers, there were occasions when scrapers could not be used and where some form of abrasive was necessary – as, for example, the removal of a pencil line. For this purpose sharkskin or fishskin was used since, unlike sandpaper, it did not leave a gritty deposit that would jeopardize the labour invested in sharpening tools.[26] The whole procedure produces a particularly powerful steel slurry that blackens the hands almost indelibly. This presented something of a problem in the mid-nineteenth century when wood-carving became a fashionable pursuit. In the *Manual of Wood Carving* (London, 1862), a book designed for amateurs, William Bemrose gives brief instructions on sharpening tools. By the early decades of the twentieth century many elegant practitioners preserved their hands by employing the boys of the South London School of Woodcarving (so conveniently located at South Kensington) to perform this difficult and messy job for them.

Because of the many types of edged tool used by the wood-carver, familiarity with a particular kit of tools is important. These are ranged on the bench with the blades pointing towards the carver. An experienced craftsman will pick up the tools in succession almost without looking at them and if each one is handled in a slightly different way it is possible to know immediately by touch if the required tool has indeed been picked up. This instinctive handling of the tools of the craft is important if the freedom of the art is to be achieved.

Small scantlings could be worked on if held in various types of dog, cramp, and holdfast which were often used in conjunction with a bench (fig. 280). However, large baulks of timber did not need to be held. The traditional carver's bench is fitted with an end vice which, in conjunction with a series of square holes in the top, is designed to close up a pair of 'stops' to hold a run of moulding. With some relief work where the basic outline is established by means of a saw, a bench-screw is essential but for a very small-scale work it is necessary to glue it to a temporary back-board, and it is this board that is then held. To facilitate the ultimate separation of the work from the board, layers of newspaper are glued down between the two to act as a parting agent. With the frontal attack accomplished, the carving is separated from its temporary background (bench or back-board) and the 'backing off' completed. This very necessary procedure has the effect of giving dramatic shadow which releases the carving from the plank.

An auxiliary but no less essential part of the wood-worker's trade was the seasoning and preparation of the timber. Once felled, wood retains many of the organic qualities of the growing tree. It is vital that this is respected if the

278 Erhard Schoen, *The Unfinished Man*, woodcut, *c.* 1533. Note the use of 'dogs' to hold the timber.

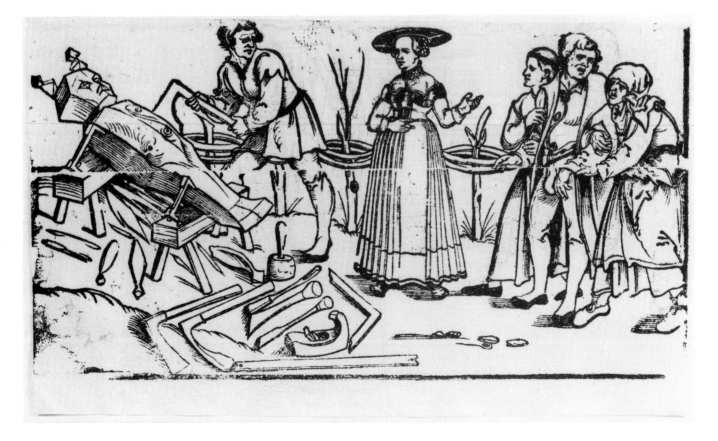

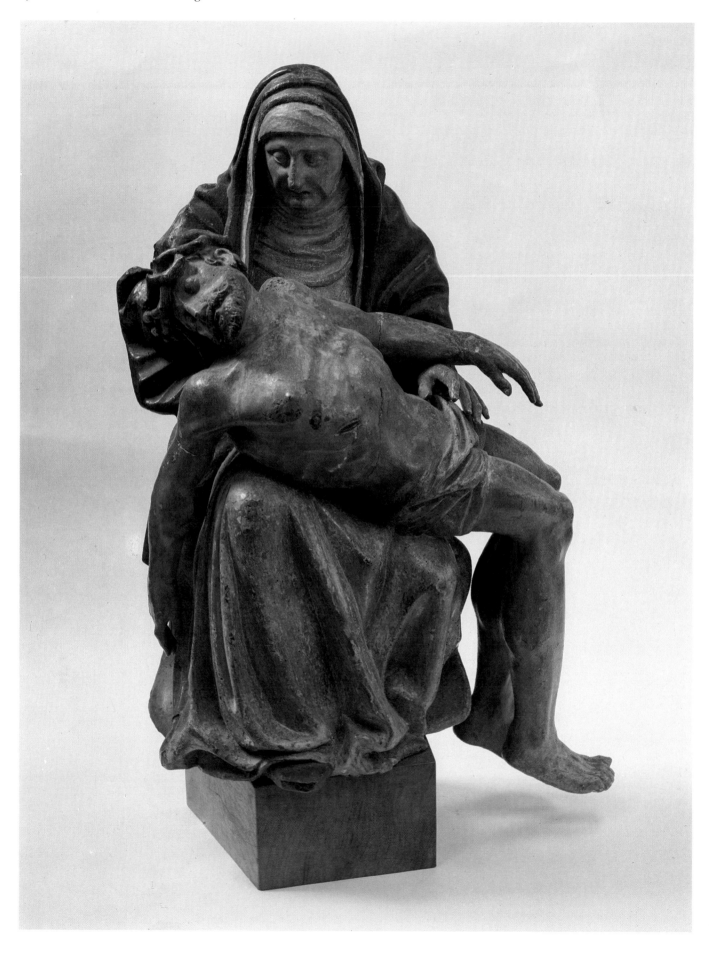

problems of warping and splitting are to be minimized. In seasoning, timber is gradually (and the more gradually the better) drained of its sap. This is often loosely referred to as 'drying' the timber but it is a misnomer since the best (and slowest) method of seasoning is to place the log, suitably tethered, in a flowing stream or river. Celia Fiennes made reference to this on her visit to Rochester in 1697 when she noted that the dockyards there included 'in one place a sort of arches like a bridge of brick-work, they told me the use of it was to let in the water there and so they put their masts in to season.'[27] Seasoning, then, is not accurately defined as 'drying', it is signified by the absence of sap. For this reason timber seasoned in the log is matured by storing in a vertical position so as to drain out the sap. Kiln-dried timber is less sound than air-dried wood but the practice has some tradition amongst the turners of bowls in Fresnaye-sur-Chédouet (Sarthe), France, who dried their products over an open fire *after* turning. Evelyn, when writing in the seventeenth century of the 'universal use the *French* make' of walnut, states that '*Joyners* put the boards into an Oven after the

batch is forth*, or lay them in a warm *Stable*.' He adds that it 'should not be put to work till thoroughly seasoned, because it will shrink beyond expectation.'[28] The turners seem in general to have been something of an exception in that they frequently worked in 'green' (unseasoned) timber. This was the case with the bodgers of Buckinghamshire who both prepared the scantlings and turned the legs for Windsor chairs on a pole-lathe in the woodlands.

Seasoning may be accomplished more quickly if the wood is reduced to its required scantlings. However, a 2 in. board will take more than twice as long to season as a 1 in. board. The length of time required for seasoning is related not only to the dimensions of the timber but also to its species. In general, the 'softwoods', that is to say the conifers, require less seasoning than the 'hardwoods' which are from deciduous trees. On the other hand, a hard 'softwood' like yew may need more seasoning than a soft 'hardwood'.

Medieval sawyers found that if timber for boards was quarter-sawn the resulting planks were less likely to split, warp or 'go in winding'. As a bonus it was also found that in timbers with strong medullary rays, such as oak or plane, the 'figure' or patterning of the grain was accentuated if quarter-sawn. So different is the effect produced by quarter-sawn plane tree that the resulting material is often known as 'lace-wood'. Despite all these precautions, the organic quality of wood is so unpredictable that even after the most stringent precautions (or even after hundreds of years) wood can 'move'. Such move-

280 Wood-carver's bench, walnut, Italian, early nineteenth century. A wood-carver's bench has a working surface at a height of 37¾ in. (96 cm.); the average cabinet-maker's bench is 4 or 5 inches lower. *Private Collection*

281 The division of a log in 'quarter sawing'. Planks sawn in this way warp less and the resulting timber has better 'figure'.

282 The back of the *Pietà* in fig. 279. These limewood carvings were hollowed out to reduce the tension in the wood and limit any tendency to split.

OPPOSITE
279 *Pietà*, South German, late fifteenth century, painted and gilded limewood, height 36 in. (91.5 cm.). See fig. 282. *Private Collection*

ment in a panel could be corrected by means of various 'tricks of the trade'. According to Vasari, Leonardo da Vinci held a badly warped buckler by the fire to straighten it.[29] This would have had the effect of shrinking the wood on the heated side and pulling the buckler back to its original state – the alternative was to dampen one side with the opposite effect.

For large three-dimensional wood-carvings, seasoning is a formidable problem. This is mitigated if a partially seasoned baulk of timber is reduced to the 'boasting line' of the intended work and then permitted to acclimatize itself to that new found condition. Such work was best executed in timber taken from large trees. A segment of a log is less likely to produce a 'star shake' than will the whole log. The northern European sculptors were fortunate since their favoured wood, oak, may grow to a prodigious size. The limewood sculptors of South Germany were less fortunate since the lime tree rarely if ever grows to such large diameters. Even so, these carvers preferred wood from the broadleafed lime (Tilia platyphyllos) which grew larger than the small-leafed species (Tilia cordata) which was smaller.[30] Limewood sculptors traditionally hollowed out the back of their work as a means of short-circuiting the tensions that the annual rings of growth are otherwise likely to produce. Despite all these precautions, these tensions are ever present and carvers commonly placed damp rags over the end-grain at the head and base of their work to keep the wood swollen and minimize the risk of star shakes. With polychromed wood, provided the movement of the timber was arrested, patches in splits, clefts, knots, and even druxy areas would not show.[31] Furthermore, since a three-dimensional woodcarving must be created with grain running along its major axis there were certain subjects (most notably the Crucifixion) where this was not possible and the composition was therefore constructed out of an assemblage of timbers. Some woods like holly and lime are virtually devoid of an interesting grain and may therefore be jointed up almost invisibly. Indeed that 'original genius, a citizen of Nature', as Walpole described Grinling Gibbons,[32] evidently relied upon this feature of his beloved lime tree in which successive layers of elaboration were built up *after* the lower layers had been carved. No other hypothesis will adequately explain Gibbons's use of laminated timber for the relatively small volumes of wood that he employed.

The association, touched on earlier, between the carving of wood and ivory is confirmed in the chryselephantine work, known since antiquity, which combines both materials in one work. Close-grained small-tree woods like box, apple, pear, and holly are similar in both their

RIGHT
283 Partly finished Crucifix figure, limewood, Upper Rhenish, *c.* 1500. The experienced wood-carver works the initial stages with the free use of a mallet and a very flat gouge. *Historisches Museum, Basle*

OPPOSITE ABOVE
284 Generations of experience have established the best ways of holding carving tools. Here a wood-carver holds a tool with hands juxtaposed for maximum control.

OPPOSITE BELOW
285 For 'setting-in' the wood-carver threads a tool through the fingers of his guiding hand (the best wood-carvers are ambidextrous), a method described by Joseph Moxon in the late seventeenth century (see p. 199).

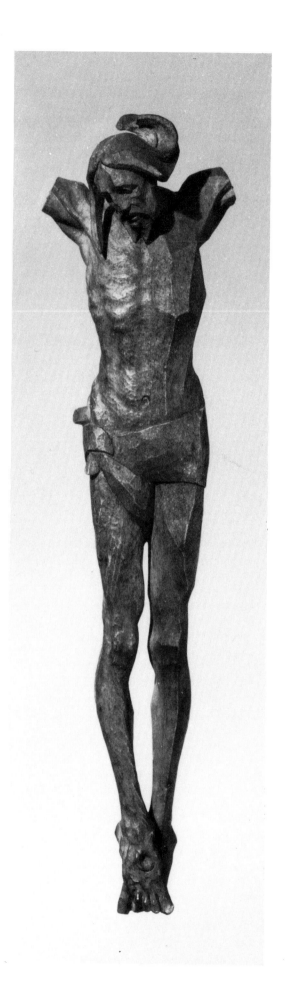

quality, handling, and scale to ivory. Carvers specializing in this work needed a good selection of small tools. Among those whose reputation was based upon such work was James Francis Verskovis who 'executed whole figures in small and vases [in ivory] with perfect taste and judgement and carved also in wood.'

In small carvings the mallet was used less than in larger works but an equivalent level of strength was involved – a strength to restrain energy. That is why a carver will hold a tool in two hands with each hand opposed to the other – the one to push forward, the other to hold that momentum in check (see fig. 284).

With relief work the 'setting-in' is performed with the aid of a mallet or the still smaller dummy – the mallet is itself the diminutive of the 'mall'. It should be remarked here that the cuboid mallet of the 'maker' was not used by the carver (or for that matter by the mason). The all-important part of 'setting-in' devolves on the hand that holds the edged tool. Where possible the ball of the hand holding the chisel rests on the surface of the wood so that the tool may be placed with greater accuracy. In general this means that the shank, rather than the helve, of the edged tool is held by the fingers. To give still greater control the shank of the tool is threaded through the individual fingers rather than being grasped collectively by them (see fig. 285). Moxon is apparently describing something of the sort when he writes of the use of the 'Paring Chissel' as follows: 'It is not knockt upon with the Mallet, but the Blade is clasped upon the out-side of the hindmost Joints of the fore and little Fingers . . . This way of handling, may seem Preposterous to manage an Iron tool in . . .' and yet, as Moxon goes on to explain, it is the traditional and best way for certain work.[33]

Large-scale architectural work and ship carving involved a very different method. The angels on the hammer beams of the Law Library at Exeter illustrate the point. They have evidently been carved with all the casual precision, confidence, and verve that is only possible with the experienced and exclusive use of the mallet and chisel combined. The direct quality, the immediacy of action and realization of these carvings has not been sullied by the use of tools more tentatively driven by the hand.

The mallet and chisel were of course used in the 'roughing out' stage of most large sculptures in wood. The great American wood-carver William Rush (1756–1833) hired a man, 'a woodchopper', and stood by to 'give directions where to cut',[34] a procedure that with a large figurehead would do much to maintain an appropriate sense of proportion and balance and help in orchestrating the parts into a cohesive whole. The sculptural qualities that Rush brought to his

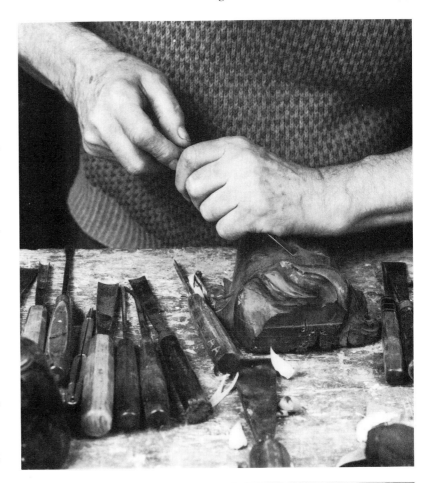

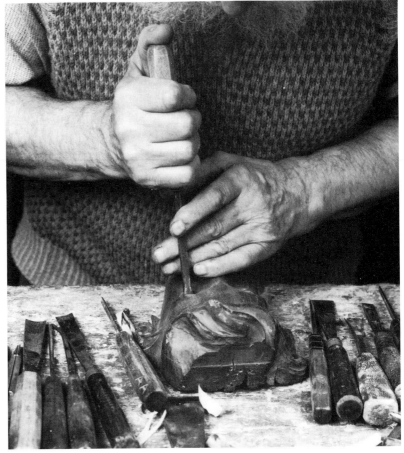

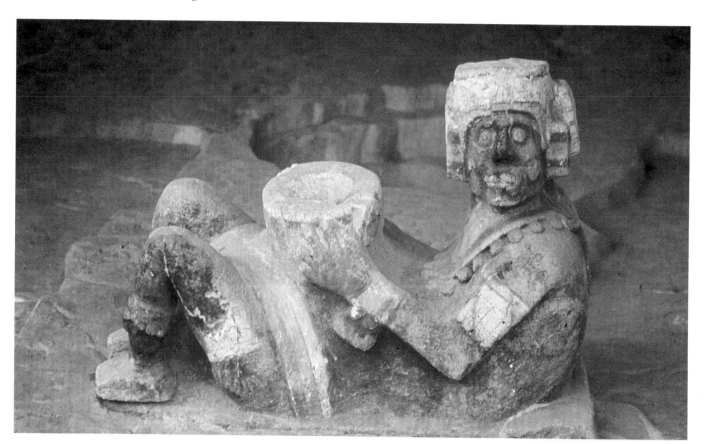

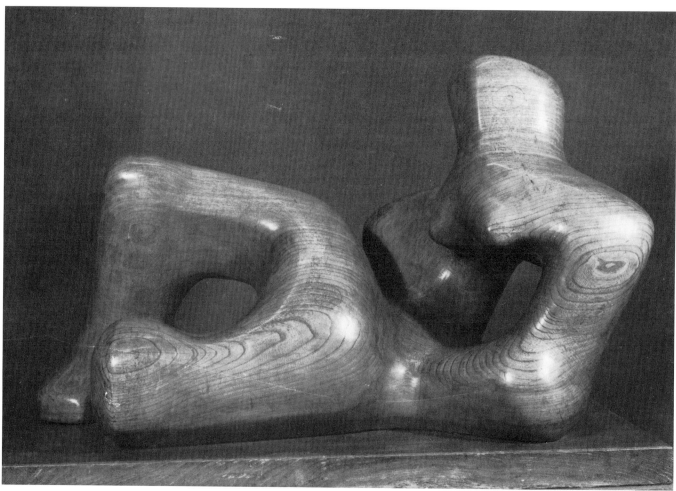

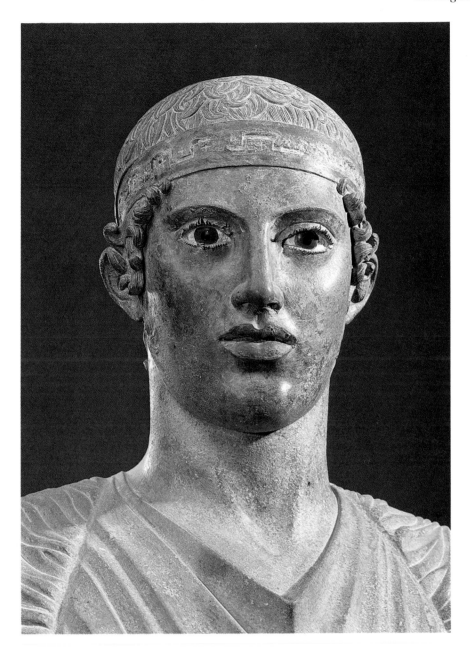

figureheads and the shipyard vigour that his sculptures reveal were soundly based on an understanding of anatomy, as his sectional models of various parts of the human body reveal. These were made for the Medical School of the University of Pennsylvania where they remain in use.[35] Despite Rush's many achievements, Dunlap records the familiar disdain for wood-carving: 'Mr Rush, who, though by trade a carver of ship's heads, was, by talent and study an artist.'[36] This 'ship-carver's' serious intent as a sculptor should not be underestimated. It is known that the ship carvers in the Port of London were so impressed with Rush's figurehead for the *William Penn* that 'Carvers there would come in boats and lay near the ship and sketch the designs from it. They even came to take casts of plaster of Paris from the head.'[37]

There has been much confusion over the distinction between the subtleties of scale and the mere arithmetic of size. A sculpture may be small in inches and majestic in scale or, as Nollekens so simply phrased it, 'a grand thing don't depend upon the size'.[38] The wood-carver was not a carpenter who could work to any dimension. Some were certainly able to work in different scales but in general the carving trade divided along lines established by scale. *The London Tradesman* (1747) mentions the 'House Carver' and the 'Carver and Gilder of picture and looking-glass frames'.[39] These were the two basic divisions of the trade – those who worked on an architectural scale and those who provided the smaller and more tactile embellishment for furnishing a house, including the specialist furniture carvers. In eighteenth and nineteenth-century England

there were numerous carvers who worked exclusively on this small scale suitable for domestic work – carvers and gilders like T. Fentham of 52 Strand, London (*Directories*, 1783–93).[40] In America, especially in the eighteenth century when skill was at a premium, most craftsmen were expected to be versatile although only some were capable of being so. Joseph True (1785–1873) of Salem successfully combined the eye necessary to work as a ship, architectural, and furniture carver[41] but Samuel McIntire (1757–1811), also of Salem, attempted a similar range and failed. In essence his tentative two-dimensionsal sense of linear pattern was most suitably employed on furniture carving. Whatever the dimensions that this Massachusetts carver was working to, his work was always small in scale. The Skillin family of shipcarvers had the full sense of three-dimensional form essential for large-scale work.

In eighteenth-century London William Puckridge of Hosier Lane (*Directories*, 1790–1809) advertised that he made 'all sorts of signs in Elm or Mahogany, Plain or Carved'.[42] With such competition from tooled-up workshops and with men trained to work within a defined set of circumstances, Simon Henekin (of Edward Street, Soho, *Mortimer's Directory*, 1763) was probably something of an exception in London. His label states that he executed 'Carving and Gilding in the Building, Ship, Sign or Furniture way . . . NB. Frames of all sorts made in the neatest taste.'[43]

In the late nineteenth century the Arts and Crafts Movement fostered a belief in a 'truth to materials'. The early twentieth-century exponents of this thesis manifestly believed that such 'truth' was best exemplified in sculpture by keeping forms in both wood and stone simple and by the virtual exclusion of detail. Whilst this approach undoubtedly produced some attractive work, it was an outlook, even a style, which bore little relationship to an objective truth to materials. Henry Moore's great reclining figures, be they in Hornton stone or in elm, owe much to the Chacmool sculptures of Pre-Columbian Mexico and share their stone forms. That is to say the granular nature of stone may only support itself if it is treated in a certain monolithic way. In contrast, the fibrous nature of wood is such that it will easily sustain itself along the grain in quite thin elongated forms. Literally and metaphorically the long ribbons and thin petals of lime tree carved by Grinling Gibbons and his followers are confections that express the full possibilities of wood. It was that school of carvers, rather than their more tentative successors in the twentieth century, who established the definitive 'truth' of the ultimate potential of carved wood.

THE SURFACE TREATMENT OF SCULPTURE

The archaeological zeal of the Greek Revival placed architects and sculptors in an exceptionally powerful position. In comparing the fortunes of painting and sculpture in England in 1813, the painter Prince Hoare the younger referred to 'the more favoured art of sculpture'. At the same time the physical condition of surviving examples of Classical statuary presented the practitioners of 'the more favoured art' with a dilemma. What surface treatment were they to give to marble sculptures? The evidence for Classical precedent was meagre.

Canova the Italian, Thorvaldsen the Dane, and Flaxman the Englishman all worked in Italian marble which may be left polished or unpolished and placed either indoors or outside.[1] At this period most successful sculptors worked on commissions that were to be placed indoors.[2] In general their works in marble were given a friction polish and the more successful amongst them employed specialist *lustratori* for the purpose.[3] For a true friction polish, pumice stone was first used, followed by chalk from Tripoli (or so Vasari tells us), leather, and wisps of straw.[4] In 1640 Nicholas Stone, who was living in Rome, noted the use of both paler and darker pumice used dry, or ground and placed on a damp rag to create 'a glasse one the marble' which could then be finished with 'bone burnt rubb'd with a peece of leather'. Other abrasives which he mentions include lumps of lead dusted with emery powder.[5] The final stages could be tricked by means of the use of an acid such as 'salts of sorrel' (potassium oxalate) and Nicholas Stone presumably had something of the sort in mind when he saw the 'strong water' used by the Romans to polish marble. This was then carefully washed away with water. When dry the marble was sometimes waxed. A polish gave translucence to many marbles and at the same time revealed their colour. Even a limestone like Purbeck 'marble' reveals a beautiful range of blue-greens that resemble marble when polished. Victorian sculptors and monumental masons would on occasion boil alabaster so that when polished it did not become translucent.

Vasari was of the opinion that marble could only be made to resemble flesh if given a lustre that only polishing could achieve.[6] Most sculptors seem to have agreed with this view, but there was at least some dissent. Joseph Wilton's copy of the *Venus de Medici* was well received but it was considered that it lost 'much of the effect of the original by being highly polished'.[7] Although the antique Venus was doubtless found in an unpolished condition, the implication that it was not originally so treated may not be

sustained. The friction polish was well known in Classical antiquity and the use of abrasives was for the early Greeks more than a surface treatment, it was a means of establishing form. Richard Westmacott in his *The Schools of Sculpture Ancient and Modern* (Edinburgh, 1865) describes the use of abrasives by 'the ancients' to produce a polish and speculates on their possible use of waxes to give 'a soft and glowing surface [to] the marble'.[8] Some years earlier, Sir Charles Eastlake, citing Vitruvius, established that the Romans used 'a solution of wax in a fixed oil', such as olive oil, to polish their statuary.[9] Wax polishing is of course a common treatment for wood and Evelyn mentions that walnut tree was polished 'over with its own Oyl very hot which makes it look black and sleek'.[10] In medieval Europe a wax emulsion provided the medium for much polychrome wood sculpture. The use of a wax finish to otherwise untreated wood was resisted by Grinling Gibbons who preferred the dry whiteness of the untreated lime tree. Much work of the Gibbons's school has suffered from subsequent deliberate or involuntary staining. Had such carving been waxed it would have better preserved the effect that was originally intended. Wax provides a useful protection on wood but on architectural stonework it may all too easily trap moisture and acids which, in their need to escape, will cause the surface of the stone to spall.[11] Stone treated with linseed oil or limewash does not suffer these problems. In the choice of preservatives it is important that decisions should be taken on the basis of experience rather than on their immediate visual effect.

The white marbles of the Mediterranean that were generally used for statuary varied considerably in quality, texture, and hue. The cream-coloured Pentelic marble of Greece possessed a natural warmth of colour which often shares the patination that long-buried marble carvings acquired through the soil – especially those with some ferruginous content. Once again, the sculptor's eye was conditioned by archaeology. The sterile whiteness of Carrara marble in its natural state was not generally liked. In 1808 Baron d'Uklanski noted that 'Canova usually washed his statues, when completely finished, with a kind of yellow tinge to give them a colour similar to that of Parian marble and an appearance of antiques'.[12] By 1817 the Duke of Bedford was writing to Canova for information on the use of this preparation designed to 'give a mellow tone to your sculpture'.[13] 'Tobacco-water' was a widely used stain for this purpose and was certainly used by Nollekens in the 1760s in Rome where he was involved in the 'restoration' of some antique statuary.[14]

Quite how widespread was the practice of staining marble sculpture is not easy to assess –

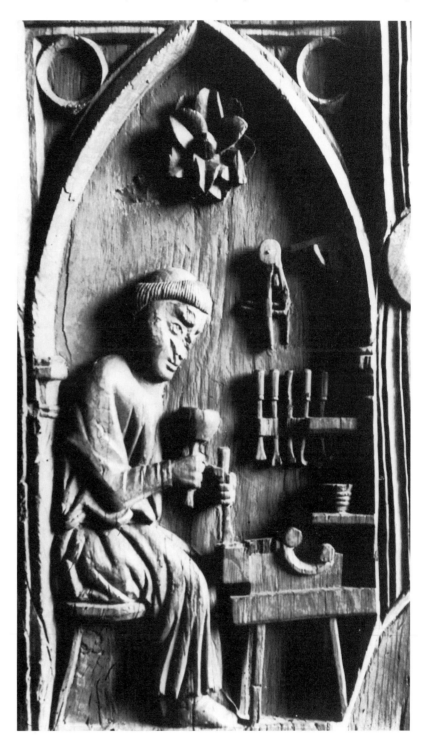

289 Carved wood choir stall (*c.* 1285), showing a monk carving with a mallet and chisel. The grain of wood encourages wood-carvers to switch the mallet and chisel from one hand to the other to vary the angle of attack. *Provinzial Museum, Hanover*

290 Portrait bust of Colley Cibber, workshop of the Cheeres (?), *c.* 1740, coloured plaster with glass eyes, height 26 in. (66 cm.). The Cheere workshops were well known for the production of coloured ornamental garden statuary. *National Portrait Gallery, London*

OPPOSITE
291 Purbeck marble shrine, *c.* 1305–11, height 5 ft. 6 in. (1.68 m.), in St Michael's Church, Stanton Harcourt, Oxfordshire. It was the painting of Purbeck marble that brought about a decline in the use of this intractable and beautiful material.

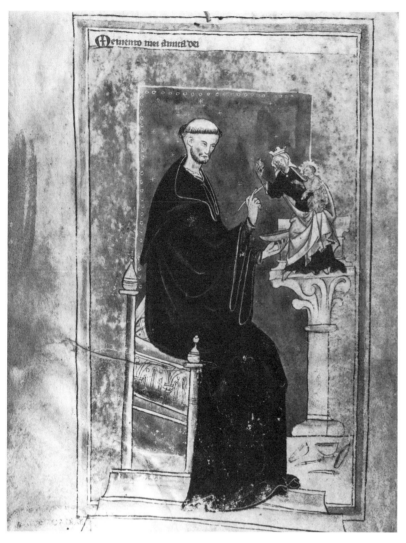

292 A monk painting a statue of the Virgin and Child, from a thirteenth-century miniature of the Apocalypse. *Lambeth Palace Library*

293 Nino Pisano (d. *c.* 1368), *Angel of the Annunciation*, wood. Detail showing painted decoration. *Victoria and Albert Museum, London*

OPPOSITE
294 William Sergeant Kendall (1869–1938), *Quest*, 1910, carved and painted cherry, 24⅛ × 14 × 16 in. (86.7 × 35.5 × 40.7 cm.). *Pennsylvania Academy, Philadelphia*

the natural patination of age has given most works a mellowness that they may not always have possessed. Certainly, as with the question of polishing, two views were held. Richard West-macott was in favour of the discreet use of stain-ing 'to get rid of glare',[15] whereas Baron d'Uklanski preferred 'dazzling white marble, in its original state'.[16]

There was one area where opinion was generally united. This concerned the polychrome treatment of sculpture. It was wholeheartedly condemned. The attitude is with us still and dem-onstrates the residual power of the Classical outlook. We have seen how in some of Rodin's early portraits shadow in hollows and textures was manipulated to suggest local colour – to the purist this is contrary to the sculptor's discipline.

Egyptian, Greek, and Roman sculptors con-fronted no such difficulties – they simply inlaid the eyes with their 'proper' colour using ivory, glass, and other substances or they painted them. Medieval sculptors did much the same although glass was more often than not reserved for 'jewels'. The whole question of the treatment of human and animal eyes in sculpture underlines

the theoretical difficulties for those who argue, as many have, that sculpture should not be painted.

Although the notion of polychromed sculp-ture was never utterly extinct, it was the Classical Revival in its reassertion of the importance of Classical precedent that drew attention to the use of colour on sculpture in antiquity. The attempt to revive it in the early nineteenth century was widely rejected. J. T. Smith, referring to Roubiliac's marble figure (1751) of Sir John Cass, objected that 'this fine statue has lately been most villainously painted of various col-ours'.[17] This retrospective 'improvement' was perhaps a clear 'villainy', but Canova's *Venus and Sleeping Endymion*, with its lips and cheeks tinted red, was described by Richard Westma-cott as a 'dangerous innovation, capable of doing great injury to art'.[18] The *Carlisle Patriot* of 2 October 1824 firmly stated that 'to attempt a deception in a statue would be certain to produce disgust. To put natural colours, for example, on a statue, would only produce a stone monster, lifeless and voiceless.'[19] In nineteenth-century Britain the most famous (even notorious) sculp-

295 *King John*, hand-coloured engraving from C. A. Stothard's *The Monumental Effigies of Great Britain* (1817). The original polychrome decoration on this Purbeck marble effigy was destroyed when the figure was gilded by order of Queen Victoria.

296 A plate from C. A. Stothard's *Monumental Effigies* showing the colours used to embellish the royal tombs at Fontevrault, France.

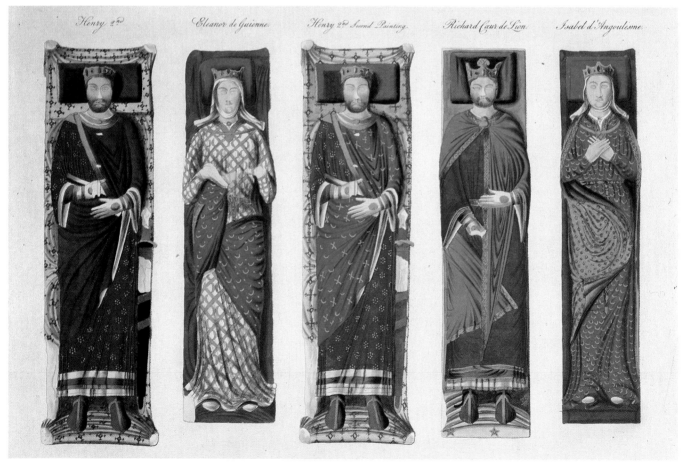

tor to experiment with polychrome sculpture was John Gibson (1790–1866) and his tinted Venuses of the 1850s. Although he began his experiments as early as 1839, his first major work to be tinted was a portrait statue (1844) of Queen Victoria. Sir Charles Eastlake quite possibly had Gibson's work in mind when he objected that a tinted Venus in a country house 'can look like an impertinent intruder in undress'.[20] The precedent was easier to identify than to emulate.

In those periods that have considered painted sculpture as the norm, the work generally demanded the subtle consideration and experience of specialists. In 1485 a commission was given to Michel Erhart of Ulm for a carved-wood altarpiece, but its polychrome embellishment was to be done by Gumpold Gültlinger, the Augsburg painter.[21] Moreover, in this instance the carver was promised between 40 to 60 florins but the painter was to receive an estimated 150 to 200 florins. Although much of the cost of the painting and gilding was doubtless absorbed by the high cost of the materials, these two estimates emphasize that in medieval Europe the painting of sculpture was an important consideration from the outset, far removed from the hesitant tinting that served as a postcript on the work of men like Gibson. Neither should it be assumed that the medieval sculptor was necessarily subsidiary to the painter in importance. The wood-carver Jörg Lederer of Kaufbeuren contracted out the painting of a retable to Peter Zech and also appointed an assistant.[22] Some sculptors, though these were probably a minority, painted their own works. A possible example is Master Simon de Wells who may have worked as a sculptor at Wells Cathedral and, in 1257, at Westminster where he appears as Simon le Peyntour or Pictor.[23]

So widespread was the use of polychrome decoration both inside and outside medieval churches and cathedrals that one may too easily conclude that all surfaces were either painted or gilded. This was of course not so. The use of labour-intensive materials like Tournai (Belgian black) marble may only be justified by polishing them to reveal their natural colour and/or pattern. It was the painting of Purbeck 'marble' in the early fourteenth century that marks the decline of its use.

In England the last flamboyant manifestation of painted decoration (combined with an almost Roman use of coloured marble) recurred in the early seventeenth century – its use was widely accepted especially in connection with ecclesiastic buildings throughout the century. In 1698 Celia Fiennes visited Durham where she remarked that the font was *not* coloured, and Patshull Park where she saw in the grounds a pair of 'brick pillars with stone heads on which stood a Turky Cock on each, cut in stone and painted proper'.[24] Perhaps one of the last links with the medieval tradition for painted sculpture was John Cheere (d. 1787) who took over both the yard and the stock-in-trade of John van Nost (d. 1729):

> The figures [in Cheere's yard] were cast in lead as large as life and frequently painted with an intention to resemble nature. They consisted of Punch, Harlequin, Colombine, and other pantomimical characters; mowers whetting their scythes, haymakers resting on their rakes, gamekeepers in the act of shooting and Roman soldiers with firelocks, but above all, that of an African, kneeling with a sundial on his head found the most extensive sale.[25]

Van Nost supplied Melbourne Hall, Derbyshire, with the figure of the Blackamoor for £30 (c. 1700) and from the accounts it is evident that his lead sculpture there was repainted at regular intervals: 'for colouring ye urns and 2 large statues; for gilding 2 flames for ye urns; for colouring ye boys and ye 2 pedestals.'[26] Such regular painting served to maintain the deception. In 1697 Celia Fiennes saw at Woburn 'a figure of stone resembling an old weeder woman used in the garden . . . which is done so like and her clothes so well that at first I took it to be a real living body.'[27] This was probably one of the Nost/Cheere lead figures.

On 14 March 1771 the Council of the Royal Academy 'Resolved that no Models in coloured Wax shall be admitted in the Exhibitions.' This effectively sealed the epitaph on the tradition for the polychrome embellishment of the 'polite art' of sculpture (accepting and excepting its continuance at the popular level for inn signs, etc.). Its reappearance in the nineteenth century was quite definitely a revival. The flirtations with tinted Venuses amongst the Classicists did not come to much but painted decoration became for the Victorian Gothic Revivalists a central part of their vision. In some ways it began with C. A. Stothard's book *The Monumental Effigies of Great Britain* (1817) which so carefully recorded (with hand coloured details) the surviving painted decoration then visible on so many effigies (figs. 295, 296). In 1882 W. & G. Audsley published their *Polychrome Decoration as applied to Buildings in the Medieval Style*. It was a plea for the reintroduction of painted decoration on architecture but its thirty-six plates have a milky look that remains determinedly Victorian in outlook, no matter how much they sought to re-establish the flamboyance of the medieval tradition. Apart from the interiors of Victorian churches or non-conformist chapels, the painting of sculpture since then has been largely a matter for individual experiment.

VI POSTSCRIPT

Painters and sculptors who work on commissions confront their chosen media in a way not shared by those who work speculatively. In practice many artists were involved in both approaches, but in the past most work was made at the behest of a patron whereas in the modern world this procedure has been generally reversed. The wider implications of this significant change of emphasis have been more seriously examined by economic historians than by art historians, and yet for the latter there is considerable potential.

Patrons were once regularly part of the creative process; they did not simply write cheques. For the artist working to the specification of a job the sometimes conflicting demands of the client, the 'idea', and the location were resolved through the appropriate choice of materials and the techniques and tools involved in their use. It was a stimulating equation. Those less tangible qualities to which all artists aspire were possible and even thrived in these conditions. In contrast to this, for the painter or sculptor who exhibits his wares for sale to a patron (who applies his munificence, as it were, retrospectively), these practicalities are of much less importance. As a consequence, both the objectives and the means of their realization are centred upon the individual artist. The painters and sculptors of the past who worked by the medieval standards institutionalized by the guilds were expected to produce a consummate example of their skill, which may or may not have come to be seen as a work of art – the master piece as masterpiece. In the creation of such works these individuals were dependent upon regiments of other craftsmen, the joiners, gilders black- and white-smiths, masons, braziers, founders, and chasers. Their skills were deployed collectively in such a way that the whole was more important than the constituent parts. The post-medieval decline in these relationships was reinforced by the Industrial Revolution. By the eighteenth century, if not before, the 'client economy' of the past gave way in England to the 'consumer society' of the modern world. This has had a lasting influence not only on the production of such things as textiles and buttons but also on the facture of art. The use of substitute materials was less often ordained by the objective opinion of a client than by the commercial interests and judgement of the producer. Artists no less than industrialists assumed a dominance over their 'consumers' that was unknown to earlier generations.[1] These changing circumstances are reflected in the types of art instruction available to painters in England in the late eighteenth century and in books that were published on these matters at this time.[2] The earlier traditions that included the craft of preparing and working paint produced a freedom and expressionistic verve for those artists who were 'bred'[3] to paint such things as signboards[4] which contrasts strikingly with the more intellectually demanding, if ultimately more constricting, discipline placed upon those educated in academies of art. Few innovations arose to give sculptors such 'advantages'. Coade stone was not fundamentally different from terracotta even if, in certain lights and at sufficient distance, it could resemble prestigious marble or stone. The early nineteenth-century promise of electrolytically created metal statuary was seldom fully realized. In effect the pace of change was established by painters at a time when neo-classicism gave sculptors an otherwise exceptionally powerful position.

The decline in the importance of 'making' marks an important shift of emphasis, in which painting and sculpture was produced with the expectation that it should be a work of art executed by one person with a signature.[5] The burden was intolerable. Only skill (certainly not art) could be delivered on demand with a guarantee, and once the mainstay of skill was removed by the industrialization of many of the artist's materials, tools, and techniques, rebellion was inevitable. Working to order, which painters and carvers had long accepted, came to be seen not simply as inappropriate but contrary to the very idea of the 'artist' as opposed to the 'artisan'.

More recently the notion of art as a 'product' has been questioned by those for whom the promiscuous pleasures of conception are everything – the 'Conceptualists'.

The subtle interplay of the many forces that go into the creation of a work of art is a self-evident mystery. These forces are the more elusive since each has changed in its relative degree of importance through history. In general the theocracies have been concerned with 'content' in art whereas those societies influenced by the tenets of humanism have emphasized the importance of 'form'. For medieval Europeans religion and the demands of the patron were almost more important than the team of artisans who translated the client's motive into the craftsman's motif. The pre-Christian origins of Renaissance thought that first appeared in Catholic Europe also nourished the Reformation and began a revolution in the visual arts in which subjective inspiration rather than objective faith provided the *raison d'être* for creative activity. The lack of a knowledge of the evolution and processes of craftsmanship amongst many art historians has divorced them from aspects of their discipline. Furthermore the central role accorded to artists over the last five hundred years or so has led to the biographical approach to art history. There are of course other factors to be taken into account in looking at the works of art of the past in addition to the background of the individual maker. An important example would be the effects of climate upon architectural design and even to some extent on the arts of painting and sculpture. A reasoned assessment of the work of Palladio and his followers could be constructed on such a premise and Bruegel's response to the hot summer of 1565 is celebrated in his *The Harvest* of that year with no less force than are his winter scenes.[6] With Palladio we are concerned with 'form' and in the case of Bruegel with 'content', but in both climate has had an important bearing on the resulting work. The shorter life expectancy of past centuries had remarkably little effect, since seven-year apprenticeships starting in boyhood were commonplace. Only by this means could the cumulative knowledge and experience of many generations be passed on. Only in youth was it possible for the necessary skills to be ingrained; knowledge could be acquired at any age, but the reflexes of the physical manipulation of materials were determined less consciously and achieved by a physique conditioned by early training to the needs of a particular craft. In both training and practice the master craftsman arrived early at a level of education and achievement that the long working days of the past made possible.

The painter was presumed to have a wrist that was 'dexterous, resolute, and rapid' and a sculptor was expected to be able 'to hold a bite' with the chisel in the piece of stone he was cutting. These skills were assumed to be present and have therefore too easily been ignored. Even the removal of a skill from the artist's workshop could, as we have seen, have important consequences for the resulting work. It was of course this variety of skills coupled with an empirical scientific knowledge that helps to explain the seemingly unrelated activities of painters like Samuel F. B. Morse, Charles Wilson Peal, or for that matter Leonardo da Vinci.[7]

The extinction of some skills is sometimes compensated for, if not replaced, by new technologies. Centrifugal casting has made chasing less necessary, but neither is a substitute for the other; each has its individual characteristics. At a time when making and designing are seldom seen as simultaneous activities, the loss of skill is all but invisible. In this state of innocence ideas are supposedly created in the mind rather than evolved on the bench. As a doctrine the position is indefensible; as an unthinking attitude it spells danger. In the past the work of craftsman's art was produced through the earthy experience of the maker, which owed at least as much to an almost erotic pleasure in the tactile nature of materials as to the cerebral or even unconscious questions of inspiration.

As I suggested in Chapter I, 'Art or Craft?', any distinction between art and design is a notional matter of convenience rather than a reality. Despite this limitation, such arbitrary distinctions may have their uses. It is in those artefacts that are made primarily for utilitarian purposes that one may most easily discern the significance of practical questions of construction on the ultimate appearance or 'look' of the product. Perhaps this is why Walter Crane (1845–1915) when writing about 'Art Teaching' made reference to the importance of 'certain decorative and constructive arts and handicrafts in common use, such as those of the rural waggon-maker and wheelwright'.[8] In this instance one 'decorative' feature that Crane may have had in mind was the use of chamfers and chamfer-stops to reduce weight while maintaining the strength of the mortices and tenons in this 'constructive' art. Another example of the structural cause of a visual effect was noted in 1810 by the Reverend Walter Davies when describing the farm gates of North Wales:

> The span ten feet clear between the posts: the top and bottom rails are of oak, and the intermediate ones of foreign deal, all tapering towards the fore-post in order to lessen the pressure upon the hinges.[9]

From this it is evident that the horizontal members were tapered for very practical reasons,

although this feature must have added greatly to the cost. Visually, such a gate would be an object of great subtlety, and although these details and above all their cause would be invisible to the uninitiated, their effect would be sensed by all who saw them. In architecture these questions have long been recognized in numerous details such as cornices, coffered ceilings, or architraves, all of which had their structural or practical origins but which were also decorative. Similarly the vermiculated or batted surface given to stone was inspired by a natural condition in the material or the natural effects caused by working it. In painting and sculpture no less than in the work of the mason or wainwright structural issues arose which both provoked questions and provided answers.

In the past many of those who wrote about art were themselves practising artists and, provided they were not inhibited by social aspirations, they made natural and frequent reference to matters of craft. Even the fastidious connoisseurs of the eighteenth century were not above such questions. Horace Walpole makes intermittent reference to 'the arts of picture craft',[10] although at one point where the complex technical problems involved in making dies for coins and medals arises he is compelled to retreat on the grounds of being 'ignorant myself in the mechanic part of this art'.[11] For the squire of Strawberry Hill such an admission was of no embarrassment, but once art history became (in the second quarter of the nineteenth century) a matter for professionals documentary evidence provided the principal and 'safe' basis for research. Works of art were less often examined for the physical clues to their history and only the rising importance of conservation in recent years, together with increasing financial values, have once again drawn attention to internal evidence as a means of establishing the authenticity of a work of art. This return to fundamentals has been termed in America 'technical connoisseurship'.[12] It is a system of analysis that has been used by musicologists for years. Such an approach gives voice to the anonymous arts of the past and provides a system for 'looking' that is none the less new for being founded on the old craft methods. It also gives a new means of examining the familiar. The known work by the known artist may too easily be submerged in accumulated hagiographies. It is time for stimulating heresies as the basis of future orthodoxies. The materials of art provide the tools for the construction of an alternative art history.

In the language of the workshop a craftsman in paint or wood or stone will speak of 'offering up' his work into its final position (if not location). The phrase, though used with practical intent, is also redolent of the sacrament of making, the consecration of the handmade object. In his great book *The Wheelwright's Shop* (1923), George Sturt combined the knowledge of the schoolmaster with the experience of the craftsman.[13] Sturt's prose is an elegy, a song of lamentation, which is permeated by the humility of one who was profoundly aware of the limitations of 'book learning', the approximations of words as compared with the precision of making. *The Wheelwright's Shop* is not so much a sentimental refrain for lost technical processes as a metaphor for an historical England of woodland skills, in which craftsmanship is seen as 'a knowledge as valid as any artist's'. Regrettably other pre-industrial crafts of art lacked such a chronicler, not simply to record but to celebrate the skills that were once so abundantly employed by painters and sculptors.

297 An ox-wain frame, from Ewenni, Glamorgan. Construction and function as an art. *National Museum of Wales, St Fagans*

APPENDICES

1 Sizes of Frames

Frames were made to accommodate pictures of all dimensions and proportions. By the early eighteenth century (if not before) they were probably being made to standardized sizes. Oblique evidence for this is provided by the series of portraits painted by Kneller during 1702–17 of members of the Kit-Cat dining club – so called after Christopher Cat, in whose tavern near Temple Bar the club held its first meetings. These portraits were painted on canvases of an unusual dimension, 36 × 28 in. (91.5 × 71 cm.), a size known since then as a 'Kit-Cat'.

The standard dimensions for English frames include:

20 × 16 in.	(50.5 × 40.5 cm.)
24 × 20 in.	(61 × 50.5 cm.)
30 × 25 in.	(76 × 63.5 cm.)
36 × 28 in.	(91.5 × 71 cm.)
40 × 30 in.	(101.5 × 76 cm.)
50 × 40 in.	(127 × 101.5 cm.)

The standard dimensions for Continental frames include:

Portrait		Landscape	
$21\frac{3}{4}$ × 18 in.	(55 × 46 cm.)	$21\frac{3}{4}$ × 15 in.	(55 × 38 cm.)
24 × $19\frac{3}{4}$ in.	(61 × 50 cm.)	24 × 18 in.	(61 × 46 cm.)
$25\frac{3}{4}$ × $21\frac{1}{4}$ in.	(65 × 54 cm.)	$25\frac{3}{4}$ × $19\frac{3}{4}$ in.	(65 × 50 cm.)
$28\frac{3}{4}$ × $23\frac{3}{4}$ in.	(73 × 60 cm.)	$28\frac{3}{4}$ × $21\frac{1}{4}$ in.	(73 × 54 cm.)
$31\frac{3}{4}$ × $25\frac{3}{4}$ in.	(81 × 65 cm.)	$31\frac{3}{4}$ × $23\frac{3}{4}$ in.	(81 × 60 cm.)
$36\frac{1}{4}$ × $28\frac{3}{4}$ in.	(92 × 73 cm.)	$36\frac{1}{4}$ × $25\frac{3}{4}$ in.	(92 × 65 cm.)
$39\frac{1}{2}$ × $31\frac{3}{4}$ in.	(100 × 81 cm.)	$39\frac{1}{2}$ × $28\frac{3}{4}$ in.	(100 × 73 cm.)

2 Dating Canvases – Winsor & Newton

The trade marks that appear on the back of many commercially produced canvases provide, through a change of name or address, a potential means of dating a picture. The history of the firm of Winsor & Newton is a good example.

1832	Winsor and Newton established at 38 Rathbone Place, London
1841–57	Appointment to Queen Victoria and Prince Albert
1857–61	Appointment to Queen Victoria and Prince Consort
1861–3	Appointment to Queen Victoria
1863–1901	Appointment to Queen Victoria and Prince and Princess of Wales
1878	Address changed from Rathbone Place, London, to Rathbone Place, London, W.
1882	Incorporated as Winsor and Newton Ltd.
1901–10	Appointment to King Edward VII
1901–25	Appointment to Queen Alexandra
1910–35	Appointment to King George V
1911–53	Appointment to Queen Mary
1917	Address changed from Rathbone Place, W., to Rathbone Place, W.1
1935	Title changed from Winsor and Newton Ltd. to Winsor & Newton Ltd. (This, however, is not a valuable clue as they used both 'and' and the ampersand indiscriminately for many years.)
1939	Address changed from Rathbone Place, London W.1, to London, England
1951	Commencement of coding: First letter = month (A–L) Second letter = year (A 1951, B 1952, *et seq.*) Third letter = internal identification

3 *Reeves, Artists' Colourman*

The following information is drawn from the late Ambrose Heal's notes in his folder of material on the Reeves brothers.

William and Thomas Reeves were in partnership at the Blue Coat Boy and King's Arms, Holborn Bridge, up till 1784 when they separated. Thomas Reeves retained the Holborn Bridge premises.

1781–4	William & Thomas Reeves Colourman at the Blue Coat Boy & Kings Arms on Holborn Bridge
1793	Thomas Reeves & Son Colourman to her Majesty and the Prince of Wales, 80 Holborn Bridge
1807	Reeves and Inwood Watercolour manufacturers, 300 Strand
1807	Reeves and Woodyer, Colour manufacturers, 80 Holborn Bridge
1817	John Reeves, Oil & Colourman, Brown Street, Bryanston Square
1817	William Reeve (*sic*), Oil & Colourman, 118 Fetter Lane
1823	W. J. Reeves & Son, Colourmen, 80 Holborn Bridge
1823	William Reeve, Oil & Colourman, 43 Green Street, Bethnal Green
1825	William Reeve, Oil & Colourman, 118 Fetter Lane & 10 Upper Thames Street
1825	Reeves & Inwood, Colourmen to artists, Holborn Bridge
1826	William Reeve, Oil & Colourman, 118 Fetter Lane
1826	W. J. Reeves & Son, Water-colour manufacturer, 80 Holborn Bridge
1827	Esther Reeve, Oil and colour warehouse, 118 Fetter Lane
1827	W. J. Reeves, Artist in water colours, 5 Woburn Place & 81 Holborn Bridge
1827	W. John & Son, Artist and colourman, 80 Holborn Bridge
1832	Abraham Reeve, Oil & colour-man, 134 Gt. Surrey Street
1838	W. T. Reeve, Oil & Colourman, 118 Fetter Lane
1838	Reeves & Sons, Watercolour manufacturers, 150 Cheapside
1839	William Thos. Reeve, Oil & Colourman, 118 Fetter Lane
1839	Reeves & Sons, Artists colourmen, 150 Cheapside
1839	William Reeves, Colourman, King Street, Hammersmith
1851	Thomas Reeve, Oil & Colourman, 16 Judd Place West, New Road
1851	William Thomas Reeve, Oil & colourman, 118 Fetter Lane
1851	Reeves & Sons, Artists & Colourmen, 113 Cheapside
1851	John Reeves, Artists colourman, 2 & 98 John Street, Fitzroy Square
1867	Mrs Ann Reeves, Artists colourman, 2 John Street, Fitzroy Square
1868–9	Mrs Ann Reeves, Artists colourman, 6 Whitfield Street
1870–80	John Reeves, Artists Colourman, 6 Whitfield Street

4 *A Sculptor's Tool-Kit*

The following names were found on the steel shanks of wood-carving tools in the kit (of over 300 tools) used by the sculptor Arthur J. J. Ayres, born 1902.

The notes on each maker have been abridged from information generously supplied by Sarah Craggs of Sheffield City Museums and by Kenneth Roberts of Fitzwilliam, New Hampshire, whose book *Some Nineteenth-Century English Woodworking Tools* (New York, 1982) is an important source of reference.

ADDIS: Probably 1850–70

ADDIS, SEN^R: Probably 1850–70

J. B. ADDIS & SONS/SHEFFIELD: 1871–1963. Although the firm of James Bacon Addis does not seem to appear in the Sheffield Trade Directories until 1871, advertisements suggest that the firm was in operation as early as 1851. This may be because the firm could not at first afford a listing in the Directories. In 1871 James Bacon Addis is listed as a 'carving tool manufacturer' at 127 Portobello Street, with a house at 46 Newcastle Street. After a number of changes of address, J. B. Addis & Sons Ltd., 'light edge tool Mfrs', make a final appearance in the Directories at 2 Mowbray Street in 1963 (the firm became a limited company some time between 1909 and 1921).

S. J. ADDIS/CAST STEEL: *c.* 1871–1910

S. J. ADDIS/GRAVEL LANE: *c.* 1871–1910

S. J. ADDIS JUN^R: *c.* 1871–1910. There were three members of the family named Samuel Joseph Addis. In 1879 Samuel Joseph Addis is listed with premises in London – probably acting as an agent for production that continued in Sheffield.

CONINGSBY: London

L & C GLAUERT/SHEFFIELD: *c.* 1875–1909. Listed in Directories from 1879 at Burgess Works, 11 Cambridge Street, with Charles Glauert's home address given as 1 Sandon Place, Warncliffe Road, and Louis Glauert's as Chantrey Villa, Glen Road, Nether Edge. (The sculptor Sir Francis Chantrey, 1781–1841, was a native of Sheffield and began his career apprenticed to Ramsay, a carver and gilder in the town.) The last entry for the firm in the Directories occurs in 1909 at the Wallace Works, Furnival Street.

W. HATTON: London (considered good for bent carving tools)

HEARNSHAW: The Hearnshaw Brothers were based at Solly Street, Sheffield from 1876.

HERRING BROS: John Herring, Navigation Works, Sheffield, 1888–93 (considered good for large carving tools)

C. HILL/SHEFFIELD: Charles Hill of Broomspring Lane, Sheffield, 1883–99

J. HOWARTH: James Howarth is listed from 1841/5 in the Sheffield Directories as 'edge tool and engraver's, die-sinkers and turner's tool manfr., cast steel drawer etc. [at] 121 Fitzwilliam Street', with a home address at 7 Broom Close. In 1879 James Howarth & Sons described themselves as 'mfrs. of edge tools, joiners' tools, augers, skates, saws, files and steel and general merchants [of] Broomspring Works, 74 to 80 Bath Street'. There seem to have been at least three generations of James Howarths in the business until the firm was taken over by Robert Sorby & Sons Ltd. some time between 1909 and 1921. Sorby's continued the business as James Howarth & Sons until about 1936.

ROWE: (?)

JOHN SMITH: Coalpit Lane, Sheffield, 1814–15 (shipyard carvers' tools?)

STUBS: Warrington, *c.* 1807–1970

TAPHOUSE: North of England? (shipyard carvers' tools?)

H. TAYLOR/SHEFFIELD: Fitzwilliam Street, 1844–1984

WARD/CAST STEEL: Sheffield, 1814–41. Became Ward & Payne at West Street, Sheffield (1843–1965). Made very large and medium-sized wood-carving tools.

WINCOT: London? This firm was known for not stamping their products with their name, and no tool by them has been positively identified in this kit of tools.

NOTES

I Introduction

THE PROSPECTIVE VIEW

1 See Winterthur Conference Report 1973, *Technological Innovations and the Decorative Arts*, ed. by Ian M. G. Quimby and Polly Anne Earl, Charlottesville, The University Press of Virginia: Cyril Stanley Smith, 'Reflections on Technology and the Decorative Arts in the Nineteenth Century', pp. 35–49.

2 Oscar Wilde, 'The Model Millionaire', *The Complete Shorter Fiction of Oscar Wilde* (Isobel Murray ed.), Oxford University Press, 1979, p. 90.

TRADE OR PROFESSION?

1 Robert C. Alberts, *Benjamin West, A Biography*, Boston, Houghton Mifflin Co., 1978, pp. 225–39.

2 Founded 1768.

3 Exceptions include the elder Pliny (AD 23–79) who cites a number of artist art historians such as the sculptor Pasiteles, 'the author of five books on all the celebrated works of art in all the world' (see *The Elder Pliny's Chapters on the History of Art*, translated by K. Jex-Blake, Chicago University reprint, 1968, p. 121), and Horace Walpole, who used the notebooks of the engraver George Vertue and others in his *Anecdotes of Painting in England*, 1762–71.

4 Sir Joshua Reynolds, *Seven Discourses Delivered in the Royal Academy by the President*, London, 1778, p. 196.

5 Reynolds, p. 19.

6 Quoted by Sir Charles Lock Eastlake, *Materials for a History of Oil Painting* (1847), New York, Dover reprint, 1960, vol. I, p. 133.

7 Eastlake, vol. I, p. 485 and vol. II, p. 110. Eastlake notes that the *Secreti* was appended to an edition of Alexius published at Lucca in the mid-sixteenth century.

8 Horace Walpole, *Anecdotes of Painting in England*, London (1762–71), 4th edn. 1786 (5 vols.), vol. III, p. 133.

9 Eastlake, vol. I, p. 461.

10 Reynolds, pp. 62–3. Reynolds is here contradicting his earlier statement cited above (n. 5).

11 Thomas Bardwell, *The Practice of Painting*, London, 1756, and Edward Edwards, *Anecdotes of Painters*, London, 1808, p. 7.

12 Reynolds, p. 72

13 Prince Hoare, *Epochs of the Arts*, London, 1813, p. 143.

14 Walpole, vol. II, p. 168.

15 Hoare, op. cit., p. 148.

16 Walpole, vol. IV, p. 79.

17 These 'knights of the pallet' were: Anthony van Dyck, Peter Lely, Godfrey Kneller, James Thornhill, Joshua Reynolds, William Beechy and Thomas Lawrence. J. T. Smith, *Nollekens and His Times* (1828), W. Whitten edn., London, John Lane, 1920, vol. I, p. 171.

18 Giovanni Paolo Lomazzo, *Tracte Containing the Artes of curious Paintinge, Carvinge and Buildinge*, 'Englished' by Richard Haydocke, Oxford, 1598. Other writers, including Vasari, make this point.

19 Edward Lucie-Smith, *The Story of Craft*, Oxford, Phaidon, 1981, pp. 114–15.

20 Giorgio Vasari, *Lives of the Most Eminent Painters, Sculptors, and Architects* (1568), translated by Gaston Du C. de Vere, New York, Harry N. Abrams, Inc., 1979, p. 583, 'Lives of Antonio and Bernardo Rossellino'. In this edition the pages are numbered consecutively through three volumes.

21 Walpole, vol. III, p. 186.

22 Walpole, vol. III, p. 126.

23 Christopher Wren, jun., *Parentalia or Memoirs of the Family of Wrens*, London, Stephen Wren, 1750, p. 214. In the eighteenth century and before the amateur of art was a lover of art. I use the word here in its twentieth-century sense, the non-professional.

24 John Evelyn, *Sculptura*, London, 1662, p. 103.

25 Introduction by Raymond V. Schoder to *The Elder Pliny's Chapters on the History of Art*, p. H. Schoder cites the 'Descriptions [ekphrasis] of Callistratus'.

26 Quoted by Trevor Fawcett, *The Rise of English Provincial Art*, Oxford, Clarendon Press, 1974, pp. 4, 10.

27 Washington Allston, *Lectures on Art*, London, 1850, p. 9.

28 Allston, op. cit., p. 29.

29 Eastlake, vol. II, p. 410.

ART OR CRAFT?

1 Christopher Wren, jun., *Parentalia or Memoirs of the Family of Wrens*, London, Stephen Wren, 1750, p. 332.

2 Vasari, p. 1838 'Life of Michelangelo'.

3 Vasari, p. 474 'Life of Piero della Francesca'; p. 348 'Life of Uccello'; p. 441 'Life of Donatello'.

4 Vasari, p. 118 'Life of Giotto'.

5 Walter Cahn, *Masterpieces: Chapters in the History of an Idea*, New Jersey, Princeton University Press, 1979.

6 Smith, *Nollekens*, vol. I, p. 338.

7 Eastlake, vol. I, p. 54.

8 Walpole, vol. III, p. 216.

9 Walpole, vol. III, p. 219. Others who worked for Kneller and mentioned by Walpole include John James Bakker (p. 215), Jacob Vander Roer (p. 216), Marcellus Laroon (p. 238), and occasionally Baptist (p. 211).

10 Eastlake, vol. I, p. 89.

11 Walpole, vol. II, p. 210.

12 Dobie of 14 Kenton Street, Brunswick Square, London. Ambrose Heal Collection of Trade Labels, British Museum Department of Prints and Drawings, 90.36.

13 Borguis of Titchfield Street, London. Banks Collection of Trade Labels, British Museum Department of Prints and Drawings, photograph in Heal Collection, 90.2.

14 Trevor Fawcett, *The Rise of English Provincial Art*, Oxford, Clarendon Press, 1974, p. 17. 'Transparencies' were decorative painted window blinds or shades.

15 William Williams, *An Essay on the Mechanic of Oil Colours, considered under these heads: Oils, Varnishes and Pigments,* Bath, 1787, pp. 10–11.
16 Pliny, p. 145.
17 John Elsum, *The Art of Painting after the Italian Manner with . . . observations how to know a good Picture,* London, 1704, p. 79.
18 Quoted by Barbara Novak, *American Painting in the Nineteenth Century,* 1974 edn., New York, Praeger, 1969, p. 61.
19 Crashlay of Long Acre, London. Heal Collection 32.13.
20 Pillgreen of Old Belton Street, Long Acre, London. Heal Collection, 32.45.
21 Heal Collection, 32.1.

II The Studio

1 F. H. W. Sheppard (gen. ed.), 'North Kensington', *Survey of London,* London, Athlone Press, University of London (for the Greater London Council), 1973, vol. XXXVII, p. 140. Many but not all artists of this period had the same sense of Victorian propriety in the planning of their studios. Val Princep's (1836–1904) models used the main entrance and staircase. Leighton's studio was completed in 1866; Frederick Lord Leighton, 1830–96.
2 Mary Sayre Haverstock, 'The Tenth Street Studio', *Art in America,* September/October 1966.
3 Eastlake, vol. II, p. 199.
4 Vasari, p. 433 'Life of Donatello'.
5 Vasari, p. 846 'Life of Mariotto Albertinelli'.
6 Vasari, p. 878 'Life of Raphael'.

LIGHT AND COLOUR

1 For a discussion of the domestic use of paper or parchment fenestrals see James Ayres, *The Shell Book of the Home in Britain,* London, Faber, 1981, p. 97.
2 Platt quoted in full by Ayres, op. cit., p. 97.
3 *Paint and Painting,* Tate Gallery catalogue, 1982, p. 75.
4 See Trevor Fawcett, *The Rise of English Provincial Art,* Oxford, Clarendon Press, 1974, p. 118. Sir John Soane (1753–1837) began his series of lectures in 1809 and they were published in 1929 under the editorship of A. T. Bolton.
5 William Dunlap, *History of the Rise and Progress of The Arts of Design in the United States* (1834), New York, Dover reprint, 1969, vol. I, p. 284.
6 Ashmolean Museum, Oxford (illustrated in Anthony Bailey, *Rembrandt's House,* London, Dent, 1978, p. 97).
7 Bailey, op. cit., pp. 95, 96.
8 Nicholas Hilliard (c. 1547–1619), *A Treatise Concerning the Art of Limning,* R. K. R. Thornton and T. G. S. Cain eds., Manchester, Mid Northumberland Arts Group in association with Carcanet New Press, 1981, pp. 72, 74.
9 Hilliard, pp. 84, 85.
10 Hilliard, pp. 84–7.
11 Dunlap, vol. I, p. 256. He goes on to say about his quarters in Charlotte Street that he also had 'a furnished bed chamber immediately over it [the painting room] and for these, my board, fire &c., I was to pay a guinea a week'. See also vol. I, pp. 257, 260.
12 From the second half of the sixteenth century and on into the eighteenth century these artists are too numerous and many of them too well known to be worth listing here.
13 Walpole, vol. III, p. 244.
14 Walpole, vol. IV, p. 103.
15 David Pye, *The Nature and Art of Workmanship,* London, Studio Vista, 1968, ch. 2.
16 Pliny, pp. 85–7.
17 Scottish National Gallery, 612.
18 Walpole, vol. II, p. 115.
19 Smith, *Nollekens,* vol. I, p. 201.
20 Walpole, vol. III, p. 23.
21 Sir Hugh Platt, *The Jewel House of Art and Nature,* London, 1594, pp. 31–2.
22 Among the artists of the period who lived there and are recorded by Walpole were Isaac Oliver (vol. I, p. 265), Le Moyne (vol. I, p. 286), Cornelius Jansen or Johnson (vol. II, p. 8), and van Dyck, who 'lodged among the King's artists at Blackfriars' (vol. II, p. 154).
23 This book contains an extraordinarily miscellaneous collection of recipes but White nevertheless apologizes for repetition on the grounds that 'the laborious Bee gathereth her cordiall Honey, and the venemous Spider her corroding poysen many times from one Flower'. This was later paraphrased as follows by Benjamin West in his inaugural *Discourse* as President of the Royal Academy (1792): 'If you aspire to excellence in your profession you must like the industrious bee survey the whole face of nature and sip the sweet from every flower.' Quoted by Dunlap, vol. I, p. 70.
24 John Constable, 'Further Documents and Records' in R. B. Beckett, ed., *The Suffolk Records Society,* Ipswich, 1968, letter from John Constable dated 30 August 1833. I am indebted to Ian Fleming Williams for drawing my attention to this letter and its significance.
25 Robert C. Alberts, *Benjamin West: a Biography,* Boston, Houghton Mifflin Co., 1978, p. 387.
26 Fawcett, op. cit., p. 120. For Turner's gallery see J. Gage, *Colour in Turner,* London, 1969, pp. 152, 162.
27 John Cornforth, *English Interiors 1790–1848,* London, Barrie & Jenkins, 1978, pp. 84–5.
28 Hugh Honour, 'Canova's Studio Practice', *Burlington Magazine,* March/April 1972, p. 148, quoting Charlotte Anne Eaton's [née Waldie] *Rome in the Nineteenth Century,* Edinburgh, 1820, vol. III, p. 299.
29 Theophilus Marcliffe, ('a feigned name' but probably William Goodwin), *The Looking Glass: a True History of the Early Years of an Artist* [William Mulready, 1786–1863] *Calculated to awaken the Emulation of Young Persons of both Sexes in the Pursuit of every Laudable Attainment: particularly in the Cultivation of The Fine Arts* (1805), F. G. Stephens edn., London, 1889, pp. 37–8.
30 Fawcett, op. cit., p. 127, n. 67.
31 Hilaire Hiler, *Notes on the Technique of Painting,* London, Faber, 1934, p. 249.

PAINTERS' STUDIOS

1 Dunlap, vol. I, pp. 18, 19.
2 Edward Edwards, *Anecdotes of Painters,* London, 1808, p. 39.
3 *Anecdotes of William Hogarth Written by Himself,* 3rd edn., London, 1785, p. 24.
4 John Fletcher and Margaret Cholmondeley Tapper, 'Hans Holbein the Younger at Antwerp and in England, 1526–28', *Apollo,* February 1983.
5 Walpole, vol. III, p. 71.
6 Isaak Walton, *The Lives of John Donne* [and others] . . ., Oxford, Clarendon Press, 1805, pp. 99, 100.
7 Edwards, p. 110.
8 Ambrose Heal Collection, British Museum Department of Prints and Drawings, 94.74.
9 Walpole, vol. III, p. 237.
10 Dunlap, vol. I, p. 278.
11 Quoted by William L. Sachse, *The Colonial American in Britain,* Madison, University of Wisconsin Press, 1956, p. 171.
12 Dunlap, vol. I, p. 415.
13 Geoffrey Beard, *Craftsmen and Interior Decoration in England 1660–1820,* Edinburgh, Bartholomew, 1981, p. 135.
14 Walpole, vol. III, p. 85.
15 Dunlap, vol. I, p. 266.

16 Vasari, p. 985 'Life of Lorenzo di Credi', and quoted by Eastlake, vol. II, p. 85.
17 Hiler, p. 250.
18 Hilliard, pp. 72, 74.
19 Dunlap, vol. I, p. 179, quoting Gilbert Stuart's description.
20 Dunlap, vol. I, p. 256. In his autobiographical section Dunlap adds that West was then working on 'a beautiful composition of Lear and Cordelia' for the Empress of Russia.
21 Walpole, vol. III, p. 90.
22 Smith, *Nollekens*, vol. I, p. 185.
23 Walpole, vol. IV, p. 115.
24 Smith, *Nollekens*, vol. I, p. 183. Sheridan and Chippendale also later lived in this house; see p. 184.

SCULPTORS' STUDIOS

1 Smith, *Nollekens*, vol. I, p. 297.
2 Theophilus, *On Divers Arts*, trans. J. G. Hawthorne and C. S. Smith, New York, Dover, 1963, p. 81.
3 Carl Bluemel, *Greek Sculptors at Work* (1927), London, Phaidon, 1955, e.g. plates 2 and 3 of colossal statue in the marble quarries of Naxos.
4 John Harvey, *Mediaeval Craftsmen*, London, Batsford, 1975, p. 77.
5 Harvey, *Mediaeval Craftsmen*, p. 77.
6 John Harvey, *The Master Builders*, New York, McGraw Hill, 1971, p. 51.
7 Benvenuto Cellini (1500–71), *The Life of Benvenuto Cellini*, trans. J. A. Symonds (1901), London, Macmillan, 1911 edn., pp. 286, 281, see also pp. 283, 296.
8 Honour, p. 147, quoting a transcript of Granet's manuscript autobiography, p. 99, in the Bibliotèque d'art et d'archéologie (Foundation Jacques Doucet), Paris.
9 Honour, p. 147, quoting H. Beyle, *Oeuvres Intimes*, Paris, 1966, p. 1146.
10 Somerville Story, *Rodin*, London, Phaidon Press, 1956, p. 4.
11 Alice Bellony-Rewald, and Michael Peppiatt, *Imaginations Chamber*, London, Gordon Fraser, 1983, p. 110.

ANATOMY AND THE HUMAN FIGURE

1 Smith, *Nollekens*, vol. I, p. 60.
2 Anthony Bailey, *Rembrandt's House*, London, Dent, 1978, pp. 53–5. The fragment of the *Anatomy Lesson* is in the Rijksmuseum, Amsterdam.
3 In a letter to his father dated 1 May 1776, the Liverpool-born sculptor John Deare (1760–98) writes, 'I have seen two men hanged, and one had his breast cut open at Surgeons' Hall. The other being a fine subject, they took him to the Royal Academy, and covered him with plaster of Paris, after they had put him in the position of the Dying Gladiator.' Quoted by Smith, *Nollekens*, vol. II, p. 237.
4 Bailey, op. cit., p. 37.
5 Walpole, vol. III, p. 190.
6 Smith, *Nollekens*, vol. I, p. 345. Spang died in 1767.
7 For Dunlap's opinion on this figure, see vol. I, p. 322.
8 A macabre interest in anatomy was shown by Jacques Antoine Arlaud (1668–1743) who, on becoming 'a victim of devotion', destroyed his painting of Leda 'in such a fit of piety, yet with so much parental fondness that he cut her to pieces anatomically'. Walpole, vol. IV, p. 79.
9 Marcliffe, *The Looking Glass* (1805), F. G. Stephens edn., London, 1889, p. 87. It is possible that it was Houdon's 'flay' that the author had in mind; certainly F. G. Stephens in his notes for the 1889 edition describes what is almost certainly Houdon's well-known figure.
10 Smith, *Nollekens*, vol. I, p. 264–5.
11 Benvenuto Cellini, *The Treatises of Benvenuto Cellini on Goldsmithing and Sculpture*, trans. C. R. Ashbee (1888), New York, Dover reprint, 1967, p. 140.

12 Walpole, vol. IV, p. 210. The figure (of *c.* 1756) was sold to Mr Hoare as 'a principal ornament' for one of the temples at Stourhead. Gilbert Stuart 'prevailed on a strong muscled blacksmith for half a dollar an evening to exhibit his person for study' in his academy (?) (Dunlap, vol. I, p. 167).
13 Elsum, p. 10. In the use of components from different figures some artists ignored the sex of the model. J. T. Smith 'stood to Mr Nollekens' for the arms of Mr Townley's *Venus* (*Nollekens*, vol. I, p. 219), although Miss Coleman posed for the legs (*Nollekens*, vol. I, p. 188).
14 Walpole, vol. III, p. 245. By the nineteenth century such a narrow view of portraiture had disappeared and Dunlap makes it quite clear that the only reason that Dr Waterhouse posed for the hands in Gilbert Stuart's portrait of 'Mr Perkins' was because of the death of the latter (Dunlap, vol. I, p. 208).
15 Dunlap vol. I, p. 324. Other examples include a full-length figure painted by Trumbull 'for which one of Mr West's hired models, who belonged to that corps furnished person, costume, and horse', in effect, a real soldier posing for an 'unknown soldier' (Dunlap, vol. I, p. 324). In the first half of the twentieth century Sir Oswald Birley employed an ex-captain of guards as a model and adviser on uniforms. A Chelsea Pensioner was used by Nollekens to pose for 'the shoulders of Mr Percival' (*Nollekens*, vol. I, p. 328), and Nollekens's 'man', Dodimy, posed for the drapery in the sculptor's portrait of Pitt in the Senate, Cambridge University (*Nollekens*, vol. I, p. 335).
16 Smith, *Nollekens*, vol. I, pp. 330–1.
17 J. T. Smith gives the following information on Reynolds's 'throne-chair'. He reports that it 'was inserted for sale by auction [in the sale of Dr Edward Fryer's (1761–1826) collection following his death] and purchased by Sir Thomas Lawrence.' The chair was 'previously owned by Lord and Lady Inchiquin who gave it to Mr James Barry [1741–1806]'. Smith quotes a letter about the chair from Barry to the Inchiquins thanking them for 'this chair, that has had such a glorious career of fortune . . . the very chair that is immortalised in Mrs Siddons' tragic muse' (*Nollekens*, vol. II, pp. 9–10). Lady Inchiquin was Reynolds's niece and heir.
18 Quoted by Eastlake, vol. II, p. 193.
19 Although reference is made to a 'lay man' in J. T. Smith's *Nollekens* (vol. I, p. 68), most were androgenous so that they could wear both male and female costumes. Smith records a nice episode when Mrs Lobb (his housekeeper) says, 'I have a great mind to break all your *gashly* images about the head of your fine Miss, in her silks and satins', mistaking his lay figure for a living model (*Nollekens*, vol. I, p. 310).
20 Letter dated October 1793 from John Wragg of Denmark Street, Soho Square, to Richard French. Wragg apparently reconditioned the figure; French of Abbot's Hill, Derby, was a friend of Horace Walpole (Museum of London, 29.130).
21 Heal Collection, 32.31. Henekin also spelt his name Hennikin – he both designed and engraved the label quoted.
22 Dunlap, vol. I, p. 303. Whilst Dunlap was in debt in the years 1828–9, he sold 'Mr Eickholtz of Philadelphia, my lay figure which was one of the best and purchased by me from the maker in Paris'. For the years Dunlap was in Europe see Dunlap, vol. I, p. 266.
23 Smith, *Nollekens*, vol. II, p. 80.
24 Smith, *Nollekens*, vol. I, p. 310.
25 Vasari, p. 475 'Life of Piero della Francesca'.
26 Eastlake, vol. II, p. 252. Anton Raphael Mengs (1728–79), portrait and history painter.
27 Smith, *Nollekens*, vol. I, p. 160.
28 Trevor Fawcett, *The Rise of English Provincial Art*, Oxford, Clarendon Press, 1974, p. 33.
29 Smith, *Nollekens*, vol. I, p. 375.
30 Smith, *Nollekens*, vol. I, p. 264.
31 Dunlap, vol. I, p. 318.
32 It is tempting to wonder what shape the Classical Revival in

female dress would have taken if the tax on coal had not been removed in 1793.

33 Walton, op. cit., p. 100.

STUDIO EQUIPMENT

1 Dunlap, vol. I, p. 18, n.
2 Smith, *Nollekens*, vol. II, p. 269.
3 Cellini, *Life*, p. 329.
4 Anthony Bailey, *Rembrandt's House*, London, Dent, 1978, pp. 35, 36.
5 Edward Croft-Murray, *Decorative Painting in England*, London, Country Life, 1962, vol. I, p. 59.
6 Trevor Fawcett, *The Rise of English Provincial Art*, Oxford, Clarendon Press, 1974, p. 34.
7 Bailey, op. cit., p. 38.
8 Walpole, vol. II, pp. 115, 116.
9 Walpole, vol. III, p. 130.
10 Walpole, vol. III, p. 33.
11 Walpole, vol. III, p. 118.
12 Walpole, vol. IV, p. 123. See also vol. III, p. 230, re pictures which Richardson in his turn inherited from the painter, Riley. Richardson 'married a near relation of Riley.' For the sale of Hudson's collection, see Smith, *Nollekens*, vol. I, p. 33.
13 Smith, *Nollekens*, vol. I, pp. 40, 285, 298.
14 For a full description of Gill's clothes and his philosophy of dress, see Malcolm York, *Eric Gill: Man of Flesh and Spirit*, London, Constable, 1981, p. 27.
15 Honour, p. 147.
16 Honour, p. 147. Nuttall's *Standard Dictionary* (Warne, 1905) defines 'Nankeen' as 'a species of cloth originally from China, made of a sort of yellowish cotton'.
17 Bailey, op. cit., p. 96. Keil's remarks were recorded by Baldinucci. See also Rembrandt's *Self-Portrait in Studio Attire*, drawing *c.* 1655. Rembrandthuis, Amsterdam, and *The Artist in his Studio*, oil on panel, 1628. Museum of Fine Arts, Boston.
18 Dunlap, vol. I, p. 71.
19 Dunlap, vol. I, p. 342. Unknown to Trumbull, Copley was dressed in this finery because of his recent marriage.
20 Dunlap, vol. I, p. 193.
21 Vasari, p. 323 'Life of Dello'.
22 Smith, *Nollekens*, vol. II, p. 320 (for Richard Cosway, 1742–1821), and p. 331 (for George Henry Harlow, 1787–1819).
23 Smith, *Nollekens*, vol. II, p. 220.
24 Vasari, p. 517 'Life of Alesso Baldovinetti'. For a discussion of the use of straw- (or leaf-) filled boxes in use as beds, see Ayres, op. cit., pp. 200–5.
25 Walpole, vol. III, p. 78.
26 Smith, *Nollekens*, vol. I, p. 47. Smith, as a disappointed beneficiary of Nollekens's will, was far from unbiased in his biography.
27 According to the *Oxford English Dictionary* Thackeray first used the term 'Bohemian' in the French sense of a gypsy (the gypsies were thought to come from that region) in *Vanity Fair* (1848), but by 1862 a Bohemian had become for Thackeray 'an artist or *litterateur*'.

III Drawing

MATERIALS AND SUPPORTS

1 Vasari, p. 517 'Life of Alesso Baldovinetti'.
2 Vasari, p. 895 'Life of Raphael'. Such cartoons could, of course, be in full colour rather than the monochrome more usually associated with drawing.
3 Vasari, p. 332 'Life of Luca della Robbia', with reference to Donatello.
4 Pliny, p. 85.
5 Walpole (vol. IV, p. 32) states that Jonathan Richardson was apprenticed to a scrivener. It should also be added that the association of these two in Chinese and Japanese tradition is of even greater consequence that it is in the West.

6 Harvey, *Medieval Craftsmen*, p. 118. With reference to the rebuilding of the great east window of Exeter Cathedral, Harvey quotes a skin of parchment being purchased for 2d. for the master mason, Robert Lesyngham, to 'paint' (pingend) or draw the new window.
7 Eastlake, vol. I. p. 132, mentions outlines drawn on white boards.
8 Theophilus, pp. 61, 62. The description occurs in relationship to drawing out a stained glass window.
9 Cennino d'Andrea Cennini (born *c.* 1370), *Il Libro dell'Arte*, translated by Daniel V. Thompson, jnr., New York, Dover reprint, 1933, pp. 4, 5.
10 Cennini, pp. 4, 5, with footnote.
11 Theophilus, pp. 29, 30 with footnotes.
12 *The Oxford Companion to Art*, Harold Osborne ed., Oxford, Clarendon Press, 1970, 'Paper'.
13 Cennini, p. 6.
14 Cennini, pp. 9, 10, 11.
15 *Vasari on Technique,* translated by Louisa S. Maclehose, G. B. Brown ed., London, Dent, 1907, p. 213.
16 Cennini, p. 13. Claude Boutat (or Boutet) in *The Art of Painting in Miniature*, English translation, London, 1730, p. 4, recommends 'Varnish'd Paper, or the Skin of a Hog's Bladder, very transparent; such as is to be had at Gold-beaters. Talc or Isinglass will likewise do as well.'
17 Charles F. Mitchell, *Building Construction and Drawing*, 8th edn., London, Batsford, 1917, p. 3.
18 For Leonardo's use of 'Rheims cloth or prepared linen', see Vasari, vol. II, p. 779, and for tracing parchment see Leonardo da Vinci, *The Notebooks*, translated by Edward MacCurdy, London, Jonathan Cape (1938), 1977, vol. II, p. 235.
19 I am indebted to Maya Hambly of the RIBA Drawings Collection for much of this information and to Mr K. E. Esmonde for his account of the manufacturing process at Winterbottom's. The packet (unused) for ox-gall is in the Heal Collection, 89.44.
20 Mitchell, p. 15.
21 *Vasari on Technique*, p. 206.
22 William Salmon, *Polygraphice* (1672), London, 1701, vol I, p. 2.
23 Kurt Wehlte, *The Materials and Techniques of Painting*, 1982 edn., New York, Van Nostrand Reinhold Co., 1967, p. 448.
24 Cennini, p. 8, gives instructions on cutting a quill.
25 Ambrose Heal, *The English Writing Masters and their Copy-Books 1570–1800*, Cambridge, 1931.
26 Theophilus, p. 15.
27 Theophilus, p. 42, n.
28 John Barrow, *The Dictionary of Arts and Sciences*, London, 1754.
29 Elsum, p. 7.
30 Cennini, p. 7.
31 James Watrous, *The Crafts of Old-Master Drawings*, Madison, University of Wisconsin Press, 1967, pp. 3–33.
32 Christopher Morris ed., *The Journeys of Celia Fiennes 1685–c. 1712* (1947), London and Sydney, Macdonald & Co., and Exeter, Webb & Bower, 1982, p. 164.
33 *The Oxford Companion to Art*, 'Pencil'.
34 *The Oxford Companion to Art*, 'Pencil'.
35 Cennini, p. 20.
36 *Vasari on Technique*, p. 213.
37 Cennini, p. 19.
38 Giovanni Paolo Lomazzo, *Tracte Containing the Artes of curious Paintinge, Carvinge and Buildinge*, 'Englished' by Richard Haydocke, Oxford, 1598, book 3, ch. IV, p. 100.
39 Salmon, *Polygraphice*, vol. I, p. 2.
40 Wehlte, p. 432.
41 Cennini, p. 75.
42 *Vasari on Technique*, p. 213.
43 Cennini, p. 104, refers to a quill in use as a holder for 'tailor's chalk'.
44 Cennini, p. 17.
45 Cennini, p. 111 for example.
46 Wehlte, p. 452.

47 Wehlte, p. 432.
48 The Victoria and Albert Museum's Department of Prints and Drawings possesses advertisements for these.
49 Wehlte, p. 433.
50 Eastlake, vol. I, p. 394.
51 *Vasari on Technique*, p. 214.
52 Elsum, pp. 29, 30.
53 Vasari, p. 791 'Life of Leonardo da Vinci'.
54 The signature dated 1901 is in the Hirshhorn Museum, Washington, DC.
55 *Vasari on Technique*, p. 206.
56 Vasari, p. 311 'Life of della Quercia', *c.* 1374–1438.
57 Smith, *Nollekens*, vol. I, p. 54.
58 Smith, *Nollekens*, vol. I, p. 344.
59 Elsum, p. 29.
60 The process is described in *Vasari on Technique*, p. 215.
61 Cennini, p. 87.
62 Robert Dossie, *The Handmaid to the Arts*, London, (1758) 1764, vol. I, p. 387.
63 Wehlte, p. 266. Pouncing is here described in relation to sgraffito techniques.
64 *Vasari on Technique*, p. 215.
65 Cennini, p. 75.
66 Eastlake, vol. II, p. 175, *re* Fr. Bartolommeo's altarpiece *The Vision of St Bernard*. See also pp. 178, 179.

AUXILIARY DEVICES
1 Hilliard, p. 85.
2 Nancy E. Richards, 'A Most Perfect Resemblance at Moderate Prices: The Miniatures of David Boudon', *Winterthur Portfolio* 9, Ian M. G. Quimby ed., Henry Francis Dupont Museum, Winterthur, Delaware, p. 89. The physiognotrace was invented in 1786 by Gilles-Louis Chrétien; see Jessie Poesch, *The Art of the Old South 1560–1860*, New York, Knopf, 1983, p. 162.
3 Trevor Fawcett, *The Rise of English Provincial Art*, Oxford, Clarendon Press, 1974, p. 23.
4 *Maryland Gazette* (Annapolis), 5 November 1807, quoted by Richards, op. cit., p. 84.
5 Elsum, p. 25.
6 Dossie, vol. I, p. 386.
7 Walpole, vol. III, p. 166.
8 'In the Museum of the Royal Society'.
9 Christopher Wren, jun., *Parentalia or Memoirs of the Family of Wrens*, London, Stephen Wren, 1750, p. 217.
10 A surviving example of a peep-show box painted by Samuel van Hoogstraten in the late 1650s may be seen in the National Gallery, London.
11 Pliny (*Nat. Hist.* XXXIV, 83).
12 Albert E. Elsen, *In Rodin's Studio*, Oxford, Phaidon, 1980.
13 This is confirmed by John Cuff's trade card of *c.* 1747 in which the optician mentions 'the CAMERA OBSCURA for exhibiting Prospects in their natural Proportions and Colours, together with the Motion of living Subjects'.
14 Dunlap, vol. I, p. 251.
15 For the association between witchcraft and the camera obscura, see John H. Hammond, *The Camera Obscura*, Bristol, Hilger, 1981, p. 24.
16 The illustration occurred in his *De Radio Astronomica et Geometrico* published in 1545.
17 Dossie, vol. I, p. 394.
18 Dossie, vol. I, p. 395.
19 Quoted by Hammond, op. cit., pp. 47, 77. Charles Wilson Peale 'made 3 drawings with the machine' (presumably a camera obscura) for the background buildings and landscape in his 1788 portrait of *William Smith and Grandson*, (Virginia Museum of Fine Art). See Poesch, op. cit., p. 85.
20 Dunlap, vol. I, p. 87.
21 Maya Hambly, *Drawing Instruments, their History, Purpose and Use for Architectural Drawings*, London, RIBA Drawings Collection, 1982, p. 28.
22 Hambly, p. 29.
23 Dossie, vol. I, p. 402.
24 Dr Allen Simpson (of the Royal Scottish Museum, Edinburgh), 'Brewster's Society of Arts and the Pantograph Dispute', 1983, publication pending in *Annals of Science*, based on his paper at the Second Greenwich Scientific Instruments Symposium, London, 1982.
25 Illustrated in Hambly, p. 29.

IV Painting

SUPPORTS AND GROUNDS
1 *Vasari on Technique*, pp. 287–8, 'Notes'.
2 Eastlake, vol. I, p. 111.
3 For examples of Danish work from the eleventh to fifteenth centuries, see R. Broby-Johansen, *Den Danske Billedbibel I Kalkmalerier*, Gyldendalske, 1948.
4 Vasari, p. 104 'Life of Giotto', for a description of Giotto's mistake in mixing these materials.
5 Vasari, pp. 1857–8 'Life of Michelangelo', for a description of Michelangelo's problems when he started work on the Sistine Chapel vault in Rome.
6 John Martin manuscript, 1699–1700, Soane Museum, London, pp. 4, 5.
7 *Vasari on Technique*, p. 221.
8 John Martin manuscript, p. 5.
9 Harvey, *Medieval Craftsmen*, p. 165. Among the colours loosely described as sinoper were cinnabar (apparently not from the same root as Sinope) and vermilion.
10 Vasari, p. 543 'Life of Viniziano'.
11 Vasari, pp. 1316–17 'Life of Sebastiano del Piombo'.
12 Vasari, p. 94, 'Life of Margaritone'.
13 Eastlake, vol. I, p. 371, and J. F. L. Mérimée, *De la Peinture à l'Huile* (1830), trans. W. B. S. Taylor, London, 1839, pp. 214–15.
14 *Connaissance des Primitifs par L'Étude du Bois*, 1961, quoted by Fletcher and Tapper (see n. 19).
15 Vera Laurina and Vasily Pushkariov, *Novgorod Icons 12th–17th Century*, Oxford, Phaidon/Leningrad, Aurora, 1980, 'Notes on Plates', pp. 278–335.
16 John Michael Montias, *Artists and Artisans in Delft*, New Jersey, Princeton University Press, 1982, p. 74. In seventeenth-century Delft a distinction seems to have been made between a *schilderij* (a painting on canvas) and *een bort* (a panel painting) – Montias, p. 231.
17 Cennini, p. 67.
18 Harvey, *Medieval Craftsmen*, pp. 34, 155, 163, 188.
19 John Fletcher and Margaret Cholmondeley Tapper, 'Hans Holbein the Younger at Antwerp and in England 1526–28', *Apollo*, February 1983, p. 88.
20 The importance of this passage in Vasari is noted by Eastlake, vol. I, pp. 204, 226, 512.
21 Eastlake quotes this passage from van Mander (who was a student of Vlieric's) in both Dutch and English, vol. I, p. 512.
22 Salmon, *Polygraphice*, vol. I, p. 180. Salmon was here describing the 'framing-up' of sundial boards.
23 *The Magazine Antiques*, New York, December 1982, p. 1216, and National Art Collections Fund *Review 1983*, pp. 90–1.
24 Montias, p. 191.
25 Anthony Bailey, *Rembrandt's House*, London, Dent, 1978, p. 103.
26 Montias, pp. 193–4.
27 John Ingamells, 'A Masterpiece by Rubens: The Rainbow Landscape Cleaned', *Apollo*, November 1982.
28 Cennini, p. 69.
29 Vasari, p. 94 'Life of Margaritone'. In this translation the word 'size' makes more sense than 'glue'. I have also substituted the word 'heated for 'boiled'. Although craftsmen occasionally

loosely talk about boiling size, this should never be done.

30 Elsum, p. 36.

31 Known to the Italians as *gesso marcio*, see Eastlake, vol. I, p. 370.

32 Cennini, p. 74.

33 Eastlake (vol. I, p. 387) goes so far as to claim that this was because the early painters were also artists in stained glass. John Harvey in recent research has to some extent confirmed Eastlake's hypothesis – Harvey, *Medieval Craftsmen*, pp. 163–4.

34 For example, Rubens's *Judgement of Paris*, National Gallery, London.

35 Quoted by Eastlake, vol. I, pp. 446–7.

36 Laurina and Pushkariov, op. cit., p. 40.

37 Quoted by J. A. van de Graaf, 'Development of Oil Paint and the Use of Metal Plates as a Support', *Conservation and Preservation of Pictorial Art*, N. S. Brommelle and P. Smith ed., London, Butterworths, 1976, p. 43.

38 Van de Graaf, op. cit., p. 49.

39 Leonardo da Vinci, vol. II, p. 214.

40 The subject of this second painting, which is in a private collection, is the *Assumption and Coronation of the Virgin*, and is attributed to a so far unidentified Italo-Flemish hand. I am grateful to Mr Martin Holmes (ex. London Museum) and Miss Rosemary Weinstein (of the Museum of London) for this information.

41 Vasari, pp. 1316–17 'Life of Sebastiano del Piombo'.

42 Walpole, vol. II, p. 243.

43 Claude Boutat (or Boutet), *The Art of Painting in Miniature*, London, 1736, p. 9.

44 Richard Graham (*The Most Eminent Painters both Ancient and Modern*, Dufresnoy, 1695) is quoted by Walpole (vol. III, p. 235) as claiming that the German painter Frederick Kerseboom (1632–90) was the first to introduce 'painting on glass' to England. Walpole adds that he supposed Graham means 'painting on looking glass'. Walpole was apparently more familiar with the Chinese export glass painting executed on imported European mirror glass.

45 Eastlake, vol. I, p. 533.

46 Edward Norgate, *A More Compendious Discourse Concerning the Art of Limning* (written 1648–50), Manchester, MidNAG and Carcanet Press, 1981, p. 120. For a brief description of the preparation of parchment, see G. Bernard Hughes, *Living Crafts*, New York, Philosophical Library, 1954, ch. 16.

47 Walpole, vol. IV, p. 202.

48 Dunlap, vol. I, p. 416.

49 Dunlap, vol. I, p. 268.

50 When Heyndrick Jansz. Vockestaert, the Delft art dealer, died in 1624, the papers prepared after his death refer to the sale of paintings on alabaster. Montias, p. 79.

51 C. M. Kauffmann, *Catalogue of Foreign Paintings*, London, Victoria and Albert Museum, 1973, vol. I (before 1800), p. 113.

52 Eastlake (vol. II, pp. 249–50) states that Correggio's *Triumph of Virtue and the Bondage of Vice* (Louvre) is painted in tempera on unprimed cloth. This cloth was almost certainly sized, although Eastlake makes no reference to this.

53 Walpole, vol. III, p. 199.

54 For early canvas supports in England see Harvey, *Medieval Craftsmen*, p. 165, which cites canvas supplied to the Prior's lodgings at Worcester Cathedral in 1424–5, presumably for hangings.

55 In Shakespeare's *Henry IV* (The Second Part), Act II, Scene I, Falstaff says, 'and for thy walls, a pretty slight drollery, the story of the Prodigal, or the German hunting in water-work, is worth a thousand of these bedhangings and these fly-bitten tapestries.'

56 Elsum, p. 36.

57 Eastlake, vol. I, p. 95.

58 For further information, though not for quite this interpretation, see Montias, pp. 138–9.

59 Cennini, p. 103.

60 Pliny, p. 99.

61 Vasari, p. 698 'Life of Mantegna'. Mantegna's *The Triumph of Caesar*, now at Hampton Court, which Vasari considered his

62 Eastlake, vol. II, pp. 249–50, 252–3.

63 Eastlake, vol. I, p. 99.

64 Eastlake, vol. II, pp. 23, 24 with footnote, which quotes Vasari in his 'Life of Filarete' alluding to a portrait of Eugenius IV which may well be this picture. Vasari gives Giovanni Focchora (1st edn.) and Fochetta, perhaps intending Giachetto Francoso of Filarete, but he may have been referring to a corruption of Fochetta or Jehan Fouquet de Tours.

65 Walter Lewis Spiers ed., *Diary of Nicholas Stone Jnr.*, Oxford University Press, Walpole Society, 1919, vol. VII, p. 191.

66 Walpole, vol. II, p. 182.

67 Eastlake, vol. I, p. 484.

68 Dunlap, vol. I, p. 178.

69 Receipt dated 1753, Heal Collection, 89.139.

70 Dunlap, vol. I, p. 246. These were seen by Dunlap in *c*. 1772.

71 William T. Whitley, *Artists and Their Friends in England 1700–99*, London and Boston, Medici Society, 1928 (2 vols), vol. I, p. 333.

72 John Physick, *Designs for English Sculpture 1680–1860*, London, Victoria and Albert Museum/HMSO, 1969, p. 131.

73 For an illustration of this floor cloth and a discussion of floor cloths, see James Ayres, *The Shell Book of the Home in Britain*, pp. 118–27, 131.

74 Dunlap, vol. I, p. 293.

75 A transcript of Rolinda Sharples's notebooks is held by Bristol City Art Gallery.

76 Heal Collection, Jones 89.85, Sandys & Middleton 19.137, Stacy 89.144, William Ward 89.169.

77 Alec Cobbe, 'Colourman's Canvas Stamps as an Aid to Dating Paintings: a Classification of Winsor and Newton Canvas Stamps from 1839–1920', *Studies in Conservation*, 21 (1976), pp. 85–94.

78 Dunlap, vol. I, pp. 39–40.

79 Dunlap, vol. I, p. 296.

80 Ralph Mayer, 'Some Notes on Nineteenth-Century Canvas Makers', *Technical Studies*, January 1942, New York City, vol. X, no. 3, pp. 131–7.

81 Dunlap, vol. I, p. 109. This anecdote given by Allan Cunningham (author of *Lives of the Painters*) to Dunlap may have been correct at the time the Academy's catalogue was going to press. However, the picture was, subsequently at least, the subject of correspondence between West and Copley, see John W. McCoubrey, *American Art 1700–1960: Sources and Documents*, New Jersey, Prentice-Hall Inc. , 1965, pp. 10–18. The subject of the portrait was young Henry Pelham, Copley's half brother.

82 Cennini, p. 103.

83 For a brief account of the development of paper making, see Hughes, op. cit., ch. 14, especially p. 134.

84 Daphne Foskett, *John Harden of Brathay Hall*, Kendal, Abbot Hall Art Gallery, 1974, p. 34. Harden was an amateur artist who attained professional standards. Ramsey Richard Reinagle (1775–1812) was an Academician.

PIGMENTS, MEDIA AND VARNISHES

1 Eastlake, vol. I, p. 489, quoting Northcote's *Life of Reynolds*.

2 Williams, pp. 35–6.

3 Eastlake, vol. I, p. 405.

4 Harvey, *Medieval Craftsmen*, p. 155, quotes the will of William Lee, the King's joiner, who died in 1483 leaving 'ij lidgers Colour stones'.

5 John Smith, *The Art of Painting in Oyl*, London, 1676, p. 1.

6 Salmon, *Polygraphice*, vol. I, p. 112.

7 Hilliard, p. 72.

8 Cennini, p. 21.

9 Smith, *The Art of Painting in Oyl*, 1705, 4th impression, pp. 1, 2.

10 Dossie, vol. I, p. 31, defines sublimation as 'the raising of solid

bodies in fumes by means of heat'.

11 John Barrow, *Dictionary of Arts and Sciences*, 'Pulverization', 1754.

12 Eastlake, vol. I, p. 529, quoting Rubens's use of spirit of turpentine.

13 Sandys & Middleton's card of *c.* 1780–90 (79 Long Acre, London), Heal Collection, 79.137.

14 As recommended by Francesco Pacheco, *El Arte de la Pintura*, Sevilla, 1649, p. 389, and quoted by Eastlake, vol. I, p. 458.

15 Eastlake, vol. I, p. 130.

16 Dossie, vol. I, p. 28.

17 J. H. Müntz (or Muentz), *Encaustic or Count Caylus's Method of Painting*, London, 1760, p. 53. This recommendation reflects Cennini's views (Cennini, pp. 21–2).

18 Eastlake, vol. I, p. 308. No author known – information from a manuscript seen by Eastlake in a private collection.

19 Williams, pp. 38–9.

20 Smith, *The Art of Painting in Oyl*, 1676, p. 4.

21 Dunlap, vol. I, p. 165, for a reference to 'beeves' bladders' for snuff.

22 Theophilus, pp. 104–5.

23 Smith, *Nollekens*, vol. I, p. 282, 'Mrs Lloyd's [Mary Moser] colour box, in which he [Mr Sharp] found a curious colour twisted up in one of Mr Garrick's play-bills.'

24 Pliny, p. 87.

25 Cennini, pp. 22–39.

26 Elsum, p. 31.

27 Wehlte, pp. 90, 95. For Indian yellow, see pp. 94–5. See also W. B. S. Taylor's translation of J. F. L. Mérimée's *Treatise*, p. 109, 'this colour is manufactured in Calcutta by an Englishman, who keeps the process quite secret.'

28 Richard Boyle, *American Impressionism*, Boston, New York Graphic Society, 1974, p. 26.

29 Heal Collection, 89.20.

30 Wehlte, p. 120. The colour was available until about 1925.

31 Dossie, vol. I, p. 2. Good though this definition is, he wrongly gives it under 'Vehicles'.

32 Giovanni Paolo Lomazzo, *Tracte Containing the Artes of curious Paintinge, Carvinge and Buildinge*, 'Englished' by Richard Haydocke, Oxford, 1598, pp. 125–6.

33 In the copy of this very rare pamphlet in Bath Public Library.

34 Pliny, pp. 151, 173. Also Müntz, p. 3.

35 Edwards, p. 15. Müntz lived some years at Strawberry Hill, Walpole's villa on the Thames, where he painted topographical views of the house in its setting. Count Caylus (1692–1765), of part Spanish descent but French upbringing, was a prominent antiquarian, collector, and amateur artist. A student of Watteau, he later became an early and influential figure in the promotion of Neo-Classical ideals.

36 According to Müntz (pp. 6–7), Count Caylus painted a head of Minerva using this method, possibly the painting (cited by W. G. Constable in *The Painter's Workshop*, London, Oxford University Press, 1954, p. 39) which he exhibited at the Paris Salon in 1754.

37 Müntz, pp. 5, 6.

38 See W. A. Newman Dorland, *The American Illustrated Medical Dictionary*, Philadelphia, W. B. Saunders Co., 1932. Salt of tartar is derived from a number of sources of which the tartar found in wine casks is one, grape juice containing tartaric acid.

39 Leonardo da Vinci, vol. II, p. 356.

40 Constable, p. 39, and Eastlake, vol. I, p. 3.

41 Wehlte, p. 563. There is also a dissertation on the eighteenth-century revival of encaustic painting by Danielle Rice of Yale, and R. W. Lightbown is also preparing a study on the history of encaustic – see Victoria and Albert Museum, *Catalogue of Foreign Paintings*, 1973, 'Cornacchini'.

42 For fuller information on this, see Hiler, p. 187.

43 William Aglionby, *Painting Illustrated in Three Dialogues*, London, 1685, p. 26. This book is very much based on Vasari.

44 Elsum, p. 36.

45 Smith, *The Art of Painting in Oyl*, 1705 edn., p. 73.

46 Vasari, p. 345 'Life of Uccello'.

47 Spiers, p. 196.

48 Smith, *Nollekens*, vol. II, p. 4.

49 Elsum, p. 35.

50 Vasari, p. 1368 'Life of Beccafumi'. He does not identify which of the Pollaiuoli brothers he is referring to.

51 Müntz, pp. 19–20.

52 I am indebted to Mr John Dick, Chief Conservationist of Pictures at the National Galleries of Scotland, Edinburgh, for this opinion on Raeburn's work. See also Mérimée, p. 344.

53 Ivar Lissner, *The Living Past*, London, Penguin, 1965, p. 284.

54 The whole thesis of Eastlake's two-volume work, but in particular vol. I, pp. 182–218.

55 Sir Balthazar Gerbier, *Counsel and Advice to all Builders*, London, 1663, p. 48.

56 Eastlake, vol. I, p. 109.

57 Leonardo da Vinci, vol. II, p. 355, recommends that the walnuts should be peeled for this purpose.

58 Eastlake, vol. I, p. 359.

59 Harvey, *Medieval Craftsmen*, p. 164, *re* twelve lead 'payntyng dyssches'.

60 Eastlake, vol. I, pp. 77–8.

61 A manuscript sold by Sotheby's in May 1845 and quoted by Eastlake, vol. I, p. 307.

62 Elsum, p. 38.

63 Eastlake, vol. I, p. 359.

64 Leonardo da Vinci, vol. II, pp. 355, 356.

65 Eastlake, vol. II, p. 267. Correggio (1489/94–1534) probably used petroleum in his medium.

66 I am indebted to Mr John Keffer of Esso/Exon Europe for this information (letter to author 13 May 1983).

67 Mérimée, pp. 59–60.

68 Eastlake, vol. II, pp. 28, 45, 270.

69 Heal Collection, 89.45.

70 Banks Collection, 89.26.

71 Banks Collection, 89.25.

72 Constable, p. 41.

73 Müntz, pp. 107–8, 116–17.

74 Heal Collection, 19.137.

75 These were transcribed by Russell's grandson, the Rev. Samuel Henry Russell, and a manuscript copy by his sister, dated 28 August 1884 is in the library of the Victoria and Albert Museum. Byrom's Shorthand was invented by John Byrom (1692–1763), an English poet and stenographer.

76 Recipe 10, Blue Green.

77 Smith, *Nollekens*, vol. II, p. 263, referring to Henry Robert Moreland.

78 *The Ladies Companion*, Mrs Loudon (Jane Webb) ed., London, 1850, vol. II, p. 72, 'Pastel Drawing'. It is not clear if the reference to pastels being easy to make refers to the materials or the pictures.

79 Strasbourg Manuscript A.VI, no. 19, quoted by Eastlake, vol. I, pp. 126–40.

80 Cennini, pp. 102–3.

81 Hilliard, pp. 72, 73.

82 Dossie, vol. II, pp. 394–5.

83 Salmon, *Polygraphice*, vol. I, p. 90.

84 Dunlap, vol. I, p. 225.

85 Dunlap, vol. I, p. 226.

86 Prince Hoare, *Epochs of the Arts*, London, 1813, p. 168.

87 Michael Goodwin, *Artist and Colourman*, London, Reeves, 1966, pp. 17, 34–5.

88 Quoted by Goodwin, p. 15.

89 Brian Wild, *The Romance of a Family Business*, London, Dryad Press, no date but *c.* 1966, p. 9.

90 John Smith, *The Method of Painting in Water Colour*, London, 1730.

91 e.g. Mrs Phelps (of Troy Female Seminary, New York), *The Female Student,* London edn., 1836.

92 Ellis Waterhouse, *Gainsborough,* London, Edward Hulton, 1958, pp. 15–17, citing eye-witness accounts by Reynolds, William Jackson (*The Four Ages,* 1798) and the *Somerset House Gazette,* 1824. See also *The Oxford Companion to Art,* 'Sandby'.

93 Dunlap, vol. I, pp. 274–5.

94 For a longer discussion of the development of landscape painting in America see James Ayres, 'The Emergence of Landscape Painting in America in the Early Nineteenth Century', Teut Andreas Riese ed., *Vistas of a Continent,* Heidelburg, Carl Winter, Universitätsverlag, 1979, pp. 88–99.

95 R. D. Harley, 'Oil Colour Containers: Development by Artists and Colourmen in the Nineteenth Century', *Annals of Science,* vol. XXVII, no. 1, March 1971, pp. 1–12.

PAINTERS' SUPPLIES

Hand Tools

1 Dunlap, vol. I, p. 191, gives the following definition and possible origin of the term:

> A painter's palette is either the piece of wood with a hole in it for his thumb and a convenient recess for his brushes, or it is the colours with which his utensil is furnished, or such pigments as his knowledge and taste induce him to use. The word taste probably indicates the origin of the name given to this necessary piece of limning furniture.

2 The palettes used in Ancient Egypt for cosmetics are analogous to the ledger used for the grinding of pigments.

3 Vasari, p. 1113 'Life of Bartolommeo da Baganacavallo and other painters of Romagna'; 'the best joke of all was that he had his belt hung all round with little pots full of tempered colours'.

4 Eastlake, vol. I, pp. 423–4.

5 Salmon, *Polygraphice,* vol. II, p. 855. This was later paraphrased by J. S. Stalker and G. Parker in *A Treatise of Japaning and Varnishing,* Oxford, 1688, London, Tiranti reprint, 1971, p. 2.

6 Williams, p. 40.

7 Eastlake, vol. I, p. 401.

8 Dunlap (vol. I, p. 137) mentions C. R. Leslie's assertion that 'Mr West painted to the last with a palette which Peale had most ingeniously mended for him, after he [West] had broken and thrown it aside as useless. It was a small palette; but he never used any other for his largest pictures.' Elsewhere, Dunlap mentions the way in which a favourite palette was passed down the generations (vol. I, p. 192). Gilbert Stuart's had belonged to Nathaniel Dance and, before him, to Thomas Hudson.

9 Elsum, p. 69.

10 A brass sleeve guard is fitted to the palette that once belonged to Robert Gibb (1845–1932), who served as His Majesty's Limner for Scotland. The palette is preserved in the Royal Scottish Academy.

11 'No Author', *School of Fine Arts,* London, William Cole, no date but *c.* 1860 (Victoria and Albert Museum library, 40.H.104).

12 F. Schmid, *The Practice of Painting,* London, Faber & Faber, 1948.

13 Williams, pp. 57–8.

14 Eastlake, vol. II, p. 387, quoting Sir George Beaumont.

15 From Johann Melchior Croeker's *Treatise,* Jena, 1753.

16 Smith, *The Art of Painting in Oyl,* 1705 edn., p. 2.

17 John Martin manuscript, pp. 34–5.

18 Eastlake, vol. II, p. 377.

19 *The Practical Carver and Gilders Guide,* Brodie & Middleton, *c.* 1880, p. 197, and the appended *Catalogue,* p. 19.

20 Pliny, p. 139.

21 Theophilus, p. 62.

22 Montias, pp. 167–9.

23 Salmon, *Polygraphice,* vol. II, p. 855.

24 Rosamond D. Harley, 'Artists' Brushes – Historical Evidence

from the Sixteenth to the Nineteenth Century', N. S. Bromelle and P. Smith eds., *Conservation and Restoration of Pictorial Art,* London, Butterworths (for the Institute of Conservation of Historic and Artistic Works), 1976, pp. 61–6.

25 Marshall Smith, *The Art of Painting etc.,* London, 1692, p. 74. This book is cited by Horace Walpole in his *Anecdotes.*

26 Salmon, *Polygraphice,* vol. II, p. 854.

27 Harvey, *Medieval Craftsmen,* p. 167. In 1423, 1s. 3d. was paid for pigs' bristles for whitening the stone vaults and aisles in the presbytery of York Minster.

28 Smith, *The Art of Painting in Oyl,* 1676, p. 6.

29 John Martin manuscript, p. 74.

30 Heal Collection, 89.45.

31 Cennini, pp. 40–1.

32 Salmon, *Polygraphice,* vol. II, p. 855.

33 Montias, pp. 90, 93.

34 Brodie & Middleton, *Catalogue, c.* 1880, p. 23, item 59.

35 J. H. Clarke, *A Practical Essay on the Art of Colouring and Painting Landscapes in Watercolours,* London, 1807, illustrates such 'softening off' brushes.

36 Smith, *Nollekens,* vol. I, p. 286.

37 Trevor Fawcett, *The Rise of English Provincial Art,* Oxford, Clarendon Press, 1974, p. 20.

38 John Martin manuscript, p. 73.

Artists' Oil and Colourmen

1 R. Campbell, *The London Tradesman,* London, 1747, p. 105.

2 Eastlake, vol. II, p. 288.

3 Information from J. Kenneth Major in a letter to the author (21 December 1982) from John G. Rhodes, Keeper of Antiquities, Oxfordshire County Museum, Woodstock.

4 *Chambers Encyclopaedia,* 1865, 'Ochres'.

5 Nina Fletcher Little, *Neat and Tidy,* New York, Dutton, 1980, p. 112.

6 This mill was patronized by the Reeves brothers in the late eighteenth century for the purchase of this very fugitive colour, see Wild, p. 16.

7 Banks Collection, 89.9, 89.10.

8 Campbell, p. 103.

9 Heal Collection, 89.53, 89.54, 89.57.

10 William Salmon, *Palladio Londinensis,* London, 1755, p. 63.

11 Heal Collection, 89.53, 89.54.

12 Campbell, p. 107.

13 Harvey, *Medieval Craftsmen,* p. 26.

14 Montias, p. 325.

15 Eastlake, vol. I, pp. 248, 275.

16 Montias, pp. 206–7.

17 For information on the cost and speed of this transport, see Montias, p. 331. One example was Amsterdam to Rotterdam (via Delft) in 13 hours.

18 Eastlake, vol. I, p. 117.

19 Walpole, vol. III, pp. 131–2.

20 Stalker and Parker, p. 23.

21 John Martin manuscript, p. 6.

22 Campbell, p. 105.

23 Campbell, p. 106.

24 Jacob Larwood and John Camden Hotten, *The History of Signboards,* London, 1866, pp. 454–5.

25 Heal Collection, 89.113, 89.163.

26 Campbell, p. 105. 'Coopers Picture Varnish' may well be a reference to the varnish that the Martin manuscript says was available from 'Mr Cooper at the sign of the three pidjohns'.

27 Smith, *Nollekens,* vol. II, pp. 162–3. According to Smith, the episode illustrated 'the Doctor and his Irish Wife', which is probably *The Marriage Contract* (Ashmolean Museum, Oxford), although the same room was subsequently used as the background for the second scene in *A Rake's Progress, The Rake Surrounded by Artists and Professors* (Soane Museum, London).

28 Goodwin, p. 16. The source is simply given as 'an early bio-

grapher'. Martin Hardie's two-volume work on English watercolours is similarly evasive, but suggests that the source was an obituary to Paul Sandby.

29 Heal Collection, 89.85, William Jones, early nineteenth-century trade card.

30 Quoted by H. A. Roberts, *Records of the Amicable Society of Blues . . .*, Cambridge University Press, 1924, pp. 53, 54. A copy of this is in the Heal Collection.

31 In the Winsor & Newton Museum at Wealdstone, Middlesex, are a number of watercolour paintings by Newton and a particularly fine watercolour, *The Old Gate and Buildings* (1856) by Winsor who, until the recent acquisition of this picture, was not known to be a painter.

32 *Paint and Painting*, Tate Gallery catalogue, London, 1982, p. 67.

33 Banks Collection, 89.25. It is not clear quite what relation (if any) G. and I. Newman were to James Newman. The latter took over James Smith's business in Gerrard Square (at the sign of the Golden Palette) in 1790 and moved to Soho Square in 1800 (see letter to Ambrose Heal from E. F. Chapman of James Newman Ltd, 15 September 1934, Heal Collection, with card 89.105).

34 Heal Collection, 89.63.

35 Trevor Fawcett, *The Rise of English Provincial Art*, Oxford, Clarendon Press, 1974, p. 40.

36 Dunlap, vol. I, p. 108, writing about West and Copley.

37 William T. Whitley, *Artists and Their Friends in England 1700–99*, London and Boston, Medici Society, 1928, vol. I, p. 330.

38 Whitley, vol. II, p. 361.

39 Whitley, vol. I, p. 332.

40 Williams, p. 24.

FRAMING

1 Many writers have commented on this, for example John Flaxman (1755–1826) in his *Lectures*, London, 1865, p. 24.

2 Cennini, p. 3.

3 Vasari, p. 262 'Life of Spinello Aretino'.

4 Henry Heydenryk, *The Art and History of Frames*, London, Nicholas Vane, 1964, p. 34.

5 Heydenryk, p. 37. Giovanni Barile executed an ornamental frame for a painting by Fra Sebastiano Viniziano del Piombo (Vasari, p. 1311). One of the Bariles also worked for Raphael on an interior, producing carved-wood doors and a ceiling.

6 Vasari, p. 1169, 'Life of Liberale de Verona'.

7 Walpole, vol. II, p. 89.

8 Walpole, vol. II, p. 117.

9 The inventory is quoted in Percy Macquoid and Ralph Edwards, *Dictionary of English Furniture*, London, Country Life, 1954 edn., 'Picture Frames'.

10 Jacob Larwood and John Camden Hotten, *The History of Signboards*, London, 1866 p. 515, quoting the original catalogue. A copy of this catalogue survives in Chiswick Public Library.

11 Sir Balthazar Gerbier, *Counsel and Advice to all Builders . . .*, London, 1663, pp. 84, 85.

12 The Trustees of the will of the late Earl of Berkeley.

13 Walpole, vol. II, pp. 249–50.

14 Montias, p. 223.

15 Macquoid and Edwards, op. cit., 'Picture Frames'.

16 Montias, p. 215.

17 John Evelyn, *Sylva*, London (1664), 1670, p. 14.

18 Cellini, *Life*, pp. 7, 8.

19 Montias, p. 231, n. 0.

20 Montias, p. 58, mentions white pine frames in a document dated 1605 – many examples survive.

21 E.g. the Dutch *kas* made in about 1650 and taken early in its history to the New Netherlands (New York) – Brooklyn Museum.

22 Joseph Moxon, *Mechanic Exercises or the Doctrine of Handy-Works* (1677), Charles Montgomery ed., New York, Praeger, 1970. Introduction by Benno M. Forman, p. XXIV.

23 Montias, p. 215.

24 Moxon, op. cit., pp. 107–8.

25 Heydenryk, p. 66.

26 Peter Thornton, *Seventeenth-Century Interior Decoration*, New Haven and London, Yale University Press, 1978, p. 254.

27 Prince Hoare, *Epochs of the Arts*, London, 1813, pp. 87–8.

28 Salmon, *Polygraphice*, vol. I. p. 177, 178.

29 Walpole, vol. III, p. 80. This information was painted on the 'straining frame' of the canvas.

30 John Constable, *Correspondence*, Ipswich, Suffolk Records Society, 1966, pp. 97, 98, letter dated 6 August 1825. For early seventeenth-century examples of English frame-makers, see Spiers, p. 96. In 1634 'Jerimey Killet' made 'a grete frame' for £1–6–0.

31 Walpole, vol. III, p. 69. Huysman, be it noted, often produced still-life paintings of the type that undoubtedly influenced Gibbons. See H. Avray Tipping, *Grinling Gibbons and the Woodwork of his Age*, London, Country Life, 1914, p. 92. Curiously, Avray Tipping does not cite this reference to Huysman by Walpole.

32 Walpole, vol. III, p. 91. Flesshier lived in the Strand near the Fountain Tavern. Walpole later (vol. III, p. 139) refers to Beal's notebooks in which 'Flesshier the frame-maker' is quoted with reference to his being a frame-maker as well as a painter.

33 Stalker and Parker, p. 70.

34 Nina Fletcher Little, *Country Arts in Early American Homes*, New York, Dutton, 1975, p. 95.

35 Heal Collection, 32.2. Ayton also advertised 'Green and Gold Dressing Glasses'.

36 Heal Collection, 32.55.

37 Campbell, pp. 173–4.

38 Heal Collection, 32.21.

39 Heal Collection, 85.20, 85.275. For a good description of the making of gold leaf, see G. Bernard Hughes, *Living Crafts*, New York, Philosophical Library, 1954, ch. 2, 'The Gold Beater'.

40 British Library, C 135.m.2.

41 John Cornforth and Leo Schmidt, 'Holkham Hall, Norfolk IV', *Country Life*, 14 February 1980. The article also refers to carved work supplied by Goodison in 1758 and additional carving made in keeping with it by Matthew Brettingham.

42 Smith, *The Art of Painting in Oyl*, 1705 edn., p. 7.

43 Spiers, p. 96.

44 Campbell, pp. 107–8.

45 Stalker and Parker, p. 57.

46 Stalker and Parker, p. 56.

47 Cennini, pp. 79, 80.

48 Stalker and Parker, p. 59.

49 Smith, *The Art of Painting in Oyl*, 1705 edn., p. 8.

50 Smith, *The Art of Painting in Oyl*, 1676, p. 8.

51 Salmon, *Polygraphice*, vol. II, p. 855. The 1676 edition of Smith's *The Art of Painting in Oyl* recommends that the cushion should be covered with 'Calves-Leather' (p. 7) and the 1705 edition gives 'Brazil Skin' (p. 7).

52 Theophilus discusses tin leaf at length, pp. 31–3.

53 Smith, *The Art of Painting in Oyl*, 1705 edn., p. 9. The 1676 edition gives a less explicit description but does suggest the use of three or so such gilding palettes of various widths from 1 in. to 3 in.

54 Salmon, *Polygraphice*, vol. II, p. 856.

55 Smith, *The Art of Painting in Oyl*, 1676, p. 8.

56 Salmon, *Polygraphice*, vol. II, p. 856.

57 Theophilus, p. 30.

58 Cennini, p. 82.

59 Hilliard, p. 99.

60 Heydenryk, p. 51.

61 Stalker and Parker, p. 61.

62 *The Practical Carver and Gilders Guide*, p. 47.

63 Heal Collection, 32.15.

64 An example signed by this carver was sold at Bonham's on 11 February 1982.

65 At a time when glass was expensive, varnish was also sometimes applied to watercolour paintings as a cheaper substitute.

66 A regulation of the Ross Society of Artists and Amateurs, reported in the *Gloucester Journal* of 12 July 1828, stipulated that 'No Drawing to be admitted with either a white margin or more uncovered paper than the effect of the Picture requires'.

67 Trevor Fawcett, *The Rise of English Provincial Art*, Oxford, Clarendon Press, 1974, pp. 53, 191, 207.

68 Fawcett, op. cit., pp. 53–4.

69 Heal Collection, 32.18. This late eighteenth-century trade receipt for Samuel Farnworth states that he supplied 'Mouldings of all sorts for Country Dealers'.

70 *The Practical Carver and Gilders Guide*, pp. 145–6, and for 'German gold', p. 148.

71 Heydenryk, p. 104, quoting Félibien's *Dictionnaire des Beaux-Arts* (1699).

72 Dunlap, vol. I, p. 207.

73 Letter to the author (6 May 1981) from Trevor Fawcett of the University of East Anglia. Both Freemans were themselves painters and exhibited at (1805–17), and were members of, the Norwich Society of Artists. Jeremiah Freeman took over from Jagger as the leading carver and gilder in Norwich in the early 1790s at 2 London Lane. Sometime between 1808 and April 1811 the firm became Jeremiah and William Freeman but in the late 1820s it was simply William Freeman.

V *Sculpture*

1 John Evelyn, *Sculptura*, London, 1662, p. 187.

2 Vasari, p. 378 'Life of Parri Spinelli'.

3 Campbell, p. 137. Although Campbell's intention is clear enough, the definition is not clear and he makes no reference to the 'sunk-raised' reliefs such as those of the Egyptians. He goes on to attempt a false distinction between 'sculpture' and 'statuary'.

4 Giovanni Paolo Lomazzo, *Tracte Containing the Arts of curious Paintinge, Carvinge and Buildinge*, 'Englished' by Richard Haydocke, Oxford, 1598, introduction by John D. Case, p. 7.

5 J. R. Kirkup, 'The History and Evolution of Surgical Instruments: Origins; Functions; Carriage; Manufacture', *Annals of the Royal College of Surgeons*, March 1982, vol. LXIV, no. 2.

6 Cellini, *Treatises*, pp. 135–6. A discussion of the importance of full-size models to the Classical Greeks may be found in Carl Bluemel, *Greek Sculptors at Work* (1927), London, Phaidon, 1955, p. 43.

7 The invention of fixed proportional dividers has been attributed to Heron of Alexandria.

8 Athens National Museum no. 1660.

9 For brief details of the lives and works of Powers and Crawford, see the Whitney Museum of American Art's catalogue, *200 Years of American Sculpture*, New York, David R. Godine, 1976, pp. 35, 41.

10 Leonardo da Vinci, vol. II, p. 368, and Cellini, *Treatises*, p. 141.

11 Honour, p. 148, quoting C. A. Eaton's *Rome in the Nineteenth Century . . . in a series of letters*, Edinburgh, 1820, vol. III, p. 299.

12 The Minutes of the Council of the Royal Academy, 19 March 1771.

13 M. Digby Wyatt, *Fine Art: A Sketch of its History, Theory, Practice and Application to Industry*, London, 1870, pp. 200–1. This refers to the sculptors John Bacon (1740–99) and Francis Chantrey (1781–1842). Wyatt states that Bacon originated the device, which is most unlikely.

14 Honour, p. 153, gives the drawing reference as 'Bassano 2626'.

15 The sculptor (James) Harvard Thomas (1854–1921) studied this method seriously and did much of his work using this system. I am indebted to my father, Arthur J. J. Ayres, for this information.

16 Smith, *Nollekens*, vol. II, p. 5.

THE PLASTIC ARTS

Modelling

1 Pliny, pp. 177, 179, 181.

2 A likely exception, and one which conforms with Pliny's account, were the Etruscans.

3 Vasari, p. 1920 'Life of Michelangelo', refers to Michelangelo and Tiberio Calcagni (a Florentine sculptor) producing an architectural model of clay at an intermediate stage between the drawings and the wooden model.

4 Paolo Giovanni Lomazzo, *Tracte Containing the Artes of curious Paintinge, Carvinge and Buildinge*, 'Englished' by Richard Haydocke, Oxford, 1598, p. 7.

5 Giacometti's work is an obvious example.

6 Lady Eastlake (Elizabeth Rigby) ed., *Life of John Gibson R.A.*, London, 1870, p. 48.

7 Antonio d'Este, *Memoire di Antonio Canova*, Florence, 1864, p. 38, quoted by Honour, p. 150.

8 Honour, p. 149.

9 Richard Westmacott, *The Schools of Sculpture Ancient and Modern*, Edinburgh, 1865, p. 366. Westmacott, who studied under Canova, recommends the use of an iron armature, p. 365.

10 Campbell, p. 137.

11 Wyatt, p. 189.

12 Smith, *Nollekens*, vol. I, p. 68.

13 Smith, *Nollekens*, vol. I, p. 327.

14 Vasari, p. 330, 'Life of Luca della Robbia'.

15 Richard Deakin, *Flora of the Colosseum of Rome*, London, 1855, pp. 29–30.

16 Smith, *Nollekens*, vol. II, p. 359.

17 See plates 2 and 3 of Riccio's *Virgin and Child* in Anthony Radcliffe's article 'A Forgotten Masterpiece by Riccio', *Apollo*, July 1983.

18 Smith, *Nollekens*, vol. I, p. 157.

19 Honour p. 148, quoting Charlotte Anne Eaton.

20 Smith, *Nollekens*, vol. II, p. 353.

21 Vasari, p. 333 'Life of Luca della Robbia'.

22 Heal Collection, 32.15.

23 Heal Collection, 32.34.

24 Smith, *Nollekens*, vol. II, p. 56. Smith states that this 'mastic' was used for 'the columns of the theatre [Royal?] in the Hay Market'. The relief was subsequently bought by the Coade factory.

25 'Address to the "Public"', *Coade's Gallery or Exhibition in Artificial Stone*, 1799 catalogue.

26 Smith, *Nollekens*, vol. II, p. 90.

27 Smith, *Nollekens*, vol. I, p. 12.

28 Rupert Gunnis, *Dictionary of British Sculptors 1660–1851*, London, Abbey Library, 1951, 'John Bacon R.A.', and Smith, *Nollekens*, vol. I, pp. 160–3, quoting Panton Betew.

29 Vasari, p. 694 'Life of Andrea Verrocchio'.

30 Smith, *Nollekens*, vol. I, p. 21. The model survives in the collection of the Worshipful Company of Coach and Harness Makers, London.

31 Cellini, *Treatises*, pp. 111–12.

32 *Vasari on Technique*, pp. 148–9.

33 *Vasari on Technique*, pp. 149, 188–90.

34 Alexander Browne, *The Whole Art of Drawing*, London, 1660, p. 22, not to be confused with the same author's *Ars Pictoria: or an Academy Treating of Drawing*, London, 1669 or 1675.

35 *Vasari on Technique*, p. 149.

36 Walpole, vol. IV, p. 216.

37 *Vasari on Technique*, p. 86.

38 Christopher Wren, jun., *Parentalia or Memoirs of a Family of Wren's*, London, Stephen Wren, 1750, p. 291. In the American South this material was known as 'tabby', see Jessie Poesch, *The Art of the Old South 1560–1860*, New York, Knopf, 1983, p. 140.

39 Abbott's sketch book is in Devon County Records Office, Exeter, (a facsimile is in the Department of Furniture and Woodwork, Victoria and Albert Museum, London) and three of his modelling

tools and other *memorabilia* are held by the Royal Victoria Museum, Exeter.

40 Gunnis, and Geoffrey Beard, *Craftsmen and Interior Decoration in England 1660–1820*, Edinburgh, Bartholomew, 1981, p. 135.

41 Beard, op. cit., p. 279, quoting an advertisement in the *Oxford Journal* (8 April 1772).

42 Campbell, p. 141.

43 Vasari, p. 306 'Life of Jacopo della Quercia'.

44 Whitney Museum of American Art catalogue, *200 Years of American Sculpture*, p. 55.

Casting in Plaster

1 Vasari, p. 693, 'Life of Andrea Verrocchio'. The fashion for collecting casts of hands, etc. , of the famous and infamous probably began quite early, e.g. Joseph Bonomi made a cast of the 'immense right hand [of] the French giant', Smith, *Nollekens*, vol. I, pp. 326–7.

2 Vasari, p. 338, 'Life of Luca della Robbia'.

3 Smith, *Nollekens*, vol. I, p. 367. Sebastian Gahagan assisted Nollekens in taking the mask of Lord Lake.

4 From Rackstrow's trade label in the V & A, E 1646–1907.

5 Pliny, p. 177.

6 The oil had to be used sparingly but J. T. Smith, in typical fashion, uses Nollekens's advice as an opportunity to criticize the master – see *Nollekens*, vol. I, p. 321.

7 Smith, *Nollekens*, vol. I, p. 321.

8 Many of these are referred to in Smith's *Nollekens* as follows: John Flaxman Snr. of Covent Garden, later 420 The Strand (vol. II, p. 351); Matthew Mazzoni of 377 The Strand (vol. II, p. 243) who kept a stock of moulds of no less than fifty-two versions of Fiamingo's 'children'; and Vevini of St James Street, who made a fine mould of a small marble copy of the *Laocoon*, a particularly difficult thing to cast (vol. II, p. 42). The Heal Collection gives David Crashlay (Crashley or Chrashley) at the Sir Isaac Newton's Head, Long Acre (32.13), and Francis Pillgreen, Old Belton Street, Long Acre (32.45).

9 Smith, *Nollekens*, vol. II, p. 244.

THE TOREUTIC ARTS

Casting and Chasing Metal

1 Albert E. Elsen, *In Rodin's Studio*, Oxford, Phaidon, 1980, p. 28. Elsen is here quoting Rodin.

2 *Encyclopaedia Britannica*, 11th edition, 1910–11.

3 This cosmetic treatment goes back at least to Vasari who, in his chapters on technique (trans. Maclehose, p. 166), states that 'Some turn it black with oil, others with vinegar make it green, and others with varnish give it the colour of black.'

4 James Larkin, *The Practical Brass and Iron Founders Guide* (1892), Philadelphia, Baird/London, Spon, 1914, p. 103.

5 I am indebted to my father, Arthur J. J. Ayres, for this information.

6 Pliny, p. 7. Allowing for the lack of purity of all metals used by a primitive metallurgy, these additional variables would account for the differing colours of 'Corinthian' bronze referred to by Pliny (p. 9) which included white and red bronze and a mixture of both. He also mentions a fourth liver-coloured bronze inferior to Corinthian but superior to those of Aigina and Delos. According to Pliny, Delos bronze was first used for furniture.

7 Cellini, *Life*, p. 387.

8 Leonardo da Vinci, vol. II, p. 380.

9 Cellini, *Treatises*, p. 62.

10 Larkin, p. 101.

11 Larkin, p. 102. Leonardo recommends vinegar for this purpose, vol. II, p. 380.

12 Cellini, *Treatises*, p. 63.

13 Cellini, *Life*, p. 295.

14 Discovered by workmen digging drains in Piraeus, National Museum, Athens.

15 Especially with the introduction of gunpowder for making cannon in times of war.

16 Cluny Museum, Paris. Ateliers Limousins 1ᵉ moitié du XIVᵉ siècle.

17 Harvey, *Medieval Craftsmen*, p. 157.

18 Vasari, p. 439 'Life of Donatello'.

19 Theophilus, p. 105.

20 Barrow, *Dictionary*, 'Foundery or Foundry'. Cellini gives the 'pith of horn' as one of the ingredients, *Treatises*, p. 63.

21 Leonardo da Vinci, vol. II, p. 380.

22 This was for the well-known equestrian portrait of Louis XIV erected in Paris in 1699.

23 The book was published as 'Description des travaux qui ont précédé, accompagné et suivi la fonte en bronze d'un seul jet de la statue équestre de Louis XV, le bien-amie', Paris, Le Mercier, 1768. See Priscilla Wrightson, *Books on Art*, 'Catalogue 42', London, B. Weinreb Architectural Books Ltd., 1979, item 718.

24 Rudolf Wittkower, *Sculpture: Process and Principle*, London, Allen Lane 1977, Penguin edn. 1979, p. 216.

25 Cheere was probably a pupil of van Nost's – see Gunnis.

26 Geoffrey Beard, *Craftsmen and Interior Decoration in England 1660–1820*, Edinburgh, Bartholomew, 1981, p. 256.

27 Gail C. Andrews, 'Prussian Artistic Cast Iron', *Antiques* magazine, February 1983, pp. 422–7.

28 Vasari, *Lives*, p. 691, illustrated p. 692.

29 Honour, p. 148, regarding the casting of the statue of Clement XII which was melted down in 1798.

30 Vasari, p. 355 'Life of Ghiberti'.

31 Vasari, p. 367 'Life of Ghiberti'.

32 Cellini, *Life*, p. 293.

33 Vasari (p. 661 'Life of Antonio Pollaiuolo') refers to works in silver that were 'wrought wholly with the chasing-tool'.

34 Vasari, p. 570 'Life of Francesco di Giorgio'.

35 Vasari, p. 370 'Life of Masolino da Panicale'.

36 Christoph Frhr. Imhoff V, 'Magnet Nuremberg', *The Connoisseur*, November 1978.

37 Vasari, p. 370 'Life of Masolino da Panicale'.

38 Beard, op. cit., pp. 242, 269.

39 Smith, *Nollekens*, vol. I, pp. 54, 161. Moser worked for the Bow Porcelain factory as a modeller.

40 Smith, *Nollekens*, vol. I, p. 319.

41 F. J. B. Watson, 'Sculpture on Furniture: An aspect of eighteenth-century technique', *Apollo*, June 1965, pp. 483–6. The article makes it clear that such bronze mounts were the prerogative of the guild of *fondeurs-ciseleurs* but if gilded they were in the province of the *ciseleurs-doreurs*, two guilds that were not united until 1776. It is evident that the *ciseleurs* were the most significant figures within each guild. Cressent, as a sculptor and furniture maker, insisted on making his own ormolu mounts which resulted in much litigation with the two guilds.

42 Heal Collection, 85.120.

43 Fortnum's book was published by Chapman Hall in the series of South Kensington Museum Art Handbooks – the reference occurs on p. 21.

Die-Sinking

1 Walpole, vol. III, p. 172.

2 Walpole, vol. III, p. 177.

3 Hilliard, pp. 32–3.

4 For example Walpole describes Antony Deric, who worked in the reign of Edward VI, as a 'capital sculptor of the monies in the Tower of London', vol. I, p. 205.

5 The two Thomas Wyons began working for the Royal Mint in 1811 and their cousin William Wyon joined the Mint in 1816. The Roman-born Benedetto Pistrucci began working for the Mint in 1815, his most famous coin design being his St George and the Dragon which first appeared on George III's crown in 1818.

6 Cellini, *Treatises*, p. 69.

7 Walpole, vol. II, p. 250.

8 In conversation with the author, 1983.
9 *Vasari on Technique*, p. 167.
10 Cellini, *Treatises*, p. 70.
11 *Chambers Encyclopaedia*, 1864, 'Die Sinking'.
12 Cellini, *Treatises*, pp. 68, 70.
13 Cellini, *Life*, pp. 157–8.
14 Cellini, *Treatises*, p. 75.
15 C. H. V. Sutherland, *The Art of Coinage*, London, Batsford, 1955, chapters VIII, IX. It should be noted that Walpole (vol. II, pp. 66–7) reports of 'Nicholas Briot . . . a native of Lorrain and graver to the King of France in which kingdom he was the inventor, or at least one of the first proposers of coining money by a press, instead of the former manner of hammering'.
16 Walpole, vol. II, p. 285.
17 John Evelyn, *Numismata*, London, 1697, p. 225.
18 *The Journeys of Celia Fiennes*, op. cit., p. 137.
19 *The Numismatic Chronicle*, London, The Royal Numismatic Society, 1971, seventh series, vol. XI, J. G. Pollard, 'Matthew Boulton and the Reducing Machine in England', pp. 311–17.
20 In the 1960s the Royal Mint, recognizing the limitations of such a non-self-regulating system, encouraged their sculptors to produce plaster patterns of only 4 in. diameter and correspondingly low relief. At the same time they encouraged their die-sinkers to produce more dies directly in the metal. It was a brave experiment but the reducing machine could hardly be uninvented.
21 Prince Hoare, *Epochs of the Arts*, London, 1813, p. 108.

THE GLYPTIC ARTS

1 E.g. Lawrence Stone, *Sculpture in Britain: The Middle Ages*, London, Penguin, 1955, p. 148. Lawrence Stone's speculation that some ivory carvers may have worked on alabaster (p. 188) may have some worth since wood-carving tools were customarily used to good effect on alabaster.

Carving in Stone and Marble

1 An example of this use of large scantlings are the urns that surmount the gate piers at Prior Park, Bath (fig. 256) adjacent to Ralph Allen's quarries. Another example cited by J. T. Smith in his *Nollekens* (vol. I, p. 304) concerns Sir William Staines who, like Ralph Allen, hoped to profit from dealing in stone, and to promote his business by using 'the thickest tombstone for its size that ever came to London' for his wife's grave. This slab of 'close Yorkshire' measured 9 ft. 8 in. × 7 ft. 3 in. (294 × 221 cm.) but unfortunately the thickness is not stated.
2 See Alec Clifton-Taylor and A. S. Ireson, *English Stone Building*, London, Gollancz, 1983.
3 Quoted by Smith, *Nollekens*, vol. II, p. 246.
4 *Vasari on Technique*, pp. 45, 120 and nn. 55, 56.
5 Mitchell, p. 158.
6 Harvey, *Medieval Craftsmen*, p. 24.
7 Clifton-Taylor and Ireson, p. 69.
8 Vasari, p. 412 'Life of Brunelleschi'.
9 Smith, *Nollekens*, vol. II, pp. 34, 35 (Roubiliac), vol. II, pp. 114–15 (blocks of marble sold at Joseph Wilton's sale, 8/9 June 1786), and vol. I, p. 336 (Nollekens).
10 Smith, *Nollekens*, vol. I, p. 231.
11 Late eighteenth- and early nineteenth-century American examples may be seen at Old Sturbridge Village, Massachusetts (they were once used by the Sandwich, Mass., chairmaker, Samuel Wing) and the Henry Francis Dupont Museum, Wilmington, Delaware (once used by the Dominy family of furniture-makers of East Hampton, New York).
12 Harvey, *Medieval Craftsmen*, p. 120.
13 Examples in the Musée des Arts et Traditions Populaires, Paris, accession no. 62.130–25, negative no. 72.124.1036.
14 Sir Balthazar Gerbier, *Counsel and Advice to all Builders . . .*, London, 1663, pp. 17, 18.
15 Gerbier, op. cit., p. 5.

16 Spiers, p. 162.
17 Vasari, p. 413 'Life of Brunelleschi'.
18 Bluemel, p. 22. Bluemel acknowledges that the early Greeks used a claw tool but he rather overstates his case and jeopardizes it when he argues (p. 34) that this is 'nothing but a more complicated kind of fine point'.
19 Stanley Casson, *The Technique of Early Greek Sculpture*, Oxford, Clarendon Press, 1933, p. 201.
20 The origin of the word 'boasted' in this sense seems to be obscure. The *Oxford English Dictionary* associates it with the mason's 'boaster' but the alternative word 'bolster' (a wide, mason's chisel) suggests the no less wide pillow or cushion of the same name. A more likely origin is found in the Italian phrase *scapell da sbòzzo* (*sbòzzo*, s.m. rough sketch draft). See Garzanti, *Italian-English/English-Italian Dictionary*, New York, Toronto, London, McGraw Hill, 1961.
21 Campbell, p. 138. Campbell appears to distinguish between the image-maker whose work is in 'Bass Relievo' or whose 'Images are fixed to the Structure, and cannot be removed', and the 'Statuary' whose works 'may be removed at pleasure', p. 137.
22 Campbell, p. 138.
23 Wyatt, pp. 200–01.
24 *Vasari on Technique*, p. 48.
25 A whitesmith works in steel, a blacksmith in iron. Some confusion has arisen over this term which is often applied to those who work in white metals such as tin – such craftsmen are best identified as tinsmiths.
26 Honour, p. 217.
27 Cellini, *Treatises*, p. 138.
28 Dunlap, vol. I, p. 428.
29 Dunlap, vol. I, p. 433.
30 Tomb of St Vincent of Avila, Castile, twelfth century. Wittkower (*Sculpture*, p. 38) has described this detail, which shows a sculptor at work in this way, as 'incorrect'. He makes no reference to the possibility of a left-handed carver being represented and neither does he discuss the importance of the double-handed skill.
31 Bluemel, pp. 22, 27.
32 Cellini, *Treatises*, p. 136. Cellini is referring to the penultimate skin of marble before finishing.
33 Wittkower, p. 11. See also p. 40 where alabaster, together with marble, are misleadingly described as 'hard stones'.
34 Cellini, *Treatises*, p. 137.
35 Christopher Wren, jun., *Parentalia or Memoirs of a Family of Wrens*, London, Stephen Wren, 1750, p. 299.
36 Heal Collection, Bath Public Library, Reference Dept. This label probably refers to Lucius Gahagan who settled in Bath in about 1820 and died there in 1866, the son of the Irish-born Lawrence Gahagan (*fl.* 1756–1820) and an assistant to Nollekens. J. T. Smith (*Nollekens*, vol. I, p. 278) refers to 'Mr Gahagan' as one of Nollekens's principal carvers and this was probably Sebastian Gahagan (*fl.* 1800–35), brother to Lawrence.
37 Gerbier, op. cit., p. 28.
38 John Harvey, *The Plantagenets*, London, Batsford, 1948, p. 115.
39 *The Journeys of Celia Fiennes*, op. cit., p. 150.
40 Also known by metal-workers as the 'parcer' (example with breast gear in Sheffield City Museum) and the 'fiddle drill' (known in Italy as the *violino*).
41 An exception is the seventeenth- or eighteenth-century English or Continental bow drill illustrated by Edward H. Pinto (*Treen and other Wooden Bygones*, London, Bell, 1969, p. 379, pl. 418.J) which may have been used by a worker in wood. Confirmation of the use of bow drills by wood-workers occurs in H. Bergeron's *L'Art du Tourneur* (Paris, 1816) which illustrates bow, fiddle, and pump drills, and in Marples's 1864 catalogue which includes fiddle drill stocks. See W. L. Goodman, *The History of Wood-working Tools*, London, Bell, 1964, pp. 163–4.
42 Smith, *Nollekens*, vol. I, p. 218. The Classical sculpture of a 'Lion's head with horns' belonged to John Townley.
43 Smith, *Nollekens*, vol. I, p. 231.

44 All these problems are discussed by Smith, *Nollekens*, vol. I, pp. 232–3.

45 Smith, *Nollekens*, vol. II, p. 33.

46 Smith, *Nollekens*, vol. I, pp. 369–70.

47 Vasari, p. 455 'Life of Michelozzi Michelozzo', *re* architecture – a marble cornice with reference to a relief sculpture.

48 Vasari, p. 208 'Life of Andrea Orcagna'.

49 Vasari, p. 227 'Life of Agnolo Gaddi'.

50 Smith, *Nollekens*, vol. II, p. 4.

51 Vasari, p. 398 'Life of Brunelleschi'.

52 Smith, *Nollekens*, vol. I, p. 290.

53 Canova was certainly a carver and Houdon may have been (two of his biographers differ on this point – G. Giacometti states that Houdon *never* worked in marble, and L. Reau that he *did* carve marble).

54 Smith, *Nollekens*, vol. II, pp. 353–4.

55 The other sculptor who worked on County Hall was Alfred Hardiman, but since he was not a carver his work must have been translated into Portland stone by assistants working from full-size models. This makes Cole's direct carving all the more remarkable since it had to compete on equal terms.

56 Smith, *Nollekens*, vol. I, p. 199.

57 Cellini, *Treatises*, p. 136.

58 Cellini, *Treatises*, p. 136.

59 Vasari, pp. 1925–6 'Life of Michelangelo'.

Carving in Wood

1 The London Marblers Company was absorbed by the Masons in 1584 – Margaret Whinney, *Sculpture in Britain 1530–1830*, Harmondsworth, Penguin, 1964, p. 16. Nicholas Stone, the son of a Devon quarryman, worked as Inigo Jones's chief mason on the Banqueting Hall, Whitehall, 1619–22. He was Master of the Masons Company in 1633 and 1634. Grinling Gibbons was admitted to the Drapers Company in 1672 but this was by patrimony.

2 Heal Collection, 32.4. Boyle is listed at Great Pultney Street in *Mortimer's Directory* for 1763.

3 Geoffrey Beard, *Craftsmen and Interior Decoration in England 1660–1820*, Edinburgh, Bartholomew, 1981, 'Select Dictionary of Craftsmen'.

4 Vasari, pp. 464–5 'Life of Giuliano da Maiano'.

5 The evidence for Gibbons as a marble carver is contradictory. Vertue argues that 'He was neither well skilled or practiced in marble or bronze, for which work he employed the best artists he could procure.' Sir Edward Deering, writing in his Diary on 11 July 1683, describes Gibbons as 'A most famous artist in carving and eminent also for working in marble'. I favour Deering's view, but since woodcarving is the rarer skill I believe that Vertue's account of Gibbons deputing others to work in marble and bronze is essentially correct.

6 Smith, *Nollekens*, vol. II, p. 122.

7 Vasari, p. 438 'Life of Donatello'.

8 John Evelyn, *Sylva or A Discourse of Forest Trees, and the Propagation of Timber in his Majesty's Dominions*, London, 1664, p. 33. Evelyn is quite wrong when he adds that elm is recommended for these purposes because of its 'not being much subject to warping'.

9 Evelyn (*Sylva*, p. 35) noted that beech grown 'In the Vallies (where they stand warm and in Comfort) they will grow to a stupendous procerity.'

10 M. V. Brewington, *Shipcarvers of North America*, New York, Dover (1962), 1972, pp. 42, 43. The 1796 *Boston Directory* lists almost as many 'head builders' as carvers but in less busy ports the carvers fitted their own work.

11 Harvey, *Medieval Craftsmen*, p. 120.

12 Sir Balthazar Gerbier, *Council and Advice to all Builders . . .*, London, 1663, p. 64.

13 Christopher Wren, jun., *Parentalia or Memoirs of a Family of Wrens*, London, Stephen Wren, 1750, p. 320.

14 Evelyn, *Sylva*, p. 14.

15 Campbell, pp. 167–8.

16 Edward Basil Jupp, *Historical Account of the Worshipful Company of Carpenters of the City of London*, 2nd edn., 1887, pp. 4–7.

17 Jupp, p. 297.

18 Jupp, p. 304.

19 Harvey, *Medieval Craftsmen*, p. 155.

20 Turners' cutting tools differ from those of 'makers' and carvers by the extreme length of their steel shanks and their wood handles which, with the larger tools, are designed to be held firmly under the armpit.

21 Quoted by Goodman, p. 197.

22 Joseph Moxon, *Mechanic Exercises of the Doctrine of Handy-Works* (1677), Charles Montogomery ed., New York, Praeger, 1970, pp. 76–8 and pl. 4.

23 Charles G. Leland and John J. Holtzapffel, *Wood Carving*, London, Holtzapffel & Co., 1894, p. 3.

24 Quoted by Charles F. Hummel, *With Hammer in Hand*, Charlottesville, Henry Francis Dupont Museum/University of Virginia, 1968, p. 84.

25 Moxon, op. cit., p. 77, pl. 4, C.4. It should be noted that *Mechanic Exercises* identifies the 'Paring Chissel' as C.2 but this numbering appears to be incorrect.

26 Smith (*Nollekens*, vol. I, p. 341) mentions that in late eighteenth- and early nineteenth-century London some people 'fine their coffee with the skin of a sole'.

27 *The Journeys of Celia Fiennes*, op. cit., p. 119.

28 Evelyn, *Sylva*, p. 55.

29 Vasari, p. 781 'Life of Leonardo da Vinci'. The buckler was made of fig tree and, as a favour, Leonardo painted a head of Medusa on it.

30 For this information, although not for this interpretation, see Michael Baxandall, *The Limewood Sculptors of Renaissance Germany*, New Haven and London, Yale University Press (1980), 1981 edn., p. 28.

31 Druxy is defined in William Sutherland's *The Ship Builders Assistant* (London, 1711) as 'decayed and Spungy' timber.

32 Walpole, vol. III, p. 149.

33 Moxon, op. cit., pp. 76–7 and pl. C.3 (probably marked incorrectly C.2).

34 Dunlap, vol. I, p. 315.

35 Brewington, op. cit., p. 38.

36 Dunlap, vol. I, p. 139.

37 Brewington, op. cit., p. 33, quoting Scharf and Westcott, *History of Philadelphia*, vol. III, p. 2337.

38 Smith, *Nollekens*, vol. I, pp. 166–7, for this and much more on size *and* scale.

39 Campbell, pp. 164, 173–4.

40 Heal Collection, 32.20.

41 Brewington, op. cit., p. 46.

42 Heal Collection, 33.46.

43 Heal Collection, 32.31. Another, though less versatile, carver was Thomas Hartley of 103 Newgate Street (*Directories*, 1790) who 'Performs all manner of house and furniture carving'.

THE SURFACE TREATMENT OF SCULPTURE

1 Prince Hoare, *Epochs of the Arts*, London, 1813, p. 77. Even here, Hoare states that the commission to create a marble figure of Pitt for Cambridge University was first offered to 'a Venetian sculptor [but that] fortunately, the amiable character of Canova preserved the honour of an University . . . he declined the splendid task.' The work was eventually undertaken by Nollekens and completed in 1808.

2 Statuary made from imported Italian marble does not take kindly to an English winter. In the eighteenth century Rysbrack's marble figure (1737) of Sir Hans Sloane in the Chelsea Physic Garden

was covered up each winter.

3 Honour, pp. 148–9. Nollekens employed 'old John Panzetta the polisher' (see Smith, *Nollekens*, vol. I, p. 93) and he also had dealings with 'a stone-polisher of the name of Lloyd' (vol. I, p. 321).

4 *Vasari on Technique*, p. 45.

5 Spiers, p. 196.

6 Vasari, vol. I, p. 151. The observation occurs in connection with his description of Nino Pisano's *Madonna*, now in the Museo di San Matteo, Pisa.

7 Smith, *Nollekens*, vol. II, p. 113.

8 Westmacott, pp. 369–70.

9 Eastlake, vol. I, pp. 160–1.

10 Evelyn, *Sylva*, p. 55.

11 E.g. the disastrous use of wax in the 1920s by Ernest Tristram on English medieval murals.

12 Baron d'Uklanski, *Travels in Upper Italy, Tuscany and the Ecclesiastical State . . . in the years 1807 and 1808*, London, 1816, vol. II, p. 111.

13 Honour, p. 219. This *acqua di rota* was mentioned by Cicognara and may have been composed of dirty water from the wet-stone used for sharpening tools.

14 Smith, *Nollekens*, vol. I, pp. 10–11.

15 Westmacott, p. 370.

16 Baron d'Uklanski, vol. II, p. 111.

17 Smith, *Nollekens*, vol. I, p. 377.

18 Westmacott, p. 376. On p. 363 Westmacott advises against copying 'extraneous accessories – as in introducing colour – because authority for it may be found among the Greeks'.

19 Quoted by Trevor Fawcett, *The Rise of English Provincial Art*, Oxford, Clarendon Press, 1974, p. 64.

20 Wyatt, p. 207. Hiram Powers admitted to Nathaniel Hawthorne that in his youth he 'had made [coloured] wax figures' but that he had ceased doing so and did not approve of Gibson's tinted Venuses. Powers concluded that the whiteness of marble 'removed the object represented into a sort of spiritual region, and so gave chaste permission to those nudities which would otherwise suggest immodesty'. See John W. McCoubrey, *American Art 1700–1960: Sources and Documents*, New Jersey, Prentice-Hall Inc. , 1965, pp. 88–9.

21 Baxandall, p. 105.

22 Baxandall, p. 119.

23 Harvey, *Medieval Craftsmen*, p. 166. Harvey also quotes (p. 167) an alabaster tomb with 'images' made between 1374 and 1378 by Henry Yeveley and Thomas Wrek which was to be painted by Richard Burgate and Robert Davy.

24 *The Journeys of Celia Fiennes*, op. cit., pp. 178, 187.

25 J. T. Smith, *Streets of London*, London, 1815, p. 11. One of the many casts of 'an African' may be seen at Okeover Hall, Staffordshire.

26 Christopher Hussey, *English Gardens and Landscapes 1700–1750*, London, Country Life, 1967, p. 62.

27 *The Journeys of Celia Fiennes*, op. cit., p. 117.

VI *Postscript*

1 For a discussion of eighteenth-century 'supply side' economics, see Neil McKendrick, John Brewer and J. H. Plumb, *The Birth of a Consumer Society: The Commercialization of Eighteenth-Century England*, London, Hutchinson & Company Ltd, 1983.

2 The transition from a craft-based art to one based on aesthetic doctrines was gradual. The chaser Michael Moser (1706–83) was a founder member of the Royal Acadamy (founded 1768) and his fellow Academician Nathaniel Marchant (1739–1816) was a die-sinker. The change in emphasis was however inexorable and ultimately such skills would be unrepresented at the Academy.

The following books were among those that had an important influence on the Academies of Art in Britain: John Gwynn, *An Essay on Design Including Proposals for Erecting a Public Academy*, London, 1749; James Barry, *An Inquiry into the Real and Imaginary Obstructions to the Acquisition of the Arts in England*, London, 1775.

3 This is eighteenth-century usage of the word 'bred' to signify apprenticeship or training in a trade or profession – e.g. Walpole vol. III, p. 189, refers to Henry Tilson who 'was bred under Sir Peter Lely'. Other examples given by Walpole include Robert Griffière (vol. III, p. 86), William de Keisar (vol. III, p. 84), William Deryke (vol. III, p. 232) and Zurich (vol. IV, p. 77) who were all 'bred' as jewellers. The portrait painter Joseph Highmore was 'bred as a lawyer'.

4 In addition to William Williams's observations on the importance of sign painting as a training for artists (see pp. 17–18), the same argument may also be found in *The Library of Fine Arts or Repertory of Painting, Sculpture, Architecture and Engraving*, London, M. Arnold, 1831 (8 vols.), vol. II, pp. 388–9.

5 Gilbertius (late thirteenth century) of Autun is an exceptionally early example of a sculptor signing his work.

6 *The Times*, London, 23 July 1983, W. J. Burroughs, 'Heated Imagination of a Hot Summer'.

7 For an account of the work of one of these painters, see: Edgar P. Richardson, Brooke Hindle and Lillian B. Miller, *Charles Wilson Peale and His World*, New York, Abrams, 1983.

8 *Encyclopaedia Britannica* 1910, Walter Crane, 'Art Teaching'.

9 Mary Corbett Harris, *Llanfachreth: Bygones of a Merioneth Parish*, Dolgellau, Merioneth County Record Committee, 1973. See also T. P. Ellis, *The Story of Two Parishes*, Newtown, Welsh Outlook Press, 1928, for the same reference.

10 Walpole, vol. II, p. 207, footnote *re* 'Hieronymo Laniere'.

11 Walpole, vol. II, p. 66, *re* Nicholas Briot.

12 Charles S. Rhyne quoting Molly Faries in the keynote lecture 'Technique and Meaning in Painting', Conference of the College Art Association, San Francisco, 28 February 1981.

13 George Sturt, *The Wheelwright's Shop* (1923), Cambridge, University Press, 1942, p. 54. See also Christopher Frayling, *The Schoolmaster and the Wheelwright*, Royal College of Art, paper no. 13, London, 1983, p. 6. Walter Rose's *The Village Carpenter* (1937) is written in much the same vein as Sturt's seminal book.

SELECT BIBLIOGRAPHY

Remarkably few publications relate directly to the history of the artist's craft. The following printed books and articles are for the most part listed for their oblique relevance or very specialist importance.

General

BARRY, JAMES, *An Inquiry into the Real and Imaginary Obstructions to the Acquisition of the Arts in England*, London, 1775.

BELLONY-REWALD, ALICE and PEPPIATT, MICHAEL, *Imaginations Chamber, Artists and their Studios*, London, Gordon Fraser, 1983. (After a good opening chapter this account rapidly becomes simply an outline history of French, and later American, art. Good illustrations.)

BRODIE & MIDDLETON (publishers), *The Practical Carver and Gilders Guide*, c. 1880. (Contains information on brushes and framing.)

CAHN, WALTER, *Masterpieces: Chapters on the History of an Idea*, New Jersey, Princeton University Press, 1979. (An important examination of the changing meaning of 'the masterpiece' and the transition of the maker to the status of the 'artist'.)

CAMPBELL, R., *The London Tradesman*, London, 1747. (A book, designed for parents and guardians, which describes many trades, their pay and status.)

DIDEROT, DENIS, *L'Encyclopédie, ou Dictionnaire Raisonné des Sciences, des Arts et des Métiers*, vol. I, Paris, 1751; vol. II, Paris, 1752, Dover reprint, New York, 1959.

DUNLAP, WILLIAM, *History of the Rise and Progress of the Arts of Design in the United States* (1834), New York, Dover reprint, 1969, 3 vols.

EDWARDS, EDWARD, *Anecdotes of Painters*, London, 1808.

GWYNN, JOHN, *An Essay on Design Including Proposals for Erecting a Public Academy*, London, 1749.

HARVEY, JOHN, *Medieval Craftsmen*, London, Batsford, 1975.

JONES, MICHAEL OWEN, *The Hand-Made Object and Its Maker*, Berkeley/Los Angeles/London, University of California Press, 1975. (An account and analysis of a living chair-maker. The book has a hand-made appearance in keeping with the subject.)

KELLY, FRANCIS, *The Studio and the Artist*, Newton Abbot, David & Charles, 1974.

LEONARDO DA VINCI, *The Notebooks*, translated by Edward Mac-Curdy, London, Jonathan Cape (1938), 1977, 2 vols.

LUCIE-SMITH, EDWARD, *The Story of Craft*, Oxford, Phaidon, 1981.

Mitchell Beazley Library of Art, London, Mitchell Beazley, 1982. (Vol. I includes a section on techniques.)

ORMOND, RICHARD, *Artists at Work*, London, National Portrait Gallery Exhibition Catalogue, 1981–2. (Emphasis on painting but includes drawing and sculpture.)

PEVSNER, NIKOLAUS, *Academies of Art, Past and Present*, Cambridge and New York, Cambridge University Press, 1940.

PLINY, THE ELDER, *The Elder Pliny's Chapters on the History of Art*, translated by K. Jex-Blake (1894), Chicago University reprint, 1968.

PYE, DAVID, *The Nature and Art of Workmanship*, London, Studio Vista, 1968.

SMITH, J. T., *Nollekens and his Times* (1828), W. Whitten edn., London, John Lane, 1920, 2 vols.

VASARI, GIORGIO, *Lives of the Most Eminent Painters, Sculptors, and Architects* (1568), translated by Gaston du C. de Vere, New York, Harry N. Abrams Inc., 1979, 3 vols.

VASARI, GIORGIO, *Vasari on Technique*, translated by Louisa S. Maclehose, G. B. Brown ed., London, Dent, 1907. (Most editions of Vasari omit these important introductory chapters on technique.)

WALPOLE, HORACE, *Anecdotes of Painting in England*, London (1762–71), 4th edn. 1786, 5 vols.

WHITLEY, WILLIAM T., *Artists and Their Friends in England 1700–99*, London and Boston, Medici Society, 1928, 2 vols. (Concerned chiefly with painters but does include some sculptors, e.g. Mrs Wright, the wax modeller.)

WRIGHTSON, PRISCILLA, *Books on Art*, 'Catalogue 42', London, B. Weinreb Architectural Books Ltd., 1979.

WRIGHTSON, PRISCILLA, *Instruction Books on the Art and Practice of Drawing and Painting*, 'Catalogue 39', London, B. Weinreb Architectural Books Ltd., 1978.

Drawing

BROWNE, ALEXANDER, *The Whole Art of Drawing*, London, 1660.

HALFPENNY, WILLIAM, *Perspective Made Easy*, London, 1731.

HAMBLY, MAYA, *Drawing Instruments, Their History, Purpose and Use for Architectural Drawings*, London, RIBA Drawings Collection Exhibition Catalogue, 1982.

HAMMOND, JOHN H., *The Camera Obscura*, Bristol, Hilger, 1981.

JOHNSON, MARK M., *Idea to Image*, Indiana University Press, 1980. (Concerns the development and changing status of the preparatory drawing.)

VARLEY, CORNELIUS, *A Treatise on Optical Drawing Instruments ... Also a Method of Preserving Pictures in Oil and in Water Colours*, London, 1845. (See also books by the better known John Varley.)

VARLEY & HAMILTON, *Drawing Book*, London, 1812. (An important early instruction manual for painting in watercolour.)

WATROUS, JAMES, *The Crafts of Old Master Drawings*, Madison, University of Wisconsin Press, 1967.

Painting

AGLIONBY, WILLIAM, *Painting Illustrated*, London, 1685.

BARDWELL, THOMAS, *The Practice of Painting*, London, 1756.

BOUTET (or BOUTAT), CLAUDE, *Traité de Mignature, Pour Apprendre Aisément a Peindre sans Maître, et le Secret de Faire les Plus Belles Couleurs ...*, 3rd edn. Paris, 1684; 2nd edn. English translation, London, 1736.

BROMELLE, N. S. and SMITH, P. eds., *Conservation and Restoration of Pictorial Art*, London, Butterworths, 1976. (Good chapters on the history of artists' brushes by Rosamond D. Harley; oil paint, and the use of metal supports, by J. A. van de Graaf.)

CAWSE, JOHN, *The Art of Painting Portraits, Landscapes, Animals, Draperies, Satins &c. in Oil Colours*, London, 1840. (Gives

instructions for 'setting a palette' for each of the above at different stages in the work.)

CENNINI, CENNINO D'ANDREA (born *c*. 1370), *Il Libro dell'Arte*, translated by Daniel V. Thompson, jun., New York, Dover reprint, 1933.

CLARKE, J. H., *A Practical Essay on the Art of Colouring and Painting Landscapes in Watercolours*, London, 1807.

COHN, MARJORIE B. and ROSENFIELD, RACHEL, *Wash and Gouache: A Study of the Development of Materials of Watercolour*, Cambridge Mass., Fogg Art Museum catalogue, 1977.

CONSTABLE, W. G., *The Painter's Workshop*, London, Oxford University Press, 1954.

COOKE, HEREWARD LESTER, *Painting Techniques of the Masters*, New York, Watson-Guptill Publications, 1972.

CROEKER, JOHANN MELCHIOR, *Treatise*, Jena, 1753.

DAVIES, MARTIN, *Paintings and Drawings on the Backs of National Gallery Pictures*, London, National Gallery, 1946.

DOERNER, MAX, *The Materials of the Artist* (1921), London, Granada, 1979.

DOSSIE, ROBERT, *The Handmaid to the Arts*, London (1758), 1764, 2 vols. (Mainly useful in relation to painting.)

EASTLAKE, CHARLES LOCK, *Materials for a History of Oil Painting* (1847), New York, Dover reprint, 1960, 2 vols. (A remarkably early and still valuable historical survey.)

ELSUM, JOHN, *The Art of Painting after the Italian Manner with . . . observations how to know a good Picture*, London, 1704.

FIELD, G., *Chromatography, or a Treatise on Colours and Pigments . . .*, London, 1835. (Field made colours for Sir Thomas Lawrence. He was also the author of *Chromatics; or an Essay on the analogy and harmony of colours*, 1817.)

GOODWIN, MICHAEL, *Artist and Colourman*, London, Reeves, 1966.

HARLEY, R. D., *Artists' Pigments c. 1600–1835*, London, Butterworth, 1970.

HAYES, COLIN ed., *The Complete Guide to Painting and Drawing Techniques and Materials*, Oxford, Phaidon, 1979. (Mainly concerned with painting but not exclusively with modern methods – it also gives a brief history of painting techniques.)

HEYDENRYK, HENRY, *The Art and History of Frames*, London, Nicholas Vane, 1964.

HILER, HILAIRE, *Notes on the Technique of Painting*, London, Faber & Faber, 1934.

HILLIARD, NICHOLAS, *A Treatise Concerning the Art of Limning*, R. K. R. Thornton and T. G. S. Cain eds., Manchester, Mid Northumberland Arts Group in association with Carcanet New Press, 1981. (Includes Edward Norgate's *Discourse Concerning the Art of Limning*.)

JANUSZCZAK, W. ed., *Techniques of the World's Great Painters*, Oxford, Phaidon, 1980.

JOHNSON, THOMAS, *Designs for Picture Frames &c.*, London, 1758.

LAURIE, A. P., *The Painter's Methods and Materials*, London, Seeley, Service & Co., 1930.

LEVEY, MICHAEL, *The Painter Depicted – Painters as a Subject in Painting*, London, Thames & Hudson, 1981.

MAYER, RALPH, *The Artist's Handbook of Materials and Techniques*, London, Faber & Faber (1940), 1982.

MÉRIMÉE, J. F. L., *De La Peinture à l'Huile* (1830), translated by W. B. S. Taylor, London, 1839.

MERRIFIELD, MARY P., *The Art of Fresco Painting, as practised by the old Italian and Spanish masters, with a preliminary enquiry into the nature of the colours used in fresco painting, with observations and notes* (1846), London, Tiranti reprint, 1952.

MERRIFIELD, MARY P., *Original Treatises Dating from the XIIth to XVIIIth Centuries on the Arts of Painting*, London, 1849, 2 vols.

MONTIAS, JOHN MICHAEL, *Artists and Artisans in Delft*, New Jersey, Princeton University Press, 1982. (A remarkable analysis of over 2,000 inventories that gives a very full impression of artists and craftsmen in seventeenth-century Delft.)

MÜNTZ (or MUENTZ), J. H., *Encaustic or Count Caylus's Method of Painting*, London, 1760.

NICHOLSON, FRANCIS, *The Practice of Drawing and Painting Landscape from Nature in Watercolours*, London, 1820.

PAYNE, JOHN, *The Art of Painting in Miniature on Ivory*, London, 2nd edn. 1798.

REYNOLDS, JOSHUA, *Seven Discourses Delivered in the Royal Academy by the President*, London, 1778.

SALMON, WILLIAM, *Polygraphice* (1672), London, 1701, 2 vols.

SCHMID, FREDERIC, *The Practice of Painting*, London, Faber & Faber, 1948. (A good study of the changing traditions in the 'setting' of a palette.)

SMITH, JOHN, *The Art of Painting in Oyl*, London, 1676, 1705, 1723, 1753. (There are many editions of this work each of which differ. The last, revised by Butcher, appeared in 1821.)

SMITH, JOHN, *The Method of Painting in Water Colour*, London, 1730.

SMITH, MARSHALL, *The Art of Painting etc.*, London, 1692. (A copy of this now very rare book is at Harvard University.)

STALKER, JOHN and PARKER, GEORGE, *A Treatise of Japaning and Varnishing*, Oxford 1688, London, Tiranti reprint, 1971.

Tate Gallery Catalogue, *Paint and Painting*, London, 1982.

THIEL, P. J. J. VAN, and KOPS, C. J. DE BRUYN, *Prijst de Lijst*, Amsterdam, Rijksmuseum Catalogue, 1984. (A fine history of seventeenth-century Dutch frames.)

THOMPSON, DANIEL V., *The Materials of Medieval Painting*, New Haven, Yale University Press, 1936.

WEHLTE, KURT, *The Materials and Techniques of Painting*, New York, Van Nostrand Reinhold Co. (1967), 1982.

WILD, BRIAN, *The Romance of a Family Business*, London, Dryad Press, *c*. 1966. (A short and very personal history of the Reeves brothers.)

WILLIAMS, WILLIAM, *An Essay on the Mechanic of Oil Colours, Considered under these heads: Oils, Varnishes and Pigments*, Bath, 1787. (A copy of this slim but important essay is in Bath Public Library.)

Sculpture

ANDERSON, M. D., *The Medieval Carver*, Cambridge, University Press, 1935.

BAXANDALL, MICHAEL, *The Limewood Sculptors of Renaissance Germany*, New Haven and London, Yale University Press (1980), 1981.

BEMROSE, WILLIAM, *Manual of Wood Carving*, London and Oxford, 1862.

BLUEMEL, CARL, *Greek Sculptors at Work* (1927), London, Phaidon, 1955.

CASSON, STANLEY, *The Technique of Early Greek Sculpture*, Oxford, Clarendon Press, 1933.

CELLINI, BENVENUTO (1500–71), *The Life of Benvenuto Cellini*, translated by J. A. Symonds (1901), London, Macmillan, 1911.

CELLINI, BENVENUTO, *The Treatises*, translated by C. R. Ashbee (1888), New York, Dover reprint, 1967.

CLIFTON-TAYLOR, ALEC and IRESON, A. S., *English Stone Building*, London, Gollancz, 1983.

ELSEN, ALBERT E., *In Rodin's Studio*, Oxford, Phaidon, 1980. (Concerned with Rodin's use of the camera as a tool for his work.)

EVELYN, JOHN, *Sylva or A Discourse of Forest Trees, and the Propagation of Timber in his Majesty's Dominions*, London, 1664.

FORTNUM, C. DRURY E., *Bronzes*, London, Chapman Hall, 1877.

GOODMAN, W. L., *The History of Woodworking Tools*, London, Bell, 1964.

GREEN, DAVID, *Grinling Gibbons; His Work as Carver and Statuary*, London, Country Life, 1964.

GUNNIS, RUPERT, *Dictionary of British Sculptors 1660–1851*, London, Abbey Library, 1951. (As with many books on post-medieval sculpture, this book largely ignores woodcarving as sculpture. Grinling Gibbons is included but mainly for his work in marble. The same limitation is true of Margaret Whinney's *Sculpture in Britain 1530–1830*.)

HOFFMAN, MALVINA, *Sculpture Inside and Out*, London, Allen & Unwin, 1939.

HONOUR, HUGH, 'Canova's Studio Practice', *Burlington Magazine*, March/April 1972. (One of the best accounts of the history of sculptors' methods.)

HUMMEL, CHARLES F., *With Hammer in Hand*, Charlottesville, Henry Francis Dupont Museum/University of Virginia, 1968.

LARKIN, JAMES, *The Practical Brass and Iron Founders Guide* (1892), Philadelphia and London, Spon, 1914.

LELAND, CHARLES G. and HOLTZAPFFEL, JOHN J., *Wood Carving*, London, 1894.

MIDGLEY, BARRY ed., *Sculpture, Modelling and Ceramics*, Oxford, Phaidon, 1982.

Ministère de la Culture et de la Communication, *Inventaire Général des Monuments et des Richesses Artistiques de la France, Principes d'Analyse Scientifique, 'La Sculpture'* – *Méthode et Vocabulaire*, Paris, Imprimerie Nationale, 1978.

MITCHELL, CHARLES F., *Building Construction and Drawing*, London, Batsford 1901, 8th edn. 1917.

MYERS, BERNARD, *Sculpture: Form and Method*, London, Studio Vista, 1965.

NOBLE, JOSEPH VEACH, *The Techniques of Painted Attic Pottery*, London, Faber & Faber with the Metropolitan Museum New York, 1966.

PORTEOUS, JOHN, *Coins*, London, Weidenfeld & Nicolson, 1964.

RICH, JACK C., *The Materials and Methods of Sculpture*, New York, Oxford University Press (1947), 1973.

SALAMAN, R. A., *Dictionary of Tools Used in Woodworking and Allied Trades c. 1700–1970*, London, Allen & Unwin, 1975. (Includes some painters' tools.)

SPIERS, WALTER LEWIS ed., *The Diary of Nicholas Stone Jnr.* (1618–47), Oxford University Press, Walpole Society, 1919, vol. VII. (As the diary of a sculptor it is to sculpture that this is chiefly relevant.)

STONE, LAWRENCE, *Sculpture in Britain: The Middle Ages*, London, Penguin, 1955.

SUTHERLAND, C. H. V., *The Art of Coinage*, London, Batsford, 1955.

SUTHERLAND, WILLIAM, *The Ship Builder's Assistant*, London, 1711. (Useful like other books on shipbuilding, e.g. Mungo Murray's *Treatise on Shipbuilding*, for references to the seasoning of timber and for woodcarving.)

THEOPHILUS (9th–14th century AD?), *On Divers Arts*, translated by J. G. Hawthorne & C. S. Smith, New York, Dover reprint, 1969. (Although 'on divers arts', mainly relevant to metal working.)

TIPPING, H. AVRAY, *Grinling Gibbons and the Woodwork of His Age 1648–1720*, London, Country Life, 1914.

WESTMACOTT, RICHARD, *The Schools of Sculpture Ancient and Modern*, Edinburgh, 1865.

WITTKOWER, RUDOLF, *Sculpture: Process and Principle*, London, Allen Lane 1977, Penguin edn. 1979. (The worth of the 'principles' is conditioned by a limited knowledge of the 'processes'.)

WYATT, M. DIGBY, *Fine Art: A Sketch of its History, Theory, Practice and Application to Industry*, London, 1870. (Includes some account of sculptors' techniques.)

GLOSSARY

Alla prima The direct method of painting without monochromatic 'underpainting'.

Armature The basic framework upon which a sculptor may model in clay (see fig. 224).

Arris The sharp edge where two planes meet. A term much used in connection with stonework.

Backing off The undercutting of the outline of a picture frame or similar pierced carving designed to be seen frontally. Hence 'backing yellow' is used in place of gold leaf to tone down the barely visible 'backing off' of a gilded frame.

Banker The block of stone which a mason uses as a bench – hence 'banker-mason'. A sculptor's banker is a development of this and is usually of wood, fitted with wheels and surmounted with a turn-table (see fig. 64).

Batted face The series of parallel incisions on the face of a masoned stone created by the use of a bolster.

Bed The natural way that stone lies in the quarry is referred to as 'the bed'. So that stone may 'weather' well, it should be laid 'on bed'.

Boasting drawing A simplified drawing of the section of an architectural detail or piece of sculpture. For carving in three dimensions at least two drawings would be made (usually full size and always 'proud' of the final measurements). These drawings generally represented the frontal and side profiles. The mason or assistant would work to the 'boasting-line' in 'roughing-out' the work for sculptors or master-masons. (See fig. 274.)

Bistre A brown pigment made from boiled soot. Much used (until the introduction of watercolour cakes in the late eighteenth century) to give tonal washes to drawings.

Bolster A wide chisel used by masons and sculptors (see fig. 257).

Camera lucida In contrast to the 'camera obscura' or dark chamber, the camera lucida (whilst not exactly a light chamber) is an instrument used for looking simultaneously at the subject and the paper (by means of an unenclosed prism) on which the drawing is to be executed (see fig. 100).

Chaser A craftsman who works direct in cold metal (annealed at intervals) to create or amend form – not to be confused with fettling or engraving. (See fig. 247).

Chiaroscuro Light and dark or the tonal system in a painting or drawing.

Chryselephantine A combination of wood and ivory for statuary or statuettes in which the flesh is ivory and the drapery wood or gilded wood. The technique was used by the Greeks from the sixth century BC and demonstrates the close affinity between the working of close-textured woods and ivory.

Claw A chisel used in working marble and stone in which the cutting edge is divided into two or many claws. For working marble each claw is pointed (see fig. 257), for working stone each claw is chisel-ended.

Cottle (or clay wall) A band of clay used to divide up the mould in making a plaster 'waste mould' or 'piece mould'. The clay wall is used as an alternative to shim or where shim would be unsuitable (see figs. 234, 235).

Donkey A four-legged stool with a 'neck' at one end to support a drawing board (see fig. 56).

Drag A piece of sheet-steel with one serrated edge used to drag over soft stone to establish a simple flat plane or geometric form.

Dryers An oil given exceptional drying properties by the addition of various minerals such as lead.

Dummy A mallet, the head of which is made of some soft material such as an alloy of zinc and lead.

Face side The face or visible side of timber, stone etc. selected for the high quality of the material and used as a point of reference for subsequent measurements.

Feathers Wedges, used in conjunction with plugs to split stone in quarrying.

Figure The decorative grain in wood.

Figure iron The angle iron that supports the armature for a clay model of a figure.

Fire-sharp A term used in connection with the 'drawing out' of edge-tools by a smith for stone and marble workers. The regular sharpening of 'fire-sharps' on a 'wet-stone' (grit-stones such as York are used) makes intermittent drawing out by the smith necessary.

Flushing The spalling or damage to an arris or edge in stonework.

Frig-bobs Saws, five or six feet in length, used for cutting stone.

Gallet The large chip of stone produced when 'pitching'. Hence 'Galleting', being chips of stone inserted into mortar joints in masonry. *Gallet* (French) = pebble.

Gesso A mixture of whitening and size. For painters both panel and canvas 'supports' may be given a gesso 'ground'. Gesso is also used as the ground for water gilding (e.g. for picture frames) and may be worked in considerable relief and carved with precise detail.

Grisaille A painting in monochrome often designed to imitate a relief sculpture. The term is sometimes used in connection with monochromatic 'underpainting'.

Ground The surface upon which paint is applied. The ground is often, but not always, an intermediate layer between the paint and its 'support'.

Grub saws Long saws without teeth used for cutting stone (with addition of sharp sand or shot).

Helve The long handle or shank of tools such as axes.

Impasto Paint laid on thickly either with the brush or with a painting knife.

Intonaco In fresco painting the final layer of plaster that received the paint.

Investment In metal casting, the term given to the mould or the material out of which the mould is made (see fig. 242). Probably related to 'investment' or 'vestment' in the archaic sense of 'clothing'.

Lanterns In foundry work, lanterns are iron tubes placed in the sand 'core' (in sand casting) to allow gas and air to escape when the molten metal is poured into the mould.

Lay figure An articulated figure (usually human), life size or smaller, on which clothes may be placed. These figures were much used by painters and sculptors (in place of living models) when working on drapery. (See figs. 49–54.)

Ledger A flat stone used as the surface upon which pigments are

ground with the 'muller' (see fig. 131); also the horizontal members in scaffolding or a memorial tablet placed flat on the ground.

Lewis A ring attachment used in lifting large blocks of masonry or sculpture. The lewis is fixed into a stone by means of a dove-tailed socket or similar means. (See fig. 270.)

Limner The painter of miniatures in watercolour. The term lost its precision by the mid-eighteenth century. The word 'limner' derives from *minium* or the vermilion much used to illuminate manuscripts.

Lost-wax (or *cire-perdue*) process In foundry work a system of casting a wax master-pattern in metal in which the wax is melted out of the mould ('lost') preparatory to pouring the molten metal.

Mahlstick Literally paint-stick – a light wooden rod held by a (right-handed) painter in the left hand as a support for the right hand. They were usually fitted with a leather pad to rest on the surface of the work without causing damage.

Maquette The pretentious term for a sculptor's small sketch model.

Mason's mitre The form made when two mouldings are cut out of the solid and meet at an angle. This produces a junction that resembles a structural mitre but in which the true joint occurs elsewhere (see fig. 298).

298 Mason's mitre worked in wood.

Maulstick See **Mahlstick**.

Medium The medium binds the pigments together and holds them on to the ground. In practice the medium often incorporates the 'vehicle'.

Mezzotint A method of engraving copper for copper-plate prints. The process, which involves the use of tools with a serrated edge, was devised by Ludwig von Siegen of Utrecht in 1642 and popularized in Britain by Charles I's nephew, Prince Rupert of the Rhine. The technique was much used in the second half of the seventeenth century and throughout the eighteenth century to produce prints of great tonal richness. The use of the process declined with the coming of lithography (discovered in 1798).

Mitre A joint or junction of two similar members each cut to the same or similar angle, which for a right angle would be 45 degrees (see fig. 299).

299 Mitre.

Mordant The term (literally 'biting hold of') is applied to preparations that are devised to hold pigment or leaf metal to a given surface – gold size is a mordant.

Muller A grinder made of a close-textured hard-stone used (in conjunction with a ledger) to reduce pigment to a powder (see fig. 131).

Pencil In modern usage a word now confined to lead (strictly graphite) pencils. Historically the finer brushes were known as pencils. In old descriptions the term pencil-stick is often met with and refers indiscriminately to the shank of a 'lead' or hair 'pencil'.

Pentimento The 'repentances' or changes of mind evident in a painting. These corrections often become visible as a picture ages.

Pitcher An edged-tool used in masonry and sculpture for the removal of large areas of stone when working to a 'boasting-line'. The edge of the pitcher is not quite square-ended (see fig. 258) and is used in conjunction with a steel pitching-hammer (of elongated form) to give a staccato knock. With these tools the stone is fractured rather than cut.

Point An edged-tool designed for use in 'roughing-out' marble. The blade is drawn out to a point (see fig. 257).

Pointing A verb applied to several systems of recording points in three-dimensional space to enable sculptors to transfer, reduce or enlarge from their original three-dimensional models. Pointing was important for sculptors wishing to translate their clay or plaster originals into wood, stone or marble (see figs. 219–21).

Portcrayon A carrier or holder for a crayon, charcoal or similar drawing material.

Pounce A verb that describes the transfer of a design from one two-dimensional surface to another. This is achieved by punching a series of small holes along the lines of a working drawing through which powdered charcoal (or some such substance) may be filtered to record the design on the ultimate surface (see fig. 85). The word is also used as a noun to refer to the powder used for this purpose. This powder is held in a 'pounce bag'.

Punch An edged-tool used in 'roughing-out' stonework. It differs from the 'point' (used on marble) in having a narrow blade about $\frac{1}{8}$ inch or $\frac{1}{4}$ inch in width (see fig. 257).

Quarter-sawing A system of dividing a log into boards (see fig. 281). Timber cut in this way is less likely to warp and is more likely to reveal an interesting 'figure'.

Quirk An edged-tool used in stone or marble in which the shank is wrought so as to be narrower than the cutting edge. This tool is specifically designed to cut narrow and deep channels. The word may also be used to refer to the channel worked with such a tool.

Riser (or air jet) In 'lost-wax' metal casting, the ducts through which gases and air pressure escape to enable the mould to be satisfactorily filled (see fig. 243). In 'sand casting', 'lanterns' serve this function.

Runner In metal casting, the ducts along which the molten bronze, lead, etc., travels (see fig. 243).

Sampson A small sturdy six-wheeled truck used in moving stone or heavy balks of timber. The sampson is devised with a wheel at each corner and a pair of central wheels. The two central wheels are set at a lower plane than the corner wheels to enable the sampson to turn. (See fig. 269.)

Sand casting In foundry work a system of making moulds of sand or loam (held in cast iron 'boxes') for metal casting.

Set (of a palette) The arrangement of paints on a palette (see fig. 160).

Setting in The process of establishing, with carving tools, the outline of a motif in wood-carving (see fig. 285).

Setting out Drawing out architectural or sculptural details full size.

Shank The shaft of a tool – e.g. the shank of a chisel.

Shim Thin sheet of brass or copper used as a barrier in dividing the sections of a piece-mould.

Sight measurement The size of the visible part of a picture – in other words the dimensions of the canvas or panel minus the rebate (or rabbet) of the frame.

Sinoper (or sinopia) A red pigment much used in preliminary drawing on plaster for a fresco.

Slip Dry clay crushed to a powder and mixed with water to the consistency of cream.

Smalt A blue glass, much used in the eighteenth century, that was broken up and ground down as a blue pigment.

Spall The flaking of the face of stone often caused by frost damage.

Spline A thin strip of wood which serves to unite two boards. It serves much the same function as the tongue, in tongue and groove boarding, and could be used to unite the necessarily narrow boards of quarter-sawn timber into one large panel.

Staff A composition of plaster and straw used for temporary statuary.

Star shakes The splits that radiate from the centre of a log and which, in cross section, resemble a star.

Stretcher The framework on which canvas is stretched for an easel painting (in seventeenth- and eighteenth-century accounts this was known as the straining frame). By the late eighteenth century, wedges were incorporated to facilitate the stretching of canvas that had become slack.

Support The chief structural 'support' to a painting. In a fresco the wall is the support and the plaster the 'ground'. Other supports include wood (panel paintings), canvas, and paper.

Swept frame A picture frame combining a sinuous outline with embellishments at the 'corners' and 'centres' (see fig. 204).

Tempera An old term for media. Generally used in connection with the media more commonly employed in the past – hence egg tempera.

Tooth The texture given to a 'ground' to enable it to hold paint. The rough surface of some watercolour papers are an example.

Turntable A horizontal working surface (much used by sculptors) that revolves on its vertical axis (see fig. 64).

Underpainting The initial monochromatic 'underpainting' in a work which is intended to be developed in polychrome with glazes, etc.

Vehicle The carrier of a pigment. A good example is watercolour in which the vehicle is water and the medium is gum arabic.

Waste-mould A plaster mould which is chipped away ('wasted') to reveal the plaster cast (see fig. 235).

Wax encaustic A method (or possibly methods?) of painting with wax as a medium, much used in classical antiquity. The word encaustic alludes to the burnt-in process.

ACKNOWLEDGEMENTS

The line drawings reproduced as figs. 21, 55, 56, 64, 81, 210, 222, 227, 235, 258, 259, 269, 270, 280, 281, 298, 299 are by the author.

The author and publishers would like to thank all those museum authorities, institutions, and private owners who have kindly allowed their works to be reproduced. They have endeavoured to credit all known persons holding copyright or reproduction rights for the illustrations in this book.

Thanks are also due for permission to reproduce the following photographs: Reproduced by Gracious Permission of Her Majesty Queen Elizabeth II, figs. 3, 194, 239, 266; Abby Aldrich Rockefeller Folk Art Center, Williamsburg, Virginia, 127, 208, 209; Accademia, Florence, 275; Albertina Museum, Vienna, 27, 143, 177; Antiquarium, Berlin, 223 (photo by Bildarchiv Preussicher Kulturbesitz); Musée Royal, Antwerp, 125 (photo by Giraudon); Art Institute of Chicago, 190; Ashmolean Museum, Oxford, 33, 251; National Museum, Athens, 213, 263 (photos by Deutsches Archäologisches Institut, Athens); Historisches Museum, Basle, 283; Bath Public Library, 86, 102, 123, 195, 274; Collection of C. A. Bell-Knight, 53; Trustees of the late Earl of Berkeley, 175; Bibliothèque Nationale, Paris, 2, 40; Birmingham Museum and Art Gallery, 253; Museum of Fine Arts, Boston, 58 (Gift of the Misses Aimée & Rosamond Lamb), 79; City of Bristol Museum & Art Gallery, 128; By courtesy of the Trustees of the British Library, 34, 71, 76, 132, 146, 242, 252, 277; By courtesy of the Trustees of the British Museum, 5, 6, 14, 29, 30, 36, 41, 70, 74, 75, 82, 89 (photo by J. R. Freeman), 92, 117, 122, 141, 153, 179 (photo by J. R. Freeman), 182, 183, 189, 201, 205, 225, 237, 238; Carolina Art Association, Gibbes Art Gallery, Charleston, 187; Château de Versailles, 163 (photo by Clichés des Musées Nationaux); Trustees of the Chatsworth Settlement, 260; Musée de Cluny, Paris, 241 (photo by Caisse Nationale des Monuments Historiques et des Sites, Paris); National Museum, Copenhagen, 154; Statens Museum for Kunst, Copenhagen, 7 (photo by Weidenfeld & Nicolson Archives), 243 (photo by Hans Petersen); Delacroix Studio, Paris, 60; Delphi Museum, 288; Deutzenhofje, Amsterdam, 191 (photo by Tom Haartsen); Dorset Natural History & Archaeological Society & Museum, 59; Trustees of Dove Cottage, 150; École des Beaux-Arts, Paris, 43; Municipal Library, Epernay, 157; Escott Collection, 221; Eyre & Hobhouse, London, 19; Museo Nazionale, Florence, 236 (photo by Mansell Collection); Courtesy of the Fogg Art Museum, Harvard University, 267; Werner Forman Archive, 286; Bibliotheek der Universiteit, Ghent, 159; *Guardian & Manchester Evening News*, 63; Calouste Gulbenkian Museum, Lisbon, 68; Provinzial Museum, Hanover, 289; From 'Wells Cathedral' by L. S. Colchester and J. H. Harvey (*The Archaeological Journal*, vol. 131 (1974), p. 214), 72; Courtesy of Henry Francis du Pont Winterthur Museum, Delaware, 18; Hobart House Antiques,

Connecticut, 188; Hofje van Oorschet Collection, Haarlem, 9; Courtesy of Hugh Honour, 212, 214, 216; Hotspur Ltd., London, 39; John Judkyn Memorial, Bath, 80; Judkyn/Pratt Collection, 204; Kalman Collection, London, 13; Victor Kennett/Robert Harding Picture Library, 26; Royal Borough of Kensington & Chelsea Library, 25; Kunsthistorisches Museum, Vienna, 17 (photo by Meyer KG); Lambeth Palace Library, 292; Musée du Louvre, Paris, 137, 158; Bildarchiv Foto Marburg, 4; Mead Art Museum, Amherst College (Bequest of Herbert W. Pratt, '95.1945.10) 142; Roy Miles Gallery, London, 62; Musées des Arts et Traditions Populaires, Paris, 259; Museum of London, 51, 54, 108, 109, 145, 172, 186, 199; Musée Monétaire, Paris, 250; National Gallery of Art, Washington (Paul Mellon Collection, 1965), 31; National Gallery, London, 85, 98, 105, 106, 111, 118, 124, 139, 148, 166, 167, 168; National Museum of Antiquities, Edinburgh, 10; National Portrait Gallery, London, 73, 140, 290; New York Historical Society, 28; New York Public Library, 226; Courtesy of the Pennsylvania Academy of the Fine Arts, 294; Philadelphia Museum of Art (Gift of George W. Elkins) 207; Private Collection, 22, 48, 52, 65, 66, 67, 95, 119, 120, 131, 151, 162, 165, 169, 171, 174, 181, 193, 196, 197, 206, 211, 215, 224, 232, 235, 248, 265, 273, 279, 280; Rijksmuseum, Amsterdam, 42, 61, 115, 116; Musée Rodin, Paris, 229 (© S.P.A.D.E.M.); Royal Academy of Arts, London, 45, 46, 47, 57, 155; Royal Commission on Historical Monuments, 12, 15, 20; Royal Mint, Llantrisant, 249, 255; Royal Scottish Academy, Edinburgh, 38; Royal Scottish Museum, Edinburgh, 217; Scala, 264; Science Museum, London, 77, 88, 93, 94, 99, 100, 101, 103, 218; Scottish National Gallery, 24, 138; Scottish National Portrait Gallery, 32, 37, 110, 164; Siena Cathedral, 113 (photo by Scala); Siena State Archives, 114 (photo by Scala); Simon van Gijn Museum, Dordrecht, 8; Sotheby's, London, 69, 254; J. B. Speed Art Museum, Louisville, Kentucky, 50; Staatliche Museen, Berlin, 49, 112, 240 (photos by Bildarchiv Preussicher Kulturbesitz); Nico van der Stam, Amsterdam, 23; Tate Gallery, 152, 161; Uffizi Gallery, Florence, 176; Victoria and Albert Museum, 11, 35, 83, 84, 121, 129, 130, 134, 135, 144, 160, 200, 228, 233, 244, 271, 272, 293, 295, 296; Wakefield Art Gallery & Museums, 287; National Museum of Wales, 297; Reproduced by kind permission of the Wallace Collection, 107, 246; Warburg Institute, 278; Warrington Museum & Art Gallery, 230; National Archives, Washington, DC, 268; Wheatley Windmill Restoration Society, 180; Winsor & Newton, London, 133, 149, 156, 178, 185; Woodbridge Collection, 78; Yale Center for British Art, New Haven, 96; York Castle Museum, 90; York City Art Gallery, 147.

Further thanks are due to Eileen Tweedy, Derek Balmer, Gordon Roberton and Simon Roberton (both of A. C. Cooper Ltd.) for additional photography.

INDEX

Italic figures indicate illustration numbers

Abbot, John, 160
Adam's composition, 159
Alberti, Leon Baptista, 65, 69
alla prima, 99
Allan, David, *The Origin of Painting*, 30; *24*
altar, portable, 4
anamorphic painting, 65; *94, 95*
anatomy, 38–40; *2, 42, 43, 44, 45*
ancona, 133
animal derivatives, in pigments, 94
animals:
 hair of, for brushes, 123
 teeth in burnishing, 143–4
Annis, James and Elizabeth, 22
Antwerp brown, 94
apograph, 71
Arione with his Violin, 168, 169; *236*
armature (in modelling), 154, 158, 159; *224, 226,
 227, 239, 242*
arris, 187
art collections, artists', 47–8
artificial light, 29–31
Arts and Crafts Movement, 22, 202
asphaltum, 94
auricular frames, 136, 137
Ayres, Arthur J. J., 261
 Portrait of Paul, 219, 220, 221
 Prometheus, 262
Ayton, J., 139

backing off, 195
backward linkage, 129
Bacon, John, 156, 159
Bagshaw, William, *The White Ram, 13*
Baldovinetti, Alesso, 51, 54
Ballantyne, John, *Frith in his Studio, 62*
Baltic oak, 179, 191
banker, mason's, 46, 177, 179; *64*
Banks, Sir Thomas, 190
Barile, Antonio, 134; *176*
Bartholdi, Auguste, *Statue of Liberty, 226*
Bartlett, Jonathan Adams, *127*
bas reliefs, 155, 159
Baskerville, John, 86
Bath stone, 177, 184; *256*
batted face (in stone), 179
Beale, Mary, 129
bed, use of stone on, 176
bench, carver's, 195
Besson, Jacques, 71
Best, Mary Ellen, *The Artist in her Painting
 Room, 147*
bevel, 192–4
Biggerstaff & Walsh, 82; *117*
bistre washes, 58, 105
bitumen, 94
black-lead pencils, *81, 82*
bladder colours, 87, 90, 110, 132

blenders (brushes), 124
blinds, 27
Blondeau, Peter, 175
boasting drawing, 179, 180; *274*
boasting line, 198
body colour, 107
bole, in gilding, 141–2, 143
bolster, 257
Bosse, Abraham, 32
 drawing frame, 65; *92*
 Le Noble Peintre, 6
Boudon, David, 65
Boulton, Matthew, 170, 172, 175
Bouts, Dieric, *Entombment of Christ*, 80
bow drill, 184–7; *265, 266, 267*
Boyle, James, 190
bread, as eraser, 60
brick, carved, 262
Brodie, William, 168
bronze, casting in, 162–8; *236, 237, 238, 239, 242,
 243, 244, 245*
Bruegel the Elder, Pieter, *Self-Portrait, 177*
Brunelleschi, Filippo, 188
brushes, 122–6; *129, 153, 158, 169, 171, 177, 178*
 hair for, 122–3
 preserving of, 126
 types of, 123–4. *See also* pencil
burnishing, 143–4; *203*
Bushnell, John, 168
butterfly (in clay modelling), 227

cabinet, painter's, 45–6; *59, 60, 61*
Caen stone, 184
Caffieri, Jacques, 169
calcagnuolo, 180
Calfe, John, 130
calipers, 147–8; *211, 212*
calking, 63
camel-hair brushes, 123
camera, 70
camera lucida, 70, 71; *100, 103*
camera obscura, 68–71; *88, 96, 97*
Campbell, Richard, *The London Tradesman*,
 126, 127, 130, 139, 147, 155, 160, 180, 191,
 201
Canaletto, camera obscura, 97
candlelight, 29–31; *34*
Canova, Antonio, 31, 147, 151, 154, 181, 203
 dress, 48, 50
 studios, 38
 tools, 260
 The Three Graces, 216
 Venus and Sleeping Endymion, 206
canvas, 72
 oil painting on, 79
 portability of, 80
 preparation of, 79, 80–3
 as support, 79–83; *115, 118, 124*
canvases, dating of, 213
carbon paper, 63
Carlini, Agostino, 151
 The Dying Gladiator, 40; *44*
carpenters, 22, 191–2
Carradori, Francesco, *Istruzione elementare, 212,
 214*
Carrara marble, 177, 178, 203
Carse, Alexander, *The Artist with his Mother
 and Sister, 32*
cartoon:
 squaring-up to, 60–1; *86*
 transference of, 62–3, 72, 73
carvers, and frame-making, 136, 139–41, 146
carving, 147
 antithesis of modelling, 153
 assistants, use of, 188
 direct, 188–9

tools, 180–8; *257, 258, 260, 261, 265, 267, 269.
 See also* marble; stone; wood
cassone, 7
casting:
 metal, 162–70; *236, 237, 238, 239, 242, 243,
 244, 245*
 plaster, 40, 45, 154, 161–2; *44, 45, 234, 235*
Catlin, George, *The Artist at Work painting
 Indians in the Plains, 31*
Cawse, John:
 The Art of Painting, 56; *160*
 Self-Portrait, 165
Caylus, Count, 95, 98
ceilers (joiners), 191, 192
Cellini, Benvenuto, 11, 38, 40, 136, 147, 160, 163,
 164, 168, 170, 172, 174, 181, 184, 189
 turntable, 46
cement, 187
Cennini, Cennino, *Il Libro dell'Arte*, 55, 56, 59,
 60, 63, 75, 76, 80, 83, 87, 93, 105, 124, 133,
 144
ceramic tiles, 78
Chacmool, 202; *286*
chair, sitter's, 42; *46, 62*
chalk, 59, 60
Chantrey, Sir Francis, 151, 162, 178, 187, 190
charcoal, 59–60, 63
chasing, 162, 168–70; *246, 247, 248*
chassis pointing method, 148–51; *215*
Cheere, John, 209
Chelvey Court (Avon), boss at, *15*
chimney-board, 139
chisels, 179, 180, 181, 182, 192, 199; *257, 261*
choir stall, 289
chryselephantine, 198
Cibber, Caius Gabriel, *Raving* and *Melancholy
 Madness*, 188–9; *271*
Cibber, Colley, 290
Clark, J. E., 170; *247, 248*
claw, carver's, 180; *257*
clay, modelling in, 42, 153–9; *219, 225, 230, 234,
 235*
clothing, 48–53; *63*
clothlets, 105
cloths:
 drawing, 56–7
 floor, 81–2
 oil, 82
club hammer, 180
Coade stone, 159; *232*
coach painters, 16, 17, 18
coal-tar, 94
coin press, 252
coins, 170–6; *251, 253*
Cole, Ernest, 188
colour:
 of studio walls, 31–2
 theories of, 12, 87
colour boxes, 114; *136, 145, 146, 155*
colour closet, 36; *40*
colour washes, 105–7
colour wheel, 129
colourmen, 12, 108, 110, 126–33, 214; *161, 183,
 186*
colours:
 number of, 93–4
 palette arrangement of, 119
 storage of, 90–3, 103–5
 use of, in sculpture, 206–9. *See also* pigments
compo, 144; *206*
Conegliano, Cima de, *Virgin and Child with
 Saints, 138*
Constable, John, 31, 138
 knife and brush, 122; *169, 171*
 portfolio stand, 66

props, 47; *65*, *67*
Stonehenge, 86, *107*
Conté, Nicolas-Jacques, 59
convex mirror, 66–8
Cooke, James, 160
Cooke, John, 160
Copley, John Singleton:
 Boy with a Squirrel, 83
 Death of Major Peirson, *152*
copper plate, oil painting on, 77–8; *108*, *109*
core, modelling on, for metal casting, 160, 164, 165–6
Cornacchini, Agostini, 98
 The Infant Christ Asleep, 78, 95; *134*, *135*
corner firmer, *194*
corpses, in anatomical studies, 40; *42*
cow-horn container, 114; *157*
cradling, in framing-up of panels, 75; *106*
craft traditions, 16–17
Crawford, Thomas, 150
crayons, 59, 102–3. *See also* pastels
Credi, Lorenzo di, 34
Cressent, Charles, 169
 'Dragon commode', *246*
Crome, John, 146
Croos, A. J., 46; *61*
crucifix figure, *283*
Cuff, John, 69
Cumberland pencils, 58; *82*
Cundy, James, 159
curtains, as picture protection, 134; *174*
cushion (in gilding), 143; *202*, *203*
cuttlefish bone, as eraser, 60

Da Vinci, Leonardo, 39, 56, 59, 61, 77, 98, 102, 134, 168, 198
 Last Supper, 72
dampness, in wall paintings, 72
Daw, George, painting-room, 26
daylight, importance of, 24–9, 37
Deakin, Richard, 156
Deare, John, 162, 177
death masks, 161
Dechaux & Parmentier, 83
Degas, Edgar:
 Henri Michel-Lévy in his Studio, 68
Delacroix, Eugène, cabinet and easel, 45; *60*
delineator, Peacock's, 65
depth gauge, in relief work, 148
Devall, John, 168
Devis, Arthur, 42
die-sinking, 170–6; *249*, *250*, *251*
diptych, 133; *111*
direct carving, 188–9
distemper, 98
dividers, 71, 148; *210*
dogs (to hold timber), *278*
dolage, 60
Donatello, 15, 165, 189, 190
 Chellini Madonna, 168; *244*
donkey, artist's, 45; *56*
Donkin, Bryan, 57
Doric order, timber origins, *16*
Dossie, Robert, 63, 65, 69, 71, 88, 94, 105
Dou, Gerard, 34
 The Artist in his Studio, 69
drag, in stone-working, 184
drawing board, 55; *73*
drawing floor, 54–5, 60; *72*
drawing frame, 63–5; *91*, *92*
drawing-out, of tools, 180, 181
drill:
 in carving, 184–7
 in die-sinking, 174
dryers, 102
drying, of timber, 73, 197

Dubois, Louis, 169
Duccio di Buoninsegna:
 Madonna del Voto, *113*
 Virgin and Child with Saints, *166*, *167*
Duffour (carver and gilder), 144, 159
Dunlap, William, 27, 29, 34, 42, 45, 69, 70, 78, 82, 105, 107, 110, 133, 146, 181, 201;
 frontispiece
Dürer, Albrecht, 65, 80, 107
 The Drawing Frame, *91*
 Piece of Turf, *143*
dust, problem of, 34–6, 37
Dutch frames, 135–6

earth colours, 93–4, 126–7
easel, 45; *37*, *38*, *57*, *58*, *60*, *142*, *144*, *154*
easel painting:
 canvas for, 79, 80
 dominance of, 16
easel stool, *48*
ebony frames, 135–6, 139; *196*
effigies, 164–5, 169; *241*, *295*, *296*
egg tempera, 114, 115; *138*, *159*
egg yolk, 98
eidograph, 71
ekphrasis, 15
elm, 190; *273*, *287*
Elsum, John, *The Art of Painting*, 13, 19, 40, 58, 61, 63, 65, 75, 98, 102, 118
Emerton & Manby (colourmen), 127; *182*
Emmett, William, 190
emulsion paint, 98
encaustic painting, 78, 95–8
engraving, 147, 181
Epstein, Jacob, *Archangel Michael*, 164
equestrian groups, *242*, *243*
erasers, 60
Erhart, Michel, 209
Evelyn, John, 15, 147, 175, 191
Eyck, Jan van:
 experiments with oils, 74, 99
 Arnolfini and his Wife, 66, 76; *139*
 St Barbara, 63; *125*
eyes, treatment of, in sculpture, 229, 283

Faed, John, *Portrait of Thomas Faed*, *164*
Falconet, Étienne, 168
feathers, in stone-splitting, 177
Field, George, *The Madder Plant*, *133*
Field, Thomas, 139
fig-tree sap, 98, 102
figure, in wood, 78
figure makers, 22
filters, in colour preparation, 88, 90
Finiguerra, Maso, illustrations of trades and crafts, *5*
fire-sharpening, 180, 181
firmer (chisel), *192*
fish skin, as abrasive, 60, 142, 195
fitches (brushes), 123
fixatives, for pastel, 103
fixing masons, 177, 188, 191
flat brushes, 124–6; *169*, *171*
Flaxman, John, 158
 St Michael Overpowering Satan, *187*
flays, 40; *43*, *44*, *45*
Fletcher, Richard, *204*, *205*
floating, of lime plaster, 72
floor cloths, 80, 81–2; *117*
floors, plaster drawing, 54–5, 60; *72*
Florence:
 Baptistery door, *245*
 San Michele predella, *264*
flushing, of stonework, 181, 187
Foldsone, John, 33
frames, *115*, *116*, *175*, *176*, *181*, *192*, *193*, *194*,

196, *197*, 200, *204*, *205*, *206*, *207*, *208*, *209*
construction of, 135–41
cost of, 139
decoration of, 136–7
development of, 133–8, 144–6
gilding of, 141–4
mass-produced, 144
materials for, 135–6, 139, 144, 146
sizes, *213*
types of, 136–7, 146
Francesca, Piero della, 15, 42
Francesco di Giorgio, 169
Freeman, Jeremiah and William, 146
freemasons, 37, 177
freestones, 177, 184
fresco, 62, 72–3
frig-bobs, for cutting stone, 177
furniture, decoration on, *7*, *9*, *10*

Gaddi, Agnolo, 187
gads, in stone-cutting, 177
Gainsborough, Thomas, 110
 showbox, *83*, *84*
galleries, lighting of, 31
Geeraerdts, M., *Miseries of a Painter*, 40
Gerbier, Sir Balthazar, 179, 184, 191
gesso, 54, 55, 58, 60, 63
 as canvas ground, 79, 80, 83
 in gilding of frames, 141, 142; *197*
 as panel painting ground, 72, 75–6, 77, 79; *74*, *112*
Gibbons, Grinling, 15, 136, 138, 190, 198, 202, 203; *181*
Gibson, John, 154, 209
gilders, *198*, *201*, *202*
 and frame-making, 139–40, 141–4, 146
 in gesso grounds, 75–6
Gill, Eric, 22, 188
 dress, 48; *63*
 studios, 38
Giouthière, Pierre, 169
glass:
 casting in, 168; *244*
 reverse painting on, 77, 78; *119*, *120*
glue, 74, 75
Gol Stave Church (Norway), *21*
gold leaf, 76–7; *202*
 in picture frames, 142–3
gouache, 105, 107
gouges, 180, 192
 sharpening of, 194; *276*
gradina, 180
granite, 176
graphite, 58–9
grinding, of tools, 194–5
grisaille, 155
grub saw, 179
guilds, 15, 16, 74, 80, 135
gum arabic, as medium for watercolour, 94
Gysbrechts, Cornelis-Norbertus, *A Painter's Easel*, *154*

Haecht, Tobias van, *The Studio of Apelles*, *174*
Hales, James, 165
hammer-headed tools, 180, 181, 182
hangings, stained, 79; *12*
hardwood, 73, 190, 191, 197
Harris, James, 110, 132
Harrison (pen-makers), 57
Head of Charles I (anon), 95
head peg, in modelling, 227
Hearne, Thomas, *Sir George Beaumont and Joseph Farington sketching a Waterfall*, *151*
hempseed oil, 102
Hilliard, Nicholas, 27, 34, 105, 144, 172
history painting, 19

Hoare, Prince, 14, 107, 138
Hogarth frame, *196*
hollow casting, 162, 163, 164, 165; *244*
Hoogstraten, Samuel van, perspective box, 66; *98*
horse, model, 67
horse-mills, 127; *161*, *182*
Houdon, Jean-Antoine, *L'Écorché*, 40; *43*
hour glass, 47, *110*
house painters, 17, 102, 123, 124, 127
human figure:
 lay figures and plaster casts, 42–5
 models, 39, 40, 41–5
 portrayal of, 40–5
 stand-ins for posing, 41
 study of, 38–40

illuminated manuscripts, 105
image makers, 14, 22, 161, 168, 169
impasto, 79, 80, 122
Indian ink, 58, 105, 130; *78*
Indian yellow, 94
India rubber, 60
ink, 58; *78*
inlay, for eyes, 283
inorganic pigments, 94
instruction manuals, 13–14, 130
intaglio dies, 172, 174
intonaco, 72
introspection, 66
investment (in metal-casting), *242*, *243*
iron casting, 168
itinerant artists, 33–4; *30*, *31*
ivory:
 carving, 176, 198–9; *17*
 as support, 78

Jamesone, George, 80
 Self-Portrait, 47; *110*
Johnson, Martin, 172
Johnson, Thomas, *200*
 Designs for Picture Frames, etc., 140–1
joiners, 74, 135, 191–2
jointing, in sculpture, 187

Keating, Robert, 130
Kendall, William Sergeant, *Quest*, *294*
keys:
 in framing-up of panels, 75
 in picture frames, 135
kiln-drying, 197
Kilpeck Church, 17; *20*

Labille-Guiard, Adélaïde, *Portrait of the Painter
 François-André Vincent*, *158*
lace-wood, 197
laid paper, 86
Lambert, George, 122
Lambert, Martin, *Portrait of the Brothers
 Beaubrun*, *163*
Lawson, Alexander, 181
lay figures, 42; *49*, *50*, *51*, *52*, *53*, *54*, *68*
lead casting, 168
lead pencil, 58; *81*, *82*
Lederer, Jorg, *209*
ledger (grinding stone), 87; *127*, *131*
Leighton, Lord, 23
 studio, *25*
Lely, Sir Peter, 33, 40, 129
 art collection, 47
lewis (in lifting tackle), 188; *270*
life mask, 161
lifting tackle, 177, 187–8; *36*
light:
 control of, 27, 30, 37
 in galleries, 31

light, studio, 24–32; *33*
 artificial, 29–31
 daylight, 24–9, 37
 north, 27
lime plaster, as fresco ground, 72–3
limestone, 182
limewash, 184
limewood, 279, 282
limner, 54
limning, 105
Lincoln Memorial (Washington, DC), *268*
linear drawing, 54
linen, architect's, 56
linseed oil, 102
Liotard, Jean Étienne, 102
long-arm pointing machine, 71, 148, 151; *217*
Lorraine, Claude, *Landscape with a Goatherd*, *148*
lost-wax process, 160, 162, 164, 165–8
Lucas, Seymour, 48
lumière mystérieuse, 27

McIntire, Samuel, *202*
magic lantern, 89, *101*
mahlsticks, 126; *37*, *163*, *179*
makers' tools, 192–4
mallets, 180, 199
maquette, 147, 151
marble, 176, 177
 moving of, 177–8
 painting on, 78; *121*
 tools for, 180, 182; *257*, *258*, *260*, *261*
 types of, 177
 working of, 182, 187, 188. *See also* stone
marble, surface treatment:
 polishing, 202–3
 polychrome, 206–9
 staining, 203–6
Margaritone, 73, 75
marine painting, 34
marouflage, 75
masks, 161; *230*, *267*
Masolino da Panicale, 169
masonry, association with quarrying and stone-
 carving, 190–1
masons:
 lodges, 37
 plaster drawing floors, 54–5, 60; *72*
 and stone working, 177, 178–80
 tools, 178–80; *257*, *258*, *259*, *260*
 use of parchment, 54
masons and carvers, 22
Masons and Coopers of Leith, arms, *10*
mastic, 159
mathematical compass, 102
matrix, in die-sinking, 172, 174, 175
medallion lathe, 175; *254*
medals, 170–6; *250*, *253*
media:
 in binding pigments, 94–102
 containers for, *157*, *158*
metal:
 casting, 162–70
 chasing, 162, 168–70
 die-sinking, 170–6
 working, 147
Michelangelo, 15, 190; *27*
 working method, carving, 189
 working method, painting, *104*
 St Matthew, *275*
 Sistine Chapel lunette, *104*
milk, as drawing material fixative, 60
mills, for grinding pigments, 127, 129
miniature-painters, 34
 easel, *142*, *144*
 palettes, 119

miniature-painting, 105
 on card, vellum and ivory, 78
mirror frames, 136, 138, 141
mirrors, 66–8
misericord, *272*
Mitchell, John, 57
mitre, 135
modelling, 147, 153–61
 antithesis of carving, 153
 clay, 153–9; *219*, *225*, *230*
 pointing-up in, 148–53; *213*, *215*, *216*, *217*, *218*, *220*
 stucco, 160
 terracotta, 153, 155, 158, 159; *229*
 tools, 156–8, 160; *227*, *231*
 wax, 153, 155, 159–60; *233*
models, 65, 67
 human, 38, 40, 41–5
 nude, 38, 40, 45
 preliminary, 147, 189
 as props, 47
Montabert, Paillot de, 32
Moore, Henry, 202
 Reclining Figure, *287*
mordants, 102
Morgan, John, 127
Mortimer, John Hamilton, *After a Self-Portrait*, *73*
Moser, George M. J., 62, 169
moulds:
 masons', 179, 191; *259*
 in metal casting, 163–4, 165–8
 in plaster casting, 161–2
Moxon, Joseph, *Mechanic Exercises*, 136, 192, 194, 199
muller, 87; *127*, *131*
mummy brown, 94
mummy portraits, 73, 75, 98; *112*, *137*
Müntz, J. H., *Encaustic*, 90, 95, 98, 102–3; *132*
murals – *see* wall painting
Mytens, Aert, 40

naphtha, 102
New Bath Guide, 83; *123*
New York, Tenth Street Studios, 23; *28*
Newman, James, 130, 132, 133
Nollekens, Joseph, 30, 38, 40, 41, 51, 63, 98, 126, 156, 158, 159, 161, 187, 188, 203
 art collection, 48
 stock pieces, 152
 workshop, 37; *41*
Noteman, H., side tables, *9*, *10*
nude models, 38, 40, 45

oak, 190, 191
ochre, 127; *180*
ogee frames, 146
oil, as medium, 98–102
oil cloths, 82
oil paint:
 dryers, 102
 storage of, *156*
 tubes for, 87, 110–11, *132*; *156*
oil painting, 98–102
 on canvas, 79
 on copper, 77–8
 on glass, 78
 invention of, 16, 74, 99
 on paper, 86
 on plaster, 73
oilmen, 130. *See also* colourmen
oilstone, 194; *276*
Opie, John, 51
optical devices, 63–71; *87–103*
organic pigments, 94
ostraca, 54; *75*

ox-wain frame, 297
Oxford frames, 146
Oxford ochre, 127; *180*

paesina, 78
Painter of Pan (attrib.), *Athena modelling a Horse*, 223
painting rooms – see studios
paints, commercial production of, 12. *See also* colours; pigments
palette knives, 122; *163, 169, 170*
palettes, 54, 111–22; *70, 144, 158, 162, 163, 164*
 balance of, 119
 evolution of, 115–18
 in gilding, 143
 materials for, 118–19
 setting of, 119; *160*
 size of, 115–18, 119
panel painting, *105, 106, 107*
 framing of, 133–4
 framing up, *75*
 ground, 75–7
 portability, 133, 134
 woods for, 73–5, *191*
pantograph, 71, 151, 175; *102*
paper:
 invention of, 56
 oil painting on, 86
 range and sizes, 56
 as support for drawings, 54, 83
 watercolour painting on, 83–6
papermaking, 71
papers, tinted, 56, 62
papier mâché, 144, 159
papyrus, 54
parchment, 54, 55–6, 60
Pars, Henry, 169
pastels, 102–3
Peale, Charles Wilson:
 Portrait of James Peale painting a Miniature, *142*
 The Staircase Group, 146; *207*
pear-wood frames, 139
pencil brushes, 123–4
pencils, 58, 123–4; *80, 81, 82*. *See also* brushes
pens, 57; *77*
pentimento, 99
penultima pelle, 182
perspective, 63, 65–6; *91, 92, 93, 95*
Perspective Apparatus, Watt's, 65; *93*
perspective box, 66; *98*
Pettit, Paul, 137; *194*
photography, 111
physiognotrace, 63, 71
pick, in stone-cutting, 177
picture drawers, 14
pictures, placing and hanging of, 137–8; *195*
piece-mould, 161
pigments:
 basic materials of, 126–7
 boxes for, *136*
 grinding of, 86–90, 95, 127, 129
 media used in binding, 94–102
 number of, 93
 organic and inorganic, 94
 vehicles for carrying, 94. *See also* colours
pila (obverse die), 174
Piombo, Sebastiano del, 73, 77, 78
Pisano, Nino:
 Angel of the Annunciation, 293
pitcher (edged-tool in masonry), 179; *258*
pitching hammer, 179; *258*
plaster:
 confusion between stucco and, 160
 as fresco ground, 72–3
 oil painting on, 73

plaster casts, 40, 45, 154, 161–2; *44, 45, 234, 235*
plaster drawing floors, 54–5, 60; *72*
plaster of Paris, 161, 162
plasterwork, *15*
plein-air painting, 12, 23, 110, 111; *146, 148, 150*
point (edged-tool for roughing out), 179–80; *257, 263*
pointing up, 62, 148–53; *213, 215, 216, 217, 218, 219*
polishing, 202–3
polychrome sculpture, 206–9; *290, 292, 295*
polychrome waxes, 160
polyptych, framing of, 134
Poole, James, 82, 130, 133; *122*
poppy oil, 102
porphyry, 181
portcrayon, 60, 180; *76*
portfolio stand, 66
portrait busts, 161; *266, 290*
portrait heads, 227, 234
pouncing, 62, 63; *85*
Powell, Edward, 130
power drills, 188
Powers, Hiram, *Greek Slave*, 45, 150
priming, 72, 77
production die, 172, 174, 175
proportional dividers, 71, 148; *215*
props, 46–7; *110*
Puckridge, William, 202
punch, in die-sinking, 172, 174
punch (edged-tool), 179, 182; *257*
Purbeck marble, 176, 177, 202; *291, 295*
Pyne, W. H., 42
 A Sculptor's Studio, *36*

quarry sap (silica), 184
quarrying, 176–7
quarter-sawing, 73, 74, 197; *281*
quartz, painting on, *121*
Quercia, Jacopo della, 161
quills, 57, 124
quirk, in stone-cutting, 187

Raeburn, Sir Henry:
 collapsible easel, 34; *38*
 sitter's chair, 42
Rand, John G., 87, 111, 132
 Self-Portrait, 187
Raphael, 61
 An Allegory, 85
reducing machine, 71, 175; *255*
reed pen, 57; *77*
Reeves, W. & T. (colourmen), 83, 87, 105, 107, 108, 110, 130–2, 214
Reid, Thomas, 71
reliefs, 154–5
Rembrandt:
 art collection, 47
 dress, 50
 props, 47
 studio, 27; *23, 33*
 Johan Deyman's Anatomy Lesson, 40; *42*
 A Model in the Artist's Studio, 27; *33*
reverse painting on glass, 77, 78
Reynolds, Sir Joshua, 11, 13, 14
 camera obscura, 88
 easel, 57
 sitter's chair, 42; *46*
Rheims cloth, 56
Rhoda Astley (anon), *140*
rigger (brush), 123
risers (in metal casting), 162, 165, 168; *242, 243*
Robbia, Girolamo della, 161
Robbia, Luca della, 156, 159
Roberts, John, 181
Roberts, William, 160

Rodin, Auguste, 162
 studio, 38
 Une Jeune Fille au Chapeau Fleuri de Roses, 155; *229*
Roger of Helmarshausen, 13
 portable altar, 4
Rottenhammer, Hans, *The Virgin and Child with St John*, 78; *121*
Rottier family, 170
Roubiliac, Louis François, 187, 206
 lay figure, 42; *51, 54*
 Bust of George II, 266
roughing out, 179, 180, 199
Rowlandson, Thomas:
 An Artist Travelling in Wales, 30
 Nollekens at Work on 'Venus chiding Cupid', 38; *41*
Rowlandson and Pugin, *Drawing from Life at the Royal Academy*, 35
Rowney, George & Co., 82, 110, 132
Royal Academy, 41, 42, 146, 151, 209; *3, 35*
Royal Accurate Delineator, Storer's, 71
Rubens, Sir Peter Paul, 14, 42, 61, 75
 The Rainbow Landscape, 107
runners (in metal casting), 162, 165, 168; *242, 243*
Rush, William, 199–201
Russell, John, 103
Rysbrack, John, 40

sable brushes, 123
saddle, 17
saddlers, 74
Saenredam, Pieter, 75
Salmon, William, 103, 114, 123, 124, 127, 138, 143
sampson, 269
sand casting, 162, 163–4, 175; *238*
Sandby, Paul:
 invention of watercolour painting, 107, 108, 110, 130
 The Artist's Studio, 29
 The Author run Mad, 179
 The Magic Lantern, 89
 Rosslyn Castle, Midlothian, 96
Sandys & Middleton, 82, 88, 103, 108, 130
Sansovino, Jacopo, *The Story of Susanna*, 228
Sargent, Henry, easel, 45; *58*
scene painters, 17
Schalcken, Godfrey, 29, 40
Scheffer, Ary, 144
Schellenberg, Johann Rudolph, *Goethe drawing Frau von Stein*, 87
Schmalcalder's rod, 65
Schoen, Erhard, *The Unfinished Man*, 278
Scott, John, 133
scrapers, 60
seals, 172
seasoning, of timber, 73, 74, 195–8
secco wall painting, 98
section method of modelling, 151–2; *222*
Seravezza marble, 177
setting in, 199; *285*
setting out, 179
shadow:
 for eyes, 229
 as optical aid, 63, 71; *87*
sharkskin, as abrasive, 195
sharpening, 194–5
sharpening stones, 180
Shaw, Joshua, 32
shells, as paint vessels, 115; *168*
shield, *11*
ship carving, 199–201, 202; *274*
ship painters, 17
shipping pieces, 34
showbox, 83, 84
siccative oil – see dryers

Siena Cathedral, *113*
sight measurement, *176*
sign-painting, 17, 199; *19*, *186*
silhouettes, *90*
silver leaf, 77
silver point, 58; *79*
Simon, Thomas, Petition Crown, 170; *251*
sinoper, 73
Sistine Chapel, *104*
size painting, 98; *12*
Skew-Former, 194
skimming, 176
skinned walnuts, 102
skylights, 24, 37
slate, painting on, 78
slip-casting, 158
slips (oilstones), 194; *276*
Smart, George, 69
Smith, Andrew, 71
Smith, John, *The Art of Painting in Oyl*, 87, 90,
 119, 122, 123, 126, 141, 143
Soest, Gerard, 51, 138
softening brushes, *129*
softwood, 73, 190, 191, 197
spall (flaking of stone), 184
Spang, Michael Henry, 40
spatulas, 156, 160
squaring up, 60–2; *74*, *86*
staff (plaster-and-straw), 161
stainers, 74, 79–80; *12*
staining, of marble, 203–6
star shakes, in wood, 198
steel pens, 57
Stevens, Alfred, cabinet, 59
stippling, 181
Stone, Nicholas, 179, 190, 202
stone, 176
 quarrying and moving of, 177, 187–8
 types of, 177
 weathering, 184
 working of, 177–80, 182–7
stone-carving, 180–9
 association with masonry and quarrying, 191
 distinction from wood-carving, 189–90
 tools, 180–8. *See also* marble
stool, folding, *150*
stove, 45; *55*
Stradet, J. van der, *The Painter's Studio*, *126*
straining frame, 83, 86, 98
stretchers, preparation of canvas on, 83; *115*
striper (brush), *123*; *173*
stropping, 194
Stubbs, George, 40; *45*
stucco, modelling in, 160
studios:
 anatomy and human figure study, 38–45
 clothing for, 48–53; *63*
 colour closet, 36; *40*
 development of, 23–4
 equipment, 45–53
 heating, 45; *55*
 light and colour, 24–32
 painters', 23–4, 32–6; *22*, *23*, *25*, *26*, *28*, *29*,
 32, *33*, *35*, *40*, *68*, *69*, *126*, *147*, *174*
 sculptors', 23–4, 37–8; *36*, *41*
stump, 60; *76*
Sturt, George, *The Wheelwright's Shop*, 212
stylus, 58; *79*
swept frame, 204
syringe dispenser, for oil colour, 110, 132; *155*

Tanagra figures, 158
tavola, *133*
Taylor, Zachary, 135
telescope, 70; *103*
temperas, 98; *159*

templates, 179
terracotta, modelling in, 153, 155, 158, 159; *229*
Thomas, (James) Harvard, 152
Thornycroft, Sir Hamo, 38
 easel stool, 48
three-legged dividers, 148
three-point pointing machine, 148, 151; *219*
timber – *see* wood
tinted papers, 56, 62
tinted statuary, 206–9; *290*, *292*, *295*
tip, in gilding, 143
Titian, *The Death of Actaeon*, *118*
tobacco water, as marble stain, 203
Tomkins, P. W., 57
torsello (reverse die), 174
tortillon, 60
tracing cloths, 56–7
trade cards and labels, *14*, *82*, *117*, *122*, *141*, *172*,
 182, *183*, *201*, *205*
trade secrets, 13–14
trade signs, 130; *186*
transparencies, 83, 84
transparent washes, 107; *145*
travelling box, painter's, 39, *136*
treadmills, 177
triptych, *166*, *167*
Trott, Benjamin, 78
truck, sculptor's, 46
True, Joseph, 202
tube oil colours, 87, 110–11, 132
Turner, J. M. W., *An Artist Colourman's
 Workshop*, *127*; *161*
turners' tools, 192–4
turntable, sculptor's, 64
turpentine, 102

Uccello, Paolo, 98
 St George and the Dragon, 80; *124*

Valckenborgh, Martin van, *The Tower of Babel*,
 77; *108*, *109*
Valckert, Werner van den, *Portrait of a Man
 with a Lay Figure*, *50*
Van Nost, John, 209
Varin, Jean, *250*
Varley's Patent Graphic Telescope, 70; *103*
varnishes, 95, 102, 107, 108
Vasari, Giorgio, 11, 15; *1*
 *Lives of the Most Eminent Painters, Sculptors
 and Architects*, 47, 51, 56, 59, 60, 61, 62, 63,
 69, 73, 74, 75, 77, 80, 98, 134, 160, 161, 165,
 168, 172, 187, 188, 189, 190, 198
vase painters, 54; *223*
vehicles (for pigments), 94, 102
vellum, 56, 78
Venetian secret, 13
Verskovis, James Francis, 199
Victoria, Queen, colour box, 110; *155*
Vischer, Peter, 169

Waitt, Richard, *Self-Portrait*, *37*
Walker, A. G., 188
wall painting, 34, 72
 secco, 98. *See also* fresco
waste-mould, *235*
water:
 as vehicle in watercolour, 94
 wax emulsion paint in, 98
water gilding, 76, 141–4; *197*
water-work, 79–80. *See also* size painting
watercolour:
 development, 108–11
 ingredients, 105
 portability, 105–7
 vehicle and medium of, 94
watercolour boxes, 114; *145*, *188*

watercolour cakes, 103, 105, 108, 110, 111,
 130–1, 132; *149*, *184*, *185*
Watercolour Class, The (anon), *190*
watercolour painting:
 frames for, 146
 paper for, 83–6, 103
Watson, John, 32
Watt, James, 175
 perspective apparatus, 65; *93*
 workshop, *218*
waving machine, 136
wax:
 as marble polish, 203
 modelling in, 153, 155, 159–60
 polychrome, 160
 portraits in, 160
wax emulsion paint, 98
wax encaustic painting, 78, 95–8, 122; *112*, *134*,
 135
weathering, 184
weaving, 80
wedges, in stone-splitting, 177
Wells Cathedral, 209
 masons' tracing floor, 72
West, Benjamin, 13, 70, 80
 clothes, 50
 studio, 31
Westmacott, Sir Richard, 154, 203, 206
wet-stone, 194
Weyden, Rogier van der, *St Luke Drawing the
 Virgin*, 79
White, John, *A Rich Cabinet with a Variety of
 Inventions*, 34
Williams, William, *Essay on the Mechanic of Oil
 Colour*, 17, 86, 93, 94, 115, 119–22, 133
 Portrait of a Gentleman and his Wife, *18*
Williams & Stevens, 83
Wilson, Richard, 46, 122
Wilton diptych, *133*; *111*
windmill, *180*
 model, 65
windows, paper, 27
Winsor & Newton, 60, 82, 110, 111, 132, 213
Winterbottom, Archibald, 56
Wollaston, William Hyde, 70
wood:
 for drawing boards, 55
 reversion from stone to, 22; *20*
wood-carving, 176, 189–202; *271*, *272*, *273*, *274*,
 278, *281*, *282*, *283*, *284*, *285*, *287*, *289*, *293*, *294*,
 297
 bench, *280*
 distinction from stone-carving, 189–90
 seasoning of timber, 195–8
 timbers used in, 190–1
 tools, 180, 190, 192–5, 199; *276*, *277*, *284*, *285*,
 289
 trade divisions, 201–2
woods:
 for frames, 135–6, 139, 146
 grain in, 78
 for panel painting, 73–5, 78
 stresses on, 74–5
 types for carving, 190–1; *273*, *287*
wove paper, 83–6; *123*
Wren, Sir Christopher, 15, 160, 184, 191
 perspectograph, 65, 66
Wright, Joseph, *The Corinthian Maid*, *30*
writer (brush), *123*; *173*

Yardley, George, 139

Zoffany, Johann, *A Gathering of Members of the
 Royal Academy in the Life Room*, *3*
Zuccari, Federico, *Michelangelo watching
 Taddeo Zuccari at Work*, *27*